To Ll___
and led the tour that
sparked Jill's interest in
Europe, especially Italy.
With great admiration
and thanks from Mary
and Dave

ART AND PATRONAGE IN THE MEDIEVAL MEDITERRANEAN

An important trade center in the medieval Mediterranean, Amalfi and the surrounding region of southern Italy produced unusual types of art and patronage from the eleventh through the thirteenth centuries. Merchant patrons realized a wide variety of religious and residential complexes that were evocative of Byzantine, Islamic, Western, and local ideas. The rise of the Angevin kingdom fueled the demise of this eclectic culture, and by the fourteenth century, Amalfitan painting and sculpture feature compromises between local and Neapolitan traditions, demonstrating the erosion of local autonomy.

This book evaluates Amalfitan art production in terms of moral, economic, and social structures, including investment strategies, anxieties about wealth and salvation, and southern Italy's diverse religious communities. Historiographical analyses and postcolonial models of interpretation offer further insight into Amalfitan art and its ever-shifting relation to the visual cultures of sovereign authorities in southern Italy.

Jill Caskey is an associate professor of fine art at the University of Toronto. A recipient of fellowships and grants from the Getty Grant Program, the Social Science and Humanities Research Council of Canada, the Samuel H. Kress Foundation, and the Fulbright Commission, she is also a Fellow of the American Academy in Rome. She received the Founders' Award from the Society of Architectural Historians in 2000.

Art and Patronage in the Medieval Mediterranean

MERCHANT CULTURE IN THE REGION OF AMALFI

JILL CASKEY
University of Toronto

PUBLISHED BY THE PRESS SYNDICATE OF THE UNIVERSITY OF CAMBRIDGE
The Pitt Building, Trumpington Street, Cambridge, United Kingdom

CAMBRIDGE UNIVERSITY PRESS
The Edinburgh Building, Cambridge CB2 2RU, UK
40 West 20th Street, New York, NY 10011-4211, USA
477 Williamstown Road, Port Melbourne, VIC 3207, Australia
Ruiz de Alarcón 13, 28014 Madrid, Spain
Dock House, The Waterfront, Cape Town 8001, South Africa

http://www.cambridge.org

© Jill Caskey 2004

First published 2004

Printed in the United Kingdom at the University Press, Cambridge

Typefaces Berthold Bodoni Light 10.5/15 pt. and Type Embellishments 2
System LaTeX 2$_\varepsilon$ [TB]

A catalog record for this book is available from the British Library.

Library of Congress Cataloging in Publication Data
Caskey, Jill, 1964–

 Art and patronage in the medieval Mediterranean : merchant culture in
the region of Amalfi / Jill Caskey.

 p. cm.

 Includes bibliographical references and index.

 ISBN 0-521-81187-2 (HB)

 1. Art, Italian – Italy – Amalfi Region. 2. Art, Medieval – Italy – Amalfi
Region. 3. Art patronage – Italy – Amalfi Region.
4. Merchants – Italy – Amalfi Region – History. I. Title.
N6919.A48C37 2004
709'.45'074 – dc22 2003066276

ISBN 0 521 81187 2 hardback

For Richard and Amelia

CONTENTS

⁓

List of Illustrations ⁓ viii

Abbreviations ⁓ xi

Acknowledgments ⁓ xiii

Introduction. The Art of *Mercatantia*: Medieval Commerce and Culture in Southwestern Italy ⁓ 1

Chapter One. The Experience and Politics of *Mercatantia* ⁓ 24

Chapter Two. Amalfitans at Home: Residential Architecture and Its Mediterranean Syntheses ⁓ 47

Chapter Three. Private and Public in Amalfitan Religious Space ⁓ 116

Chapter Four. Amalfi and the New Metropolis: The Decline of the Art of *Mercatantia* ⁓ 190

Notes ⁓ 243

Select Bibliography ⁓ 303

Index ⁓ 323

ILLUSTRATIONS

Note: Illustrations in text without credits are the author's.

1. Map of southern Italy and Sicily, with part of North Africa • 2
2. View of the Amalfi coast from Ravello toward Salerno • 4
3. Bronze doors of the Cathedral of Amalfi • 5
4. Plan of Atrani • 53
5. Amalfi, residential structures built over street • 54
6. Plan of Scala settlements, from southern Scala to northern Pontone • 55
7. Bell Tower, Cathedral of Amalfi • 58
8. Portal, Rufolo House, Ravello • 59
9. Cathedral and Monastery of Monreale, Cloister • 63
10. Plan, Rufolo House, Ravello • 70
11. The d'Afflitto residential compound with ruins of Sant'Eustachio, Pontone • 71
12. Entrance of the d'Afflitto House, Pontone • 73
13. Sasso House, Scala, early thirteenth century, hypothetical reconstruction • 75
14. Entrance tower of the Rufolo House, Ravello • 78
15. Dome of the entrance vestibule of the Rufolo House, Ravello • 79
16. Interior wall of the entrance vestibule of the Rufolo House, Ravello • 79
17. "Pavilion" tower, Rufolo House, Ravello • 80
18. Domed portico, Trara House, Scala • 81
19. Exterior wall of chapel with intarsia and inset column, Rufolo House, Ravello • 83
20. Entrance of Castel del Monte • 84
21. Castel Maniace, Syracuse, plan of *palatium* quarters • 85
22. Layout of the d'Afflitto House and Sant'Eustachio, Pontone • 87
23. Courtyard of the Rufolo House, Ravello • 88
24. Courtyard of the Rufolo House, Ravello, detail of ornament • 89

25. Courtyard of the so-called Palazzo Mansi, Scala • 90

26. Mosque of the Three Doors, Qayrawan • 91

27. Courtyard of the Vallenula House, Amalfi • 92

28. Cloister of Paradise, Cathedral of Amalfi • 93

29. Ivory oliphant, southern Italy • 95

30. Arabic stele from Pozzuoli • 97

31. Plans of three domestic baths from the region of Amalfi • 99

32. Bathing chamber of the South Toro House, Ravello, interior • 100

33. Cathedral of Caserta Vecchia, dome over the crossing • 101

34. Stucco dome of the Rufolo bathing chamber, Ravello • 104

35. Loggia or *sala* of the Rufolo House, Ravello • 105

36. Chapel of the Rufolo House, Ravello, detail of ornament • 106

37. Vaulted chamber with round ribs, Rufolo House, Ravello • 107

38. San Giovanni del Toro, Ravello, exterior, apse • 122

39. San Giovanni del Toro, façade • 122

40. San Giovanni del Toro, interior • 123

41. Plans of three private churches • 125

42. Bove pulpit, San Giovanni del Toro • 126

43. Small pulpit (or Guarna pulpit), Cathedral of Salerno • 127

44. Sant'Eustachio, Pontone, apse exterior • 129

45. Sant'Eustachio, Pontone, view of site of nave • 130

46. Cathedral of Monreale, apse exterior • 130

47. Prophet, spandrel fragment of the d'Afflitto pulpit • 131

48. San Michele Arcangelo, Pogerola pendentives and dome • 135

49. Central Ravello, with salient monuments in plan • 137

50. Nave, Cathedral of Ravello • 138

51. Ambo, Cathedral of Ravello • 139

52. Barisano of Trani, bronze doors, Cathedral of Ravello • 141

53. Plans of three cathedrals and their liturgical furnishings • 143

54. Nicola of Bartolomeo of Foggia, pulpit, Cathedral of Ravello • 145

55. Matteo of Narni, beams of dismantled ciborium, Cathedral of Ravello • 146

56. Cathedral of Ravello, interior, with hypothetical reconstruction of the Rufolo ciborium • 147

57. Large pulpit (or d'Ajello pulpit), Cathedral of Salerno • 148

58. Nicola of Foggia, lion column bases, Rufolo pulpit • 148

59. Nicola of Foggia, capital, Rufolo pulpit • 149

60. Nicola of Foggia, capital, Rufolo pulpit • 150

61. Rufolo pulpit, mosaic of the Virgin and Child • 150

62. Edmond Jean Baptiste Paulin, engraving of the Rufolo pulpit • 151

63. Matteo of Narni, capital of dismantled Rufolo ciborium • 153

64. Capitals of the dismantled Rufolo ciborium • 154

65. Fontana Moresca, Ravello • 155

66. Rufolo pulpit, detail of mosaics • 158

67. Ambo, Cathedral of Ravello, detail of Jonah's great fish • 159

68. Ambo, Cathedral of Ravello, detail of tesserae • 160

69. Two lustreware bowls from western Syria • 161

70. Bove pulpit, San Giovanni del Toro, detail of Islamic *bacini* • 162

71. The kidnapped Adeodatus, crypt of SS. Annunziata, Minuto • 163

72. Rufolo pulpit, detail of Rufolo heraldic devices • 171

73. Simone Martini, altarpiece of St. Louis of Toulouse • 173

74. Nicola of Foggia, door to the lectern stairs, Rufolo pulpit • 178

75. Nicola of Foggia, lectern base, Rufolo pulpit • 179

76. Guarna pulpit, lectern base with Abyssus, Cathedral of Salerno • 180

77. Castel del Monte, console bust • 181

78. Cathedral of Lucera, pier articulation in nave • 197

79. Reconstruction of the Spina family pulpit, SS. Annunziata, Minuto • 201

80. Crucifixion, Cloister of Paradise, Amalfi • 206

81. Roberto d'Oderisio, Crucifixion, from San Francesco, Eboli • 207

82. Followers of Pietro Cavallini, Crucifixion, formerly in Santa Maria Donna Regina, Naples • 213

83. *Noli me tangere* addition to the Bove pulpit, San Giovanni del Toro • 214

84. Pietro Cavallini, *Noli me tangere*, San Domenico Maggiore, Naples • 215

85. Stucco relief of St. Catherine of Alexandria, San Giovanni del Toro • 217

86. Detail of relief of St. Catherine of Alexandria, San Giovanni del Toro • 219

87. Pacio and Giovanni Bertini (?), scenes from the life of St. Catherine of Alexandria, originally in Santa Chiara, Naples • 221

88. Tomb slab of Sapia de Vito, Santa Chiara, Ravello • 225

89. Tomb of Marinella Rufolo Coppola, crypt, Cathedral of Scala • 226

90. Background relief of the Dormition and Assumption of the Virgin, tomb of Marinella Rufolo Coppola • 227

91. Roberto d'Oderisio, Coppola Polyptych • 229

92. Tino di Camaino, tomb of Catherine of Austria, San Lorenzo Maggiore, Naples • 233

93. Upper canopy, tomb of Marinella Rufolo Coppola • 235

ABBREVIATIONS

FREQUENTLY CITED SOURCES

Aggiornamento AIM	*L'art dans l'Italie méridionale: L'aggiornamento dell'opera di Émile Bertaux*, ed. and dir. Adriano Prandi (Rome, 1978).
É. Bertaux, *AIM*	*L'art dans l'Italie méridionale* (Paris, 1903).
G. B. Bolvito, "Registri"	Giovanni Battista Bolvito, "Registri dele cose familiari de casa nostra," Biblioteca Nazionale, Naples, Fondo San Martino 101 and 102.
M. Camera, *Memorie*	Matteo Camera, *Memorie storico-diplomatiche dell'antica città e ducato di Amalfi* (Salerno, 1876 and 1881).
J. Caskey, "Rufolo Palace"	Jill Caskey, "The Rufolo Palace in Ravello and Merchant Patronage in Medieval Campania," Ph.D. dissertation, Yale University, 1994.
M. Del Treppo, *Amalfi medioevale*	Mario Del Treppo, "Amalfi: Una città del Mezzogiorno nei secoli IX–XIV," Part 1 in *Amalfi medioevale*, by Mario Del Treppo and Alfonso Leone (Naples, 1977).
Inferno, *Purgatorio*, or *Paradiso*	Dante Alighieri, *La Divina Commedia*, ed. C. H. Grandgent and Charles S. Singleton (Cambridge, 1972).

FREQUENTLY CITED JOURNALS AND REFERENCE MATERIALS

AB	*The Art Bulletin*
Apollo	*Apollo, Bollettino dei musei provinciali nel Salernitano*
ASPN	*Archivio storico per le province napoletane*
BA	*Bollettino d'arte*

DBI	*Dizionario biografico degli Italiani* (Rome, 1973–present)
DOP	*Dumbarton Oaks Papers*
EAM	*Enciclopedia dell'arte medievale* (Rome, 1992–2000)
JSAH	*Journal of the Society of Architectural Historians*
MÉFR	*Mélanges de l'École française de Rome*
NN	*Napoli Nobilissima*
QFIAB	*Quellen und Forschungen aus italienischen Archiven und Bibliotheken*
RCCSA	*Rassegna del Centro di cultura e storia amalfitana*
RJK	*Römisches Jahrbuch für Kunstgeschichte*
RSS	*Rassegna storica salernitana*
ZKg	*Zeitschrift für Kunstgeschichte*

MANUSCRIPT SITES AND COLLECTIONS

ASN	Archivio di Stato, Naples
BNN	Biblioteca Nazionale, Naples
Cava	Archivio dell'Abbazia della Trinità, Badia di Cava
FSM	Fondo San Martino

MANUSCRIPT TRANSCRIPTIONS AND EDITED VOLUMES (FULL CITATIONS IN BIBLIOGRAPHY)

CDA	*Codice diplomatico amalfitano*, ed. Riccardo Filangieri di Candida
CDBarlettano	*Codice diplomatico barlettano*, ed. Salvatore Santeramo
PAVAR	*Le pergamene degli archivi vescovili di Amalfi e Ravello*, ed. Jole Mazzoleni et alia
CP	*Il Codice Perris*, ed. Jole Mazzoleni and Renata Orefice
RCA	*Registri della Cancelleria Angioina*, ed. Riccardo Filangieri, Jole Mazzoleni et alia
AMA	*Gli archivi dei monasteri di Amalfi*, ed. Catello Salvati and Rosa Pilone
PAVM	*Le pergamene dell'archivio vescovile di Minori*, ed. Vincenzo Criscuolo
SNSP	*Le pergamene amalfitane della Società napoletana per la Storia Patria*, ed. Stefano Palmieri

ACKNOWLEDGMENTS

MANY INDIVIDUALS AND INSTITUTIONS ON BOTH SIDES OF THE ATLANTIC AND 49th parallel have facilitated or enriched the research presented here. First among the many friends, colleagues, and teachers whom I would like to thank for their support are Walter Cahn, Charles McClendon, Creighton Gilbert, George Hersey, Jonathan Bloom, Maria Georgopoulou, the late Robert Bergman, Paul Binski, and Caroline Bruzelius. Their early interest in this project helped get it off the ground.

Twenty years of friendship and conversations with Elizabeth White Nelson have influenced this project in more ways than I can count. Many others have offered invaluable feedback or logistical assistance along the way, including Francesco Aceto, Samuel Albert, Melissa Calaresu, Anthony Cutler, Giuseppe Dardanello, Mario Del Treppo, Mario d'Onofrio, Julian Gardner, Pierluigi Leone de Castris, Robert Mason, Valentino Pace, Paolo Peduto, Ferdinando Serritiello, Kim Sexton, François Widemann, Nino Zchomelisde, and my friends and colleagues at the University of Toronto, particularly Evonne Levy. Many thanks also to Heather Coffey, Gabriella Corona, Ruth Kockler, Danielle Lam-Kulczak, Lino Losanno, Maria Laura Marchiori, Margaret Trott, and Monique Twigg, whose commendable skills helped bring the book and its illustrations to fruition. I would also like to express my gratitude to the students in my 2002 graduate seminar, who enthusiastically embraced and skillfully critiqued many of the ideas presented here; and to my parents, who have supported my academic tendencies for as long as I can remember.

I remain indebted to friends and colleagues at the Soprintendenze dei Beni Architettonici of Salerno and Naples, the Centro Universitario Europeo at the Villa Rufolo in Ravello, the Biblioteca Nazionale and the Archivio di Stato in Naples. Enzo Cioffi of the Abbazia della Trinità, Cava de'Tirreni, and Don Pepino

Imperato of San Pantaleone, Ravello, assisted with my archival research at Cava and the Cathedral of Ravello, respectively. Most critically, Giuseppe Cobalto, Giuseppe Gargano, and Ezio Falcone of the Centro di cultura e storia amalfitana in Amalfi not only provided encouragement and support, but car rides and conversations during more than a decade of visits. Thanks in no small part to them, my sojourns there were always full of discovery and adventure, from landslides and road closures to blazing sun and rejuvenating visits to off-the-beaten-track *medievalia*.

This book would not have been completed without the financial support of many institutions. The postdoctoral grant I received from the Getty Foundation in 1999 was pivotal, as it allowed me to set aside my teaching and administrative obligations for a year. During those months I was able to push my research in the new directions presented here. Other organizations that have generously supported my work are (in reverse chronological order) the Social Science and Humanities Research Council of Canada, the Connaught Fund of the University of Toronto, the Center for Advanced Study in the Visual Arts at the National Gallery of Art in Washington, D.C., the Samuel H. Kress Foundation, the American Academy in Rome, the Fulbright Commission, and Yale University.

And last but not least, Richard has brought keen insight and humor to all phases of this and many other projects. It is to Richard and Amelia that I dedicate this book.

ART AND PATRONAGE IN THE MEDIEVAL MEDITERRANEAN

The Art of *Mercatantia*: Medieval Commerce and Culture in Southwestern Italy

It is believed that the coast from Reggio to Gaeta is nearly the most delightful part of Italy. Fairly close to Salerno there is a coast that looks out over the sea, which the inhabitants call the Amalfi coast, that is full of small towns, gardens, and fountains, and men rich and proficient like no others in the act of *mercatantia*.

Giovanni Boccaccio, *Decameron* (Gior. 2, Nov. 4)[1]

T HE TOWN OF RAVELLO STRETCHES ALONG A NARROW PLATEAU, TOWERING three hundred meters above the valleys of the Sorrentine peninsula and the Tyrrhenian Sea (Figs. 1 and 2). It is a quiet place, now known primarily for its breathtaking views and cherished distance from the bustling metropolis of Naples. Yet in spite of its sleepy character, its numerous church doors and residential gates open perspectives onto a vibrant yet little-known medieval culture; they give way to spaces enlivened by soaring vaults, imposing liturgical furnishings, bold and sumptuous mosaics, delicate inlaid architectural ornament, and inscriptions identifying the families who commissioned the works of art. These monuments testify to the town's remarkable prosperity in the eleventh, twelfth, and thirteenth centuries, and to the richness of the tradition of merchant patronage that Ravello, along with other settlements that comprised the former Duchy of Amalfi, sustained for several generations.

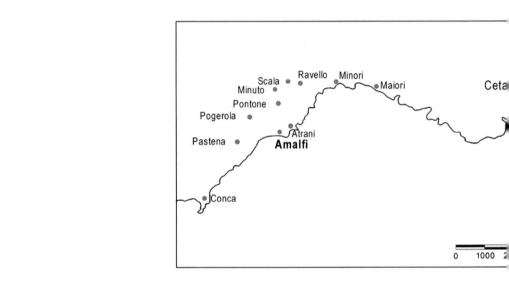

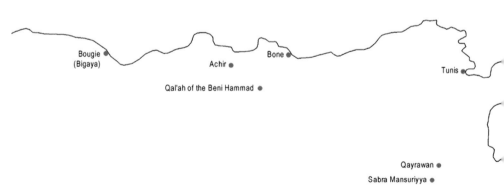

1. Map of southern Italy and Sicily, with part of North Africa (Danielle Lam-Kulczak).

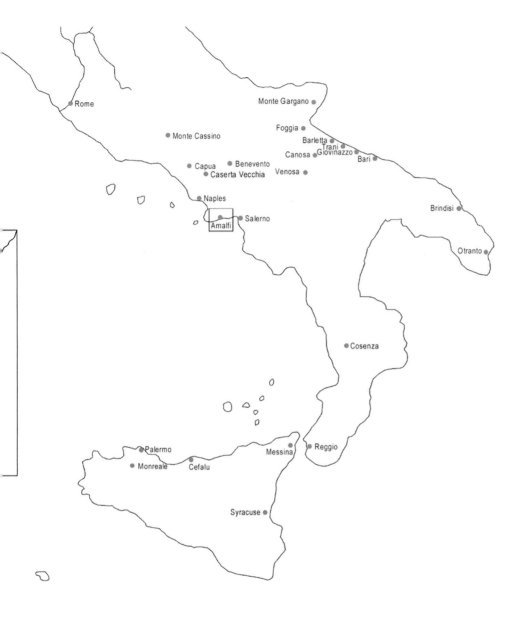

Rome

Monte Gargano ●

Foggia ●

Monte Cassino ●

Barletta ●
Trani ●
Canosa ● Giovinazzo ●
● Capua ● Benevento Bari ●
● Caserta Vecchia Venosa ●

● Naples

Brindisi ●

● Salerno
Amalfi

Otranto ●

Cosenza ●

● Palermo
Messina ● Reggio ●
● Monreale Cefalu

Syracuse ●

0 100 km

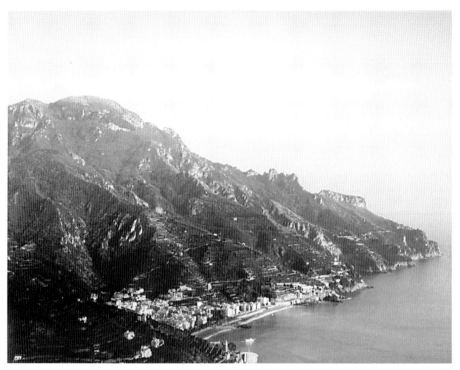

2. View of the Amalfi coast from Ravello toward Salerno.

In the case of one artistically rich site, the Cathedral of Amalfi, works of pronounced material and stylistic variety range from the bronze doors made in Constantinople around 1061 to the crypt, transept, and bell tower that were embellished after the translation of the relics of St. Andrew in 1208[2] (Fig. 3; see also Fig. 7, Chapter 2). Other buildings in the region, including vaulted domestic halls and domed bathing chambers, employ architectural forms typical of Islamic, Byzantine, Romanesque, and Gothic idioms. Although all of them were products of artists or patrons in the region, such works seemingly have little in common, and their eclectic forms elude art history's traditional systems of classification. This book argues, however, that such monuments were products of a coherent yet shifting late medieval culture that was both specific to the region and indebted to various forces well beyond its boundaries.

Completed in 1353, Giovanni Boccaccio's *Decameron* provides an evocative and useful framework for considering the coastal region's medieval art and culture and its marked heterogeneity. In a meditation on the whims of *Fortuna*, Boccaccio astutely described the coast of Amalfi as "full...of men rich and proficient like

no others in the act of *mercatantia*."[3] *Mercatantia*, a term with many nuances of meaning and no exact equivalent in English, refers to trade and the principles guiding it, to merchandise, and to commercial transactions. It evokes the broad cultural framework of a commercial society and a variety of activities that take place within it.

This book introduces a concept related to Boccaccio's act of *mercatantia*, the *art* of mercatantia. It reconstructs, through analyses of works of art and architecture commissioned by people involved in commerce, sophisticated episodes of lay patronage around Amalfi in the twelfth and thirteenth centuries.[4] Incorporating

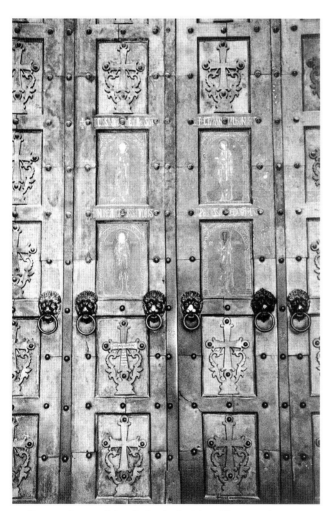

3. Bronze doors of the Cathedral of Amalfi, ca. 1061.

old components with new, local with imported, and subtle with ostentatious, the art of *mercatantia* draws from varied artistic currents in the Mediterranean basin and relates to sites of Amalfitan mercantile endeavors.

The significance of these works extends beyond the implications of their eclectic forms; they delineate a web of material, economic, social, and political interaction. The art of *mercatantia* signifies monuments variously rooted in and responding to a culture shaped by the prevalence of commerce. Paid for with profits from and created with materials made available through the act of *mercatantia*; informed by experiences and works of art observed during the process of *mercatantia*; guided by concepts and ethics derived from the practice and discourse of *mercatantia*; embodying the tensions of this society in which *mercatantia* was prevalent – the art of *mercatantia* contains these and other possibilities.

Boccaccio's invocation of Amalfitan commercial prowess introduces a tale concerning one Landolfo Rufolo of Ravello. This Landolfo risks his vast fortune on a shipment of goods bound for Cyprus, suffers a series of tragic losses, and yet manages to return to Ravello a rich though humbled man. As is the case with so many of the *Decameron*'s colorful characters, Landolfo is an embellishment of a historical figure, Lorenzo Rufolo.[5] Lorenzo, like Landolfo, was from Ravello, was immersed in Amalfi's culture of commerce, and led a life of untold wealth and abject loss. Although both shared a love of lucre, they courted it in different ways. Lorenzo belonged to the third generation of the financially minded Rufolo family to serve in the administration of the Kingdom of Sicily. The positions that he and his father, uncles, and grandfather occupied as merchants, tax collectors, and inspectors of ships and ports not only brought them generous compensation, but also facilitated the family's patronage of daring works of art and architecture in the 1260s and 1270s. The fictional Landolfo was first a merchant, as Lorenzo's elders had been, and then a ruthless pirate following financial collapse in Cyprus – Boccaccio's creative critique of Lorenzo's line of work, to be sure. But while *Fortuna* guided Landolfo back to Ravello after his brushes with poverty and death, Lorenzo did not fare as well. He was accused of corruption in 1283, arrested, imprisoned, and executed by the royal authorities whom he was commissioned to serve.

Drawing on a rich array of material and textual evidence,[6] this study reconstructs a tradition of merchant patronage that spanned two hundred years and shaped both domestic and religious environments in the coastal region. It examines in detail the culmination of that tradition, the art and architecture associated

with two generations of the Rufolo family, headed by Nicola as paterfamilias (d. ca. 1287) and his son Matteo (d. ante 1294), Lorenzo's father. The most significant Rufolo works date from the 1260s and 1270s and include a pulpit and ciborium fashioned of marble and mosaic, both located in the Cathedral of Ravello, and a sprawling residential complex adjacent to it (see Figs. 10 and 54). Other essential works, namely, the tomb of Marinella Rufolo Coppola and altarpiece of the Assumption of the Virgin (both dated to the 1330s) for the crypt of the Cathedral of Scala, belong to the era of dispersal and decline following Lorenzo's death and the family's fall from grace in 1283 (see Figs. 89 and 91).

The Rufolo commissions, along with earlier and contemporary works of merchant patronage, demonstrate that Amalfitan taste was wide ranging and embraced varied artistic idioms. From ribbed vaults of nearly canonical Gothic form to patterns of inlaid ornament resembling Islamic ivories, the works testify to the eclectic taste of the region's inhabitants. The works are also indebted to the cultural and ethnic diversity of the South. During the later Middle Ages (ca. 1000–1300), southern Italy and Sicily included Latin, Greek, French, Jewish, and Muslim inhabitants. Communities of Muslims, for instance, are thought to have resided at various times in Cetara, Atrani, Pozzuoli, Naples, and near Capua.[7] Along with the broad cultural horizons of the well-traveled merchants, mixed populations contributed to the unusually eclectic nature of the South's art. Because many merchant commissions were also animated by secular and political impulses, the works of art studied here illuminate laicization, eclecticism, and multiculturalism at the core of the region's visual culture in the Middle Ages.

The grand scale of Rufolo patronage belies the family's humble origins. By the year 1000, the Rufolos owned modest parcels of cultivated land around Minori, the seaside town below Ravello, and in Ravello proper. Upon entering into commerce, banking, and ecclesiastical affairs, the family prospered in the 1100s, and by the middle of the thirteenth century it had accumulated a vast fortune. During the 1260s and 70s, they commissioned several monuments, including the house and cathedral furnishings. The very activities and responsibilities that brought generous compensation and facilitated their artistic patronage, however, may also have spelled their demise.

Among the Rufolos' debtors was the king of Sicily, Charles I of Anjou. Facing the calamity of war with Aragon and ripples of social unrest in the wake of the Vespers rebellion in Sicily, the king's son, Charles of Salerno (the future Charles II), charged father and son Matteo and Lorenzo Rufolo with corruption

in 1283.[8] Following a swift trial, only Matteo escaped execution. These events dealt a crippling blow from which the family never fully recovered. Boccaccio's creative take on the Rufolo story sealed the family's notoriety for centuries to come.

The outlines of these events, as well as Boccaccio's version of them, suggest that the Rufolos and the other Amalfitans involved in commerce faced considerable challenges and risks. Theirs was an era of shifting economic paradigms and related artistic, social, and political uncertainties. During the twelfth and thirteenth centuries, the heyday of merchant patronage, Christian values of justice and austerity clashed with the financial practices of nascent capitalism.[9] The results of these practices – newly available wealth and imported merchandise – brought forth new conceptions of luxury, display, and urban and domestic space. Furthermore, the South's diverse population and varied visual cultures faced suppression in the name of an expanding and unified *Christianitas*, a process fueled by the newly installed Angevin dynasty and its commitment to northern European ideals.[10] This setting of social conflict and transformation is fundamental to the creation and interpretation of the art of *mercatantia* in its heyday, from the mid–eleventh through the late thirteenth century. Such conflict is especially critical to understanding the demise of that culture, which the story of the Rufolos helps to illuminate.

Mercatantia and Its Methodological Implications

Boccaccio's moralizing tale both inspires and anchors this study. His unflattering depiction of Landolfo, who embodies the problematic status of wealth and merchants in an era that deemed greed a mortal sin, illustrates the social and economic tensions that underlie commerce and the practice and commissions of merchant patronage. Banking and commercial activities engendered harsh, even damning critiques from the spiritual authorities who shaped many of the West's laws and ethical codes, as explored subsequently. In the era of Lorenzo and, two generations later, of Landolfo, the new ways in which wealth was exchanged, accumulated, and even displayed elicited profound theological, social, and psychological discomfort, as was recently the case with the advent of dot-com investment. Such tensions are critical to this analysis of Amalfitan art.

Boccaccio's language is also central to this study because it conveys conceptual keys to the world of southwestern Italy in the later Middle Ages. His characterization of the denizens of the Amalfi coast as "proficient like no others in the act

of *mercatantia*" is both astute and surprising. His claim of Amalfitan commercial superiority is somewhat unexpected; it challenges the economic preeminence of Tuscany as understood in his own time and as reiterated in decades of modern scholarship.[11] It also evokes similar tensions and imbalances in modern art historical practice, which for generations has enshrined Tuscan and particularly Florentine art of the later Middle Ages as emphatically modern, and that of the South as conservative if not *retarditaire*, separate, and above all marginal to the discipline's priorities.

Although perhaps controversial even in its time, Boccaccio's view of medieval economics is sound, particularly in reference to the centuries that preceded his own. Amalfi's commercial prowess was established centuries before the rise of central Italian economic powerhouses such as Florence and Pisa. Often mythologized, this early success is supported by compelling documentary evidence.[12] The Lombard prince of Benevento Sicard conceded an unusual freedom to travel to the Amalfitans (*de Amalfitanus qualiter peragantur*) in his *Pactum* of 836.[13] And travel they did. Chronicles and medieval privileges reveal that Amalfitan merchants traded in Cairo, Constantinople, Antioch, and even Cordova as early as the tenth century, and that they had sizable communities in Jerusalem by the second half of the eleventh.[14] The Amalfitans quickly established a profitable circuit, trading grain, oil, and lumber for silks and spices in Byzantium, Syria, and Egypt; they then returned to Italy via Aghlabid North Africa and Sicily, where they sold some of their wares for gold, a rare commodity in the West at that time. The fact that Fatimid and Byzantine currencies were used in local transactions in the tenth and eleventh centuries also demonstrates the early impact of long-distance trade on the region.[15] No wonder, then, that the twelfth-century chronicler William of Apulia wrote that Amalfitan merchants "traverse many seas" and are "well known around the world," familiar to "Arabs, Libyans, Sicilians, and Africans."[16]

The activities of Amalfitans throughout the Mediterranean basin brought distinction to their *patria*. Around 977, the Baghdadi merchant Ibn Hawqal described Amalfi as "one of the most prosperous and beautiful of the cities that enjoy the best conditions and are distinguished by their wealth and opulence." He even deemed the ancient and nearby city of Naples "inferior to Amalfi for many reasons."[17] Outside the region, the cachet of Amalfi lingered well after its heyday. The inhabitants of distant Capua, for instance, endowed annual prayers for the dead with Amalfitan *tarì* more than a century after that currency ceased to be minted.[18] In matters as critical as salvation, the Capuans apparently did not take chances with the newfangled florin or *reale*.

Surrounding hilltop and seaside settlements prospered as well. Inhabitants of the many towns of the former Duchy of Amalfi, including Ravello, Scala, and Atrani, also worked in many aspects of long-distance trade.[19] Relative to the centers that fueled the West's so-called Commercial Revolution, such as Marseilles, Bruges, and Lübeck, these coastal towns were precocious; their economies peaked a century before cities to the north came to dominate European and eastern Mediterranean markets.

Boccaccio's observations regarding the structures of Amalfitan trade are similarly sound. The "act of *mercatantia*," the key phrase in this passage from the *Decameron*, signifies the activity of engaging in trade, commerce, or exchange; it does not specify or limit the nature of participation.[20] Boccaccio's use of the term is thus apt because most Amalfitans were engaged in some form of commercial activity.[21] Those active in trade were not limited to a particular legal, social, or economic class, as one sees in often-studied settings such as fifteenth-century Florence or Bruges. Another indication of the widespread nature of mercantile activity is the fact that members of most social and professional groups around Amalfi, and all the faith communities in the South (Jewish, Christian, and Muslim), participated in commercial ventures.

Some of these merchants amassed immense wealth, while others maintained modest incomes. Those who attained social, economic, and patronal distinction tended to be active in overseas trade and to possess significant agricultural and naval resources. Despite their achievements and power, however, the Rufolos and their contemporaries were rarely referred to as merchants in their day. Little wonder that Boccaccio, born of a merchant family himself, used the accommodating *mercatantia* to describe Amalfitan proclivities, because the word evokes varied activities practiced by a range of people and is therefore far more accommodating than the specific, limited, and limiting noun "merchant."[22]

Throughout the *Decameron*, and in other early vernacular texts, *mercatantia* also yields an abstract sense of the principles guiding commerce. In still other cases, it refers to merchandise, whether goods on a ship or in a shop, or to financial transactions, whether cash loans, exchanges of goods, or even prostitution. Enlivened by its active, abstract, and material associations, *mercatantia* has many synonyms in English, but no single word embodies all its meanings.[23] Given the applicability of the term to a range of skills, economic activities, cultural structures, and material goods, *mercatantia* eloquently encapsulates the dominant characteristic of Amalfitan culture and the individuals who helped shape it.[24]

This book portrays the art of *mercatantia* as a cultural manifestation of the late eleventh, twelfth, and thirteenth centuries. It first establishes the general parameters of merchant experience in the region of Amalfi in an analysis interwoven with a narrative of the Rufolo family's rise and fall (Chapter 1). This assessment is the first scholarly reconstruction of the family's history from its origin through ca. 1400. The study then proceeds to focus on two principal sites of patronage: first, domestic architecture, as defined by various types of housing in the region of Amalfi (Chapter 2); and second, private and public religious environments (Chapter 3). While establishing the dominant characteristics of the art of *mercatantia* in both settings, this study also examines the demise of the conventions that had fueled Amalfi's visual culture and the various pressures that precipitated that decline. This waning of the art of *mercatantia* in the fourteenth century is discussed in Chapter 4.

The Works of Art

While this study examines works of art associated with merchant patrons from ca. 1060 to 1350, it emphasizes the largest and best-preserved ensemble of the art of *mercatantia* in the region of Amalfi, those commissioned by the Rufolos of Ravello. It is the first detailed art historical study of all but one of the individual Rufolo monuments. The works of art are representative of tendencies in Amalfitan patronage; each is coincident with groupings of local monuments, which offer formal, typological, material, or stylistic comparisons and which also inhabit the illuminating matrix of *mercatantia*.

Largely constructed from ca. 1260 to 1283, the House of the Rufolos is a rare and splendid example of medieval domestic architecture in the West. Related in type to the many medieval dwellings that still punctuate the Amalfitan landscape, it is a complex of interrelated buildings scattered across uneven terrain. The house employs a wide range of architectural and decorative strategies. Some structures evoke princely architecture in North Africa and Sicily, while others, like the so-called Sala (actually an open loggia), feature Gothic idioms[25] (see Figs. 10, and 35, Chapter 2).

The varied and differentiated spaces of the residential complex demonstrate a keen awareness of the decorative, formal, and ideological underpinnings of medieval housing types located around the Mediterranean basin. The house echoes grandiose Roman villas and their Byzantine and Islamic successors (e.g., Hadrian's Villa at Tivoli, the Great Palace of Constantinople, and the Alhambra).

As such, the Rufolo House epitomizes the multicultural scope of the art of *mercatantia*. But at the same time, the complex, as well as other medieval houses in the area and archival sources, illuminate the gradual expansion and elaboration of domestic architecture in coastal Campania. This phenomenon took place in southern Italy nearly two centuries before more touted examples in Avignon, Florence, and Paris.

Embodying the ambitions and tensions of the art of *mercatantia*, the house is a formidable protagonist in early narratives of the Rufolos' rise and fall. Reminiscent of Vaux-le-Vicomte, the splendor of which contributed to the imprisonment of its owner Nicholas Fouquet, the residence reputedly sparked a fatal case of palace envy. Early modern writers such as Giovanni Battista Bolvito (d. 1593), who penned the first vernacular history of the region, claimed that its sumptuousness sparked the ire of the Angevin king and precipitated the family's fall from royal favor.

Of great interest and significance in and of itself, the house derives some of its meaning from Rufolo commissions in the adjacent Cathedral of Ravello. Products of an aggressive redecorating campaign, the family's pulpit and ciborium display an abundance of sculpture and abstract and figurative mosaics of stone, glass, and ceramic tesserae. Some of these carvings are new and thoroughly up-to-date; others recycle older medieval pieces. While presenting iconographical themes established centuries earlier for liturgical furnishings, such as symbols of the evangelists and images of paradise, these works also display modern modes of visual expression, including heraldry, as well. They also mark the advent of lay patronage in the heart of episcopal space, an appearance that was unprecedented in southern Italy. This "privatization" of the cathedral draws its strength from the conventions of family church foundations that flourished in Amalfi and constituted a vital site of merchant patronage in the later Middle Ages.

In contrast to the Rufolo commissions in Ravello, with their resplendent polymaterial and eclectic forms emblematic of the art of *mercatantia*, Amalfitan art of the early fourteenth century signals the loss of cultural autonomy for the region and its increasing dependence on Angevin art production in Naples. These commissions include the remarkably intricate stucco tomb of Marinella Rufolo Coppola in the crypt of the Cathedral of Scala (ca. 1332) and the related altarpiece attributed to Roberto d'Oderisio, a figure associated with the Neapolitan workshops of Giotto and Pietro Cavallini (see Figs. 89 and 91, Chapter 4). These works illuminate the ways in which art forms born in and sanctioned by courtly

settings were desired and reinterpreted in locations distant from their source and signal the triumph of court-sanctioned aesthetics over the art of *mercatantia*.

New Directions and Orientations

Because most merchant commissions are not well known and are at times fragmentary, they require archaeological, formal, and stylistic contextualization – an essential process, but only the first of many steps. In the case of the Rufolo works, they must be evaluated as an ensemble.[26] This is an essential move for assessing their ultimate significance as products of a sustained campaign of merchant patronage and for identifying their departures from artistic and patronal conventions, both local and distant.

The concept of *mercatantia* is key to this interpretive process; the works of art engage the particular customs, practices, and institutions that framed and defined Amalfitan life. These structures, which were specific to the region of Amalfi, include investment procedures that were applicable to churches as well as to ships, cargo, mills, and vineyards; an emphasis on literacy, scribal techniques, and the monumentalization of contractual language; urban morphologies that blurred distinctions between public and private space; the legal rights and social prominence of women, derived from the fact that men were frequently absent from local affairs; and, most significantly for this study, a tradition of private patronage that began centuries before the activities of Giotto, Francesco di Marco Datini of Prato, or the Medici, the Rufolos' well-known counterparts who similarly engaged in artistic and commercial practices.

Some of the earliest evidence of this fertile tradition dates from ca. 1061, when the wealthy merchant and statesman Pantaleo of Maurus Comite donated a pair of bronze doors from Constantinople to the Cathedral of Amalfi[27] (Fig. 3). He followed suit with similar commissions at San Paolo fuori le Mura in Rome (1070) and the sanctuary of St. Michael the Archangel in Monte Sant'Angelo in Apulia (1076). His father Maurus donated an exquisite ivory box to Farfa or Monte Cassino and backed pious foundations in Antioch, Constantinople, and possibly Jerusalem. These and later monuments – for example, Barisano of Trani's bronze doors donated by Sergio Muscettola (1179) to the Cathedral of Ravello; the Bove family pulpit (ca. 1230) in San Giovanni del Toro, Ravello; the church of the d'Afflitto clan (late twelfth century) in Pontone – share significant features, such as imported materials, polymaterial and polychromy, and long, personalized dedicatory inscriptions. Demonstrating the increasingly private nature of

medieval art and worship and an attendant reduction in scale, these works constitute significant cultural antecedents for the Rufolo commissions of the later thirteenth century and help establish the parameters of a visual culture shaped by *mercatantia*.

Such works also delineate the broad horizons of Amalfitan merchant patrons. While this study interprets lay commissions and affiliated works in conjunction with the families and communities for whom they were made, it also places them within a network of artistic production that spanned southern Italy and the Mediterranean basin. Such a catholic approach recognizes the context of coastal Campania, where centuries of overseas trade, a heterogeneous population, and political autonomy fueled an eclectic culture in which a wealth of stylistic, material, and typological possibilities coexisted.[28] Some currents in painting, sculpture, and architecture flowed from Constantinople, for Amalfi's political and economic connections to Byzantium survived, albeit on a reduced scale, through the late Middle Ages. Concurrently, a range of material evidence testifies to intimate connections to Muslim North Africa and the Middle East, from the early appearance in Amalfi of the pointed arch to Amalfitan coinage that imitated Fatimid models as late as 1222. The ancient world provided another source for the rich cultural landscape, and it continued to exert a profound influence for many centuries after the collapse of Roman authority. Thus, art forms bearing the imprint of multiple cultures and faiths emerge as products of *mercatantia*.

The focus of this study diverges markedly from previous discussions of merchant culture, most of which describe fourteenth- and fifteenth-century Tuscany, a context as central to the disciplinary priorities of economic history as to those of art history. Art and architecture are often marginal to discussions of this culture of distinct preferences and priorities. The few documented cases of merchants selling works of art, such as Francesco di Marco Datini in Avignon, have been noted; but studies of the art market or what could be characterized as merchant art generally concentrate on later eras in Italy or northern Europe.[29] Deborah Howard's *Venice & the East* is an exception to this rule; although it focuses on an unusually broad range of visual and literary evidence, many of its compelling sources and monuments are later in date than the ones analyzed here.[30] In other discussions, an occasional statement offers promising glimpses of what could become a significant subject for central Italy and, by extension, the South.[31]

Whereas this study and Howard's engage material, structural, and institutional features, other writers have tended to portray the merchant culture of the later

Middle Ages as synonymous with the array of intellectual skills that engagement in commerce required, including competence in mathematics, navigation, reading, writing, and various languages.[32] Literacy and numeracy provided the foundations of a new rationalist economy, which expanded symbiotically with vernacular language, literature, and the use of cursive script, the rapid execution of which was ideally suited to the perceived fast pace of daily life.[33] Thus, the late medieval merchants of Tuscany are defined as key figures in the laicization of the West and are thus actively involved in the cultural accomplishments of the Renaissance.

Many of these conceptions of Florentine merchant culture were formulated as responses to critiques of industrialization and middle-class culture, particularly to the controversial theses of Werner Sombart.[34] Following his studies of 1913 and 1919, the salvation and even heroicization of the medieval merchant have been frequent projects of generations of renowned scholars, including Henri Pirenne, Armando Sapori, Robert Lopez, and David Herlihy.[35] Where Sombart found selfishness, Sapori et alia identified risk taking, the development of empirical reasoning, and self-sacrifice. They point out that the group Sombart portrayed as indifferent to literary culture produced writers such as Boccaccio, Giovanni Villani, and Franco Sacchetti and that the accounting techniques deemed inaccurate and disorganized are, once properly deciphered, mathematically competent and sophisticated records.

While working to recuperate the skills, "mental habits," and concerns of Tuscan merchants, such studies remain somewhat constrained by Sombart, who established the terms of the debate. They also privilege textual evidence directly related to trade, such as contracts, for instance, or household accounts. The premise of *mercatantia*, articulated by Boccaccio and conceptualized in this study, creates an alternative to the framework of that century-old debate. *Mercatantia* establishes new evidentiary parameters that are specific to Amalfi and that embrace works of art. These parameters privilege an array of material evidence and documents pertaining to (local) social history, although textual sources specifically relating to commerce are considered as well.

The Art of *Mercatantia* and Historiographical Constructions of the South

The concept of the art of *mercatantia* opens perspectives on southern Italy that differ significantly from previous views of the region. Since Émile Bertaux's

magisterial *L'art dans l'Italie méridionale: De la fin de l'Empire romain à la conquête de Charles d'Anjou* (1903), the story of southern Italian art generally has been told in terms of the commissions of political patrons and institutions – of early Lombard, Benedictine, or Basilian initiatives, for example, or later Norman and Hohenstaufen ones.[36] Effectively characterizing the South as an appendage to more important "centers," this emphasis has intensified in recent years, as most new research on the South concerns the ideological significance of royal works of art.

As fruitful as this approach has been, it limits our understanding of southern Italy in two fundamental ways. First, it tends to neglect locales distant from courtly or important monastic environments, such as Amalfi and surrounding towns. The art of *mercatantia* demonstrates that such sites fostered dynamic artistic traditions, including a pronounced eclecticism that was distinct from the varied styles found in settings that Bertaux and others have emphasized.[37] A second, related problem is that a focus on "power patronage" inevitably stresses discontinuity, casting southern Italian art as the product of a rapid succession of disparate sovereigns and their respective artistic idioms.

Historians and art historians have dealt with this apparent fragmentation in different ways. As the philosopher and historian Benedetto Croce wrote in his seminal *History of the Kingdom of Naples* (1925), "We have a history that is no history, a development that does not develop. Its notorious characteristic is to be at every step upset and interrupted."[38] Within his nonnarrative, Croce found some continuity in sectors of society that were distinct from foreign sovereigns. Wharton's interpretation of the art of the pre-Norman South makes a similar claim, as she finds value in the region's autonomy and resistance to any single hegemonic force.[39]

Whereas new generations of historians in the wake of Croce have chipped away at the relationship of the local to southern Italy's political culture, art historians tend to shy away from similar "thankless and difficult" tasks, as Croce described it.[40] The possibility of sustained cultural continuity on a local level is rarely entertained, and evidence of it not often weighed, particularly if it departs from Bertaux's classicizing ideal.[41] Where the local is addressed, it is often characterized as second-rate or imbued with connotative meanings that do not translate into broader, teleological fields.[42]

A related issue here is that Bertaux conceptualized the South's visual culture as rooted in classicism, but periodically shifting between Mediterranean and

northern European forces. This model has encouraged historians of many spe-
cializations to view the art of southern Italy as adjunct to their own fields. The
region's monuments, including those produced for noncourtly settings, are often
portrayed as provincial offshoots of sophisticated cultures centered elsewhere
and are characterized by the style, often *court* style, of a ruling dynasty – Nor-
man, Palaeologan, Angevin, and Fatimid, for example, with requisite connections
to centers such as Rome, Constantinople, the Île-de-France, and Cairo.

This tendency creates some problems. Although the nature of medieval art in
southern Italy readily accommodates a range of scholarly interests, and indeed
resists being placed within a single homogenizing framework (i.e., the Art of the
South), art historians seem predisposed to provincialize the region. Research
is framed, published, and disseminated for specialized scholarly communities,
whose territorial claims over the South increase with each new study. Yet such
strict specialization glides over the fact that most medieval works of art in southern
Italy cannot be categorized as purely Byzantine, Islamic, or western European,
terms that are problematic in such a multicultural context. Neither can they
readily be inserted into canonical taxonomies of form, a predicament that Croce
identified in 1893 in his seminal overview of art in southern Italy.[43]

The concept of *mercatantia* provides a path out of these methodological and
perceptual quagmires. It helps counteract the balkanization of southern Italian
art history, for it is inclusive and elucidates the integration of a variety of sources,
rather than emphasizing any single European or Mediterranean style, idiom,
or influence. Furthermore, it counterbalances the provincialization of southern
Italian art, for it underscores the continuity and vitality of a local culture. And
finally, it accommodates a diverse group of monuments of varied styles, which
span the eras of Romanesque and Gothic, yet in most cases correspond to neither
Romanesque nor Gothic stylistic paradigms. As such, *mercatantia* provides a
viable alternative to the predominant constructions of the South that depict its
art as either classicizing, proto-Renaissance, or outside the mainstream defined
by the "West" and northern Italy.

Flowing through the literature on medieval art in Italy is the *Questione del
Mezzogiorno* (Southern Question), which emerged following the Unification of
Italy in 1860 and calcified popular conceptions of the South as a backwater.[44]
The region was envisioned as a troubled yet promising area of the new country,
one that required serious intervention from more "civilized" northerners. The
development of the Southern Question coincided with the professionalization of

art history and with the pronounced interest among English-speaking scholars in the art of the Italian late Middle Ages, so it is reasonable to ask how it has affected views of medieval art.

Although the discursive practice of the *Questione* postdates the merchant culture of Amalfi by several centuries, it is relevant here because of the quiet ways in which it has shaped art historical research. In its assertions of the South as provincial, non-Western, and unsophisticated, the Question continues to magnify attitudes that were first articulated in the later nineteenth century. These include a tendency to emphasize the tyrannical and oppressive character of the South's medieval art, and thus to see it as less significant and heroic than contemporary "civic-minded" projects in the North (which were and remain better able to support the project of building Italian national identity and a sense of a shared culture of democracy in the West).[45] Likewise, classicizing works of art in the South have been emphasized over those with other features and their significance defined as foreshadowing the early Renaissance in Tuscany.[46] There has also been a tendency to label works of art "hybrid" and forego explorations of the implications of their form or of hybridity, a term derived from botany but one that is imbued with racist overtones in its contemporaneous applications to ethnography and art history.[47] Similarly, non-Western forms have been dismissed as exotic, even effeminate, and thus treated in an impressionistic, superficial way.[48] And finally, formalism has been maintained as the dominant mode of inquiry long after contextualization became a common approach to other Western medieval settings. In short, the Southern Question and various biases against the region, promulgated by a century of Italian politics and perhaps art historical preferences and practices, have meant that not many monuments of the South are included in dominant constructions of medieval art.

Insightful research by Aceto, Glass, Tronzo, Bruzelius, and others herald changes in attitudes, to be sure. But the discipline's provincialization and colonization of the South – its portrayal of its works of art as pale reflections of resplendent glories located elsewhere – continues, suggesting that the phantom presence of the Question still informs and constrains research. Students of the art of the South have not sought to identify or reconstruct sustained local autonomies with the same fervor displayed by legions of students of communal settings in central and northern Italy. Perhaps it is true that rich local contexts are less common in the medieval South; only time and research will tell.

Implications for Cultural History

The patronal activities of the Rufolos and their contemporaries partook of conventions and attitudes rooted in the precocious flowering of lay patronage in the eleventh century. The types of works of art commissioned, as well as their styles and materials, hark back to earlier traditions; their intended locations, similarly, suggest a continuity of spatial practices at least through the mid–thirteenth century. Such trends are not surprising. Earlier forms, customs, and social structures evoked the heyday, stability, and prestige of the region. In short, the Amalfitan culture of *mercatantia* can be characterized as residual, meaning that it continued to draw on older sources and conventions, rather than adopting wholesale the newer artistic currents found in metropolitan courtly and ecclesiastical settings.[49]

Amalfitan culture could also be described as an alternative one, relative to such authoritative contexts as Monte Cassino or Palermo. This alternative character likely derived from the unusual autonomy and prosperity of the Duchy of Amalfi before the year 1000. As an autonomous culture, Amalfitan *mercatantia* was generally tolerated by Norman (for Amalfi, 1073–1194), then Hohenstaufen (1194–1266) sovereigns, who did not, for example, suppress its private churches or vibrant traditions of bathing and bath architecture, two salient examples of Amalfitan artistic and cultural difference rooted in Mediterranean ideals.[50] But Frederick II introduced legislation that explicitly banned aspects of Amalfi's residual culture: the *Constitutions of Melfi* in 1231 outlawed Amalfi's use of Beneventan script and paper for official records, mandating the more legible curial hand and permanent parchment in their place.[51]

In some ways, this dictate was a turning point that announced the gradual cultural and religious homogenization of the South and weakening of the local as the kingdom aligned with northern Europe. By the later thirteenth century, the Mediterranean parameters of the art of *mercatantia* were challenged by rival modes and centers of cultural production. With the Angevin conquest of the South, official court patronage shifted away from the eclecticism of the Hohenstaufen. As Bruzelius has illuminated, Charles I insisted on French design in his architectural patronage, particularly after the rebellions of 1268, and seemingly forced *regnicoli* (inhabitants of the kingdom, or *Regno*) to master the requisite building techniques.[52] His patronage during those first decades must be described as imperialist. The king's espousal of French as the language of the court, with the creation of a French chancery and the presence of the poet and composer

Adam de la Halle, stands in marked contrast to Frederick II's linguistic stance, which accommodated, at times with ambivalence, the diversity of the kingdom: Frederick was the purported founder of one of the earliest schools of vernacular poetry in Italy, and his essential legal doctrines were disseminated in Latin, Greek, and, on rare occasion, Arabic.[53]

The political and economic structures of the kingdom, also reconfigured after the Angevin conquest, similarly suggest a powerful imperialist enterprise. Officially sanctioned migration from France, particularly but not exclusively from Provence, helped shift the balance of feudal power away from locals. In Sicily, for example, chancery documents from the 1270s tell the story of massive confiscations of estates, castles, mills and the like, so that nearly two-thirds of feudal holdings were in the hands of a new elite from Nice, Aix, Arles, and so on by 1280.[54] Similar concentrations of Provençal-controlled fiefs occupied the northern border of the kingdom, in the Abruzzi and Molise regions.[55] Although this process of reassigning valuable lands to northern newcomers was widespread, it was not systematic and failed to create unity among the kingdom's diverse feudal nobility.

The increasingly powerful and wide-reaching structures of governance destabilized extant power structures and relations between various groups of *regnicoli*. In the case of Sicily, locals participated in administrative affairs, but primarily only in the lower ranks, as notaries.[56] During the reign of Charles I, slightly fewer than half the officials were French, over a third were Amalfitan (including the Rufolos), and most of the remaining positions belonged to *regnicoli* from the Italian peninsula, not from Sicily itself. Thus the early political structures of the kingdom challenged local authority by placing the majority of power in the hands of "foreigners." Replicated throughout the kingdom, this imperialist structure sparked waves of discontent that finally erupted in the Vespers rebellion in 1282, as explored in the next chapter.

This broad framework of the cultural history of imperialism helps define art, whether local or metropolitan, as a salient expression of power. Relative to the Angevin political and cultural endeavors that strove to solidify the kingdom's French identity, Amalfi's merchant culture grew increasingly marginalized, and tolerant coexistence between the various cultural camps of the South became less and less viable. This emphasis on the cultural context and implications of the art of *mercatantia* helps underscore how the works of art embody a new and largely lay sensibility rooted in centuries of unprecedented prosperity, political and cultural autonomy, and cross-cultural exchange; but it also magnifies how this

sensibility destabilized extant power relations in the urban context of medieval Ravello, and also in the political and economic workings of the newly founded Kingdom of Sicily.

Paths of Medieval Cultural Influence

Although the art of *mercatantia* was a coherent, locally rooted phenomenon with autonomous traditions, its essential feature was its openness. Centered in the generally fluid field of Mediterranean art, it was open to ideas and forms emanating from diverse institutional and geographical settings. These included Monte Cassino, for example, as the configuration and decoration of the three principal churches of Ravello attest (the cathedral, Santa Maria in Gradillo, and San Giovanni del Toro); the courts of ruling dynasties, as exemplified by the d'Afflitto clan's church of Sant'Eustachio in Pontone, with its formal and icono-graphic echoes of the Normans in Sicily; and authoritative institutions in sites of commercial activity, as with the Castellomata family's church of San Michele in Pogerola, a miniature version of the quincunx Myrelaeion in Constantinople. These and other cultural spheres intersected with Amalfi's, but during the twelfth and thirteenth centuries, the heyday of merchant patronage, no single external force dominated Amalfi's art of *mercatantia*.

Amalfi itself was also a source in this fluid context. One of the earliest com-missions of merchant patronage, Pantaleo's bronze doors of the Cathedral of Amalfi, placed the visual culture of the coast at the center of a new Benedictine aesthetic.[57] This well-documented path of influence, often retraced in scholar-ship, testifies to the splendors of the mercantile center on the eve of its fall to the Normans. The Bishop of Ostia Leo Marsicanus wrote that the abbot Desiderius of Monte Cassino traveled to Amalfi in 1065 to purchase gifts for the emperor Henry IV. The abbot was so favorably impressed by the bronze doors of the cathedral ("Videns autem tunc portas ereas episcopii Amalphitani, cum valde placuissent oculis eius") that he commissioned similar ones for the new abbey church.[58]

A Cassinese redaction of Leo's chronicle notes that masons from Amalfi helped construct the Benedictine monastery.[59] It has been posited that key fea-tures of the Desiderian aesthetic, including pointed arches and cross vaults, de-rived from Amalfi via Aghlabid and Fatimid buildings in North Africa, such as the mosques in the towns of Qayrawan and Mahdiyya, both sites of Amalfitan commercial activity.[60] Filtered through Amalfi, the North African forms entered

the Benedictine lexicon that revolutionized large-scale building in southern Italy, Sicily, Rome, and, according to some, Burgundy and beyond.

This and other episodes regarding Amalfitan merchant art call into question generalizations concerning the direction of cultural influence and production in the later Middle Ages. Interpretations of medieval art tend to begin with the assumption that taste and related cultural practices were established at the pinnacle of power structures and "trickled down," inevitably and mechanistically, to more humble members of society – from cathedral to parish church, from prince to burgher. Such a view is in part dependent on the fact that elite circles are well represented by extant medieval evidence; it also reflects the discipline's general preference for "quality" works assumed to derive unproblematically from elite settings.

Thus it is not surprising that if medieval merchant art is mentioned in scholarly literature, it is generally dismissed as insignificant or debased. Jacques Le Goff, for one, has suggested that the concept of medieval merchant art merits attention, although he warns of the methodological dangers and possible disappointments of the topic; merchant art would likely reflect the taste of the nobility and consequently not address mercantile experience per se.[61] Similarly, Oleg Grabar has posited that commercial acumen and experience do not necessarily spark sophisticated artistic activity or cultural exchange. "Why should art reflect . . . trade?" he asks. "Although not entirely fair, the comparison can be made with contemporary technicians and businessmen who stay at Hilton Hotels and buy rugs in their shops."[62] Even Frederick Antal's Marx-inflected assessment of Florentine painting gives way to negative essentializing about mercantile taste and class.[63]

These perspectives recall Thorstein Veblen's view, first articulated in 1899 and reiterated by many subsequent anthropologists and sociologists, that humans instinctively imitate their social superiors and that all cultural movement is therefore downward on the socioeconomic scale.[64] Although recent studies in medieval history have underlined cases of the reverse, of "popular" informing elite, neither of these premises adequately describes the web of cultural and artistic interaction that the art of *mercatantia* embodies.[65]

Concepts of cultural influence elaborated in recent critiques of imperialism are better able to encompass the variations and vicissitudes of Amalfitan artistic production and its place in the Mediterranean basin. They also adeptly explain the Amalfitans' ambivalent and ever-changing relationship to sovereign or metropolitan authorities and their visual cultures, and vice versa. This easy

fit derives in part from the fact that postcolonial critiques begin with a premise of cultural, ethnic, or religious differences – an essential move for assessing the diverse artistic traditions, social structures, and populations of Amalfi and the South. Furthermore, their central Gramscian supposition – that the relationship between governed and governing is dynamic, prone to cross-fertilization, and subject to change – helps draw out certain features of Amalfitan art and illuminates the precarious status of patrons like the Rufolos.[66] Such formulations, unlike traditional "trickle down," "exotica," classicizing, or orientalist theories, instate art and architecture within the varied matrices of power in the South.

Mercatantia constitutes an encompassing and positive framework for Amalfitan culture in general, shaping and infiltrating many dimensions of social and cultural life. As an interpretive tool, *mercatantia* reveals Amalfitan art as a coherent, meaningful expression of Mediterranean or commercial culture. Its advantages are many: it facilitates differentiating Amalfi from the more familiar and canonical centers of medieval art production, such as royal and imperial courts, monasteries, or ecclesiastical centers of power, and thereby opens up new perspectives on the directionality of medieval culture; it magnifies the critical issues and anxieties embedded in the art and culture of that time concerning wealth, display, autonomy, and authority; and it circumvents the entrenched biases embodied in the *Questione del Mezzogiorno* and a century of writings on the art and history of the South.

The Experience and Politics of *Mercatantia*

Among the small cities is one called Ravello, where, just as today you have many rich men, so there was once one who was very rich, called Landolfo Rufolo. Since his richness did not suffice, he wished to double it, and came close to losing everything including himself.[1]

Giovanni Boccaccio, *Decameron* (Gior. 2, Nov. 4)

IN THE FATEFUL SUMMER OF 1283, SOON AFTER LORENZO AND MATTEO Rufolo were charged with corruption and imprisoned, the crown prince Charles of Salerno justified his actions in a statement containing a telling metaphor: to bring seeds to harvest, he wrote, a conscientious farmer must frequently rid his fields of thorns.[2] In comparing the crown's acts to a farmer's toil and the accused to a loathsome weed, the statement aligns the crown with its rural subjects. Its oppositional strategy deflects the discontent of *regnicoli* from the French king and his oppressive policies, toward the alleged ill-doings of his Italian administrators. In so doing, the statement divulges contemporary tensions surrounding social and ethnic identities, the distribution of wealth, and relations of royal to local authority.

This chapter, a reconstruction of four centuries of Amalfitan merchant experience and the place of the Rufolos and other families within it, takes its cue

from the prince's summoning of issues distinct from the act of fraud. The tensions unveiled by his metaphor are relevant not only to the 1280s; they shape the family's history, from its humble origins through its prominence in the political realm of *mercatantia*, abrupt expulsion from the royal administration, and patronage of the 1330s. Various medieval sources, including episcopal charters, inscriptions, chronicles, privileges, and laws help illuminate the fraught world of Mediterranean commerce. This study seeks to formulate interconnecting histories: of the varied social, economic, and religious contours of medieval Amalfi; of the Rufolo family from its origins around the year 1000 to ca. 1450, after which references to it dwindle, then disappear; and of the shifting politics of *mercatantia*. These interwoven narratives first establish the family's *local* context, unlike previous studies of the Rufolos by Eduard Sthamer and Norbert Kamp, which focused on the Angevin period and on lives lived and ended far from home. Hence the "experience of *mercatantia*" emphasizes the generally local bases of the evidence and its cumulative significance for a history of Amalfitan society; the "politics of *mercatantia*" takes the Rufolos and their peers into the public realm of monitoring and regulating the kingdom's commercial practices.

Crafted as such, this study responds to Robert Lopez's challenge that historians create a more human picture of medieval commerce by generating portraits of individual merchants and their communities.[3] Indeed *Annales*-inflected scholars, including Iris Origo, S. D. Goitein, and Richard Face, and more recently Jenny Kermode and Olivia Remie Constable, have shifted the literature toward analyses of the social foundations and implications of exchange. Although indebted to such works of economic history, this study cannot paint the Amalfitans as complex personalities with specific ambitions, priorities, or weaknesses, because the evidence does not support such a view. No intimate letters remain, as they do for Goitein's Jewish merchants, or for Origo's Francesco di Marco Datini of Prato (d. 1408). Similarly, no fourteenth-century merchant manuals akin to the colorful *Zibaldone di Canal* (Venice) or *Practica di mercatura* (Florence) survive from southern Italy to illuminate the skills, itineraries, literary tastes, or ethical concerns of *regnicoli* involved in commercial endeavors. Readers seeking a detailed portrait of medieval merchant families should consult the studies just mentioned.

That being said, this narrative of merchant experience is somewhat detailed, owing in part to the region's lively scribal traditions and extraordinary penchant for extended genealogies. From the earliest surviving charters of the ninth century through those of the fourteenth, prominent Amalfitans were identified by

their first names followed by a litany of ancestors – often up to eleven genera-
tions' worth. This scribal habit seemingly derived from the fragmented and dis-
persed nature of the merchant community; genealogical contextualization helped
place the individuals named in documents and thus rendered the texts more
comprehensible.[4] Furthermore, it has been noted that such lists extend back to
individuals who lived in the late ninth century, the period of political autonomy
and prosperity after Amalfi broke away from the Duchy of Naples in 839.[5] Those
who rose to positions of political or economic influence at that time constituted a
loosely defined elite, whose titles and then surnames – *Comite, Protonotaio*, and
so on – evoked prestigious Byzantine titles or institutions. The incessant reitera-
tion of ancestry and title provided a means for Amalfi's first "comital" aristocracy
to celebrate its heroic past and safeguard its status, particularly after the loss of
local authority to the Norman (1073), Hohenstaufen (1194), and Angevin (1266)
dynasties.

While rooted in the social structure of Amalfi's mythologized heyday, this
preoccupation with ancestry depended on a vibrant scribal culture that unfolded
with the region's interest in long-distant trade. Scribes, as trustworthy witnesses
to and careful recorders of an array of legal transactions, formed an authoritative
elite and founded veritable dynasties within the Amalfitan curia.[6] In this region
where literacy was widespread, maintaining this form of social distinction was not
easy. The eccentricities of Amalfitan documents – their complicated permutations
of Beneventan script, their large size, and their infinite lists of witnesses and
ancestors – may stem from the scribes' efforts to maintain their status by creating
documents of challenging and cumbersome form.[7]

Whatever the scribes' intentions, the genealogical specificity that was part
of contractual language is an essential tool for mapping the rise and fall of the
Rufolos and other merchant families like them. The sources, however, are not
without problems of interpretation, because medieval texts containing genealo-
gies were notorious sites of fabrication, where prestigious ancestry was readily
invented and embarrassing interludes erased. Southern Italian documents are
not free of such creative manipulation.[8] Furthermore, narratives derived from
medieval sources risk veiling new alliances formed through marriages and over-
estimating clan cohesiveness by representing bloodline as solidarity, as Patricia
Skinner noted in her groundbreaking study of the families of Gaeta.[9] Given those
issues and a typically incomplete medieval record, this account offers a sketch
of one family and its context over several generations, rather than precise family
trees.

Origins and Early Generations of the Rufolo Family

Since Boccaccio's colorful tale, many writers have continued to blend myth and archivally rooted "fact" in their accounts of the Rufolos. The sixteenth-century historians Marino Freccia and Giovanni Battista Bolvito posited a far-fetched ancient pedigree for the family to support their theory of the classical inheritance of the Amalfitans and their consequent prestige.[10] Another story found in early modern chronicles is that the Rufolos were prominent knights under the Normans.[11] Neither tale finds confirmation in Amalfitan or Southern sources, which evoke the quotidian reality of life on the coast through real-estate transactions, marriages, wills, and so on.

The family's distinction is apparent in the earliest surviving documents for Ravello: the first known reference to a Rufolo, an undated notary document from around 1000, is signed by one *Iacobus presbiter scriba Ursonis Rufuli filius scripsi*.[12] The themes of this charter endure, for later generations of Rufolo men flourished as scribes, canons, bishops, and judges. Agricultural endeavors likewise are a consistent subject in eleventh-century and later sources. The earliest dated reference to the family in local texts (from 1011) is an agreement between Gutto, son of Leonis Rufolo, and Gutto, son of Orso Rufolo, to share a vineyard in a fertile zone of Minori, the seaside town east of Ravello.[13]

These and other eleventh-century documents situate the family within a new elite, which emerged long after the codification of the comital aristocracy in the late ninth and tenth centuries.[14] In contrast to that first aristocracy, these newcomers tended to have surnames, many of which reveal agricultural origins (such as Zinziricapra, Vacca) or political associations (Del Giudice).[15] Like the old elite, these increasingly visible families invested in concentrated blocks of arable land and participated in local administrative matters. Acting as scribe, notary, or judge ensured social mobility during the first uncertain decades of Norman rule (1073 to ca. 1100), and the new families sought to fill the ranks, possibly in the wake of ideological shifts that disqualified older clans.[16]

In the decades following the earliest documents, the Rufolos grow more animated in local charters and ascend the steep hill into Ravello proper, gaining property there in addition to Minori in the early twelfth century.[17] Although agriculture remained a significant part of the family's activities, two sons of Leone Rufolo and Theodolinda Freccia, possibly Constantine and Mauro, were involved in long-distance trade.[18] Another son, Giovanni, became the third bishop of Ravello in 1157 and maintained that position until his death in 1209.[19]

Giovanni's remarkably long tenure coincided with the expansion and con-
solidation of the family's wealth and influence. The donations that townspeople
made to Giovanni and the church in those years were impressive in quantity
and quality, including buildings and land in Ravello, Lacco, Supramonte, and
Lettere (one of the Amalfitan defense outposts constructed in the ducal period).
Although there is no indication that the bishop's actions were inappropriate by
medieval standards – there is no suggestion of unethical practices like those sati-
rized in anticlerical literature – the charters reveal that the Rufolos expanded
their holdings considerably in that fifty-year span.[20] This may be the result of a
subtle strategy of land acquisition: donations to the church sometimes abutted
land already held by another Rufolo family member,[21] or the bishop purchased
land adjoining properties donated to him and his church.[22] One measure of the
family's resources is that in 1198 the bishop was able to acquire a significant por-
tion of four workshops located in Ravello's central *platea Sancti Adiutorii*. These
same lucrative properties were still in Rufolo hands a century later.[23] The family's
expanded yet concentrated holdings are consistent with comital and "nouveau"
investment strategies.

In the decades of Giovanni's episcopate, the extended Rufolo family appears
more often in local documents, thereby illustrating a well-documented pattern
in medieval society. As Skinner and Alexander Murray have posited, wealth did
not necessarily yield power (although cases of simony are of course legion), but
service readily created prestige and social mobility. The abstract, symbolic, and
actual authority embodied in an office like the episcopacy inevitably attracted and
generated gifts, donations, favors, and so on, from superiors and the flock alike.[24]
And in a prosperous society like Amalfi's, affiliation with an institution as hier-
archical and omnipresent as the Church offered a rarer type of distinction than,
say, wealth or literacy alone could garner, a distinction that artistic patronage
later reinforced in the case of the Rufolos.

The ascent of the Rufolos in the second half of the twelfth century occurred
a few generations after that of the other prominent families associated with this
second Amalfitan elite.[25] Although there were notaries and priests in the family
before Giovanni became bishop, the Rufolos did not participate in the events
that shaped the region's enduring urban and social structures: the foundation in
1018 of the private church of San Giovanni del Toro in Ravello, by the Rogadeo,
Muscettola, Pironti, and other clans, or the construction of family churches that
took place at that time, such as the d'Afflitto clan's Sant'Eustachio in Pontone,
or the Castellomatas' San Michele Arcangelo in Pogerola (see Chapter 3). A

vital realm of cultural and artistic activity existed in which the Rufolos did not participate.[26] The family's distance from such events helped shape patterns of Amalfitan patronage in the second half of the thirteenth century.

Merchants and *Mercatantia*: Problems of Classification and Class in a Multicultural Land

The early sources of the wealth of the Rufolos were varied, involving extensive land holdings and trade. As is the case with other prominent families of the coast, the details of their commercial activities are unclear. What is undeniable is that the family fortune grew to formidable proportions: by 1268, the family possessed sufficient resources to act as bankers to the newly victorious king of Sicily, Charles I of Anjou. Their property holdings, including substantial tracts of vineyards and chestnut groves and a number of shops in Ravello, reflect but alone cannot account for this financial might.[27] Long-distance trade is a probable, but not provable source; there are few explicit indications of the Rufolos' participation in this mainstay of the region's economy, although family members are referred to as merchants, financiers, and operators of fleets.[28] But this is true of most other families as well, as references to *mercatores* are few and far between in southern Italian sources until the fourteenth century.[29]

The rarity of the term reflects both the subjects of surviving documentation and the structure of Amalfitan society; it also signals the inability of medieval and modern systems of social classification to accommodate the context of Amalfi. As for the documents, most from the region focus on local property deals – agricultural production, mill rights, and the like – and thus identify people by their names and ancestry, not profession, to secure the text's legal legitimacy. Hints of distant commercial activities emerge when, for example, men are noted as *ad nabigandum*, or women witnesses filled in for male relatives who were *ab partibus ultramarinis*.[30] But the precise nature of the commercial activities of the Amalfitans, whether absent or present, is rarely elaborated.

Definitions of social groups based on modern concepts of profession and class are always treacherous and are particularly anachronistic in the case of medieval Amalfi. Unlike the fourteenth- and fifteenth-century Tuscans whose writings shape most scholarly portraits of the medieval Italian merchant,[31] the Amalfitans flourished in an earlier era in which professional specialization was but nascent, as was social classification by trade and related economic and cultural interests (i.e., class definitions appropriate to later periods). During the region's

economic heyday, the tenth to the thirteenth centuries, many Amalfitans were active in trade, including farmers, judges, clerics, artisans, noblemen, and women of varied status.[32] Furthermore, the South's prominent communities of Greek Christians, Jews, and Muslims were also active participants in commerce.[33] Such broad participation in trade, which was quite rare in the medieval West and unusual in southern Italy itself, renders the term *merchant* too specific to describe suitably the multitasking and multicultural denizens of the coast. This historical circumstance likely informed Boccaccio's use of the term *mercatantia* and shapes this account of the region's visual culture.

The Amalfitans' wide participation in commerce closely resembles other Mediterranean markets, including those in Liguria and above all in Muslim Spain. In Cordova and other trading towns, those involved in trade included doctors, soldiers, teachers, shipbuilders, shopkeepers, and the like, clearly representative of many branches of society.[34] And, as in southern Italy, these commercially minded folks were organized loosely in interconnecting groups according to religion, location, ethnicity, items traded, and so on. Amalfi's similarities to Spain are not surprising; located beyond the frontiers of Charlemagne's Christian empire, southern Italy arguably had more in common with multicultural communities in al-Andalus (as reconstructed by Constable) or Egypt (as reconstructed by Goitein) than with the central Italian or northern European settings to which it is often unfavorably compared.

Although local sources are surprisingly unforthcoming regarding the activities of *mercatores*, documents produced elsewhere reinforce the narrative of Amalfitan seafaring prowess. This variety of chronicles and privileges indicates that Amalfitan traders and settlements prospered across the Middle East and North Africa in the tenth, eleventh, and twelfth centuries, in such places as Cordova, Cairo, Alexandria, Constantinople, and Jerusalem.[35] After the arrival of the Normans in southern Italy in the eleventh century, the Amalfitans took advantage of royal privileges within the newly consolidated kingdom and swarmed to the large ports of Naples, Palermo, Messina, and Barletta, as well as to fertile inland areas near Capua and Aversa.[36]

Merchant communities were particularly concentrated along the Adriatic coast of Apulia, which provided convenient access to Balkan, Aegean, and eastern Mediterranean markets. Testifying to close relations between Apulia and Ravello is the income from lands in Giovinazzo and Barletta, which funded the diocese of Ravello at the time of its foundation in 1086 or 1087.[37] Later charters and a series of privileges granted by Frederick II indicate that Molfetta, Bitonto,

Bisceglie, Bari, and Trani continued to support large and stable Amalfitan populations through the thirteenth century. The 1230s saw the emigration of several prominent Ravellese families, including the Della Marra and Rogadeo clans, who settled in Barletta and Bitonto, respectively. These families and communities established roots in Apulia before and after the 1230s. The church of Santa Maria degli Amalfitani in Monopoli was possibly founded as early as 1059; similarly, a representative document from the early Angevin period outlines substantial Ravellese contributions to the repair of Santa Maria Maggiore in Barletta.[38]

The Rufolos participated in this process of Apulian settlement and trade. Although no evidence details their business activities there in the 1100s, the family owned substantial tracts of land in Giovinazzo in the late thirteenth century.[39] The income from these vineyards and olive groves helped endow Nicola Rufolo's funerary chapel underneath the family's pulpit in the Cathedral of Ravello in 1287. It is plausible that the Rufolos, like many other merchants operating along the east coast at the time, traded Apulian oil, wine, and grain for silk and lumber in Frankish Greece or supplied essential goods – namely food and war materials – to struggling Crusader communities in Acre and Tripoli of Syria (now in Lebanon).[40]

With their productive estates and shops located on both coasts of the Italian peninsula and their participation in overseas trade, the Rufolos illustrate the marked diversification of investment that defined the Amalfitan economy. It has been shown that generations of merchants invested in land and hence were not "just" merchants, and that farmers likewise invested in commercial shipping and were not "just" farmers. This broad participation was facilitated by the fact that ownership of ships, cargo, farms, mills, and shops was divided into sharelike units, which minimized any individual investor's financial risk. In part because of this share system, the investments of the established elite, of the newly rich, and of the less well-to-do did not differ substantially in type.[41]

Merchants to Managers: Political Eminence and Patronal Distinction

The trajectory of the Rufolo family shifted in 1250 when Frederick II hired Nicola Rufolo as *magister camerarius*, a high-ranking juridical and financial officer of the burgeoning imperial court.[42] Nicola was quickly appointed to *magister procurator* of Apulia (finance procurement chief) in 1253, then *secretus* (chief financial secretary) of Sicily in 1256 during Manfred's hard-pressed administration. It is plausible that Nicola's position was spurred by his brother-in-law Angelo Della

Marra, the son of a prominent Ravellese merchant who became one of Frederick II's financial advisors after 1232.[43] Nicola Rufolo was quickly joined by his sons Matteo and Orso, who became *secretus* of Sicily in 1262 and *vicesecretus* of Messina in 1263, respectively. In these managerial positions, the family thus helped solidify imperial power in the new jurisdictions established by Frederick II.

Considering the shape of political alliances in the South, these appointments were unusual because the denizens of the Amalfi coast were generally hostile to the Hohenstaufen dynasty, particularly in its final decades. In fact the region's elite families wholeheartedly supported the Angevin challenge to imperial rule and swelled the ranks of the French administration after its victory over Manfred in 1266.[44] But if the appointments are placed within the matrix of *mercatantia*, they make sense; the skills of the Amalfitan merchants in the logistics of finance, commerce, and navigation made them ideal administrators of the kingdom's closely monitored economy.

The Rufolo and Della Marra clans managed to maintain their positions of power in the Kingdom of Naples and secured major appointments in the early years of Angevin rule. Charles I's tolerance of these elite *regnicoli*, who were after all politically wedded to the previous and loathed regime, sharply contrasts with his attitude toward other powerful supporters of the Hohenstaufen, whom he attempted to root out through arrests and inquisitions. His acceptance of the administrators probably derived from his unfamiliarity with the political and economic landscapes of the disparate South and the consequent necessity of maintaining some administrative continuity.

From 1266 to 1283, Nicola Rufolo and his son Matteo stayed on as bankers to Charles I and his son Charles of Salerno (later king Charles II). Nicola's sons Orso and Iacopo enjoyed various high-ranking administrative appointments, as did Matteo's son Lorenzo. Tenure in these positions was brief, generally lasting one year, but the Rufolo men rotated in and out of various offices along with fellow Ravellese and Scalese clans, such as the Della Marra, Pironti, Freccia, d'Afflitto, and Panda. For the next twenty years, these men flourished in and even monopolized the financial workings of the *Regno*, holding various offices and assuming diverse responsibilities.

Nicola Rufolo's entry into the administration of Frederick II might be explained as a shrewd response to dwindling economic opportunities.[45] Although a merchant community remained in distant Crusader Tripoli as late as 1286, much of Amalfitan trade was concentrating on inland routes and short maritime hauls

by midcentury.[46] It is telling that an early Italian navigational map, a portolan chart from the mid–thirteenth century, does not indicate any towns along the Amalfi coast.[47]

Myriad factors precipitated the decline of the Amalfitan economy after ca. 1100, an era paradoxically corresponding to Robert Lopez's Commercial Revolution and a triumphant Western economy. These include the long-term effects of reduced local autonomy with the arrival of the Normans and their often hostile policy toward Byzantium, previously a key Amalfitan trading partner; the physical decline of Amalfi's port structures following Pisan attacks in 1131 and a crippling storm in 1334;[48] the growth of markets in distant Champagne and Flanders; the rise of Venice, Pisa, and Genoa as commercial forces in Asia and northern Europe, and their large galleys;[49] the protection that Charles I of Anjou offered northerners, particularly Florentine merchant bankers such as the Frescobaldi, Bardi, and Peruzzi, in the kingdom's ports;[50] and the eventual codification of a market in which the Kingdom of Sicily provided foodstuffs for northern Italy while the north developed its industrial infrastructure. If placed within Janet Abu-Lughod's world system of the thirteenth century, southwest Italy might be said to align with the Asian and African economies that were constrained by an array of external and internal circumstances, not by any inherent shortcoming, weakness, or failure. But the tenacious economic divide that emerged in this period still informs constructions of the *Questione del Mezzogiorno* six centuries later, as discussed subsequently.

The administrative positions held by the Rufolos for twenty years placed their hands on the mechanisms that kept the Kingdom of Sicily afloat financially, militarily, and culturally. In 1271, Charles ordered Orso Rufolo, then *secretus* and *portulanus* of the *Terra Laboris* (the district of Naples and Capua) and the Abruzzi, to secure as much grain as possible at any price, for he feared a severe shortage and its consequent unrest.[51] Bernardo Rufolo was appointed to distribute the new coins minted by Charles in 1270, a prestigious and lucrative task, yet one that surely sparked the ire of *regnicoli*.[52] Orso, as *secretus* of the Principato (the district of Salerno and Benevento) and Matteo, as *secretus* of Apulia, were instrumental in preparing ships and supplies for the ill-fated crusade of Charles and his brother Louis IX of France to Tunis in 1270.[53] It is likely that the family's own fleet was used on such occasions; the Rufolos may have subverted the crown's propensity to confiscate merchant ships by offering their material and human resources. In any case, it is clear that they and many other seafaring Amalfitans developed

a symbiotic relationship with the crown in volunteering their ships, navigating skills, and financial expertise when their traditional markets faced varied and intense pressures.

Most administrative responsibilities of the Rufolo, Della Marra, Pironti, and other families were distant from court life in Naples and concerned instead the workings of the kingdom's finances on a local level. The office of the *secretus* collected direct and indirect funds, such as incomes from feudal holdings, taxes, and customs duties.[54] The *magister procuratores et portulanis* had similar responsibilities, such as issuing shipping licenses, collecting dock fees, and carrying out confiscations – a prominent and controversial feature of Charles I's oppressive internal policies.[55] Nicola Rufolo and his sons Orso, Matteo, and Iacopo held these positions in the districts of Apulia, the Terra di Lavoro and Principato, and Sicily, and Matteo's son Lorenzo joined them in the mid-1270s. In this capacity they inspected ships in ports and exacted appropriate taxes, sold grain in Tunisia, and oversaw shipments of grain from Sicily and Apulia to Angevin outposts in Corfu, Albania, the Peloponnesus, and the Holy Land. All of these administrative positions and tasks helped (micro)manage the *Regno* and thus contributed to the consolidation of monarchical authority in southern Italy and affiliated territories.

The royal documents that outline tasks assigned to such officials help construct an economic history for the kingdom, to be sure; they also shed considerable light on southern Italy's diversity and material culture. We find, for example, that Orso Rufolo was in charge of paying the Muslim leopard keepers of Lucera for their uniforms and for food for the thirteen felines in their care.[56] The recorded ebb and flow of merchandise indicate lively markets for certain luxury goods and the trade routes along which cultural practices, as well as materials, might travel. Notes about shipments of cinnamon, cloves, ginger, and pepper,[57] or of sumptuous cloths bound for the royal court, enliven the administration's records of day-to-day transactions.[58] Merchants supplemented expensive and light-weight merchandise with heavier items of value, including glazed ceramics.[59] The pottery wares found in the Amalfi region effectively chart the constellation of trading centers presented in the Angevin chancery – ceramics from Syria, the Peloponnesus, the Maghreb, and Sicily predominate. These goods constituted a fundamental part of the material culture of *mercatantia*, as discussed later.

During the first two decades of the reign of Charles I, the Rufolos flourished in these administrative positions and also established their reputations as patrons of art and architecture in their home town. Three of the monuments commissioned

by the family – the house, ciborium, and pulpit – date from these busy years with the Angevins. During that time they also established themselves as financiers to the royal family, indicating that commercial activities related to their royal positions remained lucrative. Nicola and Matteo loaned money on many occasions to the cash-starved king beginning in 1268 and to his son Charles of Salerno in 1283. Their loans became more and more frequent as Charles's imperial ambitions swelled. The Angevin conquest of the Kingdom of Jerusalem, Corfu, and Achaia did little to rejuvenate the strained royal treasury, and Charles's eyes remained set on a venture to Constantinople. Although he kept tight reins on the kingdom's financial mechanisms, Charles was frequently desperate for cash. In 1276, he was reduced to pawning the very symbol of his kingship – a royal gold crown studded with precious jewels – to a consortium of financiers headed by no other than Matteo Rufolo.[60]

While pawns and loans to the king were not uncommon in the first decades of Angevin rule, such transactions were perilous. The basic nature of the deal – lending the king money in exchange for his valuable crown – placed the Rufolos on precarious theological, ethical, legal, and political ground, given the fraught status of wealth and money lending in the later Middle Ages and the vulnerability of their debtors, the Angevin king and his heir apparent.

Friends of Mammon: Discourses of Damnation and the Risks of *Mercatantia*

Mercatantia was a way of life and a fundamental aspect of Amalfitan cultural identity. Its enterprises, however, were deemed suspect. After all, many of the social tenets of Christianity rest on the integrity of poverty and, by extension, the distrust of material wealth and means of acquiring it. *It is easier for a camel to walk through the eye of a needle than for a rich man to enter the Kingdom of God; No man can serve two masters, you cannot serve God and Mammon; We should have no more use or regard for money in any of its forms than for dust*[61] – centuries of Christian literature and teaching rail against merchants and the well-to-do. Even cultures in which commerce was widespread were troubled by such issues. In 1181, the Amalfitan merchant Orso Castellomata was publicly characterized as a "friend of iniquitous Mammon" while he was atoning for his wealth by founding a church.[62] With its attendant inequalities and social dislocation, the nascent capitalism of the thirteenth and fourteenth centuries brought new vigor and venom to debates over the morality of wealth.

Usury, both reviled and omnipresent in the high and late Middle Ages, constituted the single-most controversial aspect of the burgeoning market economy. Many scholars and theologians, including the *regnicolo* Iacopo of Benevento, perceived usury as an odious manifestation of greed.[63] But anxieties surrounding the concept of money lending for gain derived in part from its status in scripture. While exalting the disenfranchised in Luke's account of the Sermon on the Plain, Jesus warned that one should "lend freely, and hope for nothing thereby" (Luke 6:35). Interpreted by Scholastics as reiterating the prohibitions of usury in Hebrew scripture (Exod. 22:24 and Deut. 23:20–21), these words encouraged many a medieval scholar to envision and shape the legal and ethical bases of an ideal Christian economy.

Lawyers, philosophers, kings, popes, mendicant monks, and parish priests agreed that the concept of a loan with interest was problematic.[64] Elaborating biblical prohibitions and patristic commentaries with theoretical objections supported by tenets of natural law, they found usury unnatural, as money is sterile and cannot reproduce; heretical, for the usurer rests in violation of man's post-Eden call to labor, while his inanimate money works incessantly, even through the night, on feast days, the Sabbath, and so on; and irrational, as it sells the *use* of money in addition to actual money, so the usurer either sells the same thing twice or sells something that does not exist. The unethical aspects of money lending, primarily that it exploits the needy, were also noted. Frequently compared with prostitutes, robbers, and Jews, the usurer was deemed a parasite, excommunicated, and relegated to the margins of urban society.[65] In death, he faced eternal damnation, at least until the Fourth Lateran Council in 1215 established the doctrine of Purgatory and allowed sinners to attain salvation posthumously. As the Constitutions of Melfi reminded *regnicoli* in 1231, "those who are unmindful of their salvation and rashly violate" Frederick II's anti-usury law faced harsh punishment on earth as well.[66]

Such scripture-based ideals were relentlessly pressured by the realities of emerging markets in the twelfth and thirteenth centuries.[67] This clash between deontological economics and commercial expansion created uneasy compromises concerning usury, interest, credit, and financial partnerships, all concepts and activities that the Amalfitans knew well. Some attitudes regarding usury began to relax and offered guidelines more compatible with contemporary commercial practices. Through rediscovered texts of Aristotle, philosophers such as Thomas Aquinas and John Duns Scotus helped shape modern, workable concepts of wealth, exchange, and profit.[68] Against the prohibitions of the early church,

they argued that honest merchants perform valuable services and therefore deserve recompense for their exertions. After all, few human settlements are fully self-sufficient, and thus some necessities must be brought in; merchants take considerable risks working to supply these products that likely serve the social good[69] – an argument of particular resonance for the Amalfitans, because their inhospitable terrain rendered them dependent on imports, as the Jewish traveler Benjamin of Tudela noted around 1167.[70] That being said, a merchant's motives for compensation must be sound, such as providing for his family and parish; the pursuit of profit in and of itself was not a legitimate endeavor.

Even as such attitudes relaxed, the legal, ethical, and professional distinctions between merchants, bankers, moneylenders, and usurers were still quite blurred in the mid–thirteenth century.[71] As the Dominican Remigio de'Girolami wrote in a sermon of ca. 1281, "usurers blush to call themselves that. So they are called lenders, or changers, or even merchants; and their usury, merit, profit, or fruit."[72] Small-scale moneylenders (i.e., locally operating pawnbrokers) engaged regularly in practices deemed usurious, to be sure; but merchants and bankers in local and international markets also left themselves vulnerable to illicit gain and eternal damnation by working with credit, interest, and even valuable pawned goods, as the Rufolo, Pironti, Freccia, Della Marra, and other Ravellese clans did on a regular basis. In fact, the ambiguous morality of commerce and money lending continued to provide fodder for preachers well through the fourteenth century.[73]

Given the oppressive weight of this discourse of damnation, it is not surprising that merchants and bankers often attempted to elude detection by concealing the interest that they charged and earned. Lenders could, for instance, agree to receive nonmonetary gifts or special favors in exchange for their loan; no doubt the Ravellese received myriad benefits, both tangible and intangible, from their loans and pawns to the king. Lenders also could inflate the purported value of a pawned object so that it included the interest charged on the loan. Engaging in such financial arrangements in general was not for the faint of heart, and doing so with sovereigns more perilous still. In 1277, Philip III of France charged scores of Italian merchants with usury after having consistently encouraged their activities in his realm.[74] The Italians paid dearly to be released from prison, which made the accuser's high moral tone ring rather hollow. Such cases testify to the unpredictable nature of late medieval justice, a system that the Della Marra–Rufolo case reveals to be so subject to political manipulation that its arbitrariness was perhaps as disquieting as the threat of fire and brimstone.

The Rufolos' frequent loans to the two Charleses and their acceptance of the crown as pawn were risky for another reason: the Angevins were financially desperate and their ability to honor debts doubtful. The economic, political, and above all human costs of incessant warfare and imperialist expansion bubble up through royal documents of the 1270s and 1280s. Chancery archives and chronicles outline complaints from impoverished and overtaxed *regnicoli* and the devastating effects of the countryside's depopulation. Royal attempts to reallocate scarce resources took different forms, from the forced and frequent collection of emergency taxes and food supplies, to the summoning of Provençal farmers to tend the land, to the promotion of austerity measures.[75] In 1272, laws sought to limit expenditures on weddings, dowries, and clothing in Messina, another affluent emporium situated at the crossroads of Mediterranean trade, and were reinforced by sweeping legislation in subsequent decades. In short, the years in which the Rufolos attained their greatest influence in the affairs of state were ones in which licitly or illicitly earned wealth offered little actual security.

Scandal

In June 1283, in a kingdomwide sweep orchestrated by the king's son Charles of Salerno, Lorenzo Rufolo and his father Matteo were arrested, charged with corruption and fraud, and imprisoned.[76] Also arrested were the high-ranking administrators Angelo, Ruggero, and Galgano Della Marra, who were nephews of Matteo Rufolo and his wife Anna Della Marra. Given the eminence of the accused, these arrests must have been shocking to *regnicoli*, much as if members of the cabinet of a present-day prime minister were, without warning, charged with appalling crimes and led off in handcuffs. Apparently the prince was well aware of the destabilizing potential of the arrests; he timed them to coincide with the feast of Corpus Christi so that widespread celebration of the fairly new holy day would muffle response to this news. Even so, the chancery effectively shut down for several days, its scribes and notaries presumably immobilized by the fate of their superiors.

The offices held by the accused varied considerably in their jurisdictions, responsibilities, and proximity to the king. Following a decade of appointments in Sicily as secretary and master of ports, Matteo was in the early 1280s overseeing shipments of grain to the Middle East and Frankish Greece.[77] Lorenzo, who had been secretary and master of ports in Sicily from 1276 to 1278, occupied those positions in Apulia in the early 1280s. In that capacity he worked with his

cousin Galgano on at least one occasion, when they were ordered to shore up the defenses of the region's castles in October 1282, during the early stages of the Vespers crisis.[78] On and off throughout the 1270s and early 1280s, Angelo Della Marra held a position near the pinnacle of the royal administration as *maestro razionale* (a position that his father Giozzolino held under both Manfred and Charles I, from 1258 until he died around 1278) and was ensconced within the king's household. Similarly, Ruggero joined the royal household around 1278 and apparently helped manage its daily affairs. While all of the prominent Della Marra men were arrested in 1283, two of Matteo Rufolo's brothers, Iacopo and Orso, were not, although they had held comparable administrative positions in the 1270s and early 80s.[79]

In the months following Charles of Salerno's tumultuous sweep, while the accused languished in prison and other family members remained under house arrest, the Rufolo and Della Marra clans were subjected to the same harsh royal policies they had previously enforced. They were stripped of valuable lands and livestock and repeatedly forced to pay exorbitant fines. Months later, Matteo Rufolo was freed from prison and returned to Ravello, and Ruggero Della Marra was pardoned and even returned to the royal household. Lorenzo and his cousins Angelo and Galgano were less fortunate; they were convicted of financial crimes and executed by December 1284.[80]

Spectacular criminal cases inspire divergent narratives. The accused are viewed as vile predators who deserve society's unconditional wrath; alternatively, the accused are hapless victims of a prejudicial society. In the various studies of Angevin rule in Italy, perspectives on the Rufolo and Della Marra families run this gamut.[81] Although Sthamer characterized the case as a flagrant miscarriage of justice, even by medieval standards, it is best to move beyond the inflammatory language of guilt or innocence and dispense with its polarities. After all, the evidence in the 700-year-old case is vague, as Sthamer himself determined, and, more to the point, concepts regarding proof of innocence are of little relevance to the thirteenth century. In evaluating the events of 1283 from our vantage point, it makes sense to focus on the broad outlines and implications of the case. It is more illuminating to consider what the Rufolos had been doing that set the accusations in motion and rendered them plausible to fellow *regnicoli*; why the royal court moved forward with the arrests, trials, and executions; and why the alleged crimes were considered so heinous. Such a perspective magnifies deeply rooted tensions concerning local and royal authority, ethnicity, dynastic struggle, and the distribution of wealth, issues that first shaped many episodes

of the art of *mercatantia* and then had disastrous consequences for Ravello's powerful families.

Background to the Arrests: The Vespers Rebellion

The arrests situate the Rufolo and Della Marra men within a larger drama, one concerning the contested nature of Angevin rule in Sicily. Fourteen months before the arrests, widespread discontent with Charles I erupted into a violent riot, now known as the Sicilian Vespers, which began in Palermo and spread across the island. Repudiating the cruelty of Angevin rule and its resulting poverty and chaos, the rebellion sparked war, as Peter III of Aragon eagerly came to the defense of the island and his claim to its crown. Incidentally, one week after the riots broke out, Matteo Rufolo was ordered to provide bread for Angevin troops bound for the Straits of Messina.[82]

In some ways, the Vespers rebellion offers a reasonable interpretive matrix for the royal accusations. Some narratives of the Vespers have even drawn direct connections between generic reports of administrative abuses, the bloody rebellion, and the arrests of the Della Marra and Rufolo men, as if each action triggered the next.[83] Indeed, embedded in Charles of Salerno's rhetorical letter of justification is the idea that the actions of the accused prompted the riot by sowing discontent. This letter is a carefully worded response to a crisis, however, one intended to impose order on a politically fractured present, as well as on a recent memory of chaos and bloodshed. A closer view of the events surrounding the arrests suggests a more complex drama of the Vespers, in which the Rufolos and Della Marras are not protagonists, but secondary characters.

The historiography of the Vespers defines a contested terrain of Sicilian cultural identity.[84] Although pertinent medieval chronicles contain the hyperbole and bias typical of such texts, modern historical accounts often amplify the perspectives of the medieval documents and, whether consciously or not, serve varied political and ideological ends. The Rufolo and Della Marra story is often embroiled in these larger debates.

Medieval and modern historians have agreed that the offices held by the accused, primarily as secretary and master of ports for Apulia and Sicily, were ripe for corruption. These officials, after all, were in charge of regulating shipments and prices, confiscating lands, collecting taxes, inspecting ships, and so on, far from the king's supervision.[85] These collections involved large sums and grew more frequent and onerous, including the dreaded *subventio generalis*, the principal source of gold for Charles's war treasury. In 1281, this tax increased to more

than 150 percent of its already high norm to fund the king's military designs on Constantinople.[86] Because the French, Provençal, and Italian elite of the kingdom generally did not pay this tax (exemption was the classic privilege bestowed on noble supporters of the king), the *subventio* fell heavily on the *regnicoli* least able to afford it, including peasants and the urban poor. It also fell on the *regnicoli* whom the king could least afford to tax: the barons of Sicily who were ambivalent about his rule. The taxation system thus aggravated existing imbalances in the kingdom's distribution of wealth and level of support for the dynasty.

Procedures of tax collection exacerbated these problems and further eroded popular good will toward the Angevins. Under Charles's administration in Sicily, tax collectors were for the most part foreigners: Provençal or mainland *regnicoli*, including the Rufolos and Pirontis. Indicative of local discontent and royal desires to ease it is the reconfiguration of the Sicilian offices in 1279, when a consortium of local nobles joined the Ravellese men who had monopolized these positions for decades. This apparent attempt to smooth ruffled feathers led in the following year to the elimination of the Ravellese from the coalition – hence their absence in Sicilian and presence in Apulian affairs in the months leading up to the Vespers and arrests.[87]

Chancery documents reveal telling episodes of popular resistance to Angevin fiscal policy and its enforcement, as do local chronicles. The disappointed Guelph chronicler Saba Malaspina highlighted other sources of discontent, the financial abuses that he repeatedly claimed were common and indeed famous in Charles's court and government. But whether loathed policies like the *subventio* constituted a break from the practice of Hohenstaufen rule remains a matter of debate.[88] And whether the officers of the fiscal administration engaged in corrupt practices, as the Rufolo and Della Marra men were accused of doing, remains equivocal, given the vague nature of the official chancery documents and the biased, generalized tone of Saba and other medieval sources.

The court's language from the time of the arrests through the executions also maintained a generic tone, reiterating in various ways only that the accused were guilty of defrauding the royal curia.[89] Documents pertaining to the case underline that the Rufolo and Della Marra men were guilty of *malicia, iniquitas, viciose fraudes*, and so on, a litany of vague accusations. The absence of any particular evidence – of witnessed crimes or missing money, for example – throws into question the legitimacy of the accusations and, by extension, the moral posturing of the crown prince around the events of 1283. So too does the steady stream of confiscations and fines, which brought goods and gold to

the curia from Marseilles, Assisi, and towns across the *Regno*. In short, the chancery evidence suggests that the accusations stemmed from the quantity of wealth that the Ravellese clans had amassed.

It follows that Charles of Salerno pressed ahead with the arrests, confiscations, and executions because the fortunes of the accused were vast enough either to have raised the specter of usury or other illicit financial practices, or to have threatened the envious (and broke) prince, or both. The families' wealth must have been conspicuous – displayed in the public realm, noticed by fellow *regnicoli*, and appraised by members of the court. Early chronicles suggest that the lavishness of the Rufolos' house constituted such a display as to spark the envy of Prince Charles, as discussed in the next chapter. That is not to discount the possibility of illicit gain; in the later thirteenth century, conspicuous wealth was subject to moral, theological, and in some cases legal censure. But given the political circumstances of the accusations, it is impossible to dismiss the fact that these fortunes, once confiscated, helped ease the financial burden of war, a boon that no doubt informed Charles's decision to arrest the five men.

This absence of specific charges against the accused is paralleled by generalized tenor of popular complaints against Angevin rule. Given the kingdom's fiscal problems and the discontent that they prompted, one would imagine that if the crown had clear evidence of wrongdoing by the accused, those facts would have been brought forth; in such a case, the arrest of the Rufolo and Della Marra men would have been celebrated by rebels and those critical of Angevin rule. Not only were the Angevin accusations generic, but the Rufolos and the other *regnicoli* who administered the politics of *mercatantia* are conspicuously absent from accounts of the rebellion. The rage in Palermo was directed explicitly at the Frenchmen who held powerful positions in juridical circles and represented an oppressive military presence on the island, not toward elite *regnicoli*. Accounts describe that the rioters ran through the streets shouting *moriantur gallici*, or, in vernacular, *muojano, muoyano y francieschi* – die, Frenchmen.[90] Some accounts claim that people suspected of being *francieschi*, including monks, women, and children, were forced to pronounce the word *ciciru* (chickpea). If they failed to do so correctly, offering proof of their Frenchness, they were executed on the spot.[91]

But would this linguistic or other tests of identity have enabled the mob to distinguish between the largely but not exclusively Provençal newcomers and the Normans who settled on the island two hundred years before?[92] For that matter, with whom would elite Normans have sided? Although one can hypothesize that they were ambivalent, the Norman position, as well as the rebels' attitude toward

the Normans, is not expressed in the chronicles. The accounts are similarly vague about the identity of the rebels. Were they representative of Palermo's varied population of shopkeepers, artisans, wealthy *regnicoli*, and the urban poor, for instance, and of Muslims, Greek and Latin Christians, and Jews? The social and ethnic demarcations of the mob are not clear in the chronicles. The texts' "us-versus-them" construction, solidified by Michele Amari's emphasis on the unifying tendencies of nationalistic fervor in early histories, is thus problematic and unsatisfying, given the absence of a monolithic "us" *or* "them" in either Palermo or Sicily. In short, medieval and modern accounts of the Vespers barely reveal the complex contours of a multiethnic society in crisis.

Instead of characterizing the arrests of the Ravellese as an immediate response to the riot in Palermo, they should be considered in a related context: that of subsequent restabilization efforts.[93] Charles of Salerno's complex strategy of regaining and solidifying Angevin authority worked in a number of political arenas. By creating new alliances, reconfiguring existing ones, and punishing convenient symbols of the controversial old order, Charles both asserted his own autonomous agenda and reinforced the house of Anjou's hegemonic rule.[94]

His arrest of the Rufolo and Della Marra clans suggests a shrewd manipulation of the mob's resentment by providing it with an alternate and southern Italian focus. His parable of the conscientious farmer helped enact this strategy. It cast a shadow of blame across provincial administrators, suggesting that the accused office holders, not the king, were responsible for developing the fiscal policies of the 1270s and 1280s and that the local *regnicoli* who held these offices, not the French dynastic newcomers, were to blame for the poverty, famine, and social dislocation that gripped the kingdom and sparked war with Aragon. Furthermore, it asserted that the prince was attentive to the concerns of the downtrodden and consequently helped him reinstate the juridical integrity of the crown, as Sthamer and others have posited.

The arrests also functioned to renegotiate relations between administrators and the Angevins. They underlined that office holders, as well as all *regnicoli* in positions of authority and responsibility, owed the crown absolute obedience. This assertion of royal authority over local was not new, of course, as directives issued by Charles I's chancery routinely threatened administrators *sub pena persone et omnum bonorum*, thereby lending each assigned task an ominous tone.[95] But it reconfigured existing alliances and distanced the prince from his father's *mala segnoria*, as Dante characterized the politics of the king in the *Commedia* (Paradiso VIII, 72).

The financial consequences of the arrests also helped strengthen Angevin hegemony in a material way. The royal purse's desperate need for funds was lessened somewhat when the crown prince channeled the families' confiscated goods and money directly toward the war effort. Much of the livestock that belonged to the Rufolo and Della Marra clans was immediately turned over to the Saracen archers of Lucera for use against Aragonese forces in Sicily. Thus the arrests helped reiterate Angevin hegemony by erasing royal debts to the Rufolos, bolstering the war effort, deflecting attention from internal and foreign policy failures, fomenting further divisiveness among an already discontent populace, and securing the allegiance of administrators in comparable positions.

Another aspect of Charles of Salerno's stabilization strategy was his accommodation of the disparate social strata of the kingdom at the Parliament of San Martino, held in March 1283. Its apparent inclusiveness of barons, counts, clergy, and city representatives and the reforms that it promised (but did not deliver) signaled to regnicoli a new era of shared power. Furthermore, Charles's assertion of military might at his disastrous attack on a rebel fleet at Nisida, where he was kidnapped in 1284, marked another stage in his efforts to forge connections and consensus among the kingdom's disparate communities.[96]

In this larger drama concerning the Angevin struggle to maintain hegemony, the Rufolo and Della Marra arrests help identify broad shifts in the cultural history of the South. Whereas these elite families previously had been tolerated, encouraged, and granted significant authority in the administration on account of their expertise in commercial affairs, the king could no longer accept their skills and related wealth and power – the cost of accepting them was getting too high. In other words, Amalfitan wealth and political clout, both rooted in mercatantia, were becoming problematic rather than helpful to the king.

This larger dynamic could readily extend beyond political realms. As this study establishes, Amalfitan artistic cultures were rooted in earlier traditions associated with the region's economic heyday. They were also relatively autonomous, unusual, and eclectic within the broader structures of the South. Because of the various political and economic pressures of the later thirteenth century, the status of Amalfitan culture shifted in the South. To borrow the conceptual framework of Raymond Williams, Amalfitan culture ceased to be tolerated as residual and alternative and became instead a threatening force – it involved too much money and power and too many visual and public displays thereof, as this study explores. Hence Charles of Salerno's move to punish the Ravellese and limit their future credibility.

In this struggle for hegemonic control over the South, the Rufolos and the local culture of *mercatantia* they represented were losing. Emblematic of their defeat is the way in which Matteo Rufolo's second fine was invested. After his release from prison, Matteo paid the crown an additional 400 ounces, above the 2,000 he had already dispensed. This portion was directed toward San Lorenzo in Naples, the Franciscan *studium* that was being rebuilt at that time. In this final, involuntary act of artistic patronage, Matteo Rufolo did not help create another monument representative of the Mediterranean-inflected art of *mercatantia*. Instead, the family's money helped erect a Gothic choir, the first to be constructed in Naples.[97] The soaring ribbed vaults, elaborate responds, and trefoil clerestory windows of San Lorenzo seemingly mock the life and remains of Lorenzo Rufolo and negate the culture he and his family represented. They embody the cultural victory of the new over the deeply rooted art of *mercatantia*.

The Decline of *Mercatantia* and the Amalfitan Elite

The Rufolo family's finances were not as decimated by the events of 1283 as their political reputations and careers were. Matteo was still able to make cash loans, for instance, in 1287.[98] Records of land acquisitions in Ravello, Naples, and Giovinazzo indicate that Francesco and Mauro, the brothers of Lorenzo, remained of considerable means after the trial. A slow dispersal of the family, however, is evident. With Naples emerging as the uncontested center of the kingdom, and the gradual decline of the coastal towns and their trade, Amalfitans like the Rufolos made lives for themselves elsewhere, often marrying into distant families of distinction. Artistic patronage did not cease but was limited and took place outside Ravello, with minor commissions and dedications in Naples and larger ones in Scala. Marinella Rufolo and her husband Antonio Coppola of Scala carried the Rufolo tradition into the fourteenth century, with the commission of a superb stucco baldachin tomb for Marinella and a polyptych by Roberto d'Oderisio in the 1330s.

Decades after the Vespers scandal, the family flourished in professional circles. Around 1341, Nicola Rufolo appears in documents as a physician;[99] before 1342, Giovanni Rufolo appears as a judge and his brothers Matteo and Andrea as abbots (canons).[100] Some of these men remained in Ravello. In his testament of 1394, Giovanni wished to be buried next to his parents in the church of Santa Chiara there.[101] Others did not stay. Carlo Rufolo (d. ca. 1401), *Legu doctore*, was the second generation of Rufolos to live in Naples and was heir of the

nobleman Marco Rufolo.[102] This Neapolitan branch of the family established a chapel in San Domenico, the showcase of the kingdom's nobility in the fourteenth century.[103] Earning distinction through ecclesiastical administration remained a family pattern through the 1300s. Francesco Rufolo (d. 1370) served as the forty-sixth bishop of Nola. Pellegrino Rufolo was the bishop of Ravello for the single year preceding his death in 1401. Mariotto Rufolo was noted as prelate of the cathedral in 1409.[104] These clerics were among the last sons from the Ravellese branch of the family, the documentary traces of which disappear after that date.

The decline of the Rufolos in the late Middle Ages resembles that of most families of the second Amalfitan elite. While the debacle of 1283 accelerated the Rufolos' dispersal, that trend was a general one, for the Amalfitan economy continued to shrink and fuel the rapid depopulation of the coast. The devastating effects of this process are made clear in a series of sixteenth-century census reports, which evoke in spare language a landscape where empty houses outnumber inhabited ones.[105] Humble signs of past occupation evoke the quotidian rhythms of abandoned lives – a sack of dried onions, a wall sconce, a barrel of salt, a figure of Our Lady – all left behind by men and women rumored to have moved to Naples.

Amalfitans at Home: Residential Architecture and Its Mediterranean Syntheses

~

F ROM THE SEA BELOW, THE RUFOLO PALACE APPEARS VERY HIGH," WROTE
Giovanni Battista Bolvito in 1585 in the first vernacular history of the re-
gion of Amalfi. "It seems to border on the clouds, as if the beautiful materials that
ennoble its every part were flown up upon wings and ascended miraculously.... It
is ornate with all of the delicate and magnificent things that could be desired in
a royal edifice of its age."[1] Perched on the Ravellese plateau, this "royal" house
commands views across the Amalfi and Cilento coasts and the azure waters of
the Gulf of Salerno.

This residence was one of many large houses of "sumptuous manufacture,"
as Bolvito avidly remarked, that once dotted the Amalfitan landscape. Fragments
of many of these buildings survive that together define a sizable corpus of me-
dieval housing. They appear in other quarters of Ravello and in nearby towns
such as Scala, Pontone, Atrani, Amalfi, Minori, and Pastena. Many of them have

fundamental features in common, including aspects of layout and uses of ornament. Although most are smaller than the Rufolo example, medieval and early modern texts indicate that other "marvelous" houses rivaled it in scale, spatial complexity, and ornamental splendor.

Bolvito's rhapsodic portrait of medieval houses supplements the numerical accounts of desolation found in sixteenth-century land surveys. Early modern historians redeemed the cold, hard facts of depopulation and its impact on the built environment by mythologizing the recent past; medieval palazzi provided symbolic foundations on which they constructed narratives of the region's golden age. Thus, for Bolvito and his predecessor Marino Freccia, domestic architecture was fundamental to conceptions of local identity, history, and culture.[2]

The early modern writers also endowed these buildings with moral qualities, such as nobility or fortitude, although they occasionally suggested something more transgressive. In so doing, they reinvigorated a concept articulated by Cassiodorus: that a ruler and his residence have a reciprocal relationship in which the qualities of one transfer to the other.[3] But in the case of Amalfi, there is a fundamental difference. That representational reciprocity involved laypeople instead of sovereigns, and houses (albeit of considerable size) instead of imperial *palatia*.

The conceptualizing views and research priorities of these early writers differ starkly from those prevalent today. Despite the fact that these buildings offer evidence of unusual late medieval housing types, the Amalfi corpus has eluded detailed analysis until quite recently.[4] Bertaux and Schiavo laid foundations for serious examination with their short studies of the Rufolo complex published in 1903 and 1940, respectively.[5] But most literature on Amalfitan domestic architecture examines particular aspects in isolation, looking at individual decorative motifs, construction materials, or vaulting types, for instance, rather than taking a comprehensive view of individual monuments, their typological families, urban setting, or broader historical and cultural implications.[6]

The limited and fractured focus of the Amalfi research closely resembles the scholarship on medieval housing as a whole. For many a generation, domestic architecture has remained peripheral in the literature on medieval art and architecture, with cathedral and monastery clearly occupying the center. Perhaps this situation is inevitable. A host of evidentiary problems surrounds the medieval domestic environment, including ones traditionally assessed by archaeologists.[7] And medieval houses relate only awkwardly to the taxonomies of form created for religious architecture and consequently do little to sustain narratives of Western

medieval art and their eschatological emphases. Furthermore, they tend toward the conservative, lacking "structural monumentality and esthetic identity," as Richard Goldthwaite phrased it,[8] and seemingly offering few technological or stylistic breakthroughs of their own. Defined primarily by their austerity, they contained few furnishings or decorations to catch the art historian's eye. Finally, whereas church architecture has generated theoretical models of understanding, from Paulinus of Nola's to Durandus's to Richard Krautheimer's, there is no conceptual matrix that applies to medieval housing as a whole.

Most studies of medieval domestic architecture tend to focus on the grand residences of sovereign authorities and their modes of self-representation.[9] Bishops' palaces, for instance, have been portrayed as seams between imperial, ecclesiastical, and chivalric cultures that drew on all three frames of reference. Royal palaces, meanwhile, are seen as carefully choreographing views of the king and access to him; a key role of architecture was to define and redefine distinctions between public and private as monarchical power grew.

In many of these cases, the meaning of a building and the taste of its patrons or inhabitants are communicated through figural representations, inscriptions, or imposing architectural motifs. How do we proceed, then, in the case of the Amalfi corpus, where figural display is negligible? And where the traditional signposts of meaning in medieval secular architecture, such as exterior loggias, elevated Great Halls, or monumental staircases, are absent? Or, vexingly, when the monuments do not readily fit into any single formal or stylistic category, given their local, Gothic, Byzantine, and Islamic characteristics?

It is quite possible to move beyond such apparent limitations in the Amalfi evidence. Although free of the elaborate ceremonial that helped generate the designs of palaces in thirteenth-century Paris or fourteenth-century Avignon, the Amalfitans nonetheless were acutely aware of the house as an effective site of artistic workmanship and display. As in the cases of popes or kings, their residences were not emphatically "private" spaces that were closed to extrafamilial eyes. The buildings suggest that the Amalfitans had access to a wide range of architectural ideas and conceived of their houses in ever more specialized ways.

This chapter reconstructs the general characteristics of a few of the housing types that dominated the Amalfitan landscape from the eleventh through the fourteenth centuries. This is not a comprehensive catalogue of all medieval houses in the region; such an enterprise is beyond the purview of this book.[10] Neither is it a detailed analysis of the material culture of the home, as evidence of furnishings and other portable domestic objects is limited to excavated pottery

sherds and generic references in wills to furniture.[11] Rather, the houses are considered here as architectural and cultural entities by examining the placement of housing types within urban morphologies, connections to various architectural and decorative traditions of the Mediterranean world, and conceptions of the house as a series of differentiated spaces and locations of display.

Constructed in part with the profits of *mercatantia*, the houses inscribe Amalfi within an architectural culture that includes, but is not limited to, North Africa. Islamic architecture in Ifrikiya (what is now roughly Tunisia) inspired some decorative as well as typological features of the houses, suggesting the impact of cross-cultural exchange on domestic environments in the West.[12] A prosperous site of architectural sophistication during the high Middle Ages, this part of the Western Mediterranean was familiar to Amalfitans, for port cities such as Tunis, Bougie (Bigaya), and Sousse were part of their commercial network; Mahdiyya had even been part of the Norman Kingdom during the reign of Roger II, *Rex Africae*.[13] Commercial connections were not without interruptions, however, as the Hilali invasions and Almohad conquest of the later eleventh and mid–twelfth centuries threw the region into chaos. But coastal towns and the commercial networks they supported were the first to bounce back from episodes of political and religious upheaval.[14] Even after the Almohads suppressed local Jews and Christians, Latin merchants continued to trade in Tunis, Bône, Sousse, and inland Qayrawan through the thirteenth century.[15]

With the advent of the Angevins, cultural relations between Amalfi and Ifrikiya became fraught, given the lack of cooperation between Charles I and the Hafsid emir of Tunis Mohammed I.[16] After Louis IX's crusade against the Hafsids ended in bittersweet victory for Charles, however, (bittersweet because his brother Louis died during the siege of 1270), close commercial relations resumed between Tunis, *regnicoli*, and other allies of Charles I in North Africa.

Some building traditions in this area of the Maghreb likely struck the Amalfitans as intellectually accessible, as the region incorporated highly worked ornament into a classicizing framework akin to the South's. Because houses were free of the holy traditions and liturgical imperatives that shaped centuries of church and mosque building, domestic architecture was apparently a site where the rules relaxed and creative and even multicultural syntheses could take place. Of course, evidence of greater aesthetic experimentation within the domestic realm is not unique to Amalfi. In the castles of Frederick II, for instance, playful sculpture in a Gothic style intermingled with the geometric configurations usually associated with secular architecture in Islamic East (see Fig. 77). Such juxtapositions

contrast vividly with the antiquarianism of more public Frederician works, such as the Capuan Gate.[17]

An array of material and textual evidence relates to the Amalfi houses and the issues they raise.[18] Supplementing the standing and excavated remains are descriptions of lost buildings, along with medieval deeds of sale, wills, and donations that address the built environment.[19] Comparisons with other towns, including Capua, Barletta, and Pisa, underline the unusually complex conceptualization of the domestic environment in medieval Amalfi.

The terminology used here makes an effort to follow and respect the diverse medieval sources consulted. Although many of the relevant buildings are referred to as palaces or villas today, medieval notaries tended to use *domus* or *casa* to describe Amalfitan houses, regardless of their form or complexity. Here, as elsewhere in the medieval world, the term *palatium* first referred to sites of institutional power: to the residences of emperors, dukes, then bishops, and finally to houses of significant scale or grandeur in the late Middle Ages.[20] In Amalfi, these distinctions are not consistent or absolute, but "house" is generally less anachronistic and problematic than the ideologically charged "palace," so it will be used here.[21]

Ultimately the Amalfitan houses transcend the conservative label usually affixed to premodern residential architecture. They are dynamic works that shaped domestic and urban environments in creative, sophisticated ways. Significantly, they do not necessarily reproduce reflexively or emulate only the dominant architectural ideas associated with the South's sovereign authorities; in fact, they call into question the Veblenian phenomenon of "trickle down" taste that has shaped influential discussions of medieval art and housing.[22] Instead, in their overall ideology and details, the Amalfi houses are inscribed within the culture of *mercatantia*.

Setting

Although the importance of *mercatantia* might suggest that seaside towns always dominated the region, inland ones were likely established first. The *Chronicon Amalfitanum* introduced an often-repeated foundation myth: nobles from Rome who had been shipwrecked en route to Constantinople constructed settlements along the slopes of the mountains north of Amalfi in the fourth century.[23] The premise of the *Chronicon* holds true. The towns of the coast were founded at various times from the fourth through the sixth centuries (although scattered

remains of villas dating from the Roman imperial period dot the area),[24] and indeed the earliest of them were located in the hills.[25] But the settlers were far less distinguished than the chroniclers imagined. They were probably the desperate inhabitants of inland towns and rural areas, who sought the protective mountains of the coast in an era of social upheaval and political collapse.

Despite the comparable foundation dates and shared culture of *mercatantia*, the towns present two types of urban fabric, both of which diverge from classical morphologies. The first appears in littoral towns (Atrani, Amalfi, and Minori) and likely developed in the ninth and tenth centuries – that is, the era of the first Amalfitan or comital elite. The second appears in the hill towns (Scala, Pontone, and Ravello) and seems to derive from the late eleventh through the early fourteenth centuries, corresponding to the primacy of the second elite. The rapid depopulation of the area after 1300 helped preserve the fabric and a number of medieval houses in both settings.

Although this study focuses on the later houses found in hill towns, an overview of the seaside towns will help establish the distinctive character of the urban morphology and housing in each location. The compact forms of the coastal settlements derive in part from the exigencies of their dramatic sites. Located in valleys where rivers meet the sea, they are hemmed in by cliffs that severely limit the amount of low-lying and level ground.[26] In the cases of Amalfi and Atrani, the main streets followed the course of rivers (they are now channeled under the main traffic arteries), and secondary alleys peel off the principal axis and wind up the outer cliffs [27] (Fig. 4). The main river axes supported industrial, artisanal, and market activities, and indeed much of the early fabric seems to have supported this economic engine. Housing was concentrated along the secondary alleys. Small, open spaces – gently widening streets or *plateae*, courtyards around which houses clustered, and cloisters – punctuate this dense urban fabric. Distinctions between public and private space, or more precisely, that of the street versus that of the house, were constantly challenged and blurred.

Such dense living conditions were ripe for conflict. An Amalfitan law code of the late tenth and early eleventh centuries (known from a redaction of 1274) sought to clarify the inherent ambiguities of such forms. For instance, the floors that divided one story from another in a house were decreed joint property of the occupants of both levels, and thus the cost of repairing them would be divided equally.[28] Rights over shared walls could be purchased for two Amalfitan tarì.

Episcopal charters provide a view into the disputes that such laws and urban forms brought forth. In Atrani in 1287, the proprietors of a large house agreed

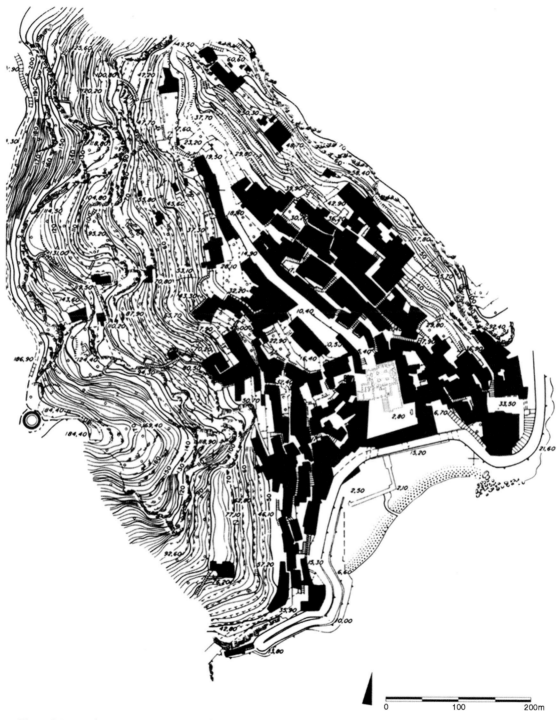

4. Plan of Atrani (Danielle Lam-Kulczak).

5. Amalfi, residential structures built over street.

not to continue with construction that would have blocked the light and air of neighboring shops that were owned by the bishop of Minori.[29] Deeds of sale carefully delineated modes of access for houses and commercial properties. In this uneven terrain, where interior private staircases were rare and exterior common ones widespread, this issue was particularly critical.

Concerns about access, light, and shared space resound through charters relating to the seaside towns. Such concerns are not, of course, unique to the region of Amalfi. Documents from medieval Barletta, the prosperous port located on the southeast coast of the peninsula, also emphasize right of access and suggest an environment of comparable spatial and legal complexity, through ca. 1300.[30]

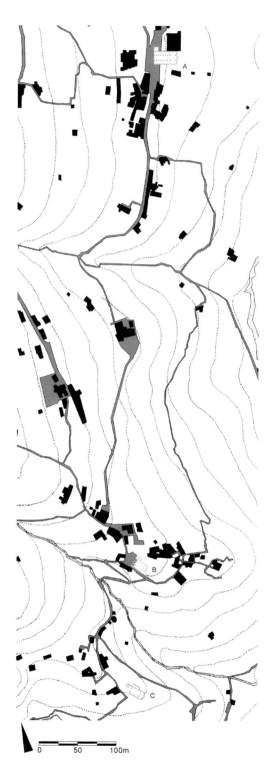

6. Plan of Scala settlements, from southern Scala to northern Pontone, with salient monuments in plan. (A) Cathedral of Scala; (B) SS. Annunziata, Minuto; (C) Sant'Eustachio, Pontone (Danielle Lam-Kulczak).

There, too, carefully negotiated balconies (*gayfi*) often cut across houses with different owners, and thus suggest the presence of contiguous townhouses.[31] In the littoral towns of Amalfi, extending the upper levels of a house over the street to form balconies or even entire rooms added value and space to the house in question (Fig. 5). As with so many building conventions of the medieval South, this one appears throughout the West and Mediterranean world in the later Middle Ages – witness the ubiquity of overhanging structures or traces thereof in Damascus, Venice, Siena, Viterbo, Cordova, Tunis, and so on.[32]

In contrast to this urban density along the coast, a looser and more linear morphology is found in hill towns such as Scala and Ravello (Fig. 6; see also Fig. 49). These places share some features with the seaside group, including central axes and subsidiary networks of small roads that lead up the faces of hills or down into valleys. The housing, however, differs fundamentally, as it consists of freestanding dwellings that generally rise to only one or two stories. The houses are spread out, rather than compact and vertical, and often have agricultural dependencies, such as gardens, groves, and vineyards. Many of them date from the twelfth and thirteenth centuries, the period of the second Amalfitan elite. This discussion focuses largely, but not exclusively, on this later housing type found in the hill towns.

Materials, Sources, and Method

The building materials used in the coast's diverse housing stock were remarkably consistent. Masonry construction prevailed in rural and urban settings from the tenth through the fourteenth centuries.[33] Walls and ceilings were made of small pieces of local stone mixed with mortar. This early insistence on masonry is unusual and significant. During the early and high Middle Ages, most housing across the Latin West featured less permanent materials, such as wood and brick. And elsewhere in the South, too, humble materials prevailed. Documents and archaeological evidence indicate that in other cities, including neighboring Salerno and centers on the east coast, wood or mixed wood and masonry houses predominated through the late Middle Ages.

The Amalfitans' use of masonry must be seen as a preference, rather than as an arbitrary reflection of, say, limited material resources on a local level. After all, high-quality lumber was abundant in the region. Forests of chestnut trees provided the raw materials for shipyards and fueled a profitable export market for centuries. Hence, the prevalence of stone there was likely a choice, born of desires

for permanence, security, and architectural elaboration and sophistication. As has been posited for England and France, "modern" stone houses expressed the wealth and power of the families who owned them; this turn to stone in the twelfth and thirteenth centuries has been correlated to the new prosperity and social competitiveness of the Commercial Revolution.[34] Amalfi's precocious culture of *mercatantia* and the wealth it produced helped shape this building trend as early as the year 1000.

This use of masonry was not the only unusual, special, or expensive aspect of the houses of the Amalfitans. Small and large ones alike contain significant quantities of decoration as well. Because residential buildings were almost exclusively constructed of rubble masonry, the material additions to that rough, functional matrix define its ornament. These accretions include the often sculpted face of plaster that smoothed over walls; intarsia, or inlaid patterns of tufa, a porous volcanic rock; painted fields of color (not figural depictions); and columns of marble or terracotta that created colonnades and embellished windows and doors. Greek and Roman ruins along the Tyrrhenian coast from Sorrento to Paestum supplied marble *spolia* for many of these details. Despite this use of ancient fragments, however, the decoration in Amalfitan houses has little to do with the traditional ornamental lexicon of antiquity.

These decorative materials were fundamental to Amalfitan religious architecture as well. The interdependence of the two spheres of the built environment is best seen in uses of intarsia, an ancient form of ornament that illustrates the deeply rooted and residual aspects of Amalfitan visual culture. In its most simple and constructive mode, in evidence during the first century and from the eleventh century well into the fourteenth, blocks of tufa outline window openings and emphasize recurrent geometries of oculi, lancets, or round-arched fenestration – for instance, the bell tower of the Cathedral of Amalfi and the paired and triple lancet windows of the Rufolo House, uncovered in 1991 (Fig. 7). Such patterns were widespread; similar outlines appear at the Castel Terracina in Salerno, identified from textual references as a royal residence from the establishment of the temporary Norman capital there in 1076 to ca. 1275.[35] Tufa voussoirs also embellish portals, although this strategy is more common in housing than in churches, where marble generally does that work.

Alternating blocks of grey and yellow tufa were also cut in interlocking profiles, as seen in a house in Pontone. In more intricate configurations, large pieces of tufa provide the ground for inset pieces of another color. A portal in the courtyard of the Rufolo House employs this two-tone technique, although the small inserts

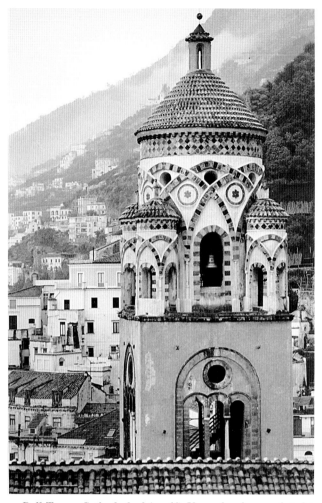

7. Bell Tower, Cathedral of Amalfi. Upper levels completed in 1276.

are lost[36] (Fig. 8). In the most complex patterns of intarsia, apparent at the Rufolo House, artists sketched out their designs of intersecting arches in red pigment (sinopia) before placing the colored, sculpted materials in the plaster[37] (see Figs. 19 and 23). In the domestic realm, such layers of ornament were more subject to variation and elaboration than in the more conventional ecclesiastical settings.

Given the absence of chronological indices such as variations in stone cutting or changing material preferences, these applied motifs are particularly important for establishing a relative chronology for the Amalfi houses. Urban context is also informative in this process. Development in the hill towns was primarily

nodal, or based on units comprising family compounds or institutions (houses, private churches, monasteries, and so on); consequently, the approximate dates of settlement often can be surmised. Episcopal charters and early modern histories offer additional chronological, social, and economic anchors for the physical evidence. Many of the connections between houses and clans remain, somewhat equivocal however. Hence, aspects of family history are developed here only in a few cases in which supporting evidence of ownership or affiliation is sustained.

Facilitating this study is the fact that Amalfitan scribes were remarkably detailed in their descriptions of properties. Deeds of sale, wills, leases, and dowries often note both the building materials of a house and its constituent parts defined by function. Land is similarly characterized according to agricultural potential or current conditions, with notes of trees, vineyards, groves, and water sources. For both architecture and landscape, descriptive specificity appears in the earliest surviving manuscripts from the region dating from the tenth century. This level of description indicates that Amalfitan scribes conceptualized domestic space as diversified and animated by specific social and economic practices.

Documents vary in their degree of detail. In 1069, a property in Cetara was described in simple terms as a two-story house that included a wine press and

8. Portal, originally with two-tone intarsia inserts. Rufolo House, Ravello, thirteenth century.

access to water.[38] A document of ca. 1079 describes a property in the hills above the seaside town of Minori as consisting of vineyards and chestnut groves, plus a two-story house of masonry, with wine presses, a cistern, and a small hut.[39] Thirteenth-century notaries brought forth new levels of specificity. A charter from Ravello, dated 1231, includes references to a *domus*, small heated room, kitchen, dressing room, and corridor. By contrast, contemporary documents from Capua, Barletta, Pisa, and Siena are relatively laconic concerning architecture.

In contrast to the rich Amalfitan scribal record, the scholarly literature on the region's housing is sparse, and aspects of it are problematic. As a result, this discussion opens with an analysis of prevailing views of the South and its cultural history as shaped by the Southern Question. An overview of key housing examples then brings the monuments and their settings into focus. These general remarks underpin a more detailed examination of the salient components of the houses and their ornamental strategies and of the wide-ranging architectural traditions with which the Amalfitans shaped their domestic sphere. Finally, these explorations lead to new perspectives on the Amalfitan corpus and its place in the history of architecture in the medieval Mediterranean basin.

Housing, Orientalism, and the Southern Question

With its disparate forms evocative of Western, Byzantine, and Islamic architecture, the built environment of Amalfi presents many complexities, some of which engage entrenched views of the South. Many (pre)conceptions fuel the literature relating to Amalfi, and these must be identified and neutralized.

Examples of Amalfitan domestic architecture have been assessed from two basic perspectives. In the first, which was attentive to social context, early modern writers saw houses as sumptuous ensembles on which their views of Amalfi's golden age were projected. These writers displayed an awareness of family history that placed architecture within almost moralizing frames of reference.

The Rufolo House, for instance, was a protagonist in Bolvito's account of the family's fall from favor.[40] Incorporating local legend, Bolvito held that the Rufolos' difficulty with the crown began at a banquet they held that Charles II and his son Robert attended.[41] Intending to impress their guests, the hosts nonchalantly tossed silver plates, pitchers, and goblets used during the meal over the cliff and into the sea. Nets that had been secured under the waves caught the precious wares secretly below. The duped and cash-starved king marveled at this unfettered display of the hosts' "infinite wealth," grew suspicious of it and

the power it bestowed, and confiscated it bit by bit, until the Rufolos had nothing left.

While the legend does not explicitly connect the king's anxieties to architecture – the luxurious portable objects and willful destruction thereof are what directly pique his envy – Bolvito's portrait of the palazzo suggests that the domestic complex was a second site of wealth and extravagance. *Splendideza, magnificenza, mirabile opificio, real sontuosità* – these are the traits of the house that Bolvito repeatedly underscores. Foreshadowing the transgressions of Nicholas Fouquet at Vaux-le-Vicomte, the domestic environment of the Rufolos comes across as too luxurious, and perhaps too luxurious and *real* (royal) for a site outside the court.

Naturally this tale cannot be taken literally as historical fact; Bolvito qualified it with an attribution to oral tradition, or what he called the *antica tradicione dei vecchi*. Adopting the strategies of writers of sermon *exempla*, *novelle*, and other forms of early vernacular literature, Bolvito brought together interpretations of historical events that diverge from the "official" discourse of the chronicles, chancery documents, and other canonical texts that he cited so carefully. But in mediating between local and authoritative sources, this passage has the merit of capturing early views of the house, its occupants, and their status, real and imagined, in the community. It also echoes the dour prophesies of a late-thirteenth-century follower of Joachim of Fiore, who condemned the inhabitants of Ravello and Scala as effeminate, corrupt men whose splendor would end in ruin and damnation.[42] Prophetic writing in this vein was widespread in the South and gained momentum in subsequent decades.[43]

Later studies introduced a new, more lasting theme: no longer "sumptuous," Amalfitan art and architecture became "oriental" or "exotic."[44] In his seminal *Storia dell'arte italiana* (1904), Adolfo Venturi interpreted the Rufolo courtyard as "oriental." Yet he did not name any actual "oriental" works; he situated it among other southern Italian buildings, such as the Cloister of Paradise in Amalfi and other works with intersecting arches[45] (see Fig. 28). Like so many of his successors, Venturi used the term to signal a general mood, rather than to identify precise geographic, cultural, religious, aesthetic, or even chronological parameters.

In the first detailed treatment of the Rufolo House (1903), Bertaux did the same. He expressed the complexity of the monument through a series of incommensurate identifications: "One could say that the creators of this fairyland architecture sought models from even beyond Sicily, in Greek or Saracen

countries, to construct for an Italian merchant, favored by a French monarch, the palace of an Oriental despot."[46] Bertaux's compelling imbrication merits close examination. While many passages in his seminal study of the art of the medieval South are models of sophistication, this one is less satisfying; he did not historicize or contextualize the unusual architectural forms he evoked so tantalizingly. He was not concerned with specific borrowings from Islamic or Byzantine architecture, relations to it, or the cultural trends that rendered an "oriental palace" viable in Southern Italy.

Many studies of Amalfitan architecture written well after 1904 maintain this ahistorical or vague tenor. In 1940, Schiavo tempered his overview of the Rufolo House's masonry techniques and decorative traditions with impressionistic visions of medieval dancing girls, strolling musicians, and enticing banquets.[47] Even recent archaeological reports, while addressing technical issues concerning building campaigns and other significant themes, describe the house as a "mysterious labyrinth," a "pleasure palace" of "artifice," "meditation, poetry, or love."[48]

What is troubling about this trend is that Islamic art had an academic profile even at the time of Bertaux and Venturi. Foundational studies in the new Orientalist tradition were available, works such as Girault de Prangey's *Essai sur l'architecture des arabes et des mores, en Espagne, en Sicile, et en Barbarie* (1841) and the Napoleonic *Description de l'Égypte* (1808–28).[49] Although both books contain the biases and misunderstandings that one would expect to find in studies from that period, many of their observations and generalizations could have assisted the early historians of southern Italy. The basic chronology and taxonomy of form that de Prangey introduced, for instance, derived from careful visual analysis, apparently unencumbered by many of the issues that vexed later historians of the South. Thus many of his generalizations still hold, more or less.[50] In fact, there are far fewer ahistorical or essentializing observations in that work than in the recent literature on the Rufolo House.

The lure of the Oriental and the exotic, another rarely historicized concept, is amplified in other contexts in the medieval South. This is particularly the case in Sicily, where connections to Islamic art are less ambiguous, given two centuries of Muslim rule and the presence of Arabic inscriptions and muqarnas ornament on scores of Norman monuments. Foundational studies often admired the complex, "exotic" character of the art of the Norman era, of which the Cubula pavilion in the royal park of Palermo (before 1180) and the cloister of the monastery of Santa Maria in Monreale (begun ca. 1176) are emblematic (Fig. 9). Works

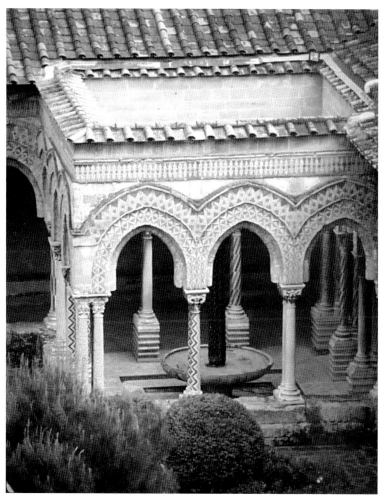

9. Cathedral and Monastery of Monreale, Cloister, begun ca. 1176.

such as Gioacchino di Marzo's *Delle belle arti in Sicilia* (1858), however, are far less enlightened than de Prangey's earlier study. Di Marzo asserted that the fundamental nature of Islamic art is decorative and thus contrasts markedly with the structural, formal, and spatial integrity of Western art. As he phrased it, "the hot climate of the Oriental homeland produced among Arabs [in Sicily] this exaggeration in imagination and effects... Soft and lascivious customs engender excessiveness in decoration."[51] Guido di Stefano's influential study of 1959 is also prone to reverie (albeit of a less racist variety), emphasizing the artificiality and fragility of the domestic architecture of the Norman kings, which he compared to a hothouse flower.[52]

Studies of the Rufolo House and other examples of Amalfitan architecture contain nearly identical emphases on ornament, artifice, and excess, and a concomitant suppression of historical context. This focus on surface ornament and vague evocations of mood comes at the expense of the larger framework of architecture – of the layout of buildings, their individual components, their patrons, or their overall significance and meaning to medieval Amalfi and to the history of art. This type of limited and limiting focus is, of course, widespread in late-nineteenth- and early-twentieth-century appraisals of Islamic architecture. The literature on Amalfi and the South coincides neatly with many of the historiographical structures critiqued by Edward Said in *Orientalism* (1987).[53]

In the context of southern Italy, Orientalism takes on specific contours; it is part and parcel of larger issues of national identity that coalesce around the so-called Southern Question. Although drawing on ideas that were rooted in such varied movements as Romanticism and scientific empiricism, the Question per se emerged at the time of Unification in 1860 to address the differences and disparities between two regions that suddenly comprised a single political unit.[54] In his influential *Lettere meridionali* (1875), the Neapolitan-born Pasquale Villari argued that the revolution that created modern Italy lacked an effective social counterpart or workable theories of unity or social cohesion. Villari, along with like-minded reformers whose writings defined the parameters of the early Question, admirably sought to alleviate poverty and exploitation in the South, to be sure. So did later intellectuals such as Antonio Gramsci and Francesco Saverio Nitti, who wrote extensively on the issue from ca. 1910 to 1930. But recent analyses of the Question point out that this emphasis on socioeconomic reform had the effect of repeatedly representing the region as fundamentally different – as separate, less developed, and effectively primitive – in short, as less European than the North was.[55] These early representations helped justify the conquest of the region as a civilizing venture and fueled stereotypes for generations. Negative characterizations of the South also highlighted the sophistication of the North and the latter's affiliation with European culture. Thus the Question calcified persistent North-South polarities: rich-poor, urban-rural, civilized-uncivilized, modern-backward, productive-parasitic, European-non-European, Italian-African – binaries that placed the South outside any coherent narratives of historicocultural development.

Because the Question constructs the South as the uncivilized alter ego of the North, the South's cultural practices that diverged most tangibly from the North's were particular sources of attention and anxiety. The presence of Muslim

communities in the medieval South introduces a literal Orientalism to the binaries of the Southern Question that are in and of themselves so reminiscent of Orientalism.

Because the Question and Orientalism drew on deeply rooted themes and a wide range of perspectives, some of their premises inevitably had an impact on early art historical studies. After all, the coalescence of the Question in the second half of the nineteenth century coincided with intellectual foment in the new discipline and the sketching of the canon's basic contours. Traces of the Question and its ideological underpinnings or anxieties about them appear in some of the early seminal works on Italian art, informing what cultures, figures, and monuments were evaluated and how those subjects were portrayed. For instance, works of medieval art associated with communal systems of governance were perceived as modern, just, and logical bases on which to construct national identity and a sense of a common past. Building on the theoretical foundations of art history laid by Alberti and Vasari, such central Italian contexts received and continue to receive the lion's share of attention in the history of late medieval art.[56]

Travel literature and popular magazines published in the decades after Unification contributed to this imbalance, with their lack of attention to works of art in the South and glorification of its natural rather than cultural-artistic landscape.[57] For instance, many such texts create the impression that there was no art in Naples outside its two famous museums and suburban archaeological sites;[58] visitors seemingly came for the views and for excursions into the countryside. As the American author of a popular travelogue series explained in 1909, "Thus far, in Southern Italy the appeal is to the Senses and the Imagination, and it is overpowering. In Rome I know full well the appeal will be to the Intellect through antiquity and the historic sense."[59] The few texts that actually mention medieval and early modern art in Naples tend to dismiss it as unoriginal and inauthentic on account of its "imported" status.[60] Given the diffusion of these ideas in many types of literature, it is not surprising that so many art historians in this pivotal period focused their attention on the rest of Italy.

These observations are generalizations, but ones that are worth extending to the art historical literature on the South. Take, for instance, Bertaux, whose *L'art dans l'Italie méridionale* functioned to connect the separate South to European and Renaissance ideals and canons. He accomplished this by emphasizing the classicizing traditions of the region, from Early Christian basilicas in Cimitile and Nola to Frederick II's Castel del Monte (see Fig. 20).

In many ways, Bertaux's work forms a sort of prequel to Jacob Burckhardt's conceptions of Renaissance humanism and statecraft[61] – a commendable enterprise to be sure, executed with critical acumen that reads as precocious. On the other hand, such a focus cannot help but gloss over the characteristics of the South that do not fit readily within that unitary narrative, including Lombard, Byzantine, or Islamic features – in other words, sources of "otherness" that lay at the heart of the Question. This does not imply that Bertaux was anti-Southern – far from it. His work helped establish the cultural and artistic richness of the region, a remarkable accomplishment given the trying circumstances in which he conducted his research.[62] But although his antiquarian focus reads as an eager critique of the biases embedded in the Question, his emphasis on classical material inadvertently suppresses the features of the South that do not fit within this unitary model of Italian history.

Furthermore, Bertaux's emphasis on antiquarianism does not necessarily respect the internal chronologies and cultural shifts in this diverse region. Where and when he chose to conclude his magisterial study is telling: he does so with Nicola Pisano in Tuscany. Here, as elsewhere, Nicola is logically portrayed as a seam between South and North, between medieval and Renaissance. This authoritative model makes sense when classicism is the ultimate point of reference. But if the art of the South, broadly construed, is the subject, then other points of rupture seem more apt. Nicola's departure in the 1240s or 1250s was transformative for his adopted Tuscany, to be sure, but other sculptors of the dispersed Foggia workshop (including Nicola di Bartolomeo, who worked in Ravello) remained active in the *Regno* well through the 1280s. The pronounced rupture in the art of the South comes not with the absence of Nicola, but rather with the presence of Pietro Cavallini and Giotto and their central Italian contemporaries in Naples. Their radical approaches transformed artistic practices, styles, materials, and typologies throughout the South in the first half of the fourteenth century, as discussed in Chapter 4.

Other traces of the Southern Question appear in the apologetic tones of editors of primary texts from the South. One historian found the medieval evidence of political and economic sophistication redemptive, an argument to silence the clamor of antisouthern voices that saw the South as primitive.[63] Others located in the "holy bloodshed" of the Vespers rebellion a triumphant message that had the potential to galvanize Sicilians, thereby taking Amari's activist premise into a new century and political context (that of Unification and a king from Piedmont).[64]

Some early studies penned by southern authors were constructed around local issues of self-identity and betray ambivalence toward "Islamic Italy" or other binaries established around the Question. Emblematic of this (multi)cultural anxiety is *Delle antichità d'Amalfi e ditorni* (1859), penned by Scipione Volpicella during the struggle for Unification. This work emphasizes Christian content in Amalfitan art and architecture and "corrects" forms and images that diverge from standard Western paradigms.[65] The pointed, intersecting arches on the façade of the Cathedral of Amalfi and its Cloister of Paradise might be known in popular parlance as Gothic or Arabic, he wrote, but they must be understood as Christian. Viewers must not imagine that the dark skin of Mary in a fourteenth-century painting of the Virgin and Child is a truthful likeness; Jesus's skin, like his mother's, was the color of wheat, as is represented in so many other paintings and as John of Damascus clearly stated. Resembling a nineteenth-century Durandus, Volpicella insisted that nearly all elements of the built and natural environment "are" pure Christological signs, even if, from our perspective, their appearance might throw into question such a one-dimensional interpretation. Volpicella was determined to place Amalfi's art within a European ideal of uncontested *Christianitas*.

In sum, many studies of medieval architecture in Amalfi written in the wake of Unification have been quick to point out its "oriental" look, but at the expense of the larger issues embodied in the built environment and culture that produced it. This work seeks to correct that imbalance by addressing a series of questions. What, if anything, is "oriental" about the Amalfitan housing corpus? What specific taxonomies of form and type apply to these buildings and their decoration? What is the significance of Islamic or Byzantine artistic concepts appearing in medieval Amalfi in the thirteenth century, within a culture of *mercatantia*? Because ornament is traditionally the site of Orientalist fantasies and projections, and indeed has been so in the case of Amalfi, these questions must apply to decoration as well as to issues of building form and layout.

Houses of the Hill Towns: Overview

The economic decline and depopulation of the coastal region in the fourteenth and fifteenth centuries took a toll on the hill towns. Often in ruins, many medieval houses of considerable scale remained potent symbols for generations. They were "veramente di notabile grandeza" and of "sontuosa manifattura," as Bolvito wrote in 1585. In Ravello, the houses of the Freccia, Castaldo, Muscettola, Della Marra,

Confalone, Rogadeo, Grisone, and Rufolo families were particularly magnificent, he claimed.[66] But these houses were not the only ones emblematic of medieval prosperity. The neighboring town of Scala, too, was full of splendid dwellings, including those of the Trara, Coppola, and Spina families.[67] Their houses rivaled ones in Ravello, as they contained "the same arcades, columns, orders of marble cloisters, friezes, and delicate things."[68]

Spread-out complexes such as those alluded to in early modern sources were noted in thirteenth-century charters as well and were apparently common in the region. Fragments of them survive in nearly every quarter of every hill town on the coast, from Pastena and Pogerola west of Amalfi to Pontone, Scala, Ravello, and Torello to the east.

A few of the surviving houses rise to two or three stories, but generally the complexes maintain a horizontal character. The largest and best-preserved example of this building type is the Rufolo House in Ravello. Related buildings that are considered here are the houses of the Sasso, Trara, and Mansi in Scala, d'Afflitto in Pontone, and Confalone in Ravello. Others to whom family connections are unclear are designated by location, such as the South Toro House in Ravello. Most of these houses date from the late twelfth century through ca. 1300.

These Amalfitan examples diverge from (and predate) the townhouses associated with a rising commercial class in such prosperous places as Siena or Pisa. Although an occasional document refers to an Amalfitan residence with shops or workshops, the houses examined do not contain commercial properties, as central Italian ones tend to do (some had spaces for the storage of commercial goods, however). Furthermore, they are not single, self-contained units typical of such townhouses. Rather, they consist of multiple structures, some of which are woven together while others remain fairly autonomous. They can be seen as generated in a centrifugal way, that is, outward from the core courtyard into adjacent space, in contrast to townhouses that were constrained by narrow lots or walls of contiguous buildings.

Along with the loose urban morphology of the Amalfitan hill towns, this approach to building facilitated the development of large family compounds or districts where several adjacent dwellings accommodated an extended clan, as also seen in the more densely populated cities of Genoa and Florence. The d'Afflitto family occupied many houses along a wide swath of land around Sant'Eustachio in Pontone, for instance. And in the course of three generations, members of the extended Rufolo family purchased adjacent properties that eventually coalesced into the grounds and structures of the Rufolo House.[69]

It must be emphasized that most of these complexes were constructed by the second Amalfitan elite, which prospered following the loss of Amalfi's political autonomy – that is, after the Norman conquest of the region. Often connected to the land and agricultural endeavors, this second wave came to participate in the diverse aspects of *mercatantia*: they were merchants, shopkeepers, notaries, judges, bankers, and royal or imperial administrators, with connections to other commercial centers in the *Regno* and abroad. Matteo Trara, for instance, was co-owner of a ship that was sequestered in Alexandria in 1269.[70] Others managed various aspects of the kingdom's economy, from the royal mint to the salt tax, during Hohenstaufen and Angevin rule. In the Rogadeo family, Bartolomeo served as the *magister procuratores* for western Sicily in 1246 and 1247, Benedetto was a tax collector in 1243, and Iacobo served in a variety of positions in the early 1260s.[71] Among the Freccias, Nicola and his son Stefano held various offices across the kingdom under the Hohenstaufen and Angevins from 1246 through 1277; Stefano, Rigorius, and Leo acted as judges.[72] A second Nicola studied law in Naples and rose to the position of lieutenant protonotary of the kingdom in 1306. His stature was such that his boss, the acclaimed jurist Bartolomeo of Capua, penned a funeral oration in his honor.[73]

Rufolo House, Ravello

The core of the Rufolo House occupied a central position in medieval Ravello[74] (Fig. 10; see also Fig. 49). It lies on the opposite side of town from the northern Toro district, an area associated with the town's elite families in the eleventh and twelfth centuries. Following the construction of the cathedral at the south end of Toro in 1071-2, development accelerated around the site of the Rufolo House. Most of the monastic and residential fabric in that area dates from the thirteenth and fourteenth centuries.

The Rufolo House is one of the few residences in the region with a reasonably precise chronology. Stylistic, formal, and documentary evidence indicates that most of its components date from the reign of Nicola as paterfamilias, that is, from circa 1250 through 1283. The Rufolos managed to retain the property through the corruption trial and confiscations of 1283, and some members of the family remained there throughout the fourteenth century. The last Rufolo to inhabit the complex was likely Pellegrino, bishop of Ravello (d. 1401).[75]

The varied structures that comprise the Rufolo House now occupy roughly eight thousand square meters of irregular terrain. They range in scale from an entrance tower and its decorated vestibule to the intimate spaces of a bathing

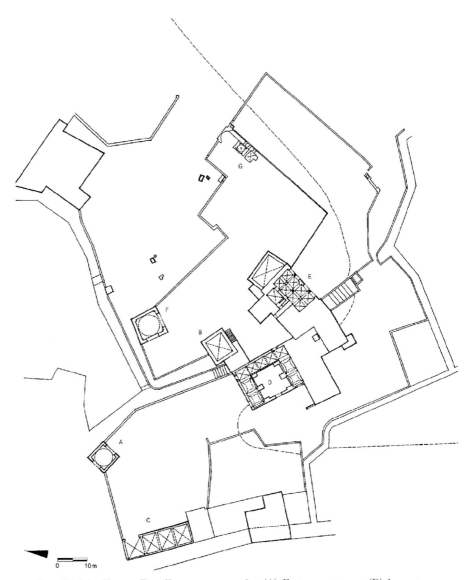

10. Plan, Rufolo House, Ravello, ca. 1250–1283. (A) Entrance tower; (B) large tower or keep; (C) chapel; (D) courtyard; (E) loggia or *sala*; (F) pavilion; (G) bath (Danielle Lam-Kulczak and Lino Losanno).

chamber. A few structures, such as a pavilion tower and high, vaulted halls, are relatively autonomous and are scattered across the complex. Other constructions, including a keep, low loggia, and most residential quarters, encircle a three-story courtyard, the heart of the complex. Painted umbrella domes, carved figures, mosaics, and vibrant patterns of intarsia contribute to the dynamism and texture

of this ensemble. Both interior and exterior received copious decoration and created a setting that was, in Bolvito's words, *uno stupore.*

Having fallen into graceful ruin over the course of six centuries, the house presents many obstacles to analysis, as do most of the Amalfi houses. Additions, terraces, a tunnel, earthquakes, and, most recently, a questionable restoration have obscured or destroyed parts of the complex's medieval fabric.[76] Although ongoing excavations begun in the late 1980s have answered many questions of chronology and settlement on the site, a definitive reconstruction will likely never be possible.[77] As with Hadrian's Villa in Tivoli or the Great Palace in Constantinople, large swaths of the house are destroyed or remain underground. Despite these difficulties, the standing medieval remains of the site are considerable and in fairly good condition.

D'Afflitto House, Pontone

The d'Afflitto House is located in the hill town of Pontone, which lies across the Dragone River valley from Ravello and overlooks Amalfi and Atrani (Fig. 11). The d'Afflitto family was one of Pontone's most distinguished. Of considerable

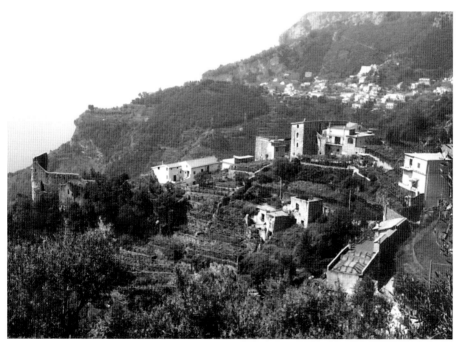

11. The d'Afflitto residential compound with ruins of Sant'Eustachio, Pontone, as viewed from Minuto, late twelfth and early thirteenth centuries.

economic, political, and cultural ambition, they sponsored the construction and decoration of two churches and several houses in the region.

According to the local traditions recorded by Bolvito, Freccia, and later geneal-ogists, the d'Afflittos traced their lineage back to St. Eustachius, a commander of the Roman army under Trajan. His gruesome martyrdom in a heated brazen bull reputedly provided the inspiration for the family name (literally "afflicted" or "hurt").[78] But it is more likely that the name derived from local toponymy, for a tenth-century document mentions vineyards in a district known as *Filecto*; residents of this zone were identified as *de Filecto*.[79]

As was the case with so many Amalfitan families, the d'Afflitto clan moved from agriculture into commerce and royal administration. Although it is possible that one member of the family served under the Hohenstaufen, most evidence relating to the family's business activities dates from early Angevin rule. At that time, members of the clan who had moved to Naples and Cosenza continued to work directly in commerce. Tommaso d'Afflitto, an inhabitant of Naples, ex-ported grain to crusader Acre in 1278, for instance. But others flourished in the administration, apparently securing their reputations as overseers of the royal mint. Constantio was the first master of the mint at Brindisi under the Angevins (1266) and went on to serve as *secretus* of Apulia in 1277. Bartolomeo followed suit at the mint in 1275–6, as did Bernardo in the early 1280s. Other members of the family had prestigious ecclesiastical careers. Costantino and Matteo d'Afflitto were bishops of Scala, from 1207 to 1226 and 1227 to 1244, respectively.[80]

This house in Pontone has been linked to the family in part because its architecture and decoration correspond to an early description of a d'Afflitto residence, and in part because of its proximity and resemblance to the family's private church that was dedicated (not surprisingly) to St. Eustachius.[81] The core of the house clusters around an irregular enclosure, with low structures and rooms arrayed around it. The walls of this open space or courtyard are enlivened by fragments of intarsia. Similarly, bands of tufa run along the robust wall leading up the stepped path to the entrance of the house (Fig. 12). A three-story rectangular tower stands immediately to the right of the entrance, on the side of the complex that faces downhill. It contains a bathing chamber and related technological features.

A variety of evidence indicates that this house was built in phases from ca. 1180 to 1250. Those decades also correspond to an intense period of d'Afflitto patronage at the adjacent Sant'Eustachio, which was founded in the second half of the twelfth century. It is probable that this house was one of many structures

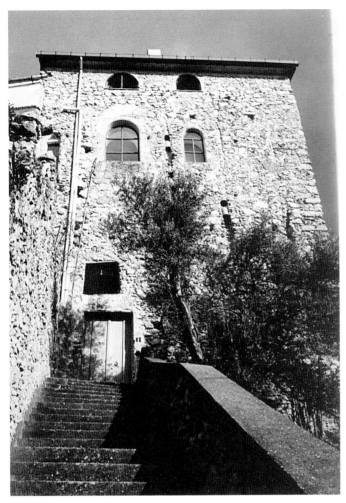

12. Entrance of the d'Afflitto House, with decorated wall (left) leading to tower with bathing chamber, Pontone.

that once defined a large, irregular domestic complex in which the extended clan resided; the remains of other buildings of comparable form and date are scattered along the hill above the church.

Sasso House, Scala
The remains of the Sasso House lie in the Campoleone district of Scala, northwest of the Cathedral of San Lorenzo. All that survives of the medieval structure is one flank of its courtyard, which sports three bays of an arcade with round arches. Although such sparse remains complicate the process of dating the monument,

the material evidence and relevant written sources suggest that construction likely began in the early thirteenth century.[82]

The house faces the main road that led from the cathedral to the Porta Santa Caterina. Monastic communities, small churches, and other medieval houses dating from the twelfth to the fourteenth centuries clung to this hillside district as well. Its orientations were toward Ravello and overland trade routes to Lettere and the Sarno Valley, rather than toward Amalfi and its bustling port. Its site, then, testifies to the importance of agriculture to the local economy and to the second Amalfitan elite.

Many early printed sources, including Marino Freccia, connected the Sasso clan of Scala to Gerardo, the legendary founder of the Knights of Saint John.[83] Research presented at the translation of the relics of the beatified Gerardo to Scala in November 2002 has verified much of that legend, which became a fundamental part of Scala's self-identity in the fourteenth century.[84] Although the house in question has long been considered Sasso property, it cannot be connected to Gerardo.

Noted in the Angevin registries in the 1270s, Pietro Sasso of Scala, a knight, was a likely inhabitant of the house.[85] He was one of the few Amalfitans in the ranks of the feudal nobility, having received a fief in Molise from Charles I. Pietro was not the only distinguished member of the family. As with the Rufolos, the Sassos held powerful positions in the administration of the kingdom. Giacomo Sasso, for instance, was the chief of the royal mint at various times from 1279 to 1281.[86] Other family members flourished in the Dominican order well through the 1300s.

The patronage of the Sasso family was not limited to their domestic compound in Scala. An inscription bearing the date 1358 names Paolo Sasso as the donor of a sculpture of the archangel Michael located in the church of San Pietro in Campoleone.[87] Although San Pietro was located in the same district as the Sasso House, the private church of San Giacomo in Scala was directly associated with the family.[88] Sasso interests, then, encompassed various parts and institutions in this one neighborhood, just as the d'Afflittos concentrated their efforts on the hillside in Pontone.

A detailed seventeenth-century description of the house offers a fuller view of the ensemble than what can be seen today and provides the basis for the reconstruction presented here (Fig. 13). Because most of the house was destroyed in the 1800s, the accuracy of this anonymous text cannot be verified, but its sophisticated language indicates a basic understanding of architectural terminology

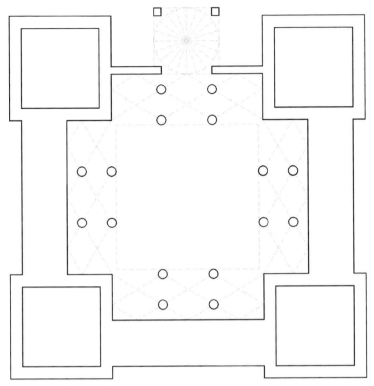

13. Sasso House, Scala, early thirteenth century, hypothetical reconstruction of the ground floor (Danielle Lam-Kulczak).

and medieval building techniques. It portrays the Sasso House as a highly ornamented and impressive residence.[89] Its many rooms were arranged evenly around a central courtyard that had "admirable interlace" (*ammirevole intrecciatura*), or intarsia. Square towers with crenellation stood in each of the house's four corners. Such geometric regularity is somewhat unusual for the region, since most surviving domestic structures in the hill towns are asymmetrical – a series of one- and two-story rooms loosely arrayed around a central courtyard, as in the d'Afflitto House in Pontone and the South Toro House in Ravello.

Layout and Ornament: Characteristics and Antecedents

In these hill-town sites, courtyards provided the center around which other structures and decorative displays multiplied. These other features define the striking characteristic of this group, its composite nature. Many houses consist of disparate

structures with varying degrees of autonomy. On the basis of their form or technological remains, several of these parts can be identified or named, as medieval notaries tended to do – references to rooms such as the *coquina* (kitchen), *balneum* (bath), *caminata* (heated room, with a fireplace), and so forth appear throughout these documents. More elective structures also appear, such as porticos, pavilions, or halls. The variety of named rooms increases in sources from the late twelfth and thirteenth centuries, indicating a greater focus on domestic space and the sophistication thereof in notarial culture, and possibly the development of increasingly complex housing in Amalfi.

For the Middle Ages, the diversification of domestic space is a process linked to court ceremonial and the increasingly elaborate rituals of the king, emperor, pontiff, caliph, or sultan. The Great Palace of Constantinople is an early and clear example of how the choreography of imperial power shaped residential space. Although so much of the palace is lost, its remaining fragments and the *Book of Ceremonies* of Constantine VII Porphyrogenitus (d. 959) provide strong foundations for reconstructing the spatial practices and prerogatives that fueled its changing forms.[90] Different building types within the palace multiplied across this swath of central Constantinople: triclinia, domed chambers, pavilions, painted halls, baths, oratories, bedrooms, and towers were conceived of as suitable backdrops for appearances by the imperial family, its entourage, and various government officials. Rather than constituting a self-contained unit, this palace was a series of interrelated structures that interfaced with nearby religious and secular institutions, such as the hippodrome and Hagia Sophia. It could readily expand to accommodate new liturgical or ceremonial practices, which included coronations, marriages, baptisms, processions of icons on feast days, and so on.

As in the case of Constantinople, some medieval Islamic settings inherited this composite sensibility that was steeped in Roman imperial building traditions.[91] Similar piecemeal approaches and multiple building campaigns shaped the disparate forms of monuments as varied as the Citadel of Cairo and the Alhambra. These multifunctional complexes coordinated the elaborate religious, military, and diplomatic ceremonial of the Mamluk and Ayyubid caliphs in Cairo and the Nasrid sultans in Granada, and created iconographically charged and highly worked backdrops for such displays of power.

The *Book of Ceremonies* and Islamic architectural exemplars help establish the extent to which the residences of medieval sovereigns in the Mediterranean were composite and public sites, where spatial practices emphasized display rather than sheltering what might be called today private activities, those

associated with family life.[92] The Amalfitans enacted comparable processes. They conceptualized parts of their houses as places of artistic workmanship and display that were open to and intended for viewers from outside the family. In other words, their concerns were not merely with sheltering the "private," but with creating complex environments that accommodated the family yet articulated their status to others. A prevalent view of residential architecture as composite, to which new structures could readily be added (versus the relatively unitary design of northern townhouses) fueled this process, as did the desire for ostentation and public display.

To emphasize the piecemeal conceptualization of Amalfitan domestic architecture, the following analysis of housing is organized around its salient parts. Features that survive in multiple settings and thus were likely widespread in the region, are considered in detail. They include structures usually associated with defense, central courtyards, and bathing chambers. Secondary structures, such as chapels, open halls or loggias, and other subsidiary rooms, are discussed later in conjunction with ornament.

Exteriors: Walls, Towers, Entrance Pavilions, and Other Liminal Features
Several houses in the hill-town group contain(ed) architectural features associated with defense, such as towers, crenellation, and encircling walls. This is not particularly surprising because the inhabitants of the coast suffered their share of violence, with waves of conquerors from the Normans through the Angevins, Pisan invasions in the 1130s, and intermittent bouts of civil war. Furthermore, wealthy families likely had to store and protect valuable goods at home, given the frequency with which the exchange of gold objects, precious gems, and large sums of money is mentioned in local sources. The Amalfitans' desire for security and their apparent will to fortify are therefore understandable, but it is worth noting that they did not band together into militialike *consorterie*, as did the residents of Genoa, Florence, and other Italian cities where houses gained a fortified appearance in the twelfth and thirteenth centuries.[93] It is also critical that these residential walls in Amalfi were sometimes decorated, creating an accessible and often public expanse of material display. Their designs were also at times so permeable that they were at odds with true defense.

The most elaborate residences of the hill towns, those of the Rufolo and Sasso families, were clearly fortified. Because, however, the encircling rubble walls of the Rufolo complex in places measure less than a meter thick and less than three meters high, their defensive value is questionable. They served to separate the

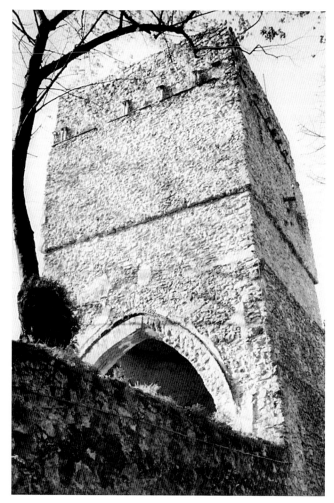

14. Entrance tower of the Rufolo House, Ravello, ca. 1260–83.

complex from adjacent properties and to evoke strength and status. This was likely the case with the enceinte and crenellation of the Sasso House and the wall leading to an entrance of the d'Afflitto House.

The square entrance tower of the Rufolo complex contains a vestibule on the ground level that displays a panoply of ornamental types and patterns[94] (Fig. 14). Instead of presenting the technological markers of defense, such as loopholes or machicolation, it supports a segmented dome of sculpted and painted stucco, with carved pinecones protruding from alternating segments (Fig. 15). Along the drum of the dome runs a blind arcade of terracotta colonnettes with intersecting grey tufa arches (Fig. 16). Each corner contains a figure sculpted in yellow tufa.

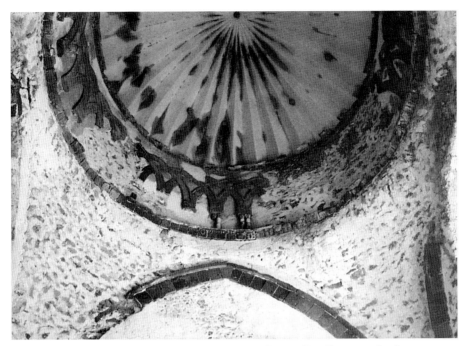

15. Dome of the entrance vestibule of the Rufolo House, Ravello, ca. 1260–83.

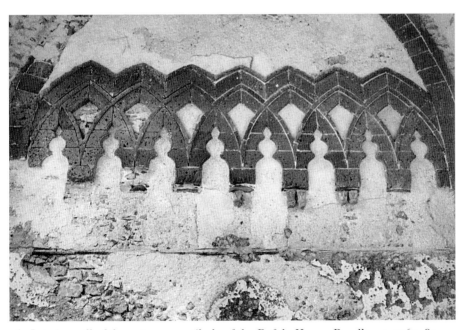

16. Interior wall of the entrance vestibule of the Rufolo House, Ravello, ca. 1260–83.

17. "Pavilion" tower, Rufolo House, Ravello, ca. 1260–83.

With its arcades, colonnettes, undulating surfaces, polychromy, and smooth walls, this space displayed a wealth of texture, color, and material.

In the northeast corner of the Rufolo walls lies a second large, nearly square chamber that is now open to the sky.[95] This second "pavilion" tower consists of four joined arches of rubble construction that support a drum (Fig. 17). Although rubble walls fill in the north and east arches, the remaining two sides are open, creating a pavilionlike space that faces the core of the complex. A blind arcade of terracotta colonnettes and gray tufa intersecting arches enlivens the interior of the drum, which once supported a cupola.

The Rufolo vestibules were not unique in Amalfitan domestic architecture. A door leading into the Trara House in Scala, for instance, is preceded by a single dome supported by a column and the walls of the house, thereby creating a one-bay portico[96] (Fig. 18). The entrance vestibule of the Sasso House was open on four sides and topped with a segmented dome with interlace ornament in terracotta, glazed materials, and tufa (see Fig. 13). Serpentine designs and intersecting arches stretched up the wall of the space.[97]

Domed or vaulted chambers, including ceremonial ones that created transitions between interior space and the outdoors, were widespread in the western Mediterranean, including in palaces located in present-day Tunisia and Algeria. They appeared in princely residences in Achir, Mahdiyya, the Qal'ah of the Beni Hammad, and possibly Bougie, buildings largely known from excavations that illustrate a vibrant period in North African architecture in the tenth and eleventh centuries.

While the holy city and capital of Qayrawan was founded as early as 671 and constituted the commercial, agricultural, and religious center of the newly conquered area, a second era of political autonomy and prosperity began during

18. Domed portico, Trara House, Scala (Centro di cultura e storia amalfitana).

Aghlabid rule in the early ninth century.[98] At that time, close connections to the caliphs in Baghdad facilitated the conquest of Sicily and a building boom across North Africa. Sprawling palace complexes outside Qayrawan, al-Abbasiyya (800), and Raqqada (877) were veritable towns, as they included mosques, markets, and a hippodrome in addition to baths, courtyards, residential quarters, gardens, and barracks. The Aghlabids also energized many coastal areas by (re)constructing ports, mosques, waterworks, and ribats (fortresses that were pious foundations with religious as well as defensive functions) at Sfax, Tunis, and Sousse. The conquest of the area in the early tenth century by the Fatimids brought a second building boom, with the creation of the new capital city Mahdiyya in 916. A series of palaces there, including Sabra al-Mansuriyya, rivaled the Aghlabid foundations with their lavish gardens and waterworks.

Many of these palaces were authoritative ones that shaped architectural production in North Africa and Norman Sicily, as with the Cubula and Zisa in Palermo.[99] Several of the palaces contained domed or vaulted rooms and pavilions, such as the domed central chamber of the Tower of the Manar in the Qal'ah (late eleventh century).[100] Under the Fatimids, these elevated, prominent chambers announced the ruler's dominance and were key settings for ceremonial and display. A late-tenth-century poet in the court of the Fatimids wrote about the palace Sabra al-Mansuriyya in these terms: "Now that glory has become great and the great one rules over the stars, a porticoed pavilion spreads. /He built a dome for the dominion in the midst of a garden which is a delight to the eye. /In well-laid-out squares, whose courtyards are green, whose birds are eloquent."[101] According to a twelfth-century description, domed pavilions defined the basic unit of the Fatimid Eastern Palace in Cairo.[102] Ayyubid and Mamluk constructions there continued this tradition of open audience chambers well into the fourteenth century.[103] These widespread building conventions helped shape the open vestibules of the Rufolo, Trara, and Sasso Houses.

Another distinct component of the hill-town houses is their exterior and encircling walls. In the case of the Rufolo and possibly d'Afflitto Houses, their ornament undermines the conventional purpose of the walls and transforms them into something new. The wall leading to the entrance of the d'Afflitto House, for instance, bears bands of lozenge-shaped tufa inlay. This wall, then, far from being merely utilitarian, was intended to embellish the exterior and stepped entrance of the residence.

The most prominent walls of the Rufolo complex run along the southern edge of the Piazza del Duomo, from the house's entrance tower to the remains of two

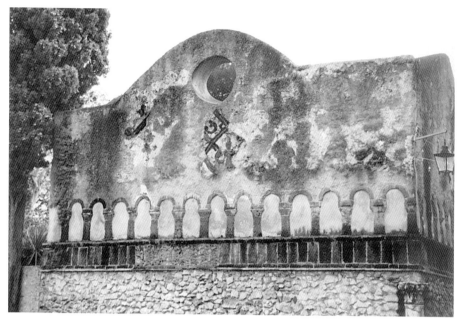

19. Exterior wall of chapel with intarsia and inset column, Rufolo House, Ravello, ca. 1260–83.

vaulted halls and to the chapel[104] (Fig. 19). Blocks of terracotta and tufa, the latter emblazoned with single carved rosettes, define a lively cornice along the side of the chapel. An arcade of short gray tufa pilasters and rounded arches rise above this textured band. Intricate interlace patterns grace the upper registers.[105] At the corner where the wall turns to the south, a vulnerable place where typical fortifications would thicken, the Rufolo walls are thinned out to accommodate an inset column and capital.

Bolvito described the encircling walls of the Rufolo House as covered with terracotta colonnettes, porphyry, serpentine, and semiprecious red, green, and yellow stones. Indeed it is clear that the primary functions of the enceinte, entrance tower, and pavilion were not defense, for the walls are rubble, thin, low, and draped in ornament that could not withstand a hostile siege. Their textured and delicate materials – tufa, terracotta, carved stucco, and according to Bolvito, semiprecious stones – effectively turn these walls into a decorative display, a façade. Placed along the most "public" expanse of walls facing the cathedral, these sumptuous materials and intricate ornament strike an aggressive tone and offer conspicuous testimony of the Rufolos' material and artistic resources.

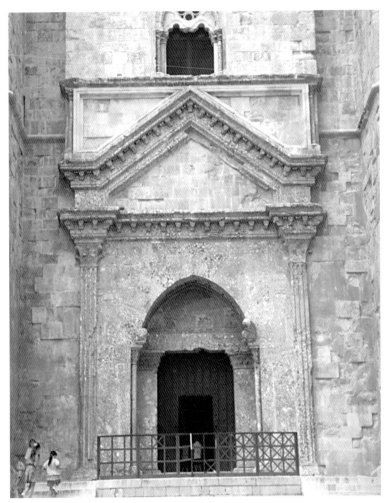

20. Entrance of Castel del Monte, 1240s.

This bold architectural statement finds no parallel in surviving textual or material evidence from contemporary domestic settings elsewhere in the *Regno*. Although royal and imperial buildings tended to display sophisticated stone-cutting and moldings (for example, castles of Caserta Vecchia, Trani, and Barletta), the odd case of a luxuriant exterior functions in a very different and traditional way: at Castel del Monte, the polychromy and polymaterial of outer walls have the effect of emphasizing fenestration and portals, rather than of negating mass, structure, and function (Fig. 20).

Thirteenth-century castles in the South artfully combined military strength with a new elegance befitting the political and cultural ambitions of the courts.

Scribes in the chancery of Frederick II, for instance, articulated distinctions (albeit not consistently) between the technological apparatus of the *castrum* and the residential quarters within them, the *palatium*, a term of clear Roman imperial resonance.[106] Hohenstaufen *palatia* often contained large, rectangular spaces bearing carved capitals and rib vaults, as at Syracuse, or marble revetment, as at Castel del Monte (Fig. 21). The Angevins continued this trend, reconstructing *palatia* in forts of strategic importance (Taranto, 1273; Melfi, work after 1277; Trani, 1279), or developing new residential spaces that were more consonant with their aesthetic, political, and military needs (Castel Nuovo, Naples, begun ca. 1280).[107] Frenchmen were generally supervisors of these royal projects, including Pierre d'Angicourt in Bari, Melfi, and Naples, and Jean de Toul in Trani.[108] Some decorative programs in the new Angevin *castra* and *palatia* were completed only after the Vespers crisis waned in the 1290s and concluded temporarily in 1302, when Frederick of Aragon was recognized as ruler of Sicily. This period of relative peace inaugurated an era of great building for the court and affiliated families in

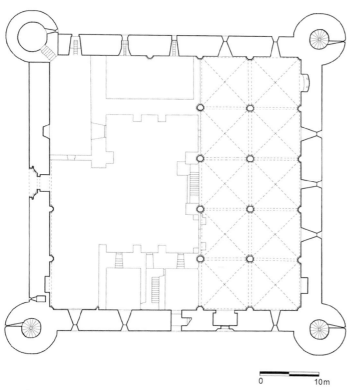

21. Castel Maniace, Syracuse, plan of surviving *palatium* quarters, ca. 1239 (Danielle Lam-Kulczak, after Soprintendenza per i Beni Culturali e Ambientali di Siracusa).

Naples, as Boccaccio's descriptions of the fountains, gardens, and baths of Castel Nuovo and nearby *palatia* suggest.[109]

Of all the Amalfitan houses, the Sasso residence best corresponds to the forms of such royal and imperial exemplars. Given its supposed geometric regularity, it likely resembled parts of some Hohenstaufen castles. The central quarters of Lagopesole (ca. 1240–50), Syracuse (ca. 1239), and Augusta (ca. 1239–42), to name salient imperial buildings in both rural and urban settings, are rectangular in plan, with a central courtyard and rectangular towers similarly rising in the four corners (Fig. 21). These castles of geometric rigor also contained residential rooms of decorative elaboration (the *palatia*), suggesting further conceptual overlaps with the Sasso residence. However, these Frederician castles date from the last decades of the emperor's rule and likely were built after the house in Scala. Further distancing the Sasso House from imperial exemplars is its ornamental features unknown in Frederician castles – rubble masonry, entrance vestibules with segmented domes, and intarsia interlace, for instance, in contrast to the ashlar masonry, ribbed vaults, and carved capitals typical of Hohenstaufen projects.

The exterior faces of the Rufolo, Sasso, d'Afflitto and Trara Houses emphasize decorative display and variety, instead of catering to strictly martial concerns. Emblematic of this focus are the domed entrance pavilions, which dramatize transitions between exterior and interior and emphasize the permeability of the residential complexes. Rather than drawing on such prestigious models as the castles or fortified dwellings of the Hohenstaufen and Angevin sovereigns in the South, the houses appropriate the blurred distinctions between interior space and the outdoors and aesthetic interest in material variety and display from Islamic building traditions in North Africa and elsewhere.

Courtyards

Courtyards were fundamental to Amalfitan conceptions of the domestic environment in dense urban, hill-town, and even semirural locations, just as they were in so many other towns in the later Middle Ages (for instance, Volterra, Florence, Venice, Oslo, London, Tunis, and Fustat).[110] The diffusion of courtyards is not surprising, since these flexible spaces provided needed wells of light and fresh air in dense urban areas and mediated between public, private, artisanal, agricultural, and commercial activities – features that the ancient Romans and early medieval Lombards appreciated as well.[111]

22. Layout of the d'Afflitto House (A) and Sant'Eustachio (B), Pontone (Danielle Lam-Kulczak).

In Amalfi, the courtyard provided a node around which the various rooms and activities of the house converged.[112] In places of relatively level terrain, such as the South Toro House in Ravello, the sheltering structures are loosely arranged around an open space and do not necessarily seal it off completely with a continuous mural surface. Houses of greater elaboration tend to be more regular, with rooms arranged in a relatively geometric pattern off a closed courtyard. These sites were places of decorative emphasis. Each courtyard presented here contains at least one of the four key ingredients of Amalfitan ornament: inlaid tufa, terracotta, carved stucco, or ancient *spolia*.

Built in the late twelfth and early thirteenth centuries, the d'Afflitto House is arranged around an irregular courtyard that has no colonnade or portico (Fig. 22). The walls of rubble masonry are interrupted only by fenestration, inset terracotta pipes that fed a bath, and inlaid tufa. Of similar date and form is the South Toro House in Ravello, with its low structures that include a bathing complex with a vaulted vestibule supported by *spolia* arrayed around an asymmetrical courtyard.

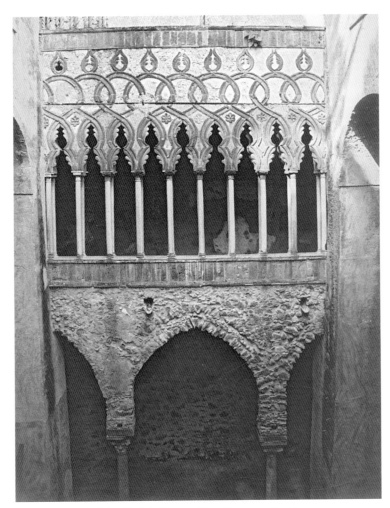

23. Courtyard of the Rufolo House, Ravello, ca. 1260–83.

No evidence of intarsia remains at this house, however, as the exterior walls have been refaced.

Much of the extant medieval fabric of the Rufolo House clusters around a courtyard. Unlike the d'Afflitto and South Toro Houses, the Rufolo space defines a closed rectangle (Figs. 23 and 24). A web of sinuous intarsia and terracotta ornament conceals the architectural work that the courtyard performs: its neat rectangular design separates and distributes three stories of living quarters across irregular terrain. These include residential quarters for the family above and *familiares* below; a low vaulted loggia or open hall; cisterns, waterworks, and possibly a kitchen in the basement level; and the adjacent tower or keep.

Two stories of arcades support this complex arrangement. The marble columns of the subterranean first floor arcade carry *spolia* capitals and elongated impost blocks. Imposts with comparable high profiles were common in this region during the high and late Middle Ages (such as the courtyard of the Confalone House of ca. 1250 in the Toro district, currently incorporated into the Hotel Palumbo, and the late-thirteenth-century Palazzo Mansi in Scala; Fig. 25). They also appear in many ecclesiastical works, including the bell tower of Amalfi, the porticoes of Sant'Angelo in Formis, Sessa Aurunca, and other churches built in the wake of Desiderius's Monte Cassino.

While defining a part of the Amalfitan matrix that informed architectural production at Monte Cassino, such forms are ultimately of Islamic origin. Extended imposts topped with cornices energize the prayer room of the Great Mosque at Qayrawan, the first large-scale architectural project in the Muslim "West" and the inspiration behind many building projects in North Africa for the next two hundred years.[113] Other Aghlabid buildings, including the façade of the Mosque of the Three Doors (Fig. 26) also in Qayrawan (866-7) and the Ribat at Sousse (early

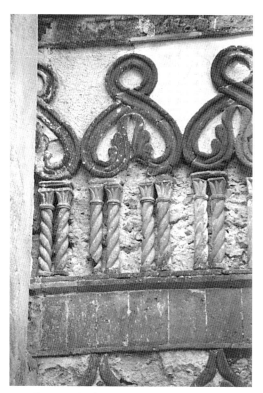

24. Courtyard of the Rufolo House, Ravello, detail of ornament.

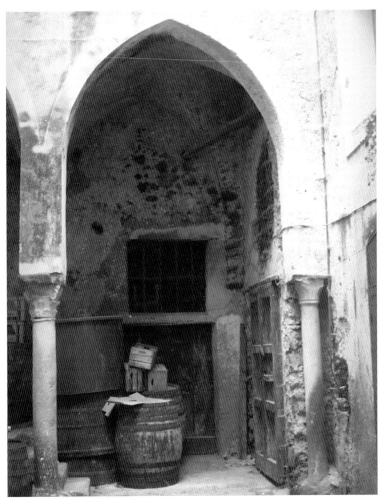

25. Courtyard of the so-called Palazzo Mansi, Scala, late thirteenth century.

ninth century), configure arches in the same way. After the Aghlabid emirs conquered Sicily in the ninth century, such arches possibly appeared in large-scale constructions on the island.[114]

Although the ornament that originally spread across all four faces of the Rufolo courtyard are exceptionally rich, the basic layout and effect of it were not unique or unprecedented. A majestic colonnade comprising of fluted *giallo antico* columns figured prominently in the courtyard of the Confalone House, now the Hotel Palumbo. Similarly, the description of the Sasso House in Scala mentions a regularized courtyard with interlace ornament and a colonnade that rivaled that of the Rufolos.

The narrow, elongated proportions of the Rufolo courtyard closely resemble those in littoral towns. Multiple-story courtyards were a standard feature of densely populated urban settings in the region by ca. 1100.[115] In Amalfi and Atrani, streets flow off an axial artery, gradually diminish in width, and terminate in dead-ends. Houses faced these truncated streets and transformed them into common courtyards. One of the few such spaces with extant medieval ornament is a house in the Vallenula quarter of Amalfi, which was likely built around 1100 (Fig. 27). Although exterior plasterwork has transformed the narrow courtyard over the centuries, medieval capitals, columns, arches, and vaults are still visible. As with the Rufolo House, they articulate four stories of arcades that overlook a narrow, rectangular space.

The intarsia of the courtyard of the Rufolo complex is, however, unusually rich. Although a host of scholars have labeled the work "exotic" or "oriental," generally only local and Christian antecedents are cited for its designs. But such comparisons – to cloisters at San Pietro in Amalfi (Cistercian; before 1210), the Cathedral of Amalfi (begun 1266; Fig. 28), or San Domenico in Salerno (around 1277) – hold only on a superficial level.[116] The Rufolo courtyard marks a dramatic

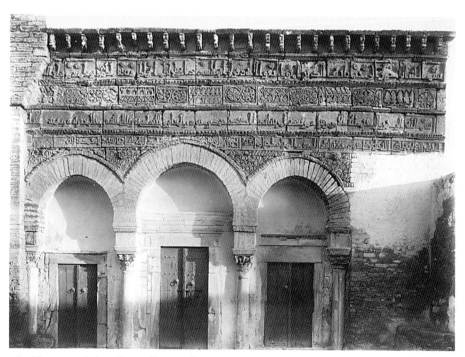

26. Mosque of the Three Doors, Qayrawan, 866/67. Copyright reserved to Creswell Archive, Ashmolean Museum, Oxford (neg. C. 263).

27. Courtyard of the Vallenula House, Amalfi, twelfth century.

departure from monastic paradigms. First of all, it displays a rich variety of struc-
tural and applied polychromy, whereas the cloisters offer a conservative range
of material – the basic constructive units are white marble columns and plaster-
covered arches. Second, the domestic intarsia is not based on the building up
of flat or uniform planes, as the squared ornament of the cloisters tends to be.
In some places, the edges of the applied tufa of the central arcade are raised
and bulbous; in other places, they are gently beveled. Colonnettes twist and turn,
and concave recesses hold small rosettes (see Figs. 23 and 24). Similar displays
of intarsia embellished several courtyards in Scala. After all, Bolvito reported

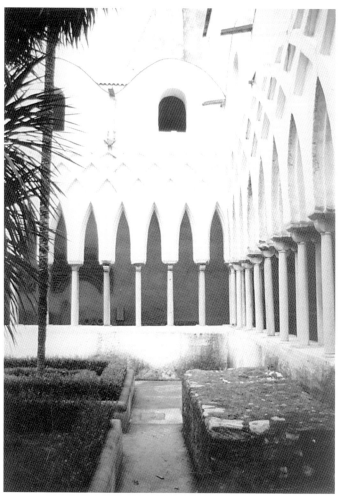

28. Cloister of Paradise, Cathedral of Amalfi, 1266.

that houses in Scala had "the same arcades, columns, orders of marble cloisters, friezes, and delicate things" that were found in Ravello.[117]

In contrast to the more common practice of outlining doors and windows, the intarsia of the Rufolo courtyard ultimately negates the surface of the wall and disrupts the emphatic rhythm of the colonnade with its probing, vinelike organic forms. This aesthetic of dissolution characterized centuries of Islamic residences, from the florid and animated friezes that zigzag along the exterior of the early Umayyad castle at Mshatta (Jordan, second quarter of the eighth century), to the stucco arabesques of the Abbasid palaces at Samarra (Iraq, ninth

century), to the multiple and multifaceted chambers of the Alhambra in Granada (Spain, begun 1238). This type of antimural ornament also appears in religious architecture associated with the austere Almoravid and Almohad rule, as with twelfth-century minarets in Tlemcen and Seville (1136 and 1176, respectively). In the example from the Qasbah mosque in Tunis, dated by inscription to 1233, intricate webs of blind tracery continue this tradition and evoke works in Spain and Marrakesh. Residences of the mid–thirteenth century outside Tunis likely contained similar types of decoration, as descriptions of them and the influx of immigrants from Spain to the Hafsid domain strongly suggest.[118]

Although North African port cities clearly lay within the boundaries of the Amalfitan experience of *mercatantia*, the multicultural character of the *Regno* itself must have shaped awareness of Islamic art and culture and rendered monuments in North Africa comprehensible to Amalfitan merchant patrons. In the early and high Middle Ages, Muslim communities were reputedly established at Cetara and Atrani as well as in and around Naples.[119] Saracens from Sicily were transplanted to Lucera in 1224 and remained there until its violent suppression in 1300. After 1230, Muslim *regnicoli* were allowed to travel and participate in commercial affairs throughout the South, from Sulmona and Capua to Reggio.[120] Muslims were frequently present in the imperial and royal courts as, for instance, soldiers, masons, ceramicists, carpenters, woodworkers, dancers, and animal trainers. In short, the population of the kingdom was far from Christian only, and Muslims were active in a variety of locations and businesses, including artistic production.

The delicate intarsia patterns at the Rufolo House (and likely the lost Sasso compound) approximate those found in an array of objects, including ivories and stelai from Spain and southern Italy.[121] The heyday of Islamic art in the South preceded the second Amalfitan elite and its hill-town building boom; it corresponded to the early years of Norman rule, at least a century before the d'Afflittos, Sassos, or Rufolos embarked on the construction of their houses. Ivories attributed to the royal workshops in Palermo and others whose exact provenance remains a matter of debate approximate the patterns of the Rufolo intarsia. A twelfth-century oliphant in the Museum of Fine Arts, Boston, thought to have been carved in southwestern Italy, for example, displays bands of simple undulating vines, and others placed within zigzag-shaped frames[122] (Fig. 29).

Nine funerary stelae with Arabic inscriptions also provide evidence of the manufacture and diffusion of this type of imagery in southwestern Italy.[123] This

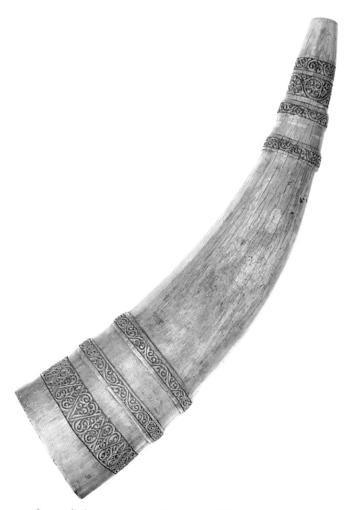

29. Ivory oliphant, southern Italy (Amalfi?), early twelfth century. Museum of Fine Arts, Boston, 50.3426, Frederick Brown Fund and H. E. Bolles Fund. Photograph © 2003 Museum of Fine Arts, Boston.

group of stelai indicates that the Muslim population in the region of Naples was sizable enough to support specialized carvers and epigraphers. Inscriptions place the works in the eleventh and twelfth centuries. Several aspects of a marble stele from Pozzuoli (473 A.H., or 1081 A.D.) resemble the intarsia ornament of the Rufolo courtyard and chapel exterior (Fig. 30). A sinuous trilobe design creates a frame around the inscriptions. Its floriated tips extend in reverse curves, and the outlines of the central lobe arc up and intersect, creating a loop at the top of the

composition. In the corners of the rectangular stone behind this curvilinear frame are other interlace patterns with floriated tips. Carved stelae from Qayrawan, Mahdiyya, and the Qal'ah bear similar foliate designs, as do the panels on the façade of the Mosque of the Three Doors (see Fig. 26). These same prestigious sites provided significant comparanda for large-scale architectural features as well, including the elongated impost blocks discussed earlier.

Objects attributed to workshops in Spain provide additional motif comparisons.[124] The ivory pyxis of Sayf al-Dawla, now in Braga, generates high, looped arches not unlike those of the Rufolo courtyard; a group of ivories attributed to a single workshop in Cuenca, which flourished after the destruction of Madinat al-Zahra in 1010, configures delicate intersecting vines and leaves in upside-down heart-shaped patterns reminiscent of the upper level of the Rufolo courtyard and the chapel exterior.

Because many Amalfitans participated actively in the Mediterranean-wide market for luxury goods – possibly even selling the contents of the Fatimid treasury of Cairo when it was dispersed in the 1060s, as Avinoam Shalem has argued – they surely encountered such objects at home and abroad well through the thirteenth century.[125] They were familiar with monuments in cities such as Tunis or Mahdiyya, the first capital of the Fatimids and Norman possession in the mid-twelfth century, through their sustained business connections in Ifriqiya. In the 1270s and 1280s, members of the Rufolo family supervised the royal grain monopoly in the *Regno* and along the coast of the Maghreb and acted as port inspectors in nearby Sicily. Chancery documents from Naples and notarial sources from Tunis testify to the presence of *regnicoli* and other Italians, including various administrators from Ravello, Scala, and Amalfi, in Tunisia through ca. 1300.[126]

The possible sources of inspiration for the Rufolo intarsia designs range from architectural complexes in Spain and the Maghreb to portable objects made by Muslims inside and outside the *Regno*. The Amalfitans were familiar with these sites to greater and lesser degrees: they were the ports where they monitored shipping, towns where they oversaw royal affairs, and markets where they exchanged goods, including perhaps the contents of the Fatimid treasury. What such manifestations of Islamic art in the residences of medieval southern Italy indicate – that is, whether they result from passive "influence," aggressive appropriation, or shared architectural and cultural practices – can be determined in part by considering a housing component that has a clear function involving culturally grounded practices.

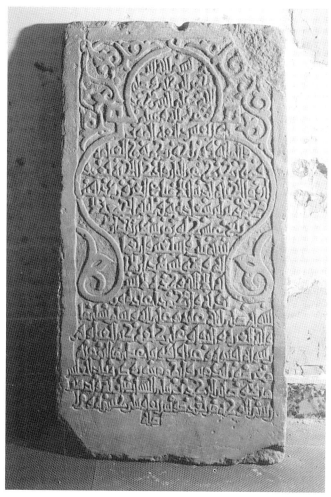

30. Arabic stele from Pozzuoli, dated 473 A.H. (1081 A.D.). Museo Archeologico Nazionale, Naples, Casa Calzola Collection (Archivio Luciano Pedicini).

Bathing Chambers and Dressing Rooms

One of the most distinctive characteristics of the medieval Amalfitans was their predilection for baths and bathing. The remains of at least five bathing chambers in Scala and Ravello alone suggest that this type of edifice was widespread on the coast and was considered a fundamental component of the houses of the well-to-do.[127]

A prominent three-story tower closes off the northeastern side of the courtyard of the d'Afflitto House in Pontone. Rather than yielding webs of delicate ornament or the technology of defense, it supports and protects the mechanics of a heated

bathing chamber.[128] Thick walls of rubble and plaster facing on the interior define a nearly square room; two rectangular niches extend from contiguous sides of that central space. Smooth pendentives and a dome with triangular segments crown the main chamber, and narrow, pointed cross vaults top the side niches (Fig. 31B).

Vertical pipes of terracotta peek through the tower's rubble masonry, suggesting that water flowed from an elevated cistern into the ground-floor chamber (see Fig. 12). Other parallel ducts indicate that smoke and steam were channeled through the walls from an adjacent furnace to heat the interior and likely its water supply. The bath's position on the downhill side of the house facilitated the disposal of used water. Such practical requirements, which were easily accommodated by the region's topography, seem to have determined the location of this and many other Amalfi baths.

The d'Afflitto structure is one of at least nine extant bathing chambers built in southern Italy in the later Middle Ages. Some, but not all, of them appear within domestic environments, including the South Toro and Rufolo Houses in Ravello and the Trara in Scala (Figs. 31A, 31C, and 32). These four baths are nearly identical in form and have been dated on the basis of style to the thirteenth century.

Textual evidence of baths in the region predates these monuments by more than 200 years. One of the earliest surviving documents from around Amalfi, dated 975, describes a rural house with a bath.[129] Reference to domestic bathing chambers with dressing rooms (*spoliatoria*, the local medieval term for *apodyteria*), cisterns, and furnaces abound in the following centuries. By the late twelfth century, the documents establish the *balneum* as one of the general features of a well-appointed house, along with a courtyard, kitchen, latrine, cistern, and dressing room. Although baths were frequently found in large domestic complexes of the wealthy, they were not exclusively an amenity for the well-to-do. Small rustic houses in agricultural settings sometimes contained *balnea*, and references to public baths crop up here and there.

This group of baths documents the reduced scale and private nature in the Middle Ages of one of the ancient world's grand public institutions. In these small structures, running hot water and hypocausts utilized ancient Roman technologies, whereas their architectural shells merge medieval Byzantine, Islamic, and southern Italian conventions.

These bath domes of segmented form, along with closely related examples in the entrance towers of the Rufolo, Sasso, and Trara Houses, have been connected

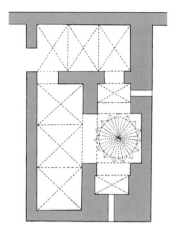

A

B

31. Plans of three domestic baths from the region of Amalfi. (A) Trara House, Scala; (B) d'Afflitto House, Pontone; (C) Rufolo House, Ravello (Danielle Lam-Kulczak after Sebastiano, Losanno, Kockler, and Venditti).

C

0 1 2 3 4 5m

32. Bathing chamber of the South Toro House, Ravello, interior, ca. 1200 (Centro di cultura e storia amalfitana).

to similar cupolas in churches in Ravello, Caserta Vecchia (Fig. 33), and Amalfi, which in turn have been said to derive from the prestigious church of Saints Sergius and Bacchus in Constantinople (527–36).[130] But closer parallels appear in North Africa, as medieval mosques there contain smaller domes clearly related to the many-segmented ones of Amalfi. Constructed of cut stone, the exterior shell of the cupola before the mihrab of the Great Mosque of Qayrawan ripples with sensuous convex lobes, whereas thin ribs divide its concave segments on the interior.[131] A similar lobed dome crowns the pavilionlike entrance to the prayer hall. A more sober variation on the same theme appears in the Great (Zaituna) Mosque in Tunis, on the tenth-century dome in the middle of the central axis of the prayer hall. While regional building traditions indebted to Byzantine architecture facilitated the use of pendentives and the proliferation of domes in southwest Italy, some of the precise formal characteristics of the Amalfitan cupolas are more akin to North African building motifs than Byzantine examples in Constantinople or southern Italy.

Similar centralized baths with segmented domes appeared in monastic and domestic settings in Byzantium in the eleventh and twelfth centuries and in Islamic residences through the 1300s (for example, Kaisariani in Greece, Damascus in Syria, Alhama in Spain). This building type was widespread in part because bathing was central to conceptions of health in medieval scientific circles. Drawing on the theories of classical medical writers, Avicenna (or Ibn Sina, d. 1037) and other philosopher-physicians argued that baths of varying temperatures and durations readjust the body's four humors and thus cure ailments ranging from bad moods to digestive disorders. Treatises in preventative medicine, such as the

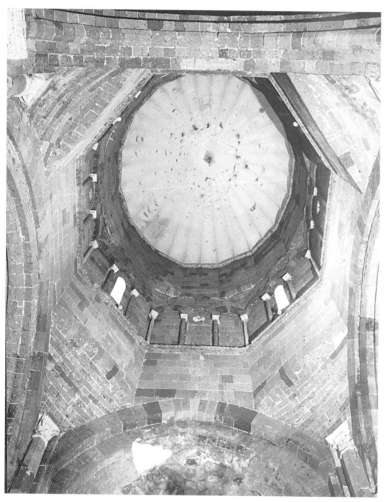

33. Cathedral of Caserta Vecchia, dome over the crossing, 1207–16 (Max Hutzel, courtesy of Mario d'Onofrio).

Regimen sanitatis from the school of Salerno, just down the coast from Amalfi, helped diffuse these theories and increased the popularity of baths in southern Italy.

The significance of the baths extends beyond such medical practices, for bathing was also a social activity, bound up in Mediterranean-wide notions of hospitality and conviviality. As healthful amenities that could be offered to guests and expected by travelers far from home, baths embodied hospitality for people of varying backgrounds and religious beliefs. Medieval chronicles of the South indicate that bathing was neither a quick nor solitary endeavor, but one to savor and draw out in the presence of attendants, friends, or distinguished guests.[132] The scale of the Amalfi baths corroborates such accounts, as their central spaces could readily accommodate two or three bathers. Amalfitans were significant participants in this "international" balneal culture of shared architectural forms, attitudes, and customs.

However inscribed within discourses of relaxation and healing, domestic baths were also sites of conspicuous consumption. The resources that they required, including renewable supplies of combustible materials and fresh running water, were not always easy to acquire in the elevated and dry Amalfi hill towns. The baths, then, participated in a trend that continues to this day: the tendency of the affluent to bring into the house expensive and sophisticated technologies that were developed in the public sphere for the public good.[133] The Amalfitans of the second elite excelled at this type of domestication or privatization, as the defensive features of houses in Scala and Ravello further underscore.

The elegant domed baths, rich inlaid ornament, open entrance pavilions and other seemingly Islamic features of the Amalfitan houses raise the possibility that artists conversant in North African building traditions were involved in construction around Amalfi.[134] The families of the second Amalfitan elite would have encountered Muslim artists who lived in the *Regno* and worked in such places as the castles of Syracuse, Lentini, and Lucera.[135] Saracen carpenters and *tarsiatori* (the latter likely woodworkers skilled in marquetry rather than in tufa inlay) worked on Hohenstaufen castles in Melfi, Canosa, and Lucera.[136] Ceramicists were active in Lucera until its transformation into a Christian city. But these were not the only places in the South where Muslim artists worked in the thirteenth century. A recently discovered kiln in Ravello has been associated with Luceran ceramics.[137] It is possible that Lucerans crafted the terracotta

colonnettes that were used in religious and domestic architecture around Amalfi and possibly helped construct buildings such as the Sasso, Trara, and Rufolo Houses.

Unlike the well-documented imperial and royal building sites in the *Regno*, for which building procedures, the identity of laborers, and costs have been recorded, there is no comparable information for medieval Amalfi. The houses themselves, however, are not mute. The hill-town group indicates that diversified workshops were involved in construction, from masons to stucco and intarsia workers. Some specialists were possibly Muslim (for instance, the ceramicists); perhaps they came from as nearby as Atrani, although it is more likely that they were hired in more distant towns such as Lucera, Bougie, or Tunis. The many similarities between religious and residential architecture suggest that artist-builders worked in both contexts and were proficient in a range of local construction techniques. Thus it is unlikely that imported or itinerant artists alone shaped the Rufolo complex and related residences of the thirteenth century.

Ornament and Spatial Differentiation

In the case of the Amalfi baths, a specific configuration of ornament and technology defined a consistent building type. The extant structures all contain a central domed space with flanking vaulted spaces that often functioned as dressing rooms. But within this corpus are significant variations. The thin, concave segments of the bathing chamber in the South Toro House in Ravello contrast with the more angular pleats of the d'Afflitto, Trara, and Rufolo examples. The pleats of the Rufolo bath bend slightly clockwise, affecting a slight swirling motion (Fig. 34). In fact, in residential settings, no two domes are identical, including the entrance vestibules and pavilions of the Rufolo House. Their proportions, pendentives, surface articulation, and color all vary.

The character of the domes suggests that in this domestic milieu, ornamental and material variety served to establish building types and to distinguish one chamber from adjacent ones. Not only is house differentiated from house and thus family from family, but also room from room in a single locale. Ornamental variety helped conceptualize the house as a series of distinct, often specialized spaces.[138]

Extant walls and vaults indicate a similar emphasis on differentiation. Just off the Rufolo courtyard is an open vaulted room or loggia with a low ceiling (Fig. 35). Unlike traditional domestic loggias in central and northern Italy, this one does

34. Stucco dome of the Rufolo bathing chamber, Ravello, ca. 1260–83.

not mediate between the public zone of the street and the private areas of the house's interior.[139] Rather, the hall faces away from the compound's entrances and toward the sea. As with the house's vestibules and courtyard, it is a liminal space that provides an extended transition between the sheltered space of the core of the residence and the outdoors.[140]

Supports alternate between single marble columns and clusters of four shafts supporting a single abacus. The arches fan out after an extended vertical rise, thereby creating the elongated profile akin to the North African-like colonnades in the Rufolo, Confalone, and Mansi courtyards. Flat, squared ribs accentuate the play between extended verticality and the lilt of these arches. They are built up on top of the impost surface and thus exaggerate the gradual thickening of the support from shaft, to capital, to impost, to rib.

As Amalfitan interpretations of Gothic ribs, these square moldings also appear in the Confalone courtyard colonnade. Such appliqués of wide, flat ribs rendered in stucco were widespread in the region, as in the Cloister of Paradise in Amalfi (1266) (see Fig. 28). Square ribs and moldings also materialize in the pilgrims' hostel (the so-called *palatium*) at the Benedictine abbey at Cava (1255–64), near Salerno.

Such moldings appear in the small Rufolo chapel as well, which is tucked into a corner of the compound's enceinte. Here, however, they are paired with niches with scalloped hoods, an ornamental motif more indebted to contemporary Islamic environments than Gothic ones (Fig. 36). This niche type of classical origin adorns many of the most influential and important religious buildings of the high and late Middle Ages in North Africa, including the minaret and mihrab of the Mosque of Mahdiyya (date of the mihrab disputed; early ninth versus twelfth century) and the minaret in the Qal'ah of the Beni Hammad (late eleventh century).[141] Such settings were likely sources of the elongated shell niches on the severe exteriors of Norman palaces and of their more delicate interior ones (for instance, exteriors of the Cuba and Zisa in Palermo, 1164–80; interior of Caronia, ca. 1150). In the Rufolo complex, these niches differentiate the room from other nearby vaulted spaces and signal its solemnity.

A small chamber adjacent to the Rufolo loggia displays a vault with thin, ropelike ribs in keeping with northern Gothic forms[142] (Fig. 37). A room in the thirteenth-century house in Pastena, in the hills west of Amalfi, has the same configuration. As in the Rufolo case, the Pastena vault is adjacent to a room with a different articulation, a simple cross vault. Similarly, in the thirteenth-century

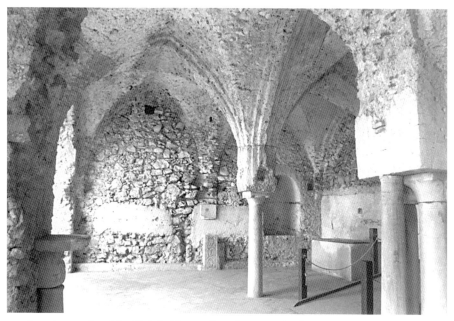

35. Loggia or *sala* of the Rufolo House, Ravello, ca. 1260–83.

36. Chapel of the Rufolo House, Ravello, square moldings of vault articulation with scalloped niche below.

Ruga bathing chamber in Amalfi, the vault that flanks the central domed space also contains round ribs. In all three cases, the round ribs appear next to rooms that have alternate systems of vaulting, suggesting an effort to vary the ceiling from one space to the next.

Heterogeneous ceiling designs differentiated spaces from one another in ecclesiastical foundations as well. The early-twelfth-century structure of San Giovanni del Toro in Ravello, for instance, adopts a traditional Desiderian truss roof for its nave, but groin vaults top the side aisles (see Figs. 40 and 41A). Domes rise over the crossings of San Giovanni and Santa Maria Gradillo, another twelfth-century church in Ravello, as well. The variations within residential settings present a far wider repertory of forms and applied ornament, however, including

the multiplicity of textures, materials, and patterns associated with intarsia's deconstructive mode.

Highly ornamental aesthetics are part and parcel of Gothic art – witness the expensive materials and richly worked surfaces of the Sainte-Chapelle in Paris or the halls of Karlstein Castle. But this Amalfitan preference for heterogeneity of layout, form, and surface contrasts vividly with Northern Europe in the thirteenth and fourteenth centuries, where structural uniformity was fundamental to achieving the golden goal of clarity (for instance, quadripartite homogeneity of the Cathedral of Chartres, the Grande Salle in the Palais de la Cité in Paris, German hall church articulation, and so forth). The long-standing medieval aesthetic of *varietas* enters into the most regularized Gothic environments through stained glass, altarpieces, and structural and applied polychromy, rather than through changes in plan and elevation. Also, compared with the lush ingredients of northern Gothic, Amalfi's disparate materials are relatively humble: carved stucco, pieces of locally manufactured terracotta, small pieces of *spolia* culled from nearby ruins, soft volcanic rock, and possibly ceramics imported from North Africa.

37. Vaulted chamber with round ribs, Rufolo House, Ravello.

Implications of the Composite Aesthetic

Written sources, including deeds of sale and other real estate transactions, point to the ensemblistic quality of the hill-town houses. They are conceptualized as the sum of their parts. For example, a charter of 1148 describes both old and new houses surrounding the episcopal palace in Ravello, houses that contained three stories, courtyards, cisterns, a bath, and a kitchen – the typical features of the region's most elaborate and best-appointed domestic compounds.[143] In 1222, a residence in the Lacco quarter of Ravello was dissected into constituent parts, including a small paved area, warm room (with a fireplace), portico, kitchen, stairs, a first floor, roof, room on a second floor, cellar, cistern, dressing room, bath, and courtyard.[144] Other documents from the thirteenth century refer to properties of similar complexity that also include fountains, pergolas, and workshops.

Although this naming of parts says little about the actual forms of the houses in question – the documents could describe any number of configurations, including modern ones – they do corroborate other evidence of an accretionary approach to shaping the domestic realm in the hill towns. The same texts from the twelfth and thirteenth centuries narrate a widespread practice: adjacent lands were purchased one at a time over a few generations; houses were built, expanded, or consolidated to create a family compound; and the construction of a nearby church often completed this nodal unit. This process was clearly documented in the cases of the d'Afflittos in Pontone, the Castellomatas in Pogerola, and the Rufolos in Ravello.[145]

The language of the Amalfitan charters corresponds thematically to the additive nature of the architecture itself. Layout was conceived of not as a unified, single design, but as a series of thoughtful interventions that took into account topographical complexities, social function, and, increasingly, a seemingly competitive concern with public display. Although such composite residences were rooted in the Roman world and found in elite settings around the medieval Mediterranean, they seem particularly appropriate for the region of Amalfi and its merchant communities.[146] Each house could keep on expanding, as the Rufolos' did, providing adjacent properties could be purchased; the size of the house, or rather the number of structures that comprised it, became a visual indication of one's swelling (or shrinking) coffers and ambitions. The formal language of the structures also testified to the experiences of Amalfitan merchants abroad and their familiarity with the architectural and social conventions of various communities in the Mediterranean basin.

It is tempting to hypothesize that this conception of the Amalfitan landscape as dotted with specialized forms of architecture ultimately derived from the Amalfitans' keen interest in the value of material goods and, by extension, of real estate. Not only were the region's cargo shipments divided into sharelike investment units, but arable land, mills, private churches, ships, and houses were assessed in the same way. They were sold in divisible twelve-unit shares, based on the calendrical rhythms of trade and agriculture. Houses were similarly conceptualized as a series of specialized, discrete spaces, an expandable good or commodity.

Contemporary charters from three other prosperous cities, Pisa, Barletta, and Capua, do not contain the same degree of specificity about architecture.[147] Generally speaking, sources from these other sites begin to differentiate between components of housing only in the mid–thirteenth century, and then, with a few exceptions, not to the same extent as the Amalfitan ones. In the *Regno* itself, documents from the east coast commercial center of Barletta continue to refer to the *domus*, without reference to layout, stories, rooms, parts, or basic levels of spatial complexity, through the fourteenth century.

In some ways, this relative lack of specificity is not surprising. After all, the ultimate purpose of this type of documentation was to establish property rights and ownership, largely through delineation of boundaries. The condition of the property in question, such as what was built on it or what grew on it, is mentioned, but generally for specific reasons: when, for instance, these items constitute some sort of capital – mature vines, fruit trees, livestock, a shop, or a mill – or when the transaction involves repair of existing structures or new construction.[148] Thus, arable land and attendant resources consistently appear first in the documents from Barletta and Capua, followed by references to housing.[149] Representative language in the Pisa group states that a transaction governs land and its crops, and then adds the phrase "and whatever buildings are on the land."[150] This formulaic note appears in document after document, for properties on which structures must have varied widely in site, size, material, and type.

This generalization applies to properties owned by people of diverse status. Take, for instance, the will of Egidia della Marra of Barletta, a widow related to the ill-fated clan that was convicted of corruption with the Rufolos. Dated 1302, the will describes an impressive collection of silks and linens that were to be dispersed among her many servants and relatives. Yet the house in Barletta of this wealthy woman is described simply as a *domus*.[151] Similarly the will of Mabilia de Iordana, dated 1301, lists money, furnishings, tunics, linens and even a camel's hair cloak to be distributed among her heirs in Barletta; but her house

is a *domus* described only in terms of its location.[152] Other wills and dowries reveal a similar focus on and descriptive elaboration of portable luxury items rather than houses per se. To be sure this discrepancy reflects the requirements of legal documentation, particularly the need to differentiate between, say, silk shawls of varied color or design to distribute them properly among heirs. But it must be kept in mind that this linguistic discrepancy does not occur in Amalfi, where architectural details appear even when of little obvious relevance to the transaction.

The contrasts between these notarial conventions help establish the cultural values of each town. In this era of rapid urbanization and commercial expansion, the specific characteristics of housing in Barletta were seemingly less important than agricultural properties, which were the traditional and potent sources of wealth even in mercantile economies. They were also less prized than luxury textiles and jewelry, the new outward markers of affluence and status. In contrast to the situation in Amalfi, where elaborate residences expressed wealth and prestige, the configurations and characteristics of the Barlettan houses were not seen as relevant or significant issues.

Despite the social, linguistic, and conceptual disjuncture between the two towns, houses in Amalfi are somewhat analogous to Mabilia's sartorial displays. The Amalfitans embellished the exteriors and interiors of their houses with increasingly elaborate ornament, possibly including semiprecious stones, as Bolvito posited. As with camel's hair cloaks and Egyptian linens, key aspects of Amalfi houses were, loosely speaking, "imported" – that is, partially indebted to architectural practices of Islamic North Africa that were reinterpreted through local building traditions and materials. As with clothing, the houses established individualized, ornate, and permeable boundaries between the public space of the city street and the contours of family life. In short, this group of houses was a site of significant expenditure, artistic workmanship, family identification, and display. It vividly contrasts with the domestic austerity or lack of "esthetic identification" that possibly characterized housing in the early Middle Ages and late medieval settings elsewhere in Italy.

Architectural elaboration was not without critics, as the stinging remarks about effeminate, corrupt Ravellese penned by a follower of Joachim of Fiore indicate. Expenditures judged to be excessive inspired diatribes against the material world and luxury, the latter being perceived as a potent combination of lust (the traditional sense of *luxuria*), avarice, and pride in the later Middle Ages.[153]

Well-known critiques of early Gothic architecture, including Peter the Chanter's attacks on Notre Dame in Paris or Hugonis de Folieto's on bishops' palaces, tended to condemn spendthrift Christian institutions for their failure to care for the poor.[154] In addition to underlining the *superfluitas* of modern architecture, their strident views touched on other sites of excess that they observed among the laity, including clothing, food, furniture, and livery.

These visible manifestations of wealth elicited varied responses from religious authorities. Although Hugonis de Folieto's text was known and cited in the South in the mid-1200s, preachers in the *Regno* and the rest of Italy often had more moderate views.[155] Sermons attempted to shape a viable morality of expenditure while responding to the new polyvalent *luxuria*.[156] Discussions of consumption often focused on related problems, such as vanity and the status of women. In the second half of the thirteenth century, the Dominican *regnicolo* Iacopo of Benevento railed against vain opulence and luxury and urged Christians to recognize that material comforts are useless in the face of death, decay, and eternal damnation. The Dominican preacher Giordano of Pisa (d. 1311) blamed vain women and the money they wasted on hair ornaments for the misfortunes of Florence after 1300.[157] Yet wasted resources were not the only concern of Giordano and his ilk. Expensive objects, food, and clothing increasingly fed desires for new commodities that could readily transform into greed. In a sermon that could pass as a critique of globalization, Giordano warned that God distributed commodities and resources throughout the world, from the sugar of the Saracens to the spices of India to the soft wool of Flanders and England, so that no one could possess them all. To try to do so was foolhardy and endangered the soul.[158]

Not only were the imported and local products of the new economy problematic from a theological point of view, they were also potentially destabilizing. Silk garments, bejeweled head pieces, camel's hair cloaks, and the like were previously consumed and displayed only by the wealthiest and most powerful members of medieval society. As they increasingly fell within financial reach of more and more townspeople, particularly merchants, late medieval cities became places where visual distinctions between the elite old guard and the newly affluent were blurred for the first time. The same concept applies to residential architecture. Many houses of sophistication and elaboration were constructed during the thirteenth century, some of which took over large sections of the affluent hill towns of Amalfi. A few of these houses belonged to the feudal nobility, as with Pietro Sasso's, but most did not. The architecture did not respect or reflect such

definitions of official status bestowed by the king. Imposing scale, architectural and technological complexity, and ornamental splendor were available to anyone with financial means, taste, and patronal vision to realize them.

The fear of the impending collapse of social distance led to the promulgation of sumptuary legislation from Messina to Milan in the thirteenth, fourteenth, and fifteenth centuries.[159] Such laws targeted most of the sites of excessive expenditure that earlier scholars in Paris had signaled: clothing, jewelry, livery, and so on. Legislation designated who was entitled to sartorial goods such as fur collars and outlawed the public display of specific types of objects (textiles with figural imagery, for example, or gold hairnets with pearls).[160] Some laws attempted to render undesirable groups more visible, including prostitutes and Jews. Others attacked ostentation by limiting participation at weddings or funerals, defining appropriate behavior at such events, and restricting where they could take place. With few exceptions, these laws attempted to curb public display. Behavior that was technically private, meaning not in the public eye but concealed (*occultus*), was rarely addressed.

Legislation enacted in the *Regno* during the fiscal crises of early Angevin rule aimed to curb superfluous expenditures. The first such law, issued for Messina in 1272, targeted wasteful and competitive spending in that affluent trading emporium. It limited the number of guests at wedding parties, the size of dowries, and the number and value of gifts exchanged.[161] It was followed by the more sweeping law of 1290, issued during the Vespers crisis and war with Aragon. This law and others confirmed in its wake sought to cultivate frugality and *misura* (measure) and to eradicate "immodest and excessive liberality" across the *Regno*.

The specific restrictions used to realize the elusive goal of *misura* merit consideration in this discussion of visual display. The law intended primarily to suppress baronial exhibitions of power because many of the barons were not contributing enough financially to the war effort or had supported the enemy Hohenstaufen regime. In addition to enacting such typical restrictions as limiting the number of guests at weddings, the law capped expenditures on luxury textiles such as purple cloth, silk, or gold brocade, and determined how often a set of new clothes could be made (twice a year). Spending on livery was also limited.

But Angevin sumptuary legislation was unusual in that it was not merely interested in controlling behavior in public space. Along with subsequent statutes such as the Neapolitan code of 1298, the 1290 law not only shaped what could be displayed and seen on the street – the space of social conflict – but it also addressed expenditures and cultural practices that were private or *occultus* and

taking place in residential settings.[162] For instance, the 1290 law established proper methods of preparing meat and vegetables, some of which were in the Northern (i.e., French) manner. In legislating culinary procedures and suppressing the activities and sartorial displays of the powerful barons across the *Regno*, it sought to limit the absolute quantity of expenditure and display, rather than demarcating acceptable locations for them. The domestic realm was therefore as subject to the law as the street was. As such, Angevin sumptuary legislation inevitably curtailed local traditions; in some ways it can be seen as promoting a new culturally homogenized *Regno*, rather than reifying existing social distinctions and hierarchies, as most late medieval codes sought to do.[163]

How the royal, theological, or moralizing critics of lay expenditure would have evaluated the unusually lavish houses of Amalfi cannot be reconstructed precisely. But the houses and their inhabitants appear to have been on unstable ground. A range of sources, from the Joachite condemnation of the hill-town dwellers to Bolvito's account of the Rufolos' fall from grace, Angevin sumptuary legislation, and the clerical critiques of *luxuria*, expenditure, and public display, indicate the fraught nature of material displays of wealth. Yet the houses, which predate the law of 1290, also illustrate the precociousness of the region's merchant economy and investment in domestic architecture. The Amalfitans created buildings that articulated family status long before the more frequently studied and canonical communities elsewhere in the West did. But perhaps the precociousness of the Amalfitans only magnified their precarious status in an unstable and moralizing world.

Amalfi and the Domestic Architecture of *Mercatantia*

The composite houses in the hill towns of Amalfi were places of spatial differentiation and decorative elaboration, characteristics that set them apart from contemporary buildings in Italy and from simpler and more austere dwellings of the early Middle Ages. The complex characters of the houses are inseparable from the act of *mercatantia* because the financial resources of the community were channeled into creating these lavish environments. As a viable site of expenditure, housing not only surpassed the basic requirements of shelter but entered the realm of artistic expression and ostentation.

While the existence and splendor of such buildings depended on the profits of *mercatantia*, their specific forms also represented the commercial experiences of the Amalfitans. With their composite layouts and intricate webs of ornament, the

Amalfi houses coincide with North African architectural and ornamental lexicons that appeared in prominent secular and religious settings alike. Many related North African works of art were located in coastal cities such as Mahdiyya and Tunis, the commercial centers familiar to generations of Amalfitan merchants. From the eleventh century through the thirteenth, these towns were precisely where *regnicoli* sold items such as lumber, grain, and textiles in exchange for gold, leather, and ceramics.[164]

Facilitating the reception of North African idioms was the presence of Muslims in the *Regno* itself and a long-standing though fragmented tradition of Islamic art production there. Some of the ornament used in North Africa would not have seemed unusual to elite Amalfitans because it was closely related to small-scale works made in the kingdom. As with baths and bathing, it is likely that the sophisticated housing paradigm that emphasized courtyards, differentiation of space, and decorative display was part of a broader culture of affluence in this part of the Mediterranean basin, one that transcended differences in faith. In this way the Amalfitans resemble well-to-do Constantinopolitans of the twelfth century, whose awareness and appreciation of Islamic painting led them to emulate such works in the capital.[165]

The Amalfitan houses are more closely aligned with North Africa than with royal or imperial residential architecture in the *Regno* itself. In fact the Amalfi corpus seems quite distant from thirteenth-century courtly paradigms. The fundamental features of the imperial works are absent from the majority of Amalfitan houses, including the d'Afflitto, Rufolo, Trara, and Vallenula examples. The stylistic and technical preferences of the Angevins in the early decades of their rule leaned toward French Gothic idioms that were distant from modes used by the Amalfitans. In residential architecture, that meant that they preferred round towers and Gothic tracery to square towers, rubble masonry, and intarsia-rimmed fenestration.[166] In this part of southern Italy, then, the cultural currency sustained by a centuries-old tradition of *mercatantia* had a greater impact on residential architecture than did the forceful battlements of the disparate rulers of the *Regno*.

In many ways, this aesthetic choice was a logical one. The merchants of Amalfi had a longer and continuous record of cultural connections and communications with their counterparts in North Africa than with the ever-changing dynasties that ruled the kingdom. These connections extended beyond the circuit of trade. The proximity of the Maghreb to the west coast of southern Italy, the Roman inheritance of the two areas, and the fact that the economies emerged at the same time and in overlapping networks suggest strong cultural and historical

affinities between Amalfi and Ifriqiya. Domestic architecture in both regions also flourished during the thirteenth century, with the establishment of the Hafsid dynasty in Tunis in 1228 and its array of suburban residential complexes that coincided with the building campaigns of the second Amalfitan elite.[167]

The twofold development of residential elaboration proper and elaboration through Islamic forms has important implications for the cultural history of the South. In conceptualizing their houses in this way, the Amalfitans created residential environments that were grounded in their experience and activities of *mercatantia*. As such they provided an alternative to the official cultural forms and policies emanating from the Hohenstaufen and Angevin courts. Yet the houses were not fully free of, say, the Gothic idioms espoused by Charles I, as the use of ribbed vaults in a few houses demonstrates, and the structures of *mercatantia* itself depended on monarchical interventions and support, particularly in the Angevin period. Not only did Amalfitans swell the ranks of the royal administration after 1266, but the king's role in the 1270 crusade against Tunis helped revitalize commerce between the *Regno* and Ifriqiya. Hence, although this alternative architecture was deeply rooted in the experiences of Amalfitans at home and abroad, it had numerous points of intersection with the hegemonic structures of the monarchy.

Incorporating such disparate elements as ribbed vaults, segmented domes, and intarsia, the houses indicate that Amalfitans had access to a wide range of artistic forms that held diverse cultural associations, and that they applied them in selective, intelligent ways. The resulting architectural and ornamental variety is particularly significant, given that medieval domestic architecture tends to be seen as conservative. In their unusual degrees of elaboration and display, however, and perhaps because of their Islamic features as well, the houses and their owners were vulnerable to the critiques of moralists and preachers concerned with superfluous expenditure, vanity, and illicit gain. But as a potent expression of the region's cultural distinctiveness, Amalfitan residential architecture also drew attention to the cultural and religious diversity within the *Regno* itself. Its architectural forms, then, were not merely stage sets for exotic banquets and other impressionistic musings, as most of the literature on them has implied. They were expressions of wealth, cultural prestige, and difference – all fueled by *mercatantia*.

Private and Public in Amalfitan Religious Space

⌐◦⌐

O NE OF THE MOST SIGNIFICANT FEATURES OF AMALFITAN CULTURE IS ITS pronounced emphasis on private or familial contexts of worship. Defining acts of private patronage took place in two settings: first and more frequently, near or within domestic compounds, where family churches provided centers of piety and dynastic articulation; and subsequently, within the more public realm of episcopal space, with the bold commissions of the Rufolos. This chapter traces the contours of this phenomenon by examining extant buildings, decoration, and furnishings, as well as illuminating wills, deeds of sale, inventories, and chronicles. The unusually broad range of evidence helps reconstruct the complex and varied sources of the art of *mercatantia*. It also reveals the ways in which the art of *mercatantia* actively shaped new conceptions of religious space, modes of dynastic expression, and types and sites of display.

Since the late nineteenth century, historians have noted that private and lay religious foundations were widespread in the Latin West and Byzantium and have debated the extent of their "private" character.[1] Yet with few exceptions, art history has been noticeably absent from these debates (particularly in the case of Latin contexts) because of the paucity of physical remains.[2] The rare material and textual evidence from Amalfi helps move visual culture from the margins to the center of discussions of private liturgical environments. This study establishes that private patronage shaped significant aspects of medieval religious experience in southwest Italy and calls into question the widely heralded novelty of lay patrons in canonical late medieval and early modern settings.[3]

This assessment of religious space develops some of the arguments made in the earlier analysis of domestic architecture. First of all, private churches extended the representational strategies of families beyond the house, and in so doing created multiple places of devotional display. Second, the churches were salient building blocks of urban form and helped shape the centrifugal, decentralized character of hill towns and their topography of salvation. As with the residential complexes, the churches were not "private" in the nineteenth-century sense of the word; that is, they were not intended exclusively for personal or family use. Rather, they were permeable sites for family and community devotion. Also blurring distinctions between public and private was the most "public" religious space in Ravello, the cathedral interior. It had a pronounced family feel, stemming from the construction of liturgical spaces that glorified and served one clan. One must differentiate, then, between the legal status of the buildings (public or private) and the spatial practices that filled them with life.

First noted in documents dating from the prosperous tenth century, these family or private churches were more diffused in Amalfi than in any other part of southern Italy.[4] Earlier Lombard and Byzantine practices likely contributed to Amalfi's predilection for such foundations,[5] although they flourished for a variety of local and contemporary reasons, as discussed later in this chapter. In contrast to private foundations in northern Europe, which were often established in isolated, rural settings, the Amalfitan churches did not stem from the absence of other religious institutions. After all, by 1076, there were five episcopal sees in the vicinity of metropolitan Amalfi, creating a region with one of the highest concentrations of bishops in medieval Italy.[6]

The popularity of private foundations, then, was fueled by concerns other than the need for basic ecclesiastical facilities. Through the legal doctrine of

ownership known as the *ius patronatus*, such churches promised their founders a potent combination of institutional autonomy and artistic license.[7] Patrons could appoint an officiating priest who was at times accountable to episcopal control. Decisions regarding the location, construction, and decoration of the churches were made by the founders, presumably in consultation with artists as well. Ownership, which was hereditary, was often divided into twelve-unit shares. This basic feature of the region's precocious economy infiltrated most structures of ownership, production, and distribution, from ships to vineyards to shipments of wine; shares helped minimize any one person's financial risk and thus facilitated broad participation in many types of commercial activities.[8]

Despite some objections to private worship voiced during the reformist eleventh century, such foundations continued to flourish after Norman rule was firmly established in Amalfi in 1089.[9] Numerous references in episcopal charters testify to their continuing importance and prominence in local affairs through the fourteenth century. After 1200 or so, private churches were frequently bequeathed to local bishops, suggesting some pressure to suppress such foundations. But the evidence is not univocal here. A not-unusual document mentions two sisters named Anna and Imbria who rented the church they had founded, Sant'Angelo in Furcella in Minori, to their cousin Matteo in 1218.[10] Giovanni Battista Bolvito knew of ten private churches dating from the later Middle Ages that were still standing in 1585 in the town of Scala alone and claimed that they represented but a fraction of the original number.[11] Why were these foundations such a prominent feature of the Amalfitan cultural landscape? Their popularity derived in part from amassed wealth, the inevitable byproduct of *mercatantia*, and in part from the material and moral structures of Amalfitan society.

Materially, the Middle Ages are generally characterized as relatively poor in durable commodities or material sources of expenditure, thereby leaving the merchants who prospered in southwest Italy's precocious economy with fewer purchasing options than, say, their early modern counterparts. The lavish residences of the Amalfitans clearly provided key sites of expenditure, as discussed earlier. In contrast to Renaissance cities in central Italy, however, with their seductive array of intricate furnishings and tableware designed by renowned artists, the medieval southwest had fewer types of portable goods available. They consisted primarily of imported Byzantine silks, the reputation of which brought Desiderius of Monte Cassino to Amalfi in 1066 to purchase a gift for Henry IV; prized spices such as pepper, cinnamon, and ginger, which bestowed immediate

prestige on the table; and ivories and glazed ceramics from Amalfitan trading centers in the Aegean, North Africa, and the Middle East.

Apart from having a limited range of commodities on which to expend their considerable wealth, prosperous Amalfitans were also constrained by moral strictures. Religion constituted one of the few acceptable realms of investment at a time when wealth and the public display thereof were seen as potential signs of greed, pride, and illicit gain. Charitable donations to local churches were pious, social, and even legal obligations for the well-to-do, particularly for those active in trade and money lending.[12] Relative to other contexts in the medieval West, Amalfitan sources overflow with references to such gifts. Yet these acts of charity, no matter how obsessively and frequently performed, left affluent Amalfitans – those friends of iniquitous Mammon – with a surplus of wealth and a lingering sense of spiritual unease.[13]

Beginning in the eleventh century, Amalfitans invested considerable sums in religious objects destined for private and public settings. Well-known works such as the bronze doors of the Cathedral of Amalfi are part of this material culture of *mercatantia*. Commissioned by the merchant-diplomat Pantaleo de Maurus Comite around 1061, the doors, notwithstanding their beauty and uniqueness, constitute products of a complex economy based on long-distance trade. Like the other works that define the art of *mercatantia*, they are objects that were created, purchased, imported, displayed, viewed, and imitated; they define the Amalfitans' spending habits and investment strategies, as well as their taste and religiosity.

Family churches similarly embody the region's social and economic circumstances and spiritual concerns, but on a grander scale than episodic acts of patronage such as the bronze doors. The merchant Orso Castellomata, "friend of Mammon," built the small cross-in-square church of San Michele Arcangelo in Pogerola, a hill town above Amalfi, as a literal investment in his salvation, as the foundation document of 1181 states.[14] Large and small works born of private patronage attest to such eschatological concerns, to be sure, but their significance does not stop there. Such works also reveal new attitudes toward public display, as well as new conceptions of religious and episcopal space, changes driven by unprecedented prosperity in the wake of market and political expansion.

This study identifies significant traditions of lay patronage in religious settings and some of the intentions and motives of their patrons. It first reconstructs three private churches and their decoration and addresses the implications of the eclectic range of their sources and relations to the practices of *mercatantia*. It

then analyzes the bold commissions of the Rufolos for the Cathedral of Ravello. Both phases of patronage – that is, before the Rufolos and of the Rufolos – must then be viewed through the lens of the expanding markets of nascent capitalism, which granted merchants access to an increasing range of goods and materials and varied artistic prototypes. Theories of consumption practices help elucidate correlated themes, such as the contested and competitive nature of public display, shifting notions of prestige, and realignment of power in urban space, themes central to the art of *mercatantia*.[15] When the works of art are evaluated through this lens, the ambitious nature of the Rufolo commissions for the Cathedral of Ravello becomes clear.

Amalfitan Private Churches and Their Decorative Strategies before 1250

This portrait of family or private liturgical environments in medieval Amalfi is drawn from a rich array of textual and material remains, focusing on the basic features of the architecture and interior decoration of private churches. Rather than evaluating each patron, building, or object in detail, it maintains a general perspective and emphasizes the types of monuments, varied materials, and range of styles that defined the art of *mercatantia* in its heyday, ca. 1100 to 1250. Such a perspective helps illuminate the Rufolo commissions of the 1270s and 1280s because they simultaneously derived from and challenged the conventions of private patronage reconstructed here.

In medieval Amalfi, the personal nature and extent of patronal involvement in private foundations varied from church to church. In some cases, such as San Michele Arcangelo in Pogerola of the merchant Castellomata clan, and Sant'Eustachio in Pontone of the d'Afflittos, the foundations belonged to a single family. Others, such as San Giovanni del Toro in Ravello, were owned by several neighboring families and thus functioned loosely as parishes – as local sites of ritual and social interaction.

Many of the region's private foundations were located near or within a residence of the founder. In the region of Amalfi, founders worked hard to acquire property holdings large enough to accommodate both house and church – a difficult task in this place where level ground suitable for construction was in short supply. The Castellomata family, for example, had procured many parcels of land in the elevated quarter of Pogerola prior to the construction of San Michele there, while Sant'Eustachio is located near the cluster of houses that belonged to the

d'Afflitto clan.[16] This proximity of church to residence clearly resembles imperial, royal, and episcopal contexts in Byzantium and the Latin West, including nearby Salerno, where palatine chapels were constructed within or near residences of Lombard authorities.[17]

The concept of the private church proved a flexible one that reveals the creativity of Amalfitan merchant patrons. Although most of the foundations suggest an interest in securing a single location for burial and care for the dead, several other factors seemingly shaped them as well. Neighborhood solidarity, dynastic articulation and display, and social competition are among the detectable motives. Of further interest is the range of monument types, styles, forms, and media that underline the fundamentally eclectic character of the art of *mercatantia*.

San Giovanni del Toro, Ravello

San Giovanni del Toro in Ravello is the most intact private foundation around Amalfi that dates from the era before the Rufolos. It was founded in 1018 by a consortium of families, including the Pironti, Muscettola, and Rogadeo clans, although a preexisting church was possibly located on that site.[18]

The location of San Giovanni is distinctive in many ways. First, the church lies along the crest of the Ravellese plateau and now constitutes the most elevated structure of the town's skyline as viewed from the neighboring town of Scala. Intersecting arches of grey tufa enliven its three apses. Facing Scala, this design seemingly competes with the apses of churches there, including the Cathedral of Scala and Sant'Eustachio in Pontone, which in turn face Ravello (Fig. 38; see also Fig. 44). This site was a socially prominent as well, for San Giovanni was situated on the main artery that bisects the Toro district, where wealth was particularly concentrated in the high and late Middle Ages; the church's elite founders resided in that zone. Furthermore, the church was constructed in a dynamic area, near the northern gate of the medieval city where the roads from Scala and the Sarno Valley converged. The square bell tower and wide portico that extended out to the street secured the church's visual and physical prominence in this dynamic location (Fig. 39; see also Fig. 49).

Although it is possible that some essential sacred rites (including funerary ones) originally took place in San Giovanni and were transferred to the cathedral when it was founded sixty years later, the Toro foundation remained a vital center of worship through ca. 1450. A steady stream of furnishings, wall paintings, and vestments for the church, as well as donations and burials, indicate the wealth of its members and the commitment to the institution that they sustained over

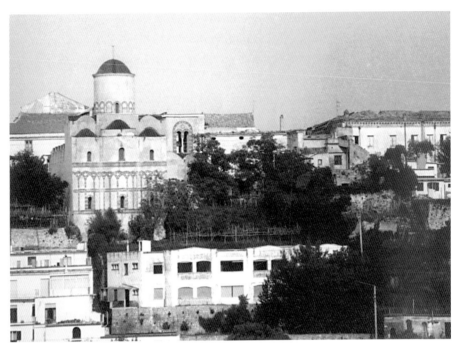

38. San Giovanni del Toro, Ravello, exterior, apse.

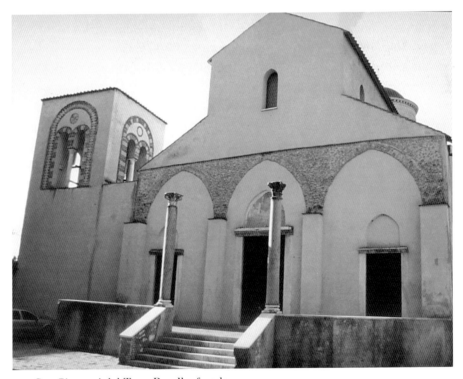

39. San Giovanni del Toro, Ravello, façade.

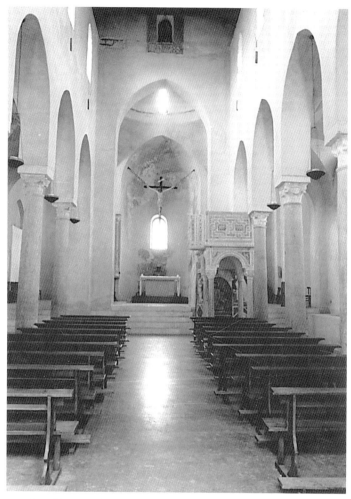

40. San Giovanni del Toro, Ravello, interior (Centro di cultura e storia amalfitana).

many generations. This site of private patronage thus reveals the various shifts in Amalfitan taste over the course of three centuries, both before and after the Rufolo commissions in the cathedral.

Debates over the date of the existing building, which scholars of generations past placed in the late eleventh century through the mid-thirteenth, have largely been resolved.[19] Although founded as early as 1018, the church was reconstructed on a larger scale in the early 1100s and consecrated in 1276. San Giovanni is an expressive variation on the austere Desiderian basilica type that proliferated in Campania after the late eleventh century (Figs. 40 and 41A). The church

contains a three-aisle nave constructed of *spolia* columns with ancient and medieval capitals. Pointed groin vaults provide a dynamic, faceted cover for the side aisles, while a wooden truss spans the nave. Inset nook columns frame the central apse; on the south side, a worn Corinthian capital creates an unusual column base. A small pumpkin dome placed on a high drum once crowned the center of the transept. Small lancet windows pierce the high walls above the arcade. A large side chamber, vaulted portico (destroyed in a storm in 1708), and square bell tower with intarsia ornament complete this ensemble.

The extant decoration of the church is the product of varied impulses at different times. From an intessellated chancel screen fragment commissioned by a son of Filippo Freccia in the mid–thirteenth century to the stucco relief of St. Catherine in the side chamber made a century later, the heterogeneity of the church's decoration provides an instructive contrast with the coordinated ensembles of furnishings commissioned in many other private settings.

Emblematic of the art of *mercatantia*, the so-called Bove family pulpit is located on the north side of the nave[20] (Fig. 42). It has been dated on the basis of style to the first decades of the thirteenth century.[21] Artists associated with the liturgical furnishings in the Cathedral of Salerno likely produced its high-quality sculpture. The design of the piece, a lectern supported on four columns with round-arched spandrels, closely resembles the small pulpit in Salerno, which was commissioned by the archbishop of Salerno Romuald II Guarno around 1175–80, although the Toro work is smaller (Fig. 43). The dynamic capitals and caryatid supporting the lectern desk also suggest the presence of artists trained in Salerno, a group that worked on a now dismantled pulpit in the Cathedral of Amalfi as well.

Local workshops created the vibrant mosaics of the Bove pulpit, which combine glass tesserae fabricated in the region with pieces glazed ceramics likely from Egypt, Syria, and Iran.[22] These imported wares, some of which bear legible Arabic inscriptions, date from the twelfth and early thirteenth centuries. The ceramics were used in the same manner as the disks of porphyry or serpentine that generated these patterns in canonical "cosmatesque" works and their variations across central and southern Italy, including Salerno.

41. Plans of three private churches. (A) San Giovanni del Toro, Ravello; (B) Sant'Eustachio, Pontone; (C) San Michele Archangelo, Pogerola (Danielle Lam-Kulczak, after Vitolo, Venditti, and Bergman).

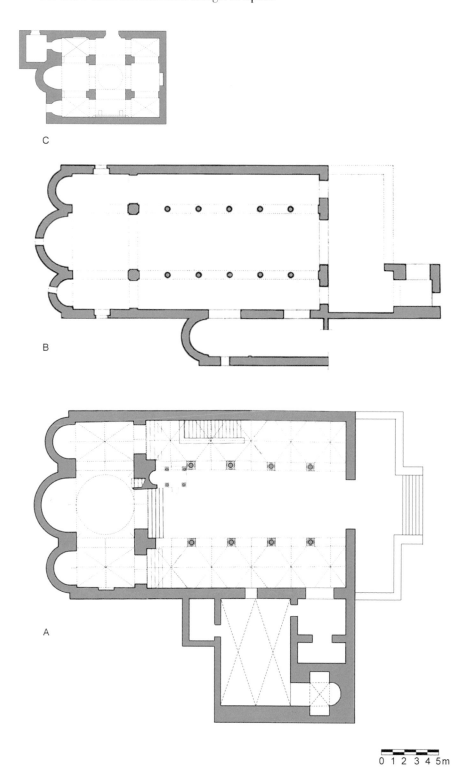

C

B

A

0 1 2 3 4 5m

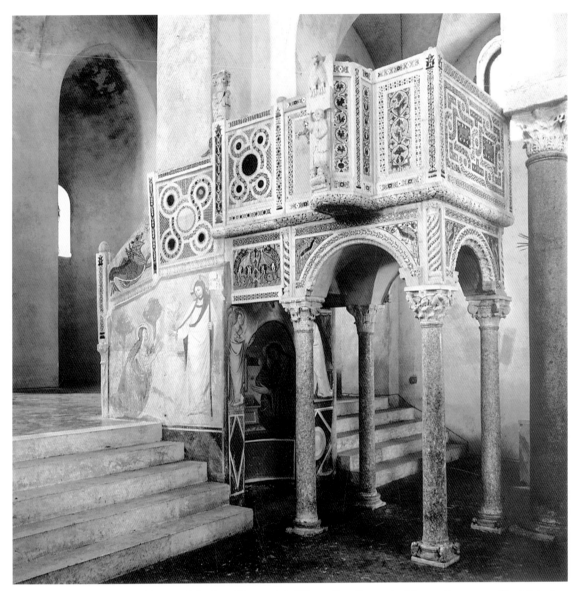

42. Bove pulpit, San Giovanni del Toro, Ravello, early thirteenth century (Archivio Luciano Pedicini).

Eight years after the consecration of San Giovanni, Nicola and Giovanni Pironti donated a large collection of vestments to the Toro church.[23] Made of red and purple silk, these objects consisted of two dalmatics, two copes, and a mitre embellished with pearls. Such works enriched the liturgical environment of San Giovanni, to be sure, but the timing of the Pironti donation merits

consideration as well. Not only did the gift postdate the celebration of conse-
cration by seven years, but by September 1283, Matteo and Lorenzo Rufolo had
been in prison for three months. Like the Rufolos, the Pirontis were engaged in
the administrative affairs of the kingdom: Giovanni oversaw the mint in Messina
in the 1270s, Giacomo was *portulanus* and oversaw salt production from 1276 to
1280, Bartolomeo was a notary in Sicily, and so on.[24] Perhaps this donation was
born of the Vespers crisis and its devastating impact on high-ranking Ravellese;
the Pirontis, as holders of sensitive offices in Sicily, felt that their standing before
the sanctimonious Charles of Salerno, the community of fellow Ravellese, and
God himself could benefit from this outward expression of piety and generosity.

A series of extant works of art and archival sources from the fourteenth century
indicate that the Toro church emerged as a significant burial site in late medieval
Ravello, as discussed in Chapter 4. This new role contrasts with previous burial
conventions. Sergio Muscettola (d. ca. 1190), a distinguished member of one of
San Giovanni's founding families, was entombed in the Muscettola chapel next to
the Muscettola bronze doors of the Cathedral of Ravello.[25] Apparently the Toro

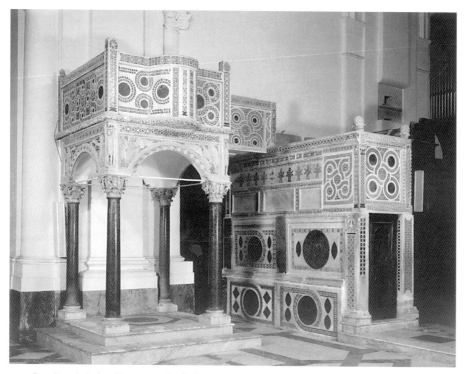

43. Small pulpit (or Guarna pulpit), Cathedral of Salerno, ca. 1175–85 (Archivio Luciano
Pedicini).

church did not constitute the sole locus of burial, patronage, or religious practice for the denizens of the district who were its members. Envisioned effectively as a parish church, it most likely functioned to support and maintain the authority and reputation of the neighborhood, which had established its elite status long before the rise of the second Amalfitan aristocracy to which the Rufolos belonged.

Sant'Eustachio, Pontone

Contrasting with the intact condition, shared ownership, and piecemeal development of San Giovanni del Toro is Sant'Eustachio, the ruins of which dominate the village of Pontone[26] (see Figs. 11 and 41B). Probably founded in the second half of the twelfth century by Matteo d'Afflitto, the church was dedicated to the family's ancestral saint.[27] Although it was consecrated as late as 1244 and suffered soon thereafter from neglect, this family of merchants, royal administrators, and ecclesiastical officials expended a substantial amount of energy and resources on the church in its first decades of use. Judging from the scale of its remains, descriptions of its original form and decoration, and an inventory of its treasury, Sant'Eustachio was one of the most grandiose private foundations in the region.

The three tall apses of the church's east end occupy a prominent site above the valley (Fig. 44). Pierced by small lancet windows, this rubble wall springs from a large lateral crypt and establishes the original scale of the building. Traces of a blind arcade of multicolored inlaid tufa and marble colonnettes adorn the exterior apses.[28] Felled columns on the site indicate that a nave arcade included a mixture of old and new capitals (Fig. 45). A vaulted portico and bell tower were also part of the complex. With its dramatic site, basilica layout, and intersecting patterns of exterior ornament, Sant'Eustachio recalls the most prestigious building projects of the time, Santa Maria la Nuova in Monreale (Fig. 46), completed by 1189 under the patronage of the Norman king of Sicily, William II.[29]

A previously unpublished description of Sant'Eustachio further corroborates Pontone's indebtedness to Monreale.[30] Giovanni Battista Bolvito described its interior in some detail in his manuscript of 1585. He wrote of Sant'Eustachio's extensive wall mosaics, which were presumably damaged by then, as the roof had collapsed by that time. He also mentioned that the church contained sculpted tombs of porphyry, calling to mind the tomb of William I (d. 1166) in Monreale and related ones in Palermo. Furthering an argument in favor of a Norman prototype, he described its impressive bronze doors, which he claimed were from Constantinople, like Pantaleo's in Amalfi. It is unlikely that these works were imported, as local bronze casters were well established in southern Italy

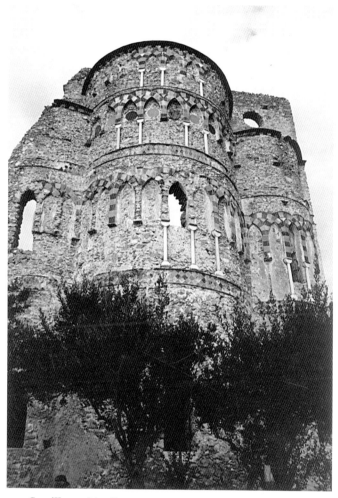

44. Sant'Eustachio, Pontone, apse exterior.

by the middle of the twelfth century. In fact one set of doors at Monreale itself was made by the artist from Apulia Barisano of Trani, who cast a nearly identical set for the Cathedral of Ravello. Thus in its site, intarsia decoration, mosaics, porphyry tombs, and bronze doors, Sant'Eustachio appropriated the salient forms and media of Monreale.

Extant fragments of the church's portal and pulpit add material dimensions to Bolvito's observations. These pieces of sculpture, including leonine column bases, two spandrels with prophets depicted in relief, and portal jambs have been dated on the basis of style to the first decades of the thirteenth century, the period preceding the dedication of the church in 1244. They are incorporated

45. Sant'Eustachio, Pontone, view of site of nave.

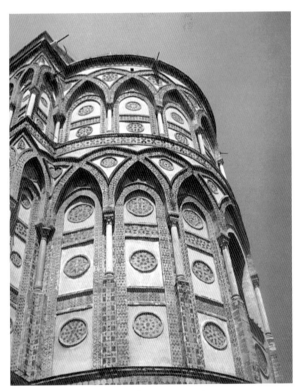

46. Cathedral of Monreale, apse exterior.

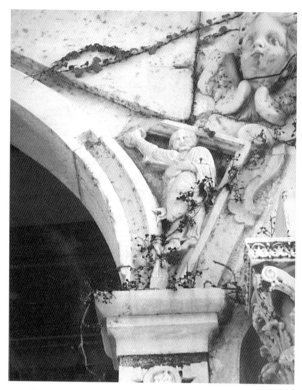

47. Prophet, spandrel fragment of the d'Afflitto pulpit from Sant'Eustachio, early thirteenth century, currently embedded in the portal of the Albergo Caruso, Ravello.

into a d'Afflitto House in Ravello, now the Hotel Caruso[31] (Fig. 47). A relief in Berlin depicting Abyssus, the bearded personification of the Underworld, has also been connected to the d'Afflitto pulpit. Such imagery was a standard component of lectern bases in prestigious episcopal sites in medieval Campania, as related works at Salerno (Guarna pulpit, ca. 1175–85) and Sessa Aurunca (ca. 1250) indicate (see Fig. 76).

A text of 1369 provides another indication of the foundation's rich liturgical environment.[32] This remarkable inventory records the contents of the treasury, which must have rivaled in size and opulence those of episcopal sees in the region. Sant'Eustachio's vestments at that time included seven chasubles, many of which were of silk with designs suggestive of Byzantine provenance; one pluvial with silk embroidery and a gold silk border; eighteen altar cloths made of taffeta, linen, or velvet, and incorporating designs of eagles, busts, or peacocks, also likely of Byzantine manufacture; and three maniples, including one ornamented with gold stars and another with glass beads. A collection of missals and other

liturgical manuscripts, chalices, a censor, and other objects critical to the mass were included as well. But what is most extraordinary are the actual objects of worship: a gilded porphyry reliquary altar, for example, and ivory caskets filled with relics, ranging from the expected bone of Eustachius himself, to a tooth of Matthew, bones of Peter and Lawrence, bread from the Last Supper, and hairs of Mary. More than twenty relics are named, including body parts of major and minor figures and objects associated with holy sites and events.

Although a fraction of the size of Monreale, Sant'Eustachio mediates between grandiose Norman building programs and local architectural and decorative traditions. Its location within the orbit of an extended d'Afflitto domestic compound in Pontone further underlines its dynastic and commemorative ambitions. Its site on a prominent outcropping ensured that it was visible from the surrounding hill towns of Ravello, Scala, and Pogerola, from Atrani down below, and even from the sea. Travelers and locals alike would have passed by and indeed through this extended family compound, for it was situated along the main road from Amalfi to Scala and the Sarno valley. The unusual location of the bell tower, situated between the vaulted portico and the main road, stretched the church's fabric from the cliff's edge to the public space of the street. Sant'Eustachio was not a closed environment created for d'Afflitto eyes alone. Its contents, site, and scale rendered it a key piece of the region's physical and devotional landscape. Its liturgical furnishings participated in a competitive culture of display.

In its artistic sophistication, liturgical mis-en-scène, and well-appointed treasury, Sant'Eustachio surely rivaled the region's cathedrals. It replicated the salvational technology of the bishop – it had scores of holy relics, religious imagery on the walls, commemorative inscriptions, an elevated pulpit with elaborate marble reliefs, and funerary altars. This replication would have undermined the centripetal function and rationale of the bishopric by creating an alternate sacred space of comparable visual authority.

The ruins of Sant'Eustachio illustrate the financial burdens of such ambition. If a founder could afford to construct and decorate such a church, employ priests to perform liturgical services, and supply candles, wafers, wine, and other periodic materials, there was no guarantee that he could do so indefinitely, or that his heirs would embrace the financial responsibilities of the *ius patronatus*. In the case of Sant'Eustachio, the ascent of two d'Afflittos to the cathedra of Scala in the early thirteenth century perhaps shifted the family's focus away from the dynastic foundation or eroded their allegiance to it. Regardless of their intentions or

preferences, the family's financial decline and inability to care for the foundation spelled the demise of the church, which even the auric presence of scores of holy relics could not stave off.

Such problems were not unique to southern Italy, but endemic to the type of foundation. Byzantine legislation dating from the sixth through the fourteenth centuries reveals that private monasteries, hospitals, and churches were often neglected and posed serious social, political, and financial problems that warranted the emperor's intervention. Justinian, for example, sought to make founders responsible for construction, maintenance, and operating expenses of their churches and monasteries. In the twelfth century, the founder's rights of ownership (*ktetoreia*) conceded some control to centralized ecclesiastical authorities, and in their diluted forms were known as founder's rights (*ktetorikon dikaion*). This scaling back of patronal control was comparable to some policies adopted in the West following Gregorian reform. In late-eleventh-century Salerno, the clergy of private churches were newly subject to the authority and discipline of the archbishopric, although private foundations continued to thrive.[33]

San Michele Arcangelo, Pogerola

Roughly contemporary with Sant'Eustachio is the small church of San Michele Arcangelo in Pogerola, a town that clings to the steep face of Monte Molignano above Amalfi. The merchant Orso Castellomata had the church constructed between 1179 and 1181.[34] Although no evidence of its liturgical furnishings or medieval decoration survives, the foundation illuminates the sophisticated and eclectic taste of Amalfitan merchants in architecture: it is one of the few cross-in-square churches in mainland Campania and the only firmly dated one in southern Italy.[35] Although it was redecorated in the seventeenth century and its central dome has collapsed, its original quincunx layout is still legible, with high pointed groin vaults articulating the four corner spaces and pointed barrel vaults over the arms of the inscribed cross (Fig. 48; see also Fig. 41C).

Like the Rufolos, the Castellomatas apparently were not descendants of the first comital elite. Yet as wealthy and well-traveled merchants, they were able to construct a private church based on prestigious Constantinopolitan prototypes. San Michele evokes a range of Middle Byzantine buildings, including the small yet imperial or aristocratic foundations of the Nea Ecclesia, constructed by Basil I (ca. 880), and the Myrelaion, commissioned by Romanus I Lepacaenus while he served as commander of the imperial fleet (ca. 925). As Bergman noted,

merchants like Orso Castellomata would have known and appreciated such prestigious buildings in Constantinople, where they had long been engaged in trade.[36] Its centuries-old Byzantine forms must have conveyed the prestige of earlier generations and, perhaps, the heyday of Amalfitan commerce.

In Pogerola, the quincunx plan was adapted to the peculiarities of Amalfitan architecture: it is located on a sharply sloping site, its three apses and adjoining bell tower marking the outer, downhill side; it was constructed following local building traditions, with rubble and intonaco; and finally, its scale is miniature, relative to the buildings on which it was modeled.

San Michele and Sant'Eustachio were each founded by an individual for his family, and it is not surprising that the upkeep of the buildings proved difficult if not impossible for their descendants. San Michele passed into monastic hands in the early thirteenth century, and Sant'Eustachio literally crumbled as resourceful members of the d'Afflitto clan moved to Naples. Given the financial obligations involved, it is not surprising that extant or well-preserved private foundations around Amalfi are later constructions, from the thirteenth and fourteenth centuries (SS. Annunziata in Ravello); had specific functions with broad appeal (Sant'Angelo dell'Ospedale in Ravello, an austere rock-cut chapel that emulates the Michelene shrine at Monte Gargano); or were the product of group initiative (San Giovanni del Toro).[37]

These three private churches dating from the hundred years leading up to the Rufolo commissions were fundamental to urban form and expansion. They were salient features of the landscape, quick to dominate a district and colonize the street. Technically private in a legal sense and often built to facilitate one family's salvation, the three foundations also reveal the eclectic character of the art of *mercatantia*. The patrons appropriated architectural lexicons that were up-to-date or based on centuries-old prestige, from Benedictine to Norman and royal to Constantinopolitan and imperial. Decorative strategies were similarly wide-ranging and sophisticated and seemingly magnified the ideological content of the architecture in the case of Sant'Eustachio. The legal freedom of the *jus patronatus* apparently facilitated aesthetic variations and choice, as the ostentation of Sant'Eustachio, to which early inventories and descriptions testify and the high-quality works in San Giovanni indicate. It also facilitated competition, as each family or consortium of families sought to create sumptuous and complete liturgical environments that rivaled each other and their episcopal sees.

48. San Michele Arcangelo, Pogerola, 1179–81, remains of pendentives and dome, before restoration of the late 1990s.

This family-based approach to structuring sacred space had the effect of widely distributing an unusually rich array of religious art and architecture, holy relics, and devotional practices across the landscape. The decentralized character of these expressions contrasts vividly with prosperous central and northern Italian towns, where liturgical embellishment tended to be concentrated in a few emphatically "public" sites. Amalfi's patronal and devotional practices also helped transform the most public religious place in Ravello, the cathedral interior, into a liturgical space that glorified one clan.

Lay Patronage in an Episcopal Domain: The Rufolo Commissions for the Cathedral of Ravello

Cradled between the Toro Quarter to the north and the agricultural and monastic establishments to the south, the Cathedral of the Assumption (now dedicated to St. Pantaleon) dominates the plateau of Ravello[38] (Fig. 49). The crisp geometrical form and imposing scale of the church lend coherence to the sprawling hill town by defining its geographical and spiritual center. Seemingly representative of the conservatism found in much of the South's Romanesque architecture, its

structure adopts Early Christian formulae sanctioned by the reconstructed Monte Cassino, including a nave arcade of *spolia*, clerestory of small lancet windows, three semicircular apses, wooden truss roof, and exterior portico[39] (Fig. 50). The interior environment, however, marks an abrupt departure from Desiderian and other sanctioned ecclesiastical ideals. The large furnishings that occupied key sites in the church, namely, the ciborium over the main altar and elevated pulpit on the north side of the nave, herald the new: the presence and involvement of laypeople in structuring the liturgical heart of the church.

These works constitute the largest public ensemble commissioned by the Rufolos and date from their heyday in the Angevin administration, the 1270s. Although the works mark an early introduction of laypeople into an episcopal domain, Nicola and Matteo clearly were not the first lay patrons in the region to commission liturgical furnishings of these types. As we have seen, generations of Amalfitans had donated similar pulpits and ciboria to private churches.

These antecedents magnify the boldness and ambition of the Rufolo commissions. The furnishings for the Cathedral of Ravello employ many strategies of representation to assert the family's presence, including genealogical inscriptions, novel heraldic devices, and varied sculptural and pictorial styles with an array of meanings and implications. As such, the monuments articulate the contested status of episcopal space in an era of commercial expansion and affluence, and point to the changing attitudes toward display that blurred distinctions between public and private. But because the radical nature of the furnishings derives in part from the context they challenge, a look at the cathedral itself and its earlier decoration is in order.

The Cathedral of Ravello as Desiderian Tabula Rasa

Ravello's architectural resemblance to Monte Cassino attests to two connections, one political, the other art historical, between the region and the Benedictine mother house. First, Desiderius established the diocese of Ravello in 1086–7 during his short pontificate as Victor III and bestowed episcopal rights and privileges there upon a Benedictine monk named Ursus Papicius.[40] Even without the political interventions of the Benedictines, the artistic influence of the abbey was inevitable, for the region of Amalfi had made a strong impact on artistic and architectural production at Monte Cassino itself. Desiderius's admiration for and emulation of the bronze doors of Amalfi prompted this interdependence; the Amalfitan masons who are thought to have participated in the abbey's construction helped secure it.[41] In short, the new abbey church reflected back to

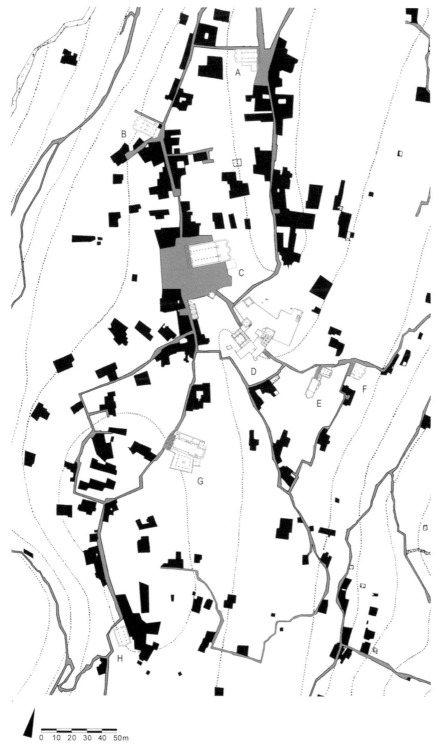

49. Central Ravello, with salient monuments in plan. (A) San Giovanni del Toro; (B) Santa Maria in Gradillo; (C) Cathedral; (D) Rufolo House; (E) SS. Annunziata; (F) San Matteo; (G) San Francesco; (H) Santa Chiara (Danielle Lam-Kulczak).

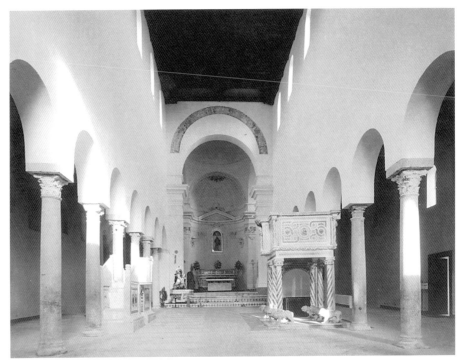

50. Nave, Cathedral of Ravello, founded 1086-7 (Archivio Luciano Pedicini).

Ravello a monumental version of the region's own architecture, one ennobled by its aggressive references to Old St. Peter's, but nonetheless recognizable as Amalfitan.

While the Cathedral of Ravello fits squarely into the Desiderian tradition of ecclesiastical architecture that flourished near the end of the eleventh century, the circumstances of its foundation, construction, and decoration are anything but typical. First of all, when the diocese was established in 1086-7, it was independent of surrounding archbishoprics – independent, then, of Salerno and Amalfi, which were elevated to metropolitan status in 985 and 987, respectively. This gesture attests to the ambitious policies pursued by the Normans who sought to organize, subdue, and resettle new territory by diversifying ecclesiastical administration.[42]

The significance of the cathedral extends beyond its highly politicized birth. The see of Ravello was created long after all of the others in the region, and thus at a different moment in the coast's artistic, economic, and social history.[43] The process of constructing and decorating the church was therefore subject to impulses, concerns, and conventions that differed from those of, say, the Cathedral

of Amalfi, much of which was probably laid out around the year 1000. Even though older churches in the region were enlarged or outfitted with new decorative programs in the twelfth and thirteenth centuries, the Cathedral of Ravello was an actual tabula rasa – an opportunity for builders, artisans, and patrons to start from scratch on a large-scale project.

Similar to its conservative Desiderian layout and articulation, the interior decoration of the cathedral initially proceeded in directions befitting its episcopal status. As was customary in central and southern Italy, high-ranking church officials commissioned the two most essential liturgical furnishings, the altar and pulpit. The second bishop of Ravello, Constantine Rogadeo, commissioned the now-lost main altar.[44] He also donated the nave's ambo, a type of pulpit of Byzantine origin that consists of a lectern core flanked by two short staircases (Fig. 51).

Constructed before 1150, the ambo corresponds to standard early designs, as illuminations of liturgical activities in Exultet rolls from southern Italy corroborate (for example, BAV Vat. Lat. 9820 from Benevento, ca. 985; Pisa Exultet #2 from Capua, ca. 1070). On the front of the ambo facing the nave are mosaics depicting Jonah disappearing into the mouth of the fish and then emerging unscathed; these staples of Early Christian iconography were also favorites in medieval Campania.[45] The walls of the ambo are made from slabs of reused

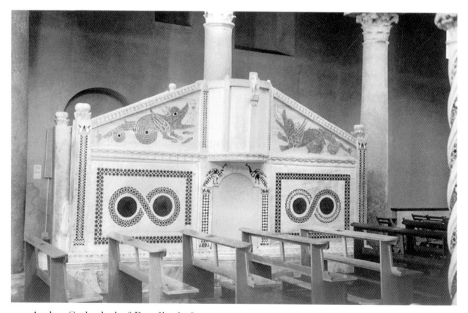

51. Ambo, Cathedral of Ravello, before 1150.

marble, for damaged yet discernible reliefs of ancient garlands and early medieval vegetal motifs in a Lombard style (such as San Prospero, Perugia) are visible on their inside faces.

When Constantine died in 1150, he was buried near or underneath the ambo, and a funerary altar was established on that site.[46] This liturgical pairing of tomb and lectern, extended along a vertical axis reminiscent of the cult of saints, defined an elite burial practice generally reserved for high-ranking ecclesiastics.[47] In the era of Constantine Rogadeo, cathedrals in the South rarely contained monumental burials of anyone other than bishops or sovereign authorities.

During the long tenure of Rogadeo's successor Giovanni Rufolo, a wealthy Ravellese named Sergio Muscettola commissioned from Barisano of Trani the bronze doors of the west portal (dated by inscription to 1179)[48] (Fig. 52). Sergio's tomb, as well as those of other prominent townspeople, was located to the left of the doors, although whether outside in the portico or just inside the door is not clear.[49] Modest ex-voto wall paintings survive here and in other cathedral churches in the region, and these too are concentrated in peripheral spaces – in chapels on the perimeters of cloisters (Amalfi), or just inside the main entrance to the church (Ravello). For a hundred years, the process of decorating the cathedral closely followed accepted local customs: the commissions of townspeople clustered around the outer edges of the church, whereas large-scale interior furnishings remained the responsibility of episcopal patrons.

In the 1270s, the Rufolo family initiated a decorative campaign that challenged these conventions of cathedral decoration. Redrawing the liturgical geography of the church to include themselves, the Rufolos transformed the interior of the cathedral by commissioning a large pulpit, ciborium, funerary chapel, and pavement for the crypt. No less essential to liturgical ceremony were the portable objects they donated, including a chalice, censor, tabernacle, altar frontals, and vestments. Most of these works of art bore images of the family's coat of arms or long genealogical inscriptions. In pictorial and written language, the furnishings asserted the Rufolos' presence in the space and marked the appropriation of the religious epicenter of Ravello and its ceremonial distinction and status.

A comparison with other liturgical ensembles in central and southern Italian cathedrals confirms the singularity of the Rufolo commissions, as no other marks the monumental presence of lay patrons into the hallowed space of presbytery or pulpit. Other roughly contemporary ensembles, such as the furnishings in the Cathedrals of Canosa, Bari, Salerno, Monreale, Ferentino, Anagni, and Sessa Aurunca, to name prominent examples in large and small towns, were all

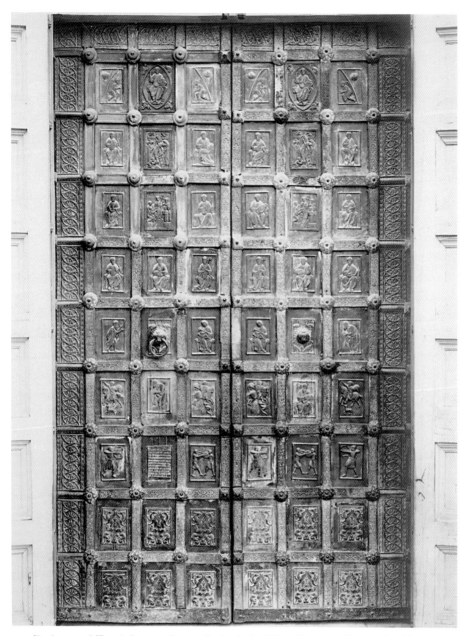

52. Barisano of Trani, bronze doors, Cathedral of Ravello, 1179 (Copyright Alinari/Art Resource, NY).

fruit of ecclesiastical or royal initiative by bishops, canons, kings, or dukes, whose commissions bestowed prestige upon themselves and "their" institutions.[50]

The scale of the Rufolo works offers a further indication of their ambition. The Rufolo pulpit is twice as high as the adjacent ambo, for instance, and towers above it. Whereas the dimensions of liturgical furnishings in the South generally reflected those of their architectural settings – large pulpits appear in large churches, small in small – the Rufolo commissions approach in size the largest pulpit in the largest cathedral in the region, Salerno. Consequently they appropriate a higher percentage of the relatively limited cathedral space (Fig. 53).

In the decades following the Rufolo commissions, lay and secular incursions into episcopal space occurred with greater frequency in the West, owing in part to the emergence of private chapels, painted altarpieces, and monumental tombs in Italy or inlaid brass tomb markers, chantries, and regalia north of the Alps. These incursions took place to such a degree that late medieval churches resemble "repositories of memories, associations, and often objects," as Andrew Martindale, one of the few art historians to have studied this phenomenon, observed.[51] The Rufolo commissions mark for southern Italy a previously unrecognized, early, and coherent phase of that process and antedate by centuries emblematic northern works discussed by Martindale, such as Margaret of Austria's commissions in Brou.

Yet in addition to the chronological primacy of the Ravello works, other aspects of the Rufolo story merit emphasis. The family's commissions for the cathedral embody varied forms and pragmatic and secular ideals, revealing the patrons' skillful negotiation of heterogeneous visual cultures and their attendant ideologies. The Rufolos' patronage did not stem purely from salvific concerns or the desire for spiritual contemplation and enlightenment, the sentiments long held to have motivated art production, particularly among laypeople in the later Middle Ages.[52] Instead, the forms and spatial context of the commissions place them within the matrix of the South's evolving visual and political cultures, where art eloquently expressed power and ambition.

The following analysis of the Rufolo monuments contains two parts. It first introduces the works, assesses their general characteristics, and places them within the context of the art of *mercatantia*. Second, it explores their new and bold techniques of self-representation, along with the implications of the works for the cultural history of southwestern Italy.

53. Plans of three cathedrals and their liturgical furnishings. (A) Salerno; (B) Caserta Vecchia; (C) Ravello (Danielle Lam-Kulczak, after Carbonara, D'Onofrio, and Schiavo).

Introducing the Rufolo Commissions: Attribution, Form, and Iconography

The Rufolo family's campaign to reconfigure the interior of the Cathedral of Ravello began in 1272, the year inscribed on the pulpit located on the south side of the nave (Fig. 54). Placed on the base of the pulpit's stairs, this dedicatory inscription also names the patron, Nicola Rufolo, and the artist, *Magister Nicolaus de Bartholomeo de Fogia marmorarius*. The Ravello pulpit is the only surviving work signed by Nicola of Foggia. It combines an unusual technique of mosaic production with an innovative style of sculpture associated with the workshops of Frederick II in Apulia and Nicola Pisano.[53] Nicola Rufolo presumably

encountered works by these artists in his capacity as financial administrator under Frederick II, Manfred, and Charles I. Following the dissolution of the Foggia workshop in 1250 or 1266 (the years of Frederick II's and Manfred's deaths, respectively; the precise date of its dissolution is unclear), he was able to lure Nicola of Foggia to Ravello. The sculptor then worked on various Angevin building campaigns, including Santa Maria di Realvalle in Scafati in 1274, the Cistercian monastery founded by Charles I to commemorate his victory over Manfred at Benevento.[54] Although some carved capitals and consoles from the castles of Lucera and Lagopesole relate closely to parts of the Rufolo pulpit and thus can be attributed to Nicola, the pulpit is the only freestanding work of his that survives.

Seven years later, Matteo Rufolo followed his father's example with the commission of the ciborium for the main altar of the church. This work also records the date of the monument, 1279, the artist's name, *Matheus de Narnia*, and incorporates sculpture with figurative and abstract mosaics. This artist's known output is limited to the Rufolo ciborium and a marble relief of Jonah, now lost, from the Cathedral of Caiazzo in northcentral Campania.[55] Because the Caiazzo piece was commissioned by a bishop from Narni, the inscription's otherwise ambiguous "de Narnia" suggests an Umbrian provenance for Matteo.[56] Like the pulpit, the ciborium would have asserted the family's presence in the church both textually and physically, centered as it was along the main axis of the building at its liturgical heart.

The pulpit's ties to imperial culture have lent it particular prestige in the canon of late medieval sculpture, and consequently it is the most studied of the works commissioned by the Rufolo family.[57] This scholarly interest never carried over to the ciborium, however, which with few exceptions is not mentioned in art historical discussions of the region. Its obscurity stems in part from its condition, for the work was dismantled in 1773 and many of its pieces subsequently dispersed, stolen, or lost.[58] Surviving components are currently displayed in Ravello's Museo del Duomo (Fig. 55), established in 1984 in the crypt of the church, as are a few pieces of the pulpit. (Figure 56 presents a hypothetical reconstruction of the ciborium.)

The Rufolo pulpit is an imposing and modernized version of the Rogadeo ambo it faces, for its elevated platform defined the hallmark of pulpit design after ca. 1170.[59] For example, the platform of the pulpit in the Cathedral of Salerno commissioned by the archbishop of Salerno Nicola Ajello (Fig. 57), rests on flat architraves (ca. 1182–94), as does the Rufolo work. Most other examples

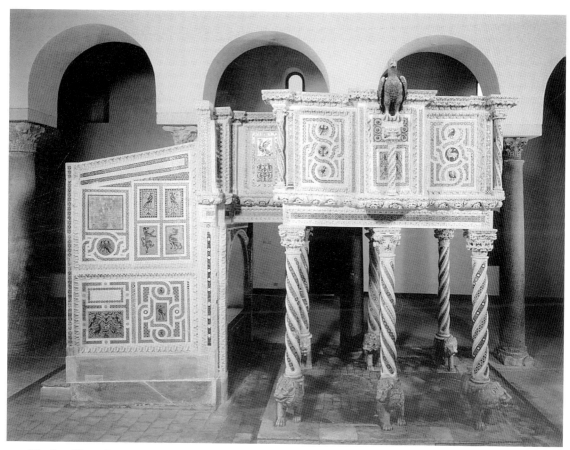

54. Nicola of Bartolomeo of Foggia, pulpit, Cathedral of Ravello, 1272 (Archivio Luciano Pedicini).

(such as San Giovanni del Toro in Ravello, Cathedrals of Canosa, Cava, Cugnoli, Moscufo, and Sessa Aurunca) rest on archivolts.

The six twisting columns supporting the platform of the Rufolo pulpit spring from lion bases of novel ferocity and naturalism in southern Italian sculpture, as each is individuated in some way (Fig. 58). The naturalism of these cats is remarkable: they growl and prowl and tug in different directions; male and female lions are rendered in anatomical detail; each has a slightly different coif (but, rather oddly, lions and lionesses have full manes). Most of the column bases and fillets are carved from the same pieces of marble as the lions themselves. In one case, a carved collar and chain harness a lioness to the column base.

The capitals also demonstrate the bold elegance of Nicola of Foggia's work. Each presents a Corinthian profile, rendered with a variety of flora and fauna.

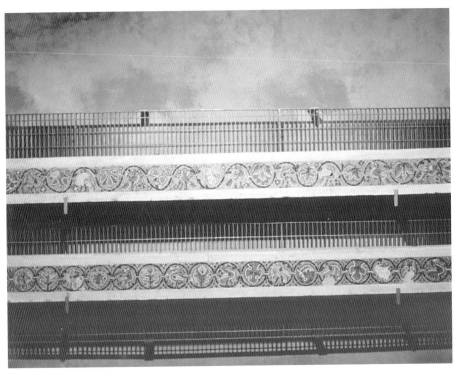

55. Matteo of Narni, beams of dismantled ciborium, Cathedral of Ravello, Museo, 1279.

These include exuberant twisting and turning morning-glory-like leaves on one capital, and curling foliage resembling kale on another (Figs. 59 and 60). These capitals are the parts of the pulpit that show the greatest association with earlier and later works attributed to Nicola of Foggia in Lucera, Lagopesole, and Scafati.

The protruding lectern desk is borne by a lively eagle that is elevated on a column; its talons clutch the Book of John.[60] Less conventional images include two profile busts in relief, located in the spandrels of the trefoil portal at the stairs, and formerly above that door, the bust of a braided and bejeweled woman ("Sigilgaita?" "Ecclesia?" Discussed later). Significant differences between the principal sculpture (capitals, reliefs, bust) and secondary ornament (some cornices, sea monsters of the niche spandrels) indicate that Nicola was assisted by less skillful hands.

Colorful abstract and figurative mosaics cover the vertical surfaces that are not carved. Many of the intessellated motifs were widely diffused in liturgical furniture as early as 1120, including the star-filled bands of gold, black, and red glass tesserae that wrap around the columns and the swirling, intersecting

"drive-belt" designs. The same is true of the mosaics' symbolic figures, such as the peacocks assembled around a fountain[61] and the sea monster now displayed in the Museo.[62] Explicit Incarnation imagery consists of Agnus Dei tondi (one placed on the upper level next to the lectern, another likely on an altar once located in the niche cut into the pulpit stairs), a lost mosaic of Christ in Majesty that possibly occupied that niche, and the Virgin and Child tondo on the west side of the platform facing the cathedral entrance (Fig. 61). An unprecedented subject in southern Italian pulpit decoration, this half-length representation of Mary with Jesus cradled in her right arm is extraordinarily detailed; tiny white tesserae highlight the bone structure of hands and feet, and tiny red ones animate round applelike cheeks. Its pictorial character vividly contrasts with the rigid symmetry, ancient and symbolic forms, and larger tesserae of the Rogadeo ambo on the other side of the nave.

The niche on the ground level of the pulpit was the focus of particular artistic and devotional energy. After the death of Nicola Rufolo in 1287, Matteo, Orso, Iacopo, and Mauro endowed a funerary chapel for their father on this site.[63]

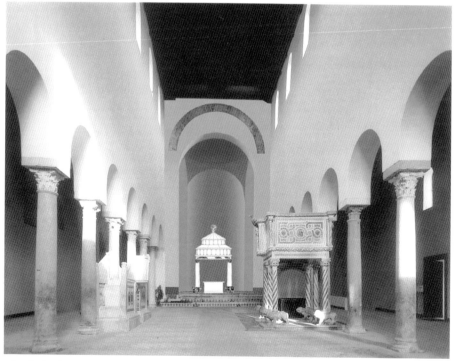

56. Cathedral of Ravello, interior, with hypothetical reconstruction of the Rufolo ciborium (Archivio Luciano Pedicini and Danielle Lam-Kulczak).

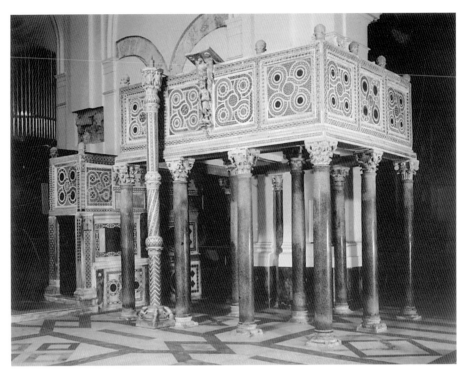

57. Large pulpit (or d'Ajello pulpit), Cathedral of Salerno, ca. 1182–94 (Archivio Luciano Pedicini).

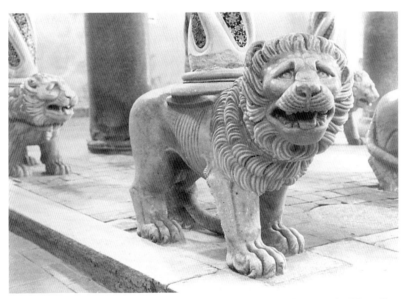

58. Nicola of Foggia, lion column bases, Rufolo pulpit, Cathedral of Ravello, 1272.

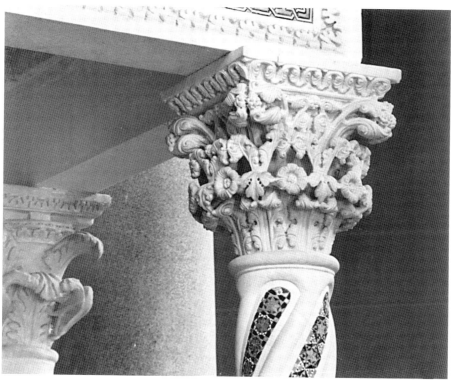

59. Nicola of Foggia, capital, Rufolo pulpit, Cathedral of Ravello, 1272.

Funerary rites took place there as late as 1392, when Mitula Rufolo stipulated in her will that masses should be sung at the "altar of the lectern" for her soul as well as those of her parents.[64] This placement within the structure of the pulpit adopts the format used by Constantine Rogadeo in his ambo across the nave, although the elevated Rufolo pulpit rises to twice the height of the ambo and creates an inhabitable space for the chapel. The fact that the chapel was established for a layperson breaks with that precedent established by and for episcopal authority.

Although the chapel niche no longer contains its original decoration, surviving textual and graphic evidence facilitates a hypothetical reconstruction of its original configuration and effect. The form of the altar is visible in an engraving printed in the 1890s but based on a drawing made by Edmond Paulin around 1876[65] (Fig. 62). Constructed of marble and mosaic, the altar presents imagery details found elsewhere on the pulpit, including the intessellated peacock, star motifs, and central Agnus Dei. Its deeply undercut cornices also echo those found on the structure of the pulpit.

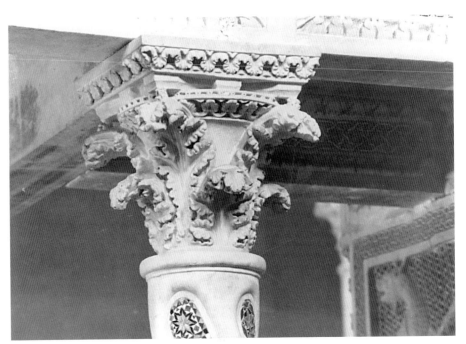

60. Nicola of Foggia, capital, Rufolo pulpit, Cathedral of Ravello, 1272.

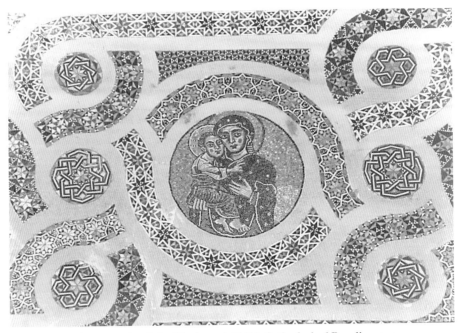

61. Rufolo pulpit, mosaic of the Virgin and Child, Cathedral of Ravello, 1272.

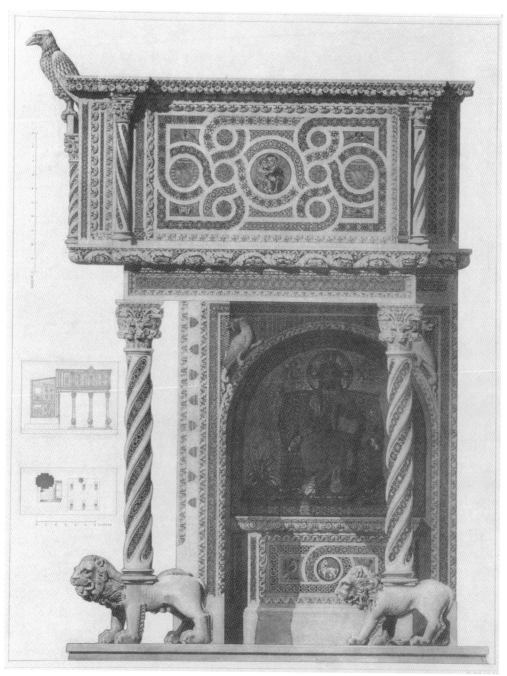

62. Edmond Jean Baptiste Paulin, engraving of the Rufolo pulpit after a drawing of ca. 1876. From Hector d'Espouy, *Fragments d'architecture du Moyen Âge et de la Renaissance* (Paris, ca. 1897). The Thomas Fisher Rare Book Library, University of Toronto.

The decoration of the niche is also visible in the same engraving. An enthroned Christ in Majesty offers the sign of benediction. This imposing image would have resonated not only with canonical apse imagery familiar from Early Christian Rome through the Desiderian *renovatio*; it also would have resembled the lost apse mosaic in the nearby Cathedral of Amalfi (before 1210; possibly as early as 1050).[66] This print image remains equivocal, for it is the only surviving evidence of this decoration. But it is a far more likely and historically plausible image to inhabit that space than the heavily repainted fourteenth-century altarpiece of the Virgin that was trimmed to fit in the niche. This altarpiece postdates the heyday of Rufolo patronage in Ravello and disappeared in 1974.[67]

The endowment for Nicola's funerary chapel lists various liturgical objects to be used there, including a gilded chalice and censor, vestments, and textiles for an altar.[68] These works, the very vehicles of eucharistic celebration, would have further affiliated the small space and the sacraments enacted in it with the Rufolo family.

Reconstructing the original form of the dismantled ciborium and contextualizing its sculpture are vexing processes. Significant pieces have been lost or stolen. No medieval documents in the Amalfi-Cava corpus refer to the work, and the principal sixteenth-century sources are uncharacteristically vague about its form.[69] The earliest detailed account, Francesco Pansa's *Istoria dell'antica Repubblica d'Amalfi* (1724), provides the logical starting point for a reconstruction;[70] it describes the widespread "cage" ciborium type seen in such churches as San Nicola in Bari and the Cathedral of Anagni, dated ca. 1130 and 1250, respectively. But Pansa also claimed that the Rufolo work incorporated symbols of the evangelists, a detail that would have set it apart from such canonical ciborium designs.

The largest fragments of the ciborium consist of four architraves, the four capitals that supported them, and three evangelist symbols. The architraves, which bear mosaic decoration and the dedicatory inscription, are the most straightforward components of the monument (see Fig. 55). Long and narrow horizontal bands of tesserae remain in three of the pieces; traces of impasto line the fourth.[71] The flora and fauna represented on the beams replicate some of those found on the pulpit. Considering these formal and other technical overlaps, the intessellation on both works can be attributed to the same workshop, as discussed later. Hence, the inscribed date of 1279 is reasonable for the ciborium's mosaics.

The same chronology does not apply to the sculpture, however. The capitals and evangelist symbols neither relate easily to 1279 nor define a stylistically

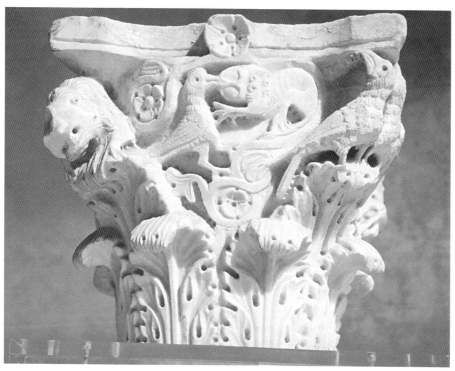

63. Matteo of Narni, capital of dismantled Rufolo ciborium, Cathedral of Ravello, 1279.

coherent group. The two historiated capitals, for instance – one in the Museo and the other formerly in the sacristy – differ fundamentally, as do their two Corinthian counterparts and the symbols of the evangelists.[72]

The historiated Museo capital follows Corinthian prototypes (Fig. 63). A lion preying on a delicate deer articulates one volute; the heads of two small birds touch to create another, and the bodies of two oxen converge in a single broad head to mark a third. Delicately carved figures in low relief, including a bird, rodent, plant stems, and flowers, dance across the upper registers of the bell.[73] The smooth, delicate flowers and bicorporal motifs closely resemble the capitals of the Bove pulpit in the church of San Giovanni del Toro in Ravello, which Glass and others have dated on the basis of style to ca. 1230.

Human activity sprouts from the wide, thick acanthus leaves of the historiated capital that embellished the arched entrance to the sacristy until a restoration in the late 1990s[74] (Fig. 64). It features an archer, a traveler or pilgrim carrying his effects over his shoulder, and volutes shaped of telamone figures. Possibly representing labors of the months, the squat characters and broad foliage of this work lack the delicacy of the Museo piece and instead resemble capitals in the

64. Capitals of the dismantled Rufolo ciborium, formerly in the sacristy of the Cathedral of Ravello.

Cathedral of Amalfi and Toronto that have been dated on the basis of style to the early thirteenth century.[75] The simplified, bare forms of the sacristy Corinthian capital likewise contrast with the more refined Museo example.

Like the capitals, the symbols of the Evangelists do not define a stylistically homogeneous group. Now in the Museo, the eagle of St. John is rigid and symmetrical, measuring roughly sixty centimeters high. Its feathers are carved in flat, uniform U shapes identical to those on the birds of the Museo capital, as if the same sculptor magnified that motif that worked well on a smaller scale. The same uniformity and low relief also characterize the Agnus Dei set within an intessellated circular frame that crowned the ciborium.[76] The eagle and Agnus Dei recall stylistic currents of the early and mid–thirteenth century.[77]

The winged ox of St. Luke and lion of St. Mark were affixed to a fountain in Ravello before they were stolen in 1975[78] (Fig. 65). The stocky animals are highly stylized: an economical grid of deep incisions articulates the lion's paws, knuckles, and claws; parallel incisions and raised clefts define the ox's rippling brow and jowl. The creatures are more akin stylistically to the animate column bases of the portals of San Nicola in Bari (ca. 1110) and Sessa Aurunca (early thirteenth century) than to the dynamic lions of the Rufolo pulpit.

The up-to-date mosaics of the architraves, stylized features of the evangelist symbols, filigreelike delicacy of some capitals, and awkwardness of others advise dates ranging from the early twelfth century through the 1270s. These inconsistencies indicate that the ciborium was not constructed *ex novo* by Matteo of Narni in 1279 but was assembled at that point out of new and recycled materials.

It is likely that the eagle of St. John and Museo zoomorphic capital were among the newly crafted materials. Despite their older look, they share many features with the Agnus Dei, a work that must have been made expressly for this project. Perhaps Matteo fashioned a few new pieces as needed – this capital, symbol, and apex of the canopy supplemented the array of medieval *spolia* at hand. The archaizing style of the three pieces would not only have approximated the components that were manufactured earlier, but also would have articulated the presence and power of the Rufolos in significant ways, as explored subsequently.

The symbols and Pansa's unusual placement of them must still be resolved. It is more likely that the ox and lion rested at ground level, rather than on the architraves or columns, where a recent reconstruction based on Pansa placed them.[79] Stone carvings as large as the Fontana ox and lion, if situated at or above

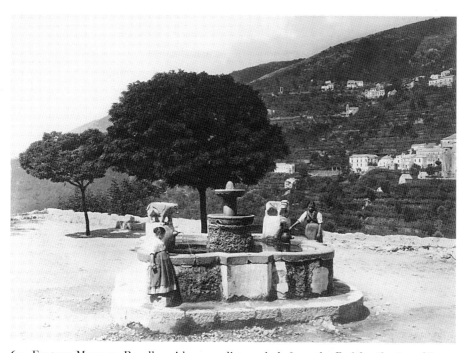

65. Fontana Moresca, Ravello, with evangelist symbols from the Rufolo ciborium (Copyright Alinari/Art Resource, NY).

the level of the capitals, would have created a structural hazard; not surprisingly, this composition is without precedent among extant Italian ciboria in marble.[80] Other locations for the symbols should be considered, such as at floor level, where they likely functioned as column bases (see Fig. 56).

Such configurations were of course the mainstay of portal design in Italy from the eleventh through the fourteenth centuries. A mid-nineteenth-century description of the Ravello fountain from which the ox and lion disappeared supports this hypothesis; it describes the backs of the two beasts as leveled so as to anchor columns.[81] Perhaps the smaller and presumably biped evangelist figures, the eagle and the lost angel of Matthew, were elevated. Such a composition would reconcile structural logic with Pansa's vexing description. It would also create a configuration akin to conventional *Maiestas domini* imagery found throughout the medieval West, from Carolingian illuminations to the façade of Angoulême, the tympana of Moissac and Tuscania, and, closer to Ravello, the apse of Sant'Angelo in Formis. In the case of the ciborium, however, such imagery would derive its significance and power from the three-dimensional space that the monument defined and enclosed. The elevation of the host within that space would complete and thus activate the imagery, creating a dynamic representation of the godhead at the focal point of the nave's longitudinal axis.

Mosaics and the Material Culture of Mercatantia

While the sculptural styles of the ciborium and pulpit have little in common, the mosaics of both monuments illustrate one of the most unusual characteristics of vertical mosaics around Amalfi, the use of glazed ceramics.[82] Ceramics were produced locally for intessellation or architectural ornament, as in the upper registers of the bell tower of Amalfi[83] (see Fig. 7). But often the mosaics incorporate objects intended for quite another function: they contain fragments of plates, bowls, or other vessels made for holding food and drink. As portable objects imported and consumed in large numbers by the Amalfitans, they illustrate one way that *mercatantia* shaped the material and visual culture of the region.

Similar materials, forms, and motifs indicate that the same workshop created the mosaics of the Rufolo pulpit and ciborium. On the pulpit, large pieces of glazed turquoise-colored pottery accentuate certain parts of the composition, such as a peacock's tail, and interrupt the sea of small tesserae of gold, black, red, and blue glass. The designs of the ciborium closely follow the precedent of the pulpit, although their tessellation is naturally limited to the thin horizontal bands of the architraves in contrast to the broad panels of the pulpit. Rings of

thin black vines encircle birds and plants and roll along one beam; vines set in a wave pattern energize another.

On both works, images of birds proliferate and are rendered in the same economical but expressive way. Slender, rounded pieces of glazed maroon ceramics define their spindly legs and feet, thin white tesserae outline their chests and abdomens, and long, narrow bands of black and white articulate their feathers. Tiny round white pieces, drilled to hold lead or another type of colored material, represent eyes. Glazed tesserae provide bold splashes of color. On the Rufolo pulpit, the central feather of a bird's wing is a large glazed azure sherd (4 × 3 cm), while the stamen of a flower is a long thin maroon one.[84] A few azure pieces contain thin black lines, indicating that the tesserae were pieces of decorated bowls possibly from Syria or Iran[85] (Fig. 66).

Earlier monuments in Ravello, including the Rogadeo ambo in the cathedral and the Bove pulpit in San Giovanni del Toro, also used pieces of glazed pottery, but not in the same manner. In the case of the ambo (dated before 1150), the curvilinear forms of the "great fish" and Jonah are rendered in small tesserae of Islamic manufacture. Many are lustreware, a type of twice-fired pottery that takes on a metallic sheen.[86] Such tesserae show linear motifs, some of which are painted, others incised into the slip (hence the term sgraffiatoware), that vividly contrast with the final layer of metallic glaze (Fig. 67). These particular ceramics are probably of North African or Syrian provenance.[87] Their soft greenish brown and blue hues and discontinuous sgraffiato designs seem appropriate for this scaly, aquatic imagery. Contrastingly, the large oval-shaped tesserae capping the faux pilaster strips include discontinuous Arabic inscriptions and other linear patterns painted in copper luster, likely from bowls manufactured in western Syria around 1100[88] (Fig. 68). Surviving works from that region contain calligraphic and sgraffiato designs (Fig. 69).

Other architectural or abstract details, such as the figure-eight bands that encircle the polished disks of porphyry, are rendered with large tesserae of cut stone (measuring 3 to 4 square cm). Meanwhile the upper band of ornament that frames the Jonah panels consists of small ceramic and glass tesserae arranged in eight-point stars, the typical materials of vertical mosaics in Campania. The tesserae of the Rogadeo ambo offer a far greater range materials, colors, and textures than conventional mosaics produced in twelfth-century Rome and Palermo, where stone and glass predominate.

Large and small pieces of imported glazed ceramics appear on the Bove Pulpit in San Giovanni del Toro in Ravello (ca. 1230). Rather than creating discontinuous

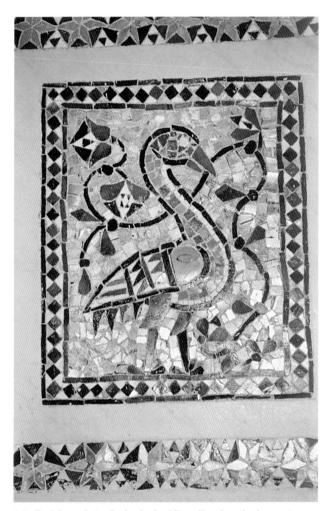

66. Rufolo pulpit, Cathedral of Ravello, detail of mosaics, 1272.

linear patterns, as with the incised designs and painted patterns of lusterware, here nearly whole bowls of Syrian, Iranian, and Egyptian manufacture form the centers of the quincunx patterns that are completed in glass and stone tesserae[89] (Fig. 70; see also Fig. 42). One cobalt piece that is molded in low relief calls to mind similar stamped vessels manufactured in Seljuk Iran from the early 1100s until the Mongolian invasion of 1258.[90] Some of the Arabic inscriptions on these bowls are legible; one early-thirteenth-century bowl from Damascus reads *al-baraka*, or blessing. Although the use of almost complete bowls in liturgical furnishings is extremely rare,[91] it has an analogue in architecture: many façades and bell

towers of medieval churches in central and northern Italy display Islamic bowls
or *bacini*, with Pisa having the highest concentration of them.[92]

When placed on church façades or bell towers, such *bacini* were effectively
out of sight. Details such as Arabic inscriptions could not be discerned or read,
as with the bowls at SS. Giovanni e Paolo in Rome that read *al-yumn* (good
luck) six times on one example, twenty-six times on another.[93] On the Bove
pulpit, however, the low placement of the bowls ensures their accessibility. Their
designs and inscriptions can be inspected from the ground and from the elevated
lectern. In contrast, the mosaicists of the Rufolo monuments did not implement
this presentational aesthetic; rather, they used glazed ceramics selectively, as
colorful and dramatic accents that illustrate their sensitivity to the expressive
potential of polychromy and polymaterial.

The tableware displayed on the Rogadeo, Bove, and Rufolo monuments was
imported in large quantities during the twelfth and thirteenth centuries. As is
the case of the Pisan *bacini*, the ceramics effectively chart Amalfitan commer-
cial activities in the Middle East and North Africa, offering tangible evidence of

67. Ambo, Cathedral of Ravello, before 1150, detail of lustreware and sgraffiato tesserae
of Jonah's great fish.

68. Ambo, Cathedral of Ravello, before 1150, detail of lustreware tesserae with Arabic inscriptions.

the effects of long-distance trade on local material culture. Amalfitan sites have yielded a higher proportion of Islamic pottery than has been found at other excavations down the coast at Velia, Capaccio, and the Castle of Salerno,[94] suggesting that the taste of the Amalfitans differed from their neighbors and was shaped by *mercatantia* in cities such as Tunis, Cairo, and Acre.

The ceramics signal a new approach to pulpit design that differentiates the Ravello monuments from their antecedents and contemporaries. Rather than employing serpentine, porphyry, and other marbles redolent of imperial and papal authority – the typical materials of liturgical furnishings, from Rome

69. Two lustreware bowls from western Syria, early twelfth century. Calligraphic designs (top), and sgraffiato patterns (bottom). Royal Ontario Museum, Toronto, 960.219.3 and 960.219.2. With permission of the Royal Ontario Museum © ROM.

70. Bove pulpit, San Giovanni del Toro, Ravello, ca. 1230, detail of Islamic *bacini*.

and San Menna to Palermo and Sessa Aurunca – the Ravello works embrace newer, more fragile materials, ones that represent the experiences of Amalfitan merchants abroad. Whereas other pulpits in Campania, including those in Sessa and Cava, use glazed tesserae, they do not incorporate the patterns, nearly complete bowls, fragmented inscriptions, relief moldings, or color variations that lend the Ravellese works their distinctiveness. Hence on some level, the *bacini* create a more apt and specific association than the older marbles and techniques were able to do.

The presence of pseudo-Arabic in a wall painting near Scala throws some light on the Ravello mosaics. These scenes from the life of St. Nicholas are in the crypt of SS. Annunziata in Minuto and date from around 1200[95] (Fig. 71; see also Fig. 6B). The patron saint of seafarers, Nicholas was revered throughout the South, and particularly so in Amalfi's commerce-driven culture. The translation of his relics to Bari in 1087 further fueled this cult, as countless representations of the saint in Amalfitan paintings and sculpture indicate well through the Baroque era.

In the Minuto cycle, the young boy Adeodatus has been kidnapped and enslaved to a Saracen king (king of the Agarenes in some sources, a sultan in

others).[96] Nicholas finds him in a luxurious dining room, where the boy holds a ceramic ewer ornamented with pseudo-Arabic inscriptions. Sumptuous textiles cover the curved table of the king. Carried home to his grateful parents by Nicholas, Adeodatus returns to what Bergman characterizes as a Christian banquet: it takes place at an altar-shaped table over which three monks preside.

The outlines of this story and the Muslim-Christian contrasts invented by the painters suggest a discomfort with and disapproval of the material trappings of Islamic culture. These glazed ewers and textiles were the desirable imports of *mercatantia*, as literary and archival references and archaeological finds make clear. In this case, however, the painters portrayed them as embodiments of Islam as an indolent, exploitative culture and incorrect faith. The Bove pulpit *bacini* work within this representational discourse. Here the attractive products of Islamic craftsmen have been neutralized: they are no longer part of a literal banquet, where the painters of the Adeodatus scene might have imagined them being used; rather, they are translated into a Christian setting, a liturgical reenactment

71. The kidnapped Adeodatus attending the sultan's table, crypt of SS. Annunziata, Minuto, ca. 1200.

of the holiest meal. But they are not only trophic. Their rendered texts replicate visually the words of the priest reading scripture behind them, and in the case of the *al-baraka* inscription, the meaning of the Arabic is consonant with the sacred Latin utterances of the mass.

In the Ravello mosaics, *bacini* added bright colors, reflective surfaces, and convex or concave forms to fields of green, red, black, gold, and white rectangular tesserae. This sensible and sensitive use of *bacini* does not strip them of their ideological charge, however, or dilute their significance as commodities. It is important to recall that this pottery was imported in significant quantities and used first and foremost as household objects. Glazed ceramics constituted one of the first widely available commodities in southern Italy that embellished the domestic environment. They were portable symbols of prosperity and its impact on quotidian existence, as well as signs of the promise and temptations of distant markets.

Modes of (Self)-Representation

Along with the liturgical instruments donated to the cathedral in 1287 and the pavement of the crypt of unknown date, the pulpit and ciborium evoke the presence of the Rufolo family in a variety of ways. First, the monuments were the largest yet constructed in the church; these physical products of patronage thus shaped and divided the space and framed its essential liturgical activities. Second, the pulpit and ciborium employ varied forms and visual cues to assert the presence of the Rufolo family in the heart of the cathedral interior. These strategies of self-representation, in conjunction with the imposing stature of the monuments, reiterated the family's presence in the church interior. Some of these modes, such as the use of long dedicatory inscriptions, are firmly rooted in the culture of *mercatantia*. In contrast, a second type of self-representation, heraldry, derived from northern contexts. The appearance of heraldry in Ravello illuminates the complex negotiations of cross-cultural exchange – that is, transmission from the courtly centers of northern Europe to the Mediterranean context of *mercatantia*. Finally, the styles of the pulpit and ciborium contributed to the prestige of the works and thus helped assert the hegemony of the Rufolo family in this episcopal space.

Examining each of these persuasive modes of representation will underscore how the family's authority was articulated and how the culture of *mercatantia* shaped each visual strategy.

INSCRIPTIONS. In addition to providing essential information regarding the pa-
tron, artist, and date of each monument, the long dedicatory inscriptions on the
Rufolo commissions are the only places where the family speaks for itself and
about itself. However carefully composed, the texts reveal some semblance of the
family's inner life – its pious practices and preferences, for example, in contrast
to its outer, public face defined by itineraries of port inspections or contents of
commercial ships. The inscriptions also anchor the family within the culture of
mercatantia and its conventions of textual self-representation.

The dedication text of the pulpit is inscribed on stones painted with a porphyry
tint.[97] The pieces contrast with the rest of the structure's polished white marble
and colorful mosaics and are made even more visually distinct by the intessellated
frames that wrap around them. The panels are placed on the wall of the pulpit
base that faces the nave. Unlike the many monumental inscriptions from the
later Middle Ages that appear at lofty heights or do not stand out from their
background, care was taken in this case to render the pulpit inscriptions legible
to visitors to the church. The upper panel reads:

> For the love of the virgin, Nicola Rufolo,
> Sigilgaita's man, dedicated this work for the honor of his *patria*.
> Of them was born Matteo, Orso, Iacopo too
> and Mauro. Lorenzo was born of the first named.
> May this please you, pious Virgin, and pray that your son
> will grant to them the same heavenly gifts.
> When a thousand two hundred twice thirty and thrice six full
> years have elapsed
> since the birth of Christ.

And on the lower slab:

> I master Nicola of Bartolomeo of Foggia marbleworker made
> this work.[98]

First and foremost, the inscription underlines Nicola's interwoven pieties: to the
Virgin, an appropriate subject of veneration in this cathedral dedicated to the
Assumption; to his *patria*, Ravello itself, where he enjoyed significant social status
and political distinction;[99] and finally, to his family, including his wife, sons, and
grandson. With its personal, entreating tone, the text resembles a private prayer for
the Virgin's protection, although here Nicola's prayer is not uttered and fleeting,
but incised in stone and permanent. His hopeful appeal now reads as ominous

or even pitiable, as we know that he lived to see the arrests of his son and in-laws and the execution of his grandson Lorenzo in 1283.

The inscription's invocation of *patria*, as distinct from *Regno*, is suggestive of the dichotomy between local and royal culture in the South of the later Middle Ages. Nicola, a well-traveled banker and member of the kingdom's elite administration, chose in this public and permanent statement to align himself with Ravello and its inhabitants alone, not with, say, Ravello *and* the political entity that he served. Whether this omission hints of ambivalence toward Angevin rule in the South cannot be determined, although it suggests the preeminence of the local in Nicola's constructed public face.

The ciborium dedication was less accessible and legible. The text is longer than the pulpit's, and its small letters are cut into a white marble architrave that would have towered several meters above the floor level of the church. It reads:

> Matteo Rufolo ordered this work made in honor of the Virgin and her son, and for the adornment of his *patria*. To him, the lord, whose wife is Anna, let these be grateful. Lorenzo, their first in order of birth, Bartolomeo is here, to none second in probity; Simone, and younger than they are Francesco, pure of crime. These are the children of the first born: Nicoletta, Giovanni, Matteo, and the boy Orso, whose bodies you not damn. Here follows a third Matteo, Simone's son; may he follow his grandfather, blessed in fame and in life. All these do you Lord on high, with fatherly affection for much time save, defend, and guide. In the thousandth two hundred and seventieth year, to these add nine. Master Matteo of Narni made this work.[100]

The ciborium inscription offers a more intimate portrait of the family. Not only does the text capture the larger size of the clan, but it conveys some sense of the individuals who comprised it. Bartolomeo's integrity comes to the fore, for example, and Matteo acknowledges his public stature when he wishes his namesake the same good fortune and fame that he had enjoyed. Also significant is the fact that the focus of Rufolo piety has shifted from Mary to God. Although Mary is named at the beginning of the text, perhaps in recognition of the cathedral's dedication, God is repeatedly evoked as the benevolent father who presides over the large brood of humanity. Matteo, similarly in the guise of concerned *pater*, wishes God to defend and guide his progeny. The inscription mentions the

patron's desire for his family's salvation, to be sure, but worldly concerns also flow through the pious text.

Given the fact that dedications were commonplace on medieval works of art throughout the Mediterranean world, perhaps this appearance of long inscriptions is not surprising. But the Amalfitan inscriptions draw on conventions of patronal self-representation rooted in the art of *mercatantia* and are distinctive in their pronounced genealogical content.

These dedications can be characterized in two ways. Some are relatively short texts that give credit to the donor, as in the case of the bronze doors of Amalfi (ca. 1061). Two inscriptions divulge the patron's name and intent.[101] First, in large letters, in one line across both valves of the door, "This work stands in mindful honor of [Saint] Andrew, the result of the efforts of Pantaleo, so that for his deeds grace may follow his sins"; and second, in small letters inscribed within a cross, "This work was done at the behest of Pantaleo, the son of Maurus, the son of Pantaleone, the son of Maurus, the son of Mauro *comes*, for the redemption of his soul"[102] (see Fig. 3). A later and less expansive version of this type of inscription appears on a chancel screen fragment from San Giovanni del Toro in Ravello (ca. 1250). This intessellated marble work contains an inscription that states, "[name lost] son of Filippo Freccia had [this made] for the honor of God and St. John."[103]

Other inscription types directly engage the reader. They may call on God or the Virgin to remember them; the reader of the text, who deciphers the very words that were directed toward the heavens, is effectively asked to do the same. Sergio Muscettola's bronze doors (dated 1179) at the Cathedral of Ravello belong to this category: "Remember Lord your servant Sergio Muscettola and his wife Sigilgaita and his sons Mauro and Giovanni and his daughter Anna, because he had this door made for the honor of God and the holy Virgin Mary"[104] (see Fig. 52). Others, like the Rufolo commissions, are more interactive still, divulging personal reasons for the commission and eliciting a prayer or another emotional response from the reader – sympathy, empathy, even disapproval, disgust, and so on. Thus in the case of the ivory Farfa Casket, commissioned by Maurus Comite for Monte Cassino or Farfa around 1070:

> Receive this modest box fit for a divine cult
> And given devoutly by your servants.
> We beseech that our names be known to you always.
> Nevertheless, a healthy sense of caution made us have them
> written here.

> I am rightly called Maurus because I have followed sin.
> My sons follow me, John with Pantaleone, Sergio and Manso,
> Maurus and also their brother Pardo. Given pardon for the
> crimes and offer the crown of heaven.[105]

The inscription on the ivory rivals the Rufolos' in its length and personal character. Still, Matteo Rufolo's text on the ciborium constitutes the longest dedicatory inscription among extant examples of Amalfitan art.

The Rufolo inscriptions suggest a marriage of two traditions, one rooted in the prominent culture of *mercatantia*, as the antecedents discussed earlier suggest, and the other in erudite monasticism. The rhymed dedication of the pulpit in particular reveals the vitality of the literary *Latinitas* that was revived at Monte Cassino under Desiderius.[106] In emulating Constantinian practices, Desiderius's new church was brimming with monumental, rhymed inscriptions, verses that have been attributed to Alphanus, who studied at Monte Cassino and was archbishop of Salerno from 1058 until his death in 1085.[107] Cassinese-influenced churches of southwest Italy, such as St. Mennas in Sant'Agata de' Goti near Benevento (dated ca. 1100) and Alphanus's own Cathedral of Salerno (consecrated in 1085) contain verse inscriptions in monumental scale. Such churches also likely informed the rhymed text on Constantine Rogadeo's ambo in the Cathedral of Ravello, completed before 1150.[108]

In the region of Amalfi, this monastic literary culture encountered and reinforced the literate culture of *mercatantia*. Amalfi's affinity for text is visible not only in the dedicatory inscriptions on works of art discussed earlier, but also in the language and scale of curial documents. The inscribed "prayers" of Nicola and Matteo for the well-being of three generations of their families recall the region's unique scribal tradition that recorded the genealogies of signatories. From the year 1000 through the fourteenth century, these extended genealogies graced Amalfitan documents, which were of unusually large size or monumentalized. With the marked repetition of first names and the rarity of surnames in the earlier period, some genealogical identification was necessary to guarantee the legal authority of the documents. The ancestral lists, however, some of which extend over nine generations, exceed the requirements of legal clarity and suggest that other dynamics, born of *mercatantia* and its unusual circumstances, were at play.

As previously discussed, the genealogical specificity that was part of contractual language was in part a product of the fragmentation of Amalfitan merchant families. Genealogy functioned to define individuals as members of old and

prestigious clans, even if they resided in Constantinople, Cairo, Barletta, or Naples and therefore were not familiar to the denizens of the coast.[109] The fact that many of these merchants lived and worked with Jews and Muslims, whose conventions of naming involved similar genealogical specificity, may also have informed this Amalfitan practice.[110]

Unlike many merchant families of the preceding centuries, the Rufolos were not residing in Amalfitan colonies in the eastern Mediterranean. But in the 1260s, 1270s, and early 1280s, they too were dispersed across the kingdom and affiliated ports. It is unlikely that the adults named in the cathedral inscriptions spent long periods of time together in their *patria*; the inscriptions thus evoke the presence of those who were largely absent and place them within the larger setting of the powerful clan.

The genealogical interests of the Amalfitans have also been interpreted as part of the efforts of elite scribes to articulate and preserve their prestige. Just as generations of Americans have boasted of ancestors aboard the *Mayflower* to claim social distinction, so the descendants of Amalfi's first comital elite actively sought to express their status through these legal documents. Given this rationale behind genealogical interest, the language of the Rufolo dedications is telling: both Nicola's and Matteo's family trees extend into the future, not into the past, thus revealing the family's "nouveau" status as part of the second Amalfitan aristocracy. This emphasis on the younger generations is most apparent in Matteo's text, which does not mention his father Nicola, who commissioned the first work of the liturgical ensemble and was still living in 1279.

Although the inscriptions on the Rufolo monuments have many features in common with texts that came before them in monastic or Amalfitan circles, one characteristic of them was unprecedented: their site. Most monuments representative of the art of *mercatantia* were placed in the conventional settings of Amalfitan lay patronage: in the interior of private churches, as with the Freccia chancel screen; in the exterior or peripheral zones of cathedrals, as with the bronze doors; or, less often, in monastic environments, as was probably the case with the Farfa casket. By contrast, the Rufolo monuments express the family's extended prayers, hopes, and genealogy in monumental form and place them at the center of episcopal space. As such, the texts literally inscribe the family within the church's liturgical proceedings.

HERALDRY. Other visual tools worked in tandem with the inscriptions to mark the cathedral as the Rufolos' own. Whereas the family's use of monumental

inscriptions was deeply rooted in Amalfitan patronal conventions, their implementation of another mode of self-representation, heraldry, was decidedly new. Appearing in multiple locations in the cathedral interior, the Rufolo shield presents three gold fleur-de-lis along its top band and six diagonal stripes, alternating gold and blue, occupying its lower two-thirds. The Rufolo armorials are the earliest extant family arms on the Amalfi coast. It is possible that the d'Afflittos developed a coat of arms before the Rufolos for display, say, on their pulpit in Sant'Eustachio (dated ca. 1230); Bolvito noted that the church contained many family *insegnie*. However, the precise date of these devices cannot be determined because Bolvito did not specify where they were located and so little remains of the original environment.[111]

The Rufolos' use of these novel forms was ambitious and thorough, and not, as one might expect in a groundbreaking project, tentative. The episcopal space was literally saturated with their arms, which are or were displayed in abundance and in visually prominent locations: in two large mosaics set within roundels on the side of the pulpit platform facing the entrance to the church (Fig. 72); in eight mosaic inserts along the white marble pilaster strip to the left of the altar niche, also facing the entrance of the church;[112] in mosaics placed along the architrave of the ciborium that overlooked the central axis of the nave; in images of unspecified material covering the pavement in the spacious cathedral crypt; and after 1287, on the altar cloth and the chasuble of the officiating priest, the embellishments of masses said in the name of Nicola Rufolo.[113]

These unprecedented images mark the absorption of a colorful, northern European mode of display into the region's visual vocabulary. Heraldry, an elaboration of such dynastic emblems as the lily for the French crown, castle for the Castilians, or eagle for the German emperors, spread rapidly in the twelfth century and flourished in a variety of media and scales – witness the champlevé tomb plaque of Geoffrey of Anjou now in Le Mans (ca. 1158), the stained glass of the Sainte-Chapelle in Paris (ded. 1248), or the nave arcade of Westminster Abbey in London (ca. 1260).[114] This shield form derives from military contexts of battle and tournament, where the easy legibility of symbols of alliance was essential for strategy and survival. By the later Middle Ages, shields without an actual military function were used in civic and clan systems of identification, through replication in official seals, placards on city gates, tombs, and so on.

Like the photographs of the U.S. president placed in American embassies all over the world, heraldic imagery is potent and not merely decorative; it designates the presence of power at sites remote from the sovereign's physical body.[115] But

72. Rufolo pulpit, detail of Rufolo heraldic devices, Cathedral of Ravello, 1272.

unlike official portraiture, heraldry distills that power to a schematic form that is easily replicable and never redundant. Its simple forms translate readily into most media, from stamped leather and struck coins to painted panels and monumental sculpture; its abstract and brightly colored forms, which can be quickly rendered, enliven and can take over any surface.

While the emergence and diffusion of heraldry in northern Europe has been the subject of numerous commendable studies, the same cannot be said of southern Italy.[116] This is in part because armorials for nonnoble families, episcopal sees, and towns were widespread north of the Alps by 1220 (along with the dispersion of the fleur-de-lis far beyond the Capetian family), but not in southern and even central Italy. Although personal emblems were used in the eleventh century, as equivocal remains at San Crisogono in Rome regarding the family of Desiderius of Monte Cassino may suggest,[117] the first papal seal to use heraldry belonged to Innocent IV, whose pontificate lasted from 1243 to 1254.[118] The 1280s and 1290s were decades of great heraldic invention and diffusion among Rome's papal and senatorial families.

Because the decades of Hohenstaufen rule in southern Italy and Sicily were free of imperial armorials,[119] the Angevin dynasty was the first in the *Regno* to

employ heraldry in a systematic way. Charles I disseminated this visual language through large- and small-scale works, many of which were designed for public consumption or display. Charles's widely circulated gold *reale* (1268) introduced armorials to the kingdom, with its shield and abundant stylized lilies or fleurs-de-lis.[120] The *reale* eloquently updated the South's currency. While it maintained the type of classicizing profile bust imprinted on Frederick II's *augustalis*, Charles substituted a cusped metal crown for the laurel of Frederick and added fashionable long hair and, on the obverse, ten fleurs-de-lis set on a shield, in contrast to the free-floating eagle symbol of the emperor's coin. Thus the Angevins, in seeking to legitimate their newly won sovereignty through visual and other modes of persuasion, appropriated some of their predecessors' signs of authority and then added the potent lily of the House of Capet (and by extension, of Anjou).[121]

Regnicoli who were unlikely to handle a gold *reale* might have encountered the lily on livestock, as animals belonging to the royal family were branded *ad florem de lisa*.[122] In more elite settings within and outside the kingdom, chancery seals on official documents also worked to disseminate Angevin armorials. The seal of Charles I, which depicts a knight on a galloping horse, similarly features lilies on armor, standard, and livery.[123]

Larger works of art were also emblazoned with arms and emblems to assert Angevin hegemony in this patently non-French land. In the newly christened City of Saint Mary, formerly the Muslim colony of Lucera that was defeated by the crown in 1300, a prominent Angevin shield provides a literal and figurative keystone to the portal of the church of San Francesco. Heraldry represents the presence and power of Charles II, the de facto crusader and patron of the new monastery and cathedral in a newly Christianized place.

From the textiles of elaborate court livery to royal tombs, Angevin armorials were displayed in multiples on many official and public representations or monuments.[124] This effort was most apparent and potent in the newly designated capital of the kingdom, Naples. The altarpiece of St. Louis of Toulouse (d. 1298), painted by Simone Martini soon after 1317 and now in Capodimonte, vividly demonstrates Angevin approaches to heraldry[125] (Fig. 73). Likely destined for a side chapel in Santa Chiara, the Clarissan monastery founded by Queen Sancia in 1310, the altarpiece commemorates the friar Louis, the designated heir of Charles II, who in the central image bestows upon his younger brother Robert the crown of kingship. The image thereby enshrines Robert's right to rule as well as Louis's saintly demeanor. The extraordinary variety and quantity of armorials displayed here work to reinforce the legitimacy of dynastic succession and

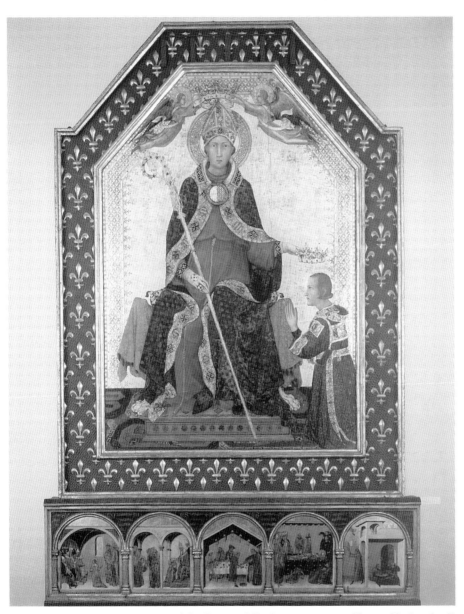

73. Simone Martini, altarpiece of St. Louis of Toulouse, ca. 1317. Museo Nazionale di Capodimonte, Naples. Copyright Scala/Art Resource, NY.

expansion. These include an abundance of the fleur-de-lis of the Houses of Anjou and Capet, including on the frame and back of the altarpiece, as well as the arms of Hungary, a new Angevin affiliate through Mary, the wife of Charles II, and Jerusalem. The imperial ambitions and accomplishments of the dynasty are thus summarized in this potent visual form.

Whether on unique works of art, such as Simone's altarpiece, or in serial manifestations, as with seals, coins, and cows, the Angevins enlisted heraldry to bolster their political and cultural authority. As part of a wider effort to subdue, rule, and govern this outpost of France from the increasingly metropolitan center of Naples, heraldry functioned as an assertion of hegemony in the visual realm.

The appearance of family armorials in Ravello so soon after the establishment of the Angevin Kingdom offers a reminder of the invented and artificial language of heraldry and provides an opportunity to examine its diffusion and implications. The Rufolo arms, apparently invented *ex novo* before 1272, work hard to assert the family's prestige: the line of lilies along the top of the shield and alternating gold and blue stripes below signify the family's allegiance to and affiliation with the new king from France. Significantly, however, this visualized affiliation with Charles I is through service, not bloodline. The years when the armorials were designed saw Nicola, Matteo, Orso, Iacopo, and Lorenzo Rufolo near the apex of their upward trajectory in the Angevin administration. Although no member of the family technically belonged to the feudal nobility, the coat of arms encapsulates their powerful status, both in the fact that the armorials were created at all and in the particular form that they take.[126]

One can imagine that the regal airs of the Rufolo coat of arms impressed fellow Ravellese and indeed prompted other families to create their own arms, but today these forms read as bittersweet. The Angevin symbols provide a glimpse of the increasingly fraught relationship between local and sovereign cultures. The varied assertions of authority emanating from the newly installed French court at Naples resembled in many ways imperialist enterprises of the modern era. One of the most consistent features of imperialism, as Said has argued, is its ability to erode traditional social ties defined by family.[127] Family identification or filiation is replaced with social identification or affiliation, generally with institutions or groups independent of the family or local community. Within the context of Amalfi and the Rufolos, this emergence of affiliation signals a step away from the Mediterranean art and culture of *mercatantia* and toward the Francophone authority of Naples. Subsequent generations of merchant patrons grappled with the relationship of local to metropolitan culture, as discussed subsequently.

The features of the Rufolo devices that evoke the sovereign House of Anjou (fleur-de-lis, blue, gold) define a type of affiliation and its resulting prestige. The specific placement of the devices within the Cathedral of Ravello creates a second context of affiliation. The shields on the elevated pulpit flank a mosaic of the Madonna and Child, and thus in modern heraldic language declare the Rufolos' devotion and spiritual proximity to the Virgin. This triptych signals another meaning for the fleur-de-lis, the lily associated with Mary. As a Marian symbol, the stylized flowers in the Rufolo coat of arms possibly reinforce the pulpit's dedicatory inscription, with its appeal to the Virgin as protector of the family and the dedication of the Cathedral of Ravello to the Assumption. Thus these multivocal lilies resonate with Mary, the cathedral space dedicated to her, the House of Capet and Anjou, and the Rufolo family, binding together all meanings into one potent and repeated motif.

The Rufolo armorials create a third context of affiliation, one that aligns the family with episcopal space, power, and holiness in an unprecedented and bold act. Heraldry asserts and enacts the family's hold over the church in various ways. The (Rufolos') Virgin and her protectant shields face the main portals of the church and thus welcome all entrants and comfort all believers. This ensemble of images also provides a physical and visual frame for the liturgical readings and ceremonies occurring at the lectern behind them, and thereby signal the liturgy as a Rufolo endeavor. This association between armorials and liturgy is reiterated below the elevated lectern, as eight shields demarcate the outer edge of the altar niche; this was a site of eucharistic celebration at least after the foundation of Nicola's funerary chapel in 1287 (see Fig. 62). Furthermore, the holiest moment of liturgical ceremony in the cathedral, the elevation of the host at the main altar, was similarly framed by Rufolo arms on the front of the ciborium, which would have hovered just above the host. Thus the holiest sites of the church were clearly and repeatedly defined and demarcated as Rufolo spaces.[128]

The multiple armorials establish the ways that heraldry articulated the salvific aspirations of the family. After the space below the pulpit became a funerary chapel, those images made explicit connections between funerary liturgies and the patrons and donors. As Michael Michael has theorized, heraldry offered a stable, perpetual form of identification that performed a critical role in the commemoration of the dead by the living, and ultimately in their salvation.[129] The fact that later examples of heraldry around Amalfi are most concentrated in funerary settings suggests that these ideas continued to resonate (as on the mid-fourteenth-century tomb slabs of Sapia de Vito Freccia in Santa Chiara, Ravello,

and Filippo Spina in San Giovanni, Pontone, see Fig. 88). Eschatology provides but one way of understanding heraldry in addition to the social meanings of prestige, affiliation, and spatial demarcation.

Created, placed, and viewed in Ravello, these heraldic devices bear little material resemblance to heraldry in its original courtly or northern settings. The shields are not rendered in the bright paint, silk livery, and waxen seals of early Angevin works; rather, they are manufactured by local workshops in a favorite local medium, mosaic. The defining characteristics of heraldry, bold outlines and easy legibility, are undermined by this technique of fragmentation: the small tesserae of the Ravello work create irregular fields of reflective color. This technical practice and its visual effects were rooted ultimately in the South's *romanitas* and various revivals of it, most notably at Desiderius's Monte Cassino and its affiliates and the large-scale churches of the Normans in Sicily (and of course Rome as well). In fact, from the late eleventh century to ca. 1300, mosaic was one of the few artistic techniques that was a critical, prominent component of the most prestigious institutions and foundations of the South.

This shift in material and effect, from courtly to Ravellese, marks part of the recontextualization of heraldry, as the apt language of consumption theory would phrase it.[130] The essential pictorial quality of heraldry as a northern, courtly idiom was tempered or altered at the site of display.[131] Thus these early armorials bring together two systems of signification – local culture and authority in mosaic and royal authority in heraldry – to bridge old and new, Mediterranean, and northern European.

The family's adept use of armorials reveals their understanding of how this novel type of imagery aggressively constituted power and status. In the case of the cathedral commissions, repeated recourse to heraldry reinforces the sense that the Rufolos sought to mark the heart of episcopal space. The physical presence of the monuments, their inscriptions, and their heraldic displays reiterate Rufolo affiliation with the cathedral interior. Far from being merely a pictorial or even picturesque feature of chivalric culture, coats of arms embody the embattled field of establishing and maintaining presence, status, prestige, and authority, whether in *patria* or in *regno*.

The display of family armorials was widely imitated in the South in successive generations. Associational types of heraldic expressions, such as the molten metal of the d'Afflitto arms that intended to evoke the martyrdom of their holy ancestor in a brazen bull, conveyed prestige through an invented history, rather than

through current status, as the Rufolos did. Symbols derived from last names (rebus designs), such as a cup for the Coppolas of Scala or arrows for the Freccias of Ravello, embellish works of art and architecture on the coast from ca. 1300. The ease and speed with which the system of heraldry spread in the region is not surprising; it provided an abbreviated way to express, assert, and celebrate the family line, which Amalfitans had been doing avidly in other ways since the tenth century. The Rufolos and their successors were bridging an ancient custom – possession through genealogical text inscription, or both – with the new pictorial mode developed by the ruling dynasties of Europe.

In all the works of art commissioned by the Rufolo family, the coats of arms are the feature most indebted to courtly or Angevin precedent. In his famous study of New World heraldry and other forms of ostentation during the Gilded Age, Thorstein Veblen described imitation as a fundamental characteristic of human nature. Thus patrons of less exalted status imitate the motifs, themes, or styles associated with elite modes of self presentation, inevitably and without much reflection or cultural recontextualization.[132] The traditional language of art history often upholds such assumptions regarding the direction of cultural movement from elite to popular. The case of heraldry in Ravello reveals the limits of such "trickle down" theories of cultural production and consumption that depend on the passivity of the influenced. Such theories create little space for the formation of new meaning. This study seeks to construct such a space, where the issues addressed here – namely, visual persuasion, affiliation, and the material conventions of the art of *mercatantia* – can reside.

THE PROBLEM OF PORTRAITURE ON THE RUFOLO PULPIT. A third type of self-representation, portraiture, has received the lion's share of scholarly attention, yet ironically it is the most problematic of the various modes used on the pulpit. Specific images have been interpreted as representations of the donor family, namely, the profile busts of the stair portal, the female bust now in the Museo, and the faces on the lectern base (Figs. 74 and 75).

Although donor portraits appear on earlier examples of Amalfitan lay patronage, the pulpit images should be seen in light of the sculptor's naturalistic style and creative approach to traditional iconography and architectural ornament.[133] Nicola of Foggia viewed conventional imagery through the lens of Hohenstaufen palace projects and portable luxury objects, thereby lending some images on this liturgical work a courtly, worldly air. Although this up-to-date style provides another visual language that expresses the Rufolo family's prestige, it does not

74. Nicola of Foggia, door to the lectern stairs, Rufolo pulpit, Cathedral of Ravello, 1272. Copyright Alinari/Art Resource, NY.

75. Nicola of Foggia, lectern base, Rufolo pulpit, Cathedral of Ravello, 1272.

de facto signal an early attempt to capture portrait likeness or convey exclusively secular content.[134]

For instance, the grimacing boy and girl on the lectern base need not represent the newest generation of Rufolos, but instead constitute modernizations of a theme typical of southwest Italian pulpits of the twelfth and thirteenth centuries: that of Abyssus, the Underworld, who often inhabits this surface parallel to the nave's floor, as at Salerno[135] (Fig. 76). Peering out from a nest of leaves, these faces in Ravello nearly transform Abyssus into a "green head," that mainstay of northern Gothic design. But their pained expressions are in keeping with the Abyssus identification, for they evoke the hell described in Matthew 8:12: "The children of the kingdom shall be cast out into outer darkness; there shall be weeping and gnashing of teeth."

The smoothly polished profile busts in the spandrels of the trefoil-arched door leading to the pulpit stairs often are identified as the patron Nicola and his wife Sigilgaita.[136] As in the case of bronze doors with donor portraits, the busts occupy a liminal zone, the portal granting access to the stairs that ascend

76. Guarna pulpit, lectern base with Abyssus, Cathedral of Salerno, ca. 1175–85.

to the lectern. Despite their solemn site, these images are not reverential. They seem distant from the profile busts located in comparable spandrels, those of the niches on the interior west façade of the Cathedral of Reims.[137] Instead, the fashionable attire and bemused expressions of the profile figures in Ravello evoke the secular world of the well-to-do, the dolce vita depicted in Manfred's copy of his father's treatise *De arte venandi cum avibus* (BAV Pal. Lat. 1071). The small mosaic birds that seemingly issue from their foreheads are also inconsistent with donor portraits, the seriousness of the site, and the Reims reliefs.

Despite some touches of realism on the profile busts – take, for example, the man's ear, the structure of which is visible beneath his tight cap – they need not represent any single person or concept, as they belong to the world of generic architectural imagery and small-scale classicizing objects. As white marble accents set in colorful fields, they are akin to the ornamental masks sculpted by Roman marble workers in the cloisters of San Giovanni in Laterano and San Paolo fuori le Mura, or on the spandrels of the tomb of Pope Hadrian V (d. 1276) in Viterbo.

In style and effect, the Ravello busts also resemble cameos, the small-scale luxury objects of classical inspiration that were created and circulated during the thirteenth century. A cameo of French or southern Italian origin depicts a similar composition of facing male and female figures.[138] Redolent of Frederick

II's classicizing patronage, this sort of cameo was also a highly prized object, an exquisite and expensive work that would have been available only to the most elite members of southern Italian society. While the highly polished Ravello reliefs seemingly magnify the imagery and effect of such cameos, they also convey some of the elite associations of such precious objects and the courtly settings of the Hohenstaufen *renovatio.*

The so-called Bust of Sigilgaita is the most discussed component of the Rufolo pulpit. Its provenance, date, attribution, and iconography have all been disputed at some point in the last two hundred years. Many uncertainties stem from the fact that the work's original location is not known.[139] At some point it was placed somewhat precariously on the architrave above the trefoil stairway door, where it remained until it was moved to the Museo in 1983. Although scholars now accept that Nicola of Foggia carved the bust and place it within the general chronological orbit of the pulpit, whether the bust was part of the pulpit remains unclear.[140]

A more intense debate surrounds what or whom the bust represents. Some writers, primarily but not exclusively local historians, have identified the object

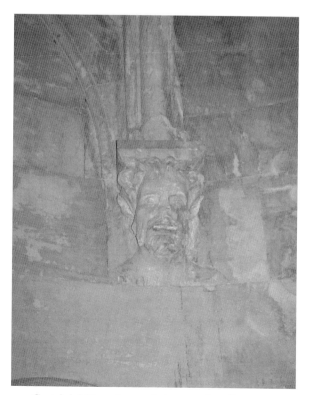

77. Castel del Monte, console bust, stairwell, 1240s.

as a portrait of Queen Giovanna of Naples (d. 1382), Sigilgaita, wife of Nicola Ru-
folo (d. ante 1286), or Anna Della Marra, wife of Matteo Rufolo (d. post 1298).[141]
Adherents of these theories evoke two later female busts, one in New York, the
other in Berlin and allegedly from Scala, as evidence that portraits of noble-
women were established art forms in the late thirteenth century in southern
Italy.[142] Philological approaches, however, have yielded competing identifica-
tions as *Mater Ecclesia* and as the city of Ravello, theories which are more likely
given iconographic similarities with a variety of personifications in the medieval
South.[143]

A consideration of the primary antecedents of the Rufolo bust, namely, ex-
amples of architectural sculpture, helps resolve these conflicting interpretations.
Separate from the piece's problematic successors in New York and Berlin, these
works include many animated sculptures of portraitlike naturalism: the array of
busts on the façade of the Cathedral of Ruvo, the long-tressed woman and elfin
man in a stair tower of Castel del Monte (Fig. 77), two similar ones above the en-
trance to the keep of the castle of Lagopesole (possibly made by Nicola of Foggia
himself), and the portrait busts and personifications of the Capuan Gate.[144]

Most of these sculpted works are elevated and within a larger architectural
setting. Their position provides an important precedent for the Ravello bust.
Because the work now resides in a display case in the Museo, viewers can circle
around it, look directly into the face, scrutinize the less finished top of the head,
or the inside rim of the crown – in short, viewers can approach the bust as a free-
standing work of art. The figure appears bemused from these vantage points, like
the profile busts of the trefoil portal. Her lips part slightly to reveal hints of teeth
(they are not fully rendered), and her smile is vaguely mocking. If observed from
a lower vantage point that a viewer would have if the work had been elevated,
this ambivalent smile disappears and turns to ominous admonition.

The apparent sobriety is suggestive of an imposing personification, not a radi-
cally new monumental portrait of a layperson. The bust of Iustitia or Capua from
the Capuan Gate provides a likely model for this type and form of representa-
tion. But while the Ravello piece seemingly draws its mood from Capua, its style
is more closely affiliated with Frederick's private works, such as the exuberant
capitals and consoles that embellish his palaces.[145]

Although the Rufolo bust shares some basic iconographical features with
southern Italian representations of Ecclesia – namely, the crown and jewels –
the theory that the bust represents the city of Ravello holds more weight. City
personifications in the manner of the ancient *tyche* appear on southern Italian

coins and in other media, from the relief of Nineveh in Sessa Aurunca to the wall painting of Jerusalem in San Vincenzo al Volturno.[146] Bolvito's history of Amalfi further corroborates this view. It describes a painting of an enthroned, crowned woman, the "antico simulacro di Amalfe" that was located in the local assembly or *seggio* of Amalfi.[147] During the years of Hohenstaufen and Angevin rule, *seggi* convened in Amalfi and Scala, and finally under Charles I, in Ravello. Buildings that housed such activities were also called *seggi*.[148] Bolvito described the Amalfi *seggio* as such:

> Thus they painted Amalfi, in the form of a beautiful little lady, adorned with a royal crown, and richly clothed in brocade, who is sitting in a royal throne. With her right (hand), she holds a golden apple; and with her left, holds a lion that rests in her lap. This is what these things represent: the nymph of Amalfi, ruler and queen of the entire coast, seated in the royal throne of that Republic. Ruling her law, all rule, all the land of her domain, and adorned with all her gold vestments, thus, of many riches, and in every part of this realm the men of this people possess.[149]

This text provides local evidence that the Rufolo bust was possibly an *antico simulacro* of Ravello, but it does not situate the work within any specific context, be it liturgical, civic, or domestic. Perhaps the piece was, like the nymph of Amalfi, originally located in the *seggio* of Ravello, which was near the episcopal palace and possibly at one point in the Rufolo House: the domed pavilion tower closest to the episcopal palace corresponds roughly to the *seggio* design typology. But if the bust of Ravello initially belonged to the pulpit, it would have resonated with Nicola Rufolo's invocation of *patria* in his dedicatory inscription and thus constituted an unusual expression of local pride and awareness.

Nicola of Foggia's elegant courtly vocabulary served the Rufolos well by associating the family with works of unprecedented rhetorical power in the South. Whether feeding into the classicizing or stylish Gothic streams of Frederick II's patronage, the components of the Rufolo pulpit generally derive from secular contexts. These representations are then juxtaposed with the mosaics, the technique, materials, and ancient imagery of which belong to Amalfi's residual culture of *mercatantia*. Thus the mosaics ultimately temper the secular style, taming it, as it were, for episcopal space. But it is also conceivable that the courtly functioned to sanction this advent of lay patrons, as if a courtly style brought with it the power and prerogative to occupy liturgical space.

Archaism and Authority in the Rufolo Ciborium

In contrast to the pulpit, the Rufolo ciborium claims much of its expressive and ideological power through its use of the old. Matteo of Narni's juxtapositions of a style associated with previous generations, medieval *spolia*, and newly manufactured mosaics, inscriptions, and heraldry were unprecedented among Amalfitan liturgical furnishings. Aspects of them are not unique, however, for the Rogadeo pulpit in Ravello also incorporated *spolia* slabs, although the ancient and early medieval reliefs were concealed within the structure rather than outwardly displayed. Closer to Matteo's work are two pulpits formerly in Benevento (dated by inscription to 1311) that accommodated diverse styles, including twelfth-century sculpture and pieces inspired by Arnolfo di Cambio.[150]

Similar assemblages consistently defined Amalfitan architectural practices. Most churches built between 950 and 1300 contain nave arcades of *spolia*, where ancient bases, shafts, and capitals intermingle with medieval interpretations of them.[151] Generally smaller in scale, early medieval spoils often reappear in fenestration, blind arcades, and other ornamental, rather than structural, contexts. The prestige of Monte Cassino intensified these practices but did not initiate them, for *spolia* were featured prominently in pre-Desiderian churches such as SS. Cosma e Damiano or Santa Maria Maggiore in Amalfi. The ubiquity of such juxtapositions not only helps identify conceptual antecedents for the Rufolo ciborium, but also suggests that Amalfitans were familiar with recycled medieval and classical sculpture and ornament, and, by extension, with their semantic nuances.[152]

Whereas the use of *spolia* has come to be seen as sophisticated, aggressive, and ideologically charged, medieval archaism is somewhat less studied. Francesco Gandolfo, for example, recently located signs of patronal failure in the style of the sculpture of the Ravello ciborium – the inability of Matteo Rufolo to grasp the radical spirit of his father's pulpit and carry forth its "avant garde" agenda. Matteo of Narni is thus isolated from meaningful currents of modernization and cited primarily to magnify the achievements of his predecessor, Nicola of Foggia.

It is preferable to place the old-fashioned character of the ciborium within the context of other southern Italian monuments that used archaism and spoils for political and ideological purposes.[153] The throne of the Sanctuary of St. Michael at Monte Sant'Angelo appears to have been born of a rivalry between the diocese of Siponto and the nearby shrine subject to its episcopal authority.[154] Bertaux and others have argued that the throne must date from after 1066, although its gnarled appearance and crude details – crude, that is, relative to the contemporary thrones

at Canosa and Bari – suggests an earlier date. The archaizing qualities of the chair carefully express the ancient origins of the sanctuary and consequently provide a visually persuasive means for local monks to assert their rightful autonomy from Siponto. The throne, then, is both a gloss of their history and an investment in their political future.

Although similarly derived from ideological impulses and dependent on the artist's technical skills, the Rufolo ciborium does not constitute a forgery along the lines of the Monte Sant'Angelo chair. Its inscription clearly states the date of 1279 and the name of the artist – there is full disclosure here. Both Matteo of Narni and Nicola of Monteforte, the creator of the Benevento pulpit, signed their works, demonstrating that in their estimations, they "made" them. Hence, medieval spoils were deemed legitimate raw materials for signed works. This premise resonates with other aspects of Amalfitan cultural history. Just as the *Chronicon Amalfitanum* asserted the prestige of the region by inventing and mythologizing its noble Roman founders, and as the first comital elite bolstered its authority by maintaining family trees that went back two hundred years, so this work of Amalfitan art derived its strength from its antiquity, real and imagined.

The Rufolo ciborium functioned in a Janus-faced way. A marriage of old and new, the monument asserted the family's dominance over the principal liturgical space of the church and symbolically retrodated its affiliation with the high altar. This manipulation of material and style perhaps sought to evoke Giovanni Rufolo's tenure as bishop in the second half of the twelfth century, a time when the cathedral was actually controlled by the family. Such an evocation would also remind fellow Ravellese that the Rufolos' prestige was not new, although their imposing administrative power, sprawling residential complex, and liturgical ensemble were indeed recent developments. The Rufolos were, after all, relatively late arrivals in Ravello and thus had not been active participants in the spate of private church foundations during the previous century. In articulating through its archaic style that the Rufolos were present in the past, the ciborium also asserted the Rufolos' power at that moment and guaranteed them visual prominence in episcopal space for an indefinite future.

The pulpit, ciborium, and related works known from textual references proclaim the Rufolos' deep imprint on the interior of the Cathedral of Ravello. The family covered the focal points of the cathedral – the altar canopy, pulpit, vestments, articles used for celebrating mass, and crypt pavement – with their coat of arms. The works that they commissioned displayed a lavish variety of materials,

including colored marble, glazed ceramics, and precious metals. They enlisted an impressive range of visual languages, from traditional genealogical inscriptions to succinct and modern heraldic devices. Likewise the scale of the works, proportionate to that of the cathedral itself, was impressive; the pulpit in particular is larger in size than most of its relatives, with the exception of the Ajello pulpit in Salerno, which likely served as a point of inspiration.

The Rufolo commissions demonstrate the eclectic taste of the family, who commissioned the principal monuments of divergent style and ideology within a short span of seven years. The works testify to the patrons' sophisticated grasp of the rich array of artistic possibilities offered within distant Italian and Mediterranean contexts. The family had access to and could negotiate a range of old, new, local and "foreign" forms, idioms, and techniques – skills rarely acknowledged in medieval patrons and not previously imagined or posited for laypeople or practitioners of *mercatantia*. The Rufolos' accomplishments as manifest in the cathedral commissions are reminiscent of the royal patrons of the thirteenth century, such as Henry III of England or Charles I of Sicily, who seemingly understood the meanings of various styles and thus have been interpreted as sophisticated viewers or patrons or both.[155] The eclecticism of the Rufolo works, however, is not without local precedent, as the private church commissions of the twelfth and early thirteenth centuries tell a similar story of stylistic and ideological diversity within a short span of time. The broad cultural horizons of Amalfitan merchant communities undoubtedly fueled this eclectic visual culture, given that merchants and financiers traversed the Mediterranean world and often returned with imported goods and memories of distant monuments.

The Privilege of Place

The private or family-based religious spaces that multiplied in the region of Amalfi during the twelfth and thirteenth centuries were fueled in part by merchant experience in the Mediterranean world and in part by centuries of Christian ambivalence toward wealth and display. The specific topography of Amalfitan religious patronage, however, emerges from fiercely local rather than broadly based concerns.

The foundation of the cathedral in 1086-7 was a pivotal event in the history of Ravello and its urban form, as the large basilica shifted the town's center to the south. During the following two centuries, monastic and agricultural development extended toward the southern end of the plateau. The town was becoming

polarized, divided between the elite bastion of Toro and the more modern establishments near and beyond the Rufolo House, including mendicant foundations established around 1300[156] (see Fig. 49).

The enlargement of the private church of San Giovanni del Toro in the early twelfth century and the many acts of patronage that took place within its walls can be read as the patrons' efforts to maintain the distinction of their venerable institution as the town's social and urban structures rendered them increasingly peripheral. This does not imply that the church owners were necessarily antagonistic toward the cathedral; after all, some members of San Giovanni's founding Muscettola clan were buried in the cathedral, and another founding family placed their own Pantaleo Pironti on the episcopal throne from 1210 to his death in 1220. His tenure undoubtedly affirmed the importance of Toro as a neighborhood foundation connected to Ravello's oldest families. Similarly, San Giovanni likely flourished in the turbulent years following the death of Frederick II in 1250, when weakened ecclesiastical authorities in the South struggled to negotiate between the papacy and a hostile Manfred.

The victory of the Angevins in 1266 brought an end to this type of uncertainty. Sees that had been vacant for several years were filled.[157] Filippo Augustariccio was officially appointed archbishop of Amalfi in 1266, after having been blocked by Manfred for eight years. He embarked on a period of reconstruction and reform, finishing building projects that had languished and consolidating religious holdings under the banner of the church.

By contrast, the diocese of Ravello witnessed a series of short and unstable episcopates during the second half of the thirteenth century. Peter de Plano occupied the see during the politically turbulent years of 1230 until his death in 1269. There is no confirmation of his replacement until 1275, when the name of the Benedictine Peter of Durazzo appears in local documents. Evidence relating to Peter's episcopacy is limited, but it sheds some light on the Rufolo commissions. First, Peter's "foreign" status vividly contrasts with previous appointments, the majority of whom were locals. This change suggests that the Angevins, in cooperation with Rome, wished to weaken local power bases and articulate the scope of the new empire by granting this important office to someone from its outer reaches, Albania. Matteo Rufolo commissioned the ciborium of 1279 during Peter's tenure; whether he was already in office at the time of the pulpit's construction in 1272 remains uncertain. Given these unusual political circumstances, it is plausible that the absence of strong episcopal authority in Ravello facilitated the Rufolo commissions in the cathedral interior.

The commissions constitute a bold extension into the public realm of the type of private art familiar to generations of merchants in medieval Amalfi. Given the proximity of the cathedral to the sprawling House of the Rufolos, here, too, is an example of the defining feature of Amalfitan hill towns: the pairing of (private) church and residence. Sant'Eustachio in Pontone and San Michele Arcangelo in Pogerola both exemplify this urban and social paradigm. The ensemble that the Rufolo family created, however, dwarfs those of their predecessors. For its scale was not determined by a private church or modest house, but by the Cathedral of Ravello itself. While this pairing stems from local traditions, its dimensions are decidedly ambitious, imposing, and novel.

A desire to reassert the power of Giovanni's Rufolo's long tenure as bishop in the second half of the twelfth century likely was one factor in the family's appropriation of ecclesiastical space. The visual aggression of Rufolo patronage may also divulge a future goal, however. Following the death of Peter of Durazzo in 1284, virulent debate erupted over the election of the Augustinian monk Ptolomeo as his successor in 1286. Like Peter, Ptolomeo was not local; he came from distant Lydia, where he had served as bishop of Sardis. The controversy arose because the canons themselves backed another candidate – one Giovanni Rufolo, the namesake of the third bishop of Ravello. This Giovanni must have been poised for some time to solve the problem of episcopal discontinuity in Ravello, for he was ultimately rejected for the position because he was deemed too elderly.[158] It is plausible, then, that the Rufolos embarked on this visual coup d'état in the hope of placing a second Giovanni on the episcopal throne.

The daring entrance of a private family into the site of episcopal power has significant implications. Not only the material, stylistic, and iconographic contents of display, but also its location, conveyed prestige and distinction and thus shaped its ideological charge. The public status of such works challenges longstanding misgivings in the Middle Ages about luxury and public consumption, concerns rooted in fears that public display raised suspicions of illicit financial practices. In light of the mounting prosperity of the later Middle Ages, such attitudes eventually relaxed, allowing for the expansion of lay patronage in the form of prominent tombs, chapels, altarpieces, wall paintings, and so on, as is well researched for the fourteenth and fifteenth centuries.

This relaxation happened too late for the Rufolos, whose foray into the public realm was unprecedented and may have contributed to the family's demise. Whereas the church had long sanctioned lavishness as an appropriate vehicle for the praise of God, the role of wealthy laypeople was unclear; they had not

previously shaped liturgical space or its major monuments in southern Italy, although donations of smaller objects or funds for building campaigns were legion there as elsewhere in the West. It is conceivable that the Rufolos' move into that realm was controversial, given the anxieties over public ostentation at that time. Perhaps the elaborateness of the cathedral commissions contributed in part to the deadly censure of the family in 1283, as with the mortal lavishness perceived at the Rufolo House by the early historians. That these results of artistic patronage directly precipitated the arrests is unlikely. But the controversies regarding display and expenditure help underline the radical nature of the Rufolo commissions and illuminate the fact that they are products of a culture in transition.

The Rufolos' takeover of episcopal space and its conventions of display mirror appropriations that were repeated in late medieval cities on the different scale of portable goods, not monuments. Sumptuary laws, generally developed to maintain social order by rendering social status visible, worked in a variety of ways. Some laws employed biblical and moralizing language to curb greed and envy, often during purported fiscal crises. The aforementioned Angevin legislation of 1290, for example, sought to cultivate *misura* (measure) and frugality and eradicate "immodest and excessive liberality."[159] Specific restrictions attempted to realize these elusive goals or principles.

In addition to enriching the visual culture of the cities and towns in which they proliferated, the disputed goods (such as jewelry and furs) and various responses to them have ramifications for the production of medieval art. If new groups or members of society could afford to buy bejeweled crowns and dresses trimmed in gold, then they likely could also commission monuments that challenged hierarchical conventions of display, or that blurred social distinctions, as seen in the case of the hill town residences. Of further relevance is the fact that the same groups who were threatened by the wealth of merchants and sought to block their access to luxury goods were the very ones ceding prime ecclesiastical space to merchant patrons. Thus the social battles waged on the streets of Italian towns in the later Middle Ages replicate in their basic outlines the colonization of episcopal space by the Rufolo family. Whether the works in the cathedral feature "immodest and excessive liberality" is unclear; but they are certainly not lessons in "measure and frugality," the economic (and visual?) virtues that the Angevins sought to cultivate among the kingdom's *regnicoli*.

Amalfi and the New Metropolis: The Decline of the Art of *Mercatantia*

⁓

D URING THE FIRST HALF THE FOURTEENTH CENTURY, THE REGION OF Amalfi suffered an array of setbacks, including gradual economic decline, depopulation, the dispersal of elite merchant families, and a catastrophic storm in 1343.[1] No longer were the structures of Amalfitan commerce able to compete with the maritime powerhouses of Pisa, Genoa, and Venice; trade routes eventually retreated to short-haul missions within Italy proper, abandoning the long voyages of the past. Despite these problems, some Amalfitans remained prosperous and continued to commission works of art, including wall paintings, pulpits, tombs, and altarpieces. There were significantly fewer artistic initiatives, however, than during the 1100s and 1200s.

The monuments of the early fourteenth century reveal a fundamental shift away from the Mediterranean parameters of the region's art and architecture. Whereas the twelfth- and thirteenth-century monuments feature the resplendent

polymaterial and eclectic forms typical of the art of *mercatantia*, many works of the early 1300s convey a new homogeneity in Amalfitan art. Stylistic, material, and iconographic currents emanating from Naples and central Italy dominate instead. The allure of court-sponsored art and a related loss of cultural autonomy outside the capital city fueled this complex process, as did the interruption of trade in the Middle East after the fall of Acre in 1291.[2] In many ways, Amalfi testifies to a broader transformation of the artistic landscape of Italy away from the polycentrism of the Middle Ages and toward influential centers of production, with Naples becoming the undisputed dominant force in the South.

The decline in Amalfi's Mediterranean-inflected eclecticism is apparent in a variety of religious settings. In private churches, which continued to operate through the fourteenth century, commissions lack the ambitious material displays of the earlier works. Their decoration instead consists of sober wall paintings and reliefs with painted surfaces rather than intessellated marble panels. Commissions in cathedrals similarly pull back from the lavish celebrations of family power associated with the Rufolo monuments and their antecedents in private churches. Reverting to the conventions of patronage that existed before the 1270s, such works occupy the margins of episcopal space.

To convey a sense of the variety of Amalfitan art in the first half of the fourteenth century, different settings, types of commissions, and media are evaluated here.[3] This range of evidence also creates many points of intersection with the earlier materials, thereby dramatizing the shift in patronal and visual culture that occurred in the course of two generations. Wall paintings in both episcopal and private churches, for instance, reveal a new focus on funerary motifs and the stylistic language of central Italian painters such as Giotto and Pietro Cavallini. Both of these artists resided in Naples and worked on various high-profile projects, such as the frescoes of the Brancaccio Chapel in San Domenico, attributed to Cavallini and dated ca. 1310, and the nuns' choir in the royal convent of Santa Chiara, overseen by Giotto from 1328 to 1330.[4] Painted altarpieces similarly drew on metropolitan prototypes and styles associated with artists in the employ of the Angevin crown. Hence, whereas Amalfitan art of the twelfth and thirteenth centuries subverts the traditional "trickle down" model of medieval cultural influence, the works of the fourteenth century strongly support its power.

The reduction in Amalfitan patronage in the first half of the fourteenth century is somewhat surprising, because this era is renowned for burgeoning lay participation in artistic production. The arts of this time were also appealing to

commercially minded societies and patrons; this was, after all, the heyday of merchant culture as traditionally defined by Tuscan experiences. To a degree not seen in the thirteenth century, families involved in commerce and banking founded such lavishly decorated environments as the Bardi and Peruzzi chapels in Santa Croce in Florence at this time. Prominent episodes of lay patronage occurred in Naples in addition to such well-known settings, to be sure. High-ranking dignitaries in the Angevin administration, including the legal scholar, chief notary, and royal advisor (logothete) Bartolomeo of Capua (d. 1328), commissioned highly visible works of art in the capital that helped establish his prestige among *regnicoli* in addition to catering to eschatological concerns.[5] But in Amalfi, this era was as a whole one of cultural loss, not affirmation.

Although the fourteenth-century works discussed here are predominantly indebted to royal prototypes in Naples and thus signal the decline of the Mediterranean art of *mercatantia*, they are not merely simple replicas of metropolitan projects. Rather, each one raises important questions regarding the reception in small but reasonably prosperous towns of prestigious art forms. Artists who worked in Amalfi during the 1300s approached such authoritative works in a variety of ways, often transforming them to suit new physical, cultic, or functional contexts.

The process of recontextualization is particularly vivid in the case of Amalfi's stucco monuments. These works range from subtle relief carvings to freestanding furnishings of considerable scale. An exceptionally flexible and expressive material, stucco was a local technique that reworked "imported" forms and iconographic models in a local, alternative aesthetic. Through this new application of an old technique, Amalfitan patrons articulated some aspects of their local identity and culture. Yet even with the stucco works, their designs and styles betray the deep imprint of Neapolitan ideas on Amalfi.

Amalfitans in Naples

The overriding impact of Naples after 1300 derived in part from the sustained presence of Amalfitans in the metropolis. The promise of work in the court or royal administration, whether in esteemed or menial positions, spurred immigration to the city after it became the capital of the *Regno* in 1282.[6] For example, Pietro Trara of Scala was granted a prestigious position in the royal kitchen in 1310. After having moved to the city, likely around the time of this appointment,

the family quickly took its place among the Neapolitan elite and in institutions under royal patronage.

Bolvito recorded the presence of tombs of the Trara family in a chapel in Santa Chiara, including that of Roger Trara *de Scalis*, which bore the date 1368.[7] Santa Chiara, the monastery founded by Queen Sancia of Mallorca in 1310 that was originally dedicated to Corpus Christi, functioned as the official burial site of the Angevin dynasty, where aspirations to sacral authority were magnified by the ideals of holy poverty and reform preached by the friars.[8] The presence of the family from Scala in this royal space indicates their own social prestige, maintained well into the reign of Giovanna I. It also testifies to their support of the ideologies of the Franciscans at this time.

For the Rufolos, the foray into Naples ensured the family's financial, professional, and social survival in the precarious years following the corruption trial. Iacopo, for instance, owned workshops in the metropolis already in 1290.[9] Commercial connections may have facilitated their entrance into the judicial circles of the *Regno* that were centered in Naples. Anfuso was the first Rufolo known to have studied law; he appears as a judge in Ravellese documents in 1295, 1297, and 1305.[10] A series of Rufolo judges in the second half of the fourteenth century culminates with Carlo (d. ca. 1401).[11] Francesco (d. 1370), who served as the forty-sixth bishop of Nola, was also a doctor of law.[12] He was entombed in a family chapel in San Domenico in Naples.[13]

Such sepulchral monuments, commissions, and endowments indicate the skill with which elite Amalfitan families negotiated the structures of economic, social, and religious life in the metropolis. As was the case with other immigrant groups, the Amalfitans concentrated their houses, shops, and other properties within specific parts of the city. The Nido district, named after a nearby ancient sculpture of a river god understood to represent the Nile,[14] housed most but not all of the successful merchants from the Amalfi coast and other Tyrrhenian ports.[15] Located near San Domenico Maggiore, this neighborhood had as its nexus of power one of the select assemblies of noblemen that constituted the city council during the Angevin period, the Seggio del Nido.

Part of the prestige of Nido derived from its proximity to San Domenico. Founded in 1231, this monastery was the epicenter of scholasticism in the kingdom, for Thomas Aquinas himself resided there while he lectured at the University of Naples from 1272 to 1274. As elsewhere in the Latin West, this Dominican foundation launched a variety of inquisitorial investigations in the late thirteenth

and fourteenth centuries, often under royal decree.[16] Given the importance of the Order to the university and court, Charles of Salerno initiated the expansion and reconstruction of the monastery in 1283.[17] The new church was completed by 1324.

The king's support for the institution is demonstrated by the fact that his heart was kept there in an ivory container.[18] Two of his sons followed suit, with full burials in San Domenico. In addition to various royal bodies and the Rufolo chapel, this prestigious and holy environment also held family chapels of the Della Marra, Grisone, and Freccia clans of Ravello that were founded in the course of the fourteenth century.[19]

The weakening of Amalfitan autonomy and related cultural shifts derived from this diasporic process to be sure. But just as Amalfitans were flocking to Naples and indeed achieving considerable status and clout there, so the structures of governance in the kingdom were changing so that there was more of the *Regno* in Amalfi as well. A basic interpenetration of these two cultural and political spheres transformed the structures of patronage and art production on the coast.

This interpenetration is evident in ecclesiastical contexts, following decades of controversy and an occasional empty see during Hohenstaufen rule. Whereas bishoprics in the region of Amalfi traditionally had been occupied by Benedictines from local families during the eleventh, twelfth, and even thirteenth centuries – witness Matteo Capuano (1202–15) in Amalfi, Pantaleone Pironti (1212–20) in Ravello, and Costantino and Matteo d'Afflitto in Scala (1207–20 and 1227–44, respectively) – ecclesiastical appointments of the late thirteenth and early four-teenth centuries featured men who hailed from outside the region.[20] The episco-pacy of the Albanian Peter of Durazzo in Ravello (1275–84) and Guglielmo Lom-bardo *natione lombardus* in Scala (1328–42) are representative of this trend.[21] Some officeholders were from distinguished Neapolitan families, including Lan-dolfo Caracciolo, the archbishop of Amalfi from 1331 to 1351, whose appointment served to benefit the court as well as the papacy.

These changes derived in part from new political and institutional circum-stances, from the flowering of mendicant establishments in the South under Charles II and the concomitant emergence of distinguished preachers such as Landolfo Caracciolo, to the consolidation of Angevin prestige across the Italian peninsula during the reign of King Robert. They also demonstrate the ways in which the Angevin-Papal alliance was at times able to consolidate the Church's power on a local level, a move that was more difficult during the early decades of French rule and the Vespers crisis.

Naples as Metropolis: Stabilization and Cultural Prestige

Santa Chiara and San Domenico, two of the most distinguished monasteries in Naples that were supported by Amalfitans and the royal family, illustrate key changes in patronage since the reign of Charles I (d. 1285). At home and in Naples, Amalfitans in the fourteenth century were more inclined to support monasteries than the private churches that saw so much activity in previous decades and centuries. Donations to Franciscan, Clarissan, and Augustinian houses in Amalfi and Ravello increased markedly in the late thirteenth and early fourteenth centuries, although private churches continued to exist.

In a similar vein, royal support moved away from the French Cistercian houses that were keys to Charles I's imperialism. Charles II distinguished himself as a benefactor of mendicant foundations in Naples and the *Regno* as a whole. Another indication of his piety was his support of the radical hermit from the Abruzzi, Pietro del Morrone, who as Celestine V sought the protective environment of the Neapolitan court to announce his abdication from the papal throne only months after his election in 1294.[22]

As Bruzelius has argued, a new austerity characterizes the religious architecture of the reign of Charles II, one marked by sober variations on Dominican prototypes.[23] In early-fourteenth-century buildings such as the Cathedral of Lucera (Fig. 78) and San Pietro a Maiella in Naples, austere, narrow piers with two or three engaged columns support truss roofs, solid expanses of walls prevail over fenestration and Gothic tracery is limited to small openwork features such as *piscinae*. In contrast to the French modes of the Charles I, the architecture associated with Charles II moved toward what Bruzelius has characterized as an "accommodation and adaptation to local conditions, local materials, and building traditions."[24] The financial rewards of simplicity likely contributed to this shift.[25]

In other fields of artistic production, the reign of Charles II coincided with a new awareness of and interest in illuminators, painters, and sculptors from central Italy, an interest that was expressed by royal and other elite patrons in Naples. The royal support that fueled the increasingly high profile of the mendicant orders contributed to this new focus on central Italian forms, iconography, and ideology, which had the effect of eroding the centuries-old prestige of the Benedictines in the South.[26] In very general terms, then, the reign of Charles II helped sponsor the Italianization – and in painting and sculpture, the central Italianization – of the visual culture of the *Regno* and its institutional manifestations.

This trend continued through the mid–fourteenth century. Despite the unusual circumstances surrounding the succession of King Robert (he was the third-born son of Charles II, as the eldest Charles Martel died before his father and the second in line, Louis of Toulouse, abdicated for a higher, holy calling), the dynasty's clout and political power consolidated during his reign. Momentarily freed of the Sicilian problem, Robert shifted his political focus to close allies elsewhere in Italy, to Guelph communes such as Florence, where he had resided in the office of the *signoria* from 1313 to 1322, as did his son Charles of Calabria in 1326 and 1327, and to the papal curia in Avignon in Angevin-ruled Provence.

Robert and his capital constituted cultural seams between the *Regno*, the rest of Italy, Provence, and Mallorca, the home of his second wife Sancia who ruled as queen for forty-one years. Robert's piety and corpus of sermons helped establish Naples as a vibrant religious center. As with Charles II, he embraced radical religious groups, including the Spiritual Franciscans and to some degree the inheritors of Joachim of Fiore's prophetic discourse.[27] Robert's intellectual curiosity and cultural patronage extended beyond religious circles, however. Boccaccio, Petrarch, and other scholars such as Cino da Pistoia resided in the court at various times, along with Giotto and Tino di Camaino, artists with whom Robert was likely familiar from sojourns in Rome and Florence. In sum, the impact of Robert, his court, and capital city on art production was far-reaching, for they shaped many aspects of cultural and artistic production elsewhere in Italy as well as in the *Regno*.[28]

This general account of Naples and its kings in the wake of the Vespers rebellion sets the stage for examining Amalfi's response to the metropolis and its artistic and cultural transformations. In the previous chapters, the art of *mercatantia* was characterized as eclectic and often autonomous, working with the structures, priorities, products, and experience of commerce and creating competitive arenas of public display. Thus the complex and often ostentatious houses of the Amalfitans deviated in significant ways from those found in other regions of the South and from the *Regno*'s royal and imperial exemplars. Salient aspects of them demonstrated a closer affiliation with North African building traditions, though other features, including Gothic ones, were present as well. Similarly, the design and decoration of private churches and cathedrals were indebted to a range of material, iconographic, typological, and stylistic sources, rather than to any single cultural context or monument of prestige. Inscribed within the moral and theological problematics of wealth and their implications for salvation, the larger cultural framework of the earlier works was distinct from those

78. Cathedral of Lucera, pier articulation in nave, 1300–17.

surrounding predominant royal, ducal, or episcopal commissions elsewhere in the South. Amalfitan art did, however, intersect at times with such authoritative traditions, as with the Rufolos' hiring of the sculptor Nicola of Foggia. But even in those circumstances, the products of such intersections were layered with cultural practices rooted in *mercatantia*.

The arts of the early fourteenth century display considerably less autonomy than these earlier works. Seemingly receptive to paintings and sculpture redolent of monarchical authority and its religious underpinnings, the works indicate that Amalfitan visual culture ceased to be an alternative one driven by *mercatantia*. Despite the persistent use of some local materials and some ambivalence toward authoritative artistic sources, Amalfitan art ultimately became dependent on the perspectives and taste exhibited and cultivated in the capital city of Naples.

The monuments examined here include liturgical furnishings, wall paintings, relief carvings, tombs, and altarpieces. Most of these works can be dated on the basis of style and iconography to the second quarter of the fourteenth century, the period that saw the first boom in art production (albeit a minor one) after the Vespers rebellion. They illustrate how works of art deemed prestigious in the Middle Ages and canonical today were appreciated by *regnicoli*, appropriated in new commissions, and recontextualized in the small towns of the South, distant

from the courtly settings in Naples for which many of the concepts had been developed.

Not many of the works have been studied previously in detail. Hence some introductory material is required to contextualize them adequately. Unlike earlier objects such as the Rufolo ciborium, none is signed by the artist, rendering the process of attribution conjectural. Most works lack dedicatory inscriptions as well, signaling the weakening of genealogical filiation and identification. This lack of text also means that other types of evidence are brought to bear on the question of patronage. In a few cases, heraldry establishes patronal connections, and in others, written sources help reconstruct the circumstances and individuals behind the creation of a work.

Three aspects of this process and its implications are considered here: how the "new" artists in the employ of the court in Naples became dominant cultural forces in the South, with Cavallini, Giotto, and Tino di Camaino having the greatest impact on artists who worked around Amalfi; how shifts in ecclesiastical politics and spirituality pulled the liturgical environments in Amalfi away from the art of *mercatantia* and brought the region more in line with metropolitan practices; and how the remarkable and little-understood medium of stucco became a popular and desirable alternative to marble in various types of sculpture in the provinces, demonstrating the adaptability of local building techniques to "imported" forms and taste. This chapter also examines the rising hostility toward the South's diverse communities, particularly Jewish and Muslim ones. This erosion of southern tolerance facilitated the production of negative representations of Jews in particular, including a disturbingly violent image on the tomb of Marinella Rufolo Coppola in Scala (see Fig. 90).

In short, this chapter utilizes a range of visual and textual sources to explore the cultural and political transformations of the early fourteenth century in southern Italy and their impact on small-town patrons. These later works testify to the erosion of the Mediterranean roots of the art of *mercatantia* and, by extension, of the region's cultural autonomy – losses that are paradoxical, given the "progressive" and humanistic ideals usually accorded to the art of central Italy after 1300.

Established Sites of Lay Patronage

In the first half of the fourteenth century, some episodes of lay and merchant patronage in medieval Amalfi continued to occur in traditional locations. A range

of monuments, including works of sculpture and painting, appeared in private settings such as San Giovanni del Toro in Ravello. Many of these commissions introduced new types of imagery with new devotional emphases. Other works were old-fashioned, enlisting traditional monument types and forms, as at Santissima Annunziata in Minuto. Works made for cathedral settings were somewhat in between. They followed the customs of spatial distribution that flourished before the Rufolos but incorporated up-to-date types of religious imagery sanctioned by the court.

Desiderian Churches: Old Monument Types, New Materials

The church of SS. Annunziata in Minuto lies between Scala and Pontone (see Fig. 6b). It presents the familiar features of the Cassinese-inflected architecture that flourished in the region during the twelfth century, including an intact portico supported by *spolia* columns, a separate bell tower, and a spare interior with a *spolia* colonnade, clerestory, and truss roof. It is the site of the crypt wall paintings that feature two scenes of the Adeodatus miracle of St. Nicholas[29] (see Fig. 71). These works have been convincingly dated on the basis of style to ca. 1200.

No medieval documentation survives regarding SS. Annunziata, and thus key aspects of the foundation, including its date and legal status (private or parish church?), cannot be established. Early modern sources and works of art suggest, however, that it functioned loosely as a parish church, whether or not it was founded by a consortium of locals (as at the contemporary church of San Giovanni del Toro in Ravello). Bolvito, who readily attributed private churches to specific families, named no founders or patrons in his references to SS. Annunziata. Also, the key monument created for it in the second quarter of the fourteenth century was commissioned by the Spina family, which was at that same time also affiliated with San Giovanni in Pontone. In short, SS. Annunziata lacks the dynastic and univocal markers of contemporary private churches such as Sant'Eustachio in Pontone, and thus the precise circumstances of its foundation remain obscure.

Until the late nineteenth century, a pulpit stood on the right side of the nave of the church. Heraldic evidence establishes the Spina family as the patron of this liturgical work. Two armorials of the family, consisting of octagonal fields with zigzags, a diagonal band, and three roses, were carved in relief and flanked the lectern desk.[30] The Spinas were prominent in local and Neapolitan affairs in the mid–fourteenth century. The tomb slab of Filippo Spina (d. 1346) in the nearby church of San Giovanni in Pontone depicts the deceased in armor with his dogs cradling his feet.[31] This chivalric topos, complete with the canine evocations of

loyalty and courtliness (witness the proliferation of lap dogs held by princes and princesses on Angevin tomb chests) projects an image of the clan as part of the elite associated with the court.

By 1346, such visual articulations of status were not inappropriate for the Spinas. The trajectory of the family corresponds only roughly to that familiar model of the second Amalfitan elite. Scarcely documented prior to 1200, the family was ensconced in Scala by 1265.[32] During the first decade of Angevin rule, they were one of the few Amalfitan families to become members of the feudal nobility, as they received fiefs around Aversa near Naples (1271) and the baronage of Copertina and Carmignano in Apulia (1272).[33] Political prominence in the royal administration soon followed. Folcone, Galvano, and Bartolomeo Spina served in the royal administration as *secretus* (chief financial officer) of Calabria in 1284, tax assessor of Trani from 1290 to 1304, and manager of the royal stables from 1288 to 1317, respectively. The clan remained in favor well into the mid-fourteenth century, receiving additional fiefs at Castellammare di Stabia in 1344. Sigilgaita Spina served as an attendant to Queens Sancia and Giovanna I. Later dispersed among other prosperous towns in the *Regno*, including Naples, they also flourished as merchants and bankers, loaning cash to King Robert during the fiscal crisis of 1328.

A branch of the family settled in Naples during the mid-fourteenth century, fueled perhaps by these intimate connections to the Angevin court. In making that move, they of course were not alone; so many other wealthy and not-so-wealthy Amalfitans did the same as their economic horizons shrank at home. The material remains of the family's Neapolitan sojourn consist of the front of the tomb chest of Lancilotto Spina *de Scalis* (d. 1383). Originally in the Augustinian monastery of Sant'Agostino alla Zecca in Naples, the relief presents all the markers of elite tombs by Tino di Camaino and his followers – three medallions with reliefs of the Virgin and Child, Saints Peter and Margaret, Spina armorials interspersed with roses, and a short inscription.[34]

Although the Spina pulpit in Minuto was destroyed in the nineteenth century – allegedly by a priest who pulverized it in 1855 to create a fresh batch of plaster[35] – a description completed in the 1830s or 1840s by the trailblazing H. W. Schulz and a line drawing published in his posthumous *Denkmaeler* (1860) provide solid bases for understanding its form. A painting signed by Gabriele Carelli and dated 1852 corroborates Schulz's observations.[36] Both sources provide the basis for the reconstruction presented here (Fig. 79). This pulpit seems to date from the second quarter of the fourteenth century and as such is the last known example

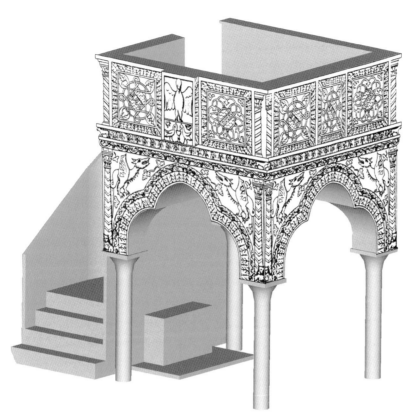

79. Reconstruction of the Spina family pulpit, ca. 1330, SS. Annunziata, Minuto (Danielle Lam-Kulczak).

of this type of liturgical furnishing created in the region in the Middle Ages. Resembling the form of the Bove pulpit in San Giovanni del Toro in Ravello, its rectangular lectern area stood on four marble columns that arched up to create trefoil-shaped spandrels. Other aspects of the Spina work evoked the Rufolo pulpit, such as the prominent heraldry, winged dragons placed in the spandrels, and variety of foliate cornices.

Despite these affinities to earlier monuments, the Annunziata pulpit lacked the expanses of colored glass, different types of marbles, and glazed ceramics of North African manufacture typical of liturgical furnishings in the region. Only its four columns were of stone. The remaining parts were made of stucco, likely built up from and secured to a wooden frame.[37]

The Spina pulpit is one of many stucco monuments made in the *Regno* during the later Middle Ages, including a relief in Ravello and a canopy tomb in Scala, both of which are discussed later in the chapter. Eleventh- and twelfth-century

stuccos in the Abruzzi, Calabria, and Sicily provide technical antecedents for these works.[38] The pulpit in the church of Santa Maria del Lago in Moscufo (near Pescara; dated 1159 and signed by the Magister Nicodemus) consists of four marble columns that support elaborately carved stucco capitals, spandrels, and lectern walls with figural and ornamental imagery.[39] With its panoply of figures and bold polychromy, however, the Moscufo pulpit is more ebullient than the symmetrical and largely aniconic forms of the much later work in Minuto.

While the Spina pulpit and other Amalfi stuccoes ultimately stem from these types of monuments in the *Regno*, they derive their expressive power and finesse from local building traditions in which stucco played a defining role. The gored dome and protruding pine cones of the entrance vestibule of the Rufolo House (see Fig. 15), along with the pleated cupolas of Amalfitan bathing chambers, demonstrate that stucco was not a second-class material. Instead, it was a material with which local artisans were as skilled as they were familiar, one that offered unprecedented potential to express varied colors, forms, and texture. In the first half of the fourteenth century, this technique was used to achieve new aesthetic goals that ranged from delicate relief carving to bold works of freestanding sculpture.

Although stucco is often dismissed unfairly as an inexpensive substitute for marble, the noble Spina family not only could afford to commission works of art in that venerable stone, but in fact did so in other contexts.[40] In the case of the Minuto pulpit, then, stucco should be seen as an expressive alternative to marble that had distinct design advantages and aesthetic effects. It provided a uniform surface that was capable of imitating a range of other materials. It could be rendered in delicate and fine detail, achieve sharp marblelike precision, take different degrees of polychromy and faux inlay, and yet remain relatively light weight.

Even the painting and schematic drawing of the Spina pulpit convey the potential of this material to create a variety of new effects. First, because stucco is lighter than marble, the pulpit could be tall and wide, without necessitating additional columns for structural support. Hence, a vaulted chapel and altar fit comfortably below the elevated lectern, creating a more spacious version of the *sub pulpitum* funerary chapels in Ravello. Second, miniature yet highly detailed versions of local architectural forms articulated the upper portions of the pulpit, including the tiny lion column bases in the corners, twisting columns with chevron designs, and undulating vine scrolls along the trefoils and lintel. Third, the single material employed meant that the work presented a new unity of

surface that the earlier pulpits lacked, given their focus on *varietas* of color, material, and texture.

Because the Spina work no longer exists, little more can be said regarding its precise form, sculptural techniques, strategies of coloration, and so on. These and related issues concerning the medium of stucco will be discussed in conjunction with other works. At this point, it must be underscored that the Spina work was the last example of monument type that was well established in the region: it was an elevated pulpit commissioned by a lay patron for a small Desiderian church. It even emulated those earlier local furnishings in its overall design and in various details of form. It is, in fact, one of the few monuments around Amalfi from the first half of fourteenth century that is not reliant on types of monuments, styles, iconography, or devotional practices that were gaining momentum in metropolitan Naples. In its use of stucco, the Spina pulpit is wholly new, and signals an aesthetic orientation away from the opulent displays of the art of *mercatantia*.

Episcopal Settings

After the bold and ostentatious Rufolo commissions, wealthy Amalfitans retreated to the old rules of lay patronage in cathedrals: they concentrated their efforts on the peripheral spaces of the complexes. Surviving documents and works of art demonstrate patronal activities in the margins, such as cloisters, portals, and crypts. Episcopal control over lay practices was more pronounced than it had been in the 1100s and 1200s. Charters from Amalfi reveal that bishops conceded licenses to altars, chapels, and so on, a procedure that is not recorded in earlier periods. Whether this process of licensing was a critical response to the "privatization" of episcopal space enacted by the Rufolos in the 1270s and 1280s is not clear, but it suggests a level of ecclesiastical discomfort about lay participation in the fashioning and function of the church.

In the case of Amalfi, licensing also testifies to the ambitions of Landolfo Caracciolo of Naples, who was archbishop from 1331 to 1351. Closely aligned with the Angevin court, and indeed formerly an administrator within it, this Franciscan friar exerted unprecedented control over his subjects through a series of investigations into heresy.[41] Perhaps the close connections between his family and the Angevins helped preserve his good standing in the court despite his campaign against the radical wing of his order, the Spirituals, who were supported by Robert and Sancia. Landolfo's father had been knighted by Charles I; he served as royal treasurer in 1303 before taking up an ecclesiastical career that branched

out into diplomacy in the 1330s and 1340s and to the highest positions in the Angevin administration under Giovanna I.

In 1333, Landolfo granted a license to Andrea Quatrario to construct a chapel dedicated to Mary Magdalen in the Cloister of Paradise (see Fig. 28), which was founded as a cemetery by the archbishop of Amalfi Filippo Augustariccio in 1266.[42] The Quatrario clan also helped endow an altar in the crypt of the same church. Their wealth stemmed in part from their considerable industrial and agricultural holdings, which included mills and groves.[43]

The dedication of the cloister chapel reflects the new status of Mary Magdalen in the court and the dissemination of her cult outside the capital city. According to a fifteenth-century account of her legend, the saint appeared in a vision to Charles of Salerno, freed the future king from prison, and directed him to the correct site of her remains. They were not located in the famed pilgrimage shrine of La Madeleine in Vézelay, but rather were in a grave in the Provençal lands of the House of Anjou. The official exhumation of her relics in 1279 was followed by the construction of the soaring vaults of Sainte-Marie-Madeleine in Saint-Maximin-la-Sainte-Baume under the aegis of Charles II. The shrine site became a Dominican house in 1295.[44]

Because of the active promotion of the cult by the Franciscans, Dominicans, and Charles II, dedications to and representations of the saint multiplied in Naples and the South. Charles II sought to rededicate the principal Dominican monastery in Naples to the Magdalen, the order's official protectress, although the name did not stick.[45] Magdalene fresco cycles embellished San Lorenzo around 1300 and San Domenico around 1308–9; those in the Celestine church of San Pietro a Maiella likely date from the late 1340s.[46] The monastery of Santa Maria Maddalena was established by Queen Sancia to house reformed prostitutes (1324).[47] Katherine Jansen has argued that Charles II perceived the Magdalen not only as his personal intercessor, but as the official protectress of the *Regno*, an idea underscored by memorial sermons, inscriptions, and the king's patronal zeal.[48] Adherence to her cult on the part of the Neapolitan elite has been interpreted as politically motivated attempts to curry royal favor. But it must be said that Magdalene chapels within monastic settings also created solidarity between elite patrons and the very monks entrusted with their salvation.

Dedications to Mary Magdalen multiplied away from the capital and court, albeit not to the degree as in Naples or central Italy. In addition to the Quatrario chapel, foundations in the region of Amalfi include the church of Santa Maria Maddalena in Atrani, purportedly founded in 1274 in gratitude for the expulsion

of Saracens from town, a wall painting in San Giovanni del Toro in Ravello, a chapel in the Cathedral of Ravello, and numerous pious donations.[49]

Licensed by a Franciscan archbishop who was closely allied with the pro-Magdalen court, the Quatrario chapel in Amalfi was but one of many lay initiatives in the Cloister of Paradise. No evidence firmly connects the Quatrario foundation to any of the chapel remains that can be discerned along the perimeter of the cloister. However, as with the dedication of the Quatrario chapel, these other devotional spaces indicate the impact of Naples and court-sponsored art on the region. Wall paintings, rather than mosaics, predominate in this liminal area of the cathedral complex. They range from aniconic expanses of faux marble patterns to standing portraits of saints and detailed biblical scenes.

The most detailed surviving narrative in the cloister that dates from the tenure of Archbishop Landolfo represents Calvary, with the crucifixions of Christ and the two thieves (Fig. 80). It occupies one wall in a side chapel and is in poor condition in some patches, having been uncovered during the restoration of 1934.[50] It teems with activity, with clusters of mourners, soldiers, and angels competing for the limited space at hand. Unlike many Amalfitan works of the previous centuries, the painting does not contain inscriptions, heraldry, or donor portraits to illuminate the circumstances of its production and assert a family line. Similarly no surviving documents refer to the artists or patrons involved. Because wealthy townspeople, however, were endowing family chapels in the cloister during the first half of the fourteenth century, it is likely that this painting is the fruit of the same type of lay initiative that was undertaken by the Quatrario clan.[51]

The wall painting in Amalfi has been attributed on the basis of style to Roberto d'Oderisio and dated circa 1335.[52] It is thought to be roughly contemporary with the Crucifixion altarpiece for San Francesco in Eboli, signed *Robertus de Odorisio de Neapoli*, now in the Museo del Duomo in Salerno (Fig. 81). As such the Amalfi work would be an early one of the artist; his long career stretched from around 1330 through at least 1382, when he was named painter to the king by Charles of Durazzo.[53]

The Amalfi Crucifixion raises fundamental questions concerning authorship and its implications for southern Italy in this pivotal time: how official metropolitan art was shaped by "imported" artists working in Naples; how the new styles, approaches, and related devotional practices in Naples were fundamental to establishing the sacral authority of the dynasty; and how such works and ideas were disseminated throughout the *Regno*. A brief discussion of the larger context of artistic and cultural change is necessary, because it reveals the anxieties

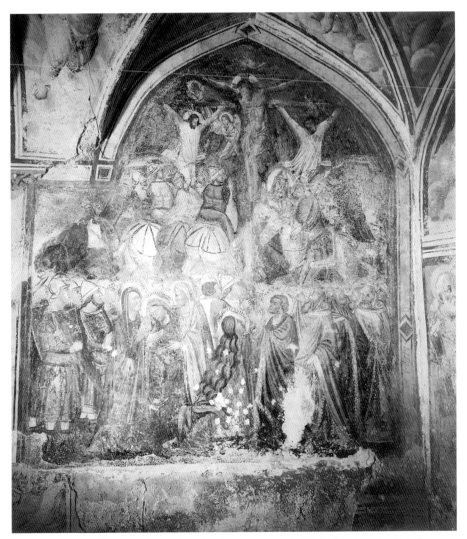

80. Crucifixion, Cloister of Paradise, Amalfi, ca. 1335 (Archivio Luciano Pedicini).

that have surrounded fourteenth-century art in the kingdom for more than three centuries.

First, the codification of the identity of Roberto d'Oderisio merits consideration. It is generally held that Roberto was shaped by the presence of Giotto in Naples. King Robert invited Giotto to the capital in 1328 and decreed him an official member of the royal household or *familiaris* two years later.[54] The works that he and his assistants executed for the crown were in religious and secular contexts: the nuns' choir at Santa Chiara (active 1328–30) and the royal

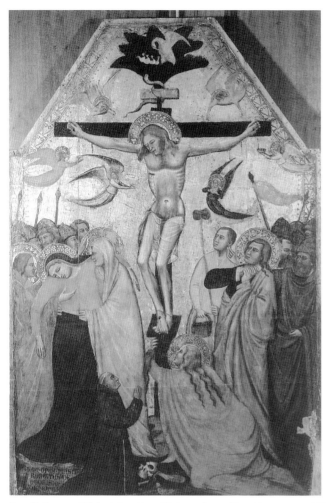

81. Roberto d'Oderisio, Crucifixion, from San Francesco, Eboli, ca. 1332, now in the Museo diocesano, Salerno (Archivio Luciano Pedicini).

residence at Castel Nuovo (active 1330–3). The remains of these projects are meager, consisting of a few fragments of the Crucifixion in the nuns' choir at Santa Chiara and some ornamental borders at the Palatine Chapel of Castel Nuovo.[55]

Giotto's presence in Naples was part of the "opening toward the great art" of central Italy, a shift in taste spurred by the House of Anjou, high-ranking ecclesiastical officials, and their support of the mendicant orders. Many of these patrons hired "foreign" artists who had worked in key Franciscan sites from the 1290s through the 1340s.[56] Along with the sculptor from Siena Tino di Camaino,

Giotto was part of the second wave of this movement, as he followed Pietro Cavallini (arrived 1308), Simone Martini (1317), and others.[57] Many of these artists had large workshops that trained locals, as scores of works of the mid–fourteenth century indicate.[58]

The degree to which these artists were committed to the Angevin court varied considerably. Whether Simone Martini even came to Naples to create the altarpiece of Louis of Toulouse has been a matter of debate.[59] One theory holds that Giotto intended to stay in Naples permanently and completed prestigious portable works destined for Rome and Florence while ensconced in the city.[60] Only after the disastrous flood of the Arno in 1333 and months of intense pressure from Florentine officials did he return to Tuscany to help with the cleanup. Tino remained in Naples in the service of the Angevins from 1323–4 until his death at age fifty-six in 1337.

The prestige of these artists and their indelible mark on the visual culture of the South have affected the scholarly literature in ways that relate once again to the issues surrounding the *Questione del Mezzogiorno*. Their presence in Naples has generated polarities and ambivalence in two areas: first, in discussions of artists who were active primarily in central Italy but who also worked in Naples; and second, in the writings of historians of or from the South, who at various times have longed for "indigenous" rather than "imported" talent and traditions.

Although fueled by the terms and binaries of the Southern Question, this divide between Naples and canonical centers can be seen in the earliest art historical literature. Giorgio Vasari wrote that Giotto came to Santa Chiara because the king "wanted [the monastery] to be adorned with noble painting by him" (*voleva che da lui fusse di nobile pittura adornata*), raising the possibility that Vasari (or Robert) thought no painters of "noble" forms were available in the *Regno* itself.[61] Vasari's neglect of southern artists and monuments in the South, including the Neapolitan interventions of Pietro Cavallini and Simone Martini, seemingly corroborates this view.

A southern discomfort with Vasari pervades the early literature, as Bernardo De Dominici's refutation of the pro-Tuscan bias in Vasari's *Vite* epitomizes. His mid-eighteenth-century collection of the *Lives* of Neapolitan artists claimed to have rediscovered talented medieval painters in addition to showcasing luminaries of the Neapolitan Baroque.[62] De Dominici's writings on the medieval artists are suspect, however; most of the ones that he discussed did not exist.[63] It is as if his references to real practitioners such as *Maestro Simone Pittore* and Antonio Baboccio were added to lend credibility to his falsifications.

Widening this divide are the modern historians of central Italian art who have not always embraced related works found in the South. Leone de Castris, for instance, has lamented what he perceived as a lack of interest in and neglect of Cavallini's late work in Naples.[64] Foundational studies of Tino tend to focus on his works in Pisa, Siena, and Florence and disregard his Neapolitan ones; the later works have been characterized as inferior to his early phase, despite the balance and subtlety of many of his commissions in the South.[65] John Pope-Hennessy's view exemplifies this trend, as he characterizes the Neapolitan works as "imperfect," "tired," and "flaccid," lacking the "energetic" and "tactile" qualities of his early work as well as their "richness or unity."[66] Although it must be said that Tino's work in Naples indeed shifts dramatically to suit the new courtly environment, it is telling that the language used to describe the shift enacts the key North-South binaries of the *Questione*. It characterizes the two phases of his work as modern versus old-fashioned or archaic, humanistic versus monarchical, democratic versus despotic, meaningful versus superficial, and vigorous versus impotent.[67]

Whereas some scholars have dismissed the Neapolitan sojourns of central Italian artists, another perspective holds that these same artists help insert Naples into the Western canon and the discourse of humanism that has shaped the history of Italian art since Vasari. Bologna's magisterial *Pittori alla corte angioina di Napoli* (1969) can be understood on one level as a recuperation and magnification of the humanist accomplishments of the South. Bologna's tireless pursuit of individual artists on whom he bestowed names is a critical part of this project.

Yet at the same time, scholars in the wake of Unification were troubled, as was De Dominici, by the fact that so many key works of art from the late Middle Ages were produced by artists from outside the *Regno* who were hired by foreign monarchs. For Benedetto Croce, the fourteenth century resembled the most famous and fertile periods of Norman and Hohenstaufen rule, which lacked an "indigenous and national character," he wrote. "[T]his history, for which we have provided but a stage, is not our own."[68]

Given what was and remains at stake in the construction of this history – regional pride, cultural legitimacy, perceived slights of the canon, the Europeanization of the South, and so on – identifying the artistic personalities who worked in the South in the early fourteenth century is a fraught endeavor. It is rendered more problematic by the fact that only a few works can be securely attributed to "named" artists for whom a meaningful biography or body of work can be sketched.

The uneven condition of the Amalfi Crucifixion hinders any sort of firm conclusion regarding authorship. Some aspects of the work are indeed reminiscent of the Eboli altarpiece signed by Roberto d'Oderisio, such as the soldier in the lower register who sports the soft melon-colored curls that were a distinctive feature of Roberto's palette throughout his career.[69] But other features in Amalfi do not measure up to the Eboli work, such as the incoherently bifurcated composition and awkward modeling of some figures.[70] The "lesser" quality of the Amalfi Crucifixion has been explained by the fact that the young Roberto was a poor fresco painter,[71] but it seems more likely that the painting was created by a workshop in which Roberto was but one of several members.

Ultimately, the significance of the work for this study derives not from its precise attribution, but from the new spiritual ideals it embodies and their implications for understanding devotional and artistic change. Critical to the diffusion of such ideas were up-to-date works of art in Naples, particularly the wall paintings in the royal convent of Santa Chiara, founded by Sancia in 1310, and in Santa Maria Donna Regina, another Clarissan convent founded after 1297 by Charles II's wife Mary of Hungary.[72]

The most striking features of the Amalfi work correspond to trends in Franciscan art and spirituality in which the suffering of Christ and the turmoil of his followers are emphasized; paintings of this ilk would stimulate an affective emotional and even somatic response in the viewer who thus would achieve a higher level of understanding.[73] In the Amalfi fresco and other contemporary Franciscan works with this imagery (such as the Eboli altarpiece, Crucifixion by the so-called Master of the Franciscan Temperas, and Crucifixion at Santa Maria Donna Regina), the contours of the bent body of Christ are rendered in heavy streaks of white, thereby rendering the dying or dead flesh in sickly and ashen tones. Christ's transparent loincloth exposes the whole of his dying flesh, as it does in the other three works; by contrast, the two thieves in Amalfi wear long white tunics with sleeves that mask their bodily pain and pallor. The viewer, then, can concentrate on the exceptional agony of Christ and intense sorrow of his followers, an idea that was emphasized in such Franciscan manuals as the *Meditations on the Life of Christ.*

Far from merely displaying a painter's naturalistic bravura, the transparent loincloth has been identified as a Franciscan motif derived from Byzantine preoccupations with the humanity of Christ.[74] Entering into Franciscan pictorial lexicons as early as the 1280s, these loincloths also testified to Jesus's poverty, his literal and figurative nakedness, as well as Francis's – the key but divisive

underpinnings of Franciscan ideology. Transparent loincloths were frequently painted by Giotto, including at Santa Chiara in Naples, the Lower Church of San Francesco in Assisi, and the Berlin Crucifixion. The Amalfi painters perhaps came to appreciate the expressive and ideological power of this motif through studying Neapolitan examples by Giotto or Cavallini or by training in the workshops that produced them.

The Amalfi work also focuses on the suffering of Jesus's followers. In both the Eboli and Amalfi works, the Virgin wears a red tunic under a long blue cloak with a gold border – not of course an unusual sartorial arrangement for her, and one that functions in part to distinguish her from surrounding characters. But Mary's red tunic also links her emphatically to the abject and prostrate figure of Mary Magdalen at the base of the cross, and (particularly in the vivid Eboli work) to the blood of Christ, iconographic details rooted in Franciscan spirituality, affective piety, and modern theories of penance.[75] An anonymous Franciscan from Marseilles summarized the value of such intense imagery when he preached, "So if we see someone weeping, we weep with him.... And so, when regarding Mary Magdalen we see her anxious, sorrowful and tearful, we too should be anxious, sorrowful and tearful along with her. If indeed you are a sinner, she gives you an example of weeping so that you will weep with her."[76] Just as the Magdalen's tears were fundamental markers of her conversion from sinner to saint, so the penitential tears of the pious viewer are potentially redemptive.

Some stylistic features of the Amalfi Crucifixion, such as the bulk of the figures and their complex, foreshortened positions in space, testify to the impact of Giotto, possibly through his work at Santa Chiara. Yet in the overall composition, the Amalfi painting is more closely aligned with the Crucifixion at Santa Maria Donna Regina than either to Giotto's spare frescoes at Santa Chiara or to Cavallini's at San Domenico[77] (Fig. 82) Attributed to the workshop of Cavallini and likely painted in the early 1320s, the scene at Donna Regina includes the crucifixion of the two thieves, prominent swooning female figures, and many distressed earthly and angelic witnesses, including one angel ascending to heaven with the soul of the good thief. Members of the Amalfi workshop knew the Donna Regina painting and possibly had worked in some capacity at the convent before leaving the metropolis for small, distant commissions such as this one. The Franciscan Archbishop of Amalfi, a Neapolitan himself with close connections to the court, surely would have approved of the fresco in the cloister chapel or even facilitated its creation, because it was so reminiscent of one recently created for the Clarissan convent under royal patronage. In the case of the cloister Crucifixion, then,

works designed for a prominent mendicant foundation in the capital provided the basis for a painting in the margins of episcopal space in Amalfi.

The medium, style, iconography, and devotional implications of the Amalfi fresco demonstrate that cultural signals were coming from outside Amalfi proper and outside its previous frames of cultural reference. The deeply entrenched Mediterranean practices that had long informed Amalfitan taste shifted toward "mainstream" Italian art, as the residents of the coast took their cues from the hegemonic power of Naples and the various preferences of the crown.

Toro Redux

A dynamic site of private patronage in the era leading up to the heyday of the Rufolos, the church of San Giovanni del Toro in Ravello also exemplifies the new patronal trends of the fourteenth century. The church remained a center of local piety for the Toro district well into the 1400s. Commissions, endowments, and burials underscore the particular importance of the church in the care for the dead. Benefactors donated shares of industrial and agricultural holdings on the coast to endow masses and burials at San Giovanni, for instance. Land as far away as Giovinazzo in Apulia was leased to the church to support commemorative liturgies.[78] A text dated 1412 refers to a cemetery and related chapel at the church, and later sources mention large-scale funerary monuments.[79]

The material remains of the vital fourteenth century appear throughout the church – in the nave, crypt, and small side chamber that links the bell tower to the north aisle. These works of art consist of several wall paintings and a relief of St. Catherine. As in the case of the Amalfi Crucifixion, they indicate a shift away from the art of the twelfth and thirteenth centuries. Instead, the fourteenth-century works at San Giovanni are indebted to innovations associated with central Italian artists and the cult practices supported by the court in Naples.

THE BOVE PULPIT IN THE FOURTEENTH CENTURY. Complete with marble reliefs, mosaics, and glazed ceramics bearing Arabic inscriptions, the so-called Bove pulpit in San Giovanni is a consummate example of the art of *mercatantia* and dates from ca. 1230 (see Figs. 42 and 70). A series of additions that were made a century later are as representative of their time and testify to the same cultural forces that shaped the Crucifixion chapel in the Cloister of Paradise. One wall painting from around 1340 depicts Mary Magdalen's encounter with the resurrected Christ (the *Noli me tangere* episode of John 20:14–18); this scene runs along the lower part of the stairs that faces the nave (Fig. 83). Painted fictive revetment anchors these

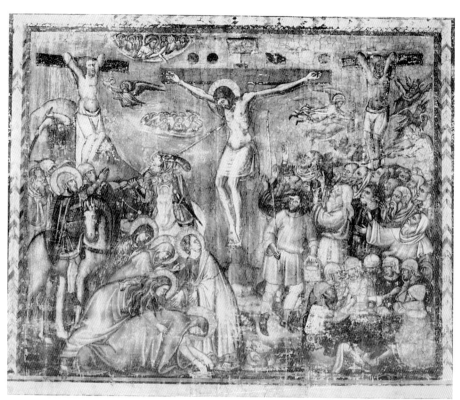

82. Followers of Pietro Cavallini, Crucifixion, formerly in Santa Maria Donna Regina, Naples, now in the Museo Civico, 1320s (Copyright Alinari/Art Resource, NY).

compositions within the structure of the marble pulpit. The paintings replaced intessellated panels of the early thirteenth century, which would have featured abstract designs and bird motifs, judging from the surviving pieces of the pulpit and from earlier furnishings in Salerno.

The themes of the new paintings signal that the Bove pulpit served a funerary function, bringing its liturgical and functional practices in line with those at the Cathedral of Ravello.[80] As discussed previously, the Rogadeo pulpit in the cathedral served as a burial site for the bishop-patron Constantine, and the Rufolo pulpit sheltered a funerary chapel that commemorated the paterfamilias, Nicola. In the case of the Rufolo pulpit, an altar was set inside a niche in the base of the pulpit stairs; this exact configuration appears in the Toro piece. It is not clear if that altar served one person, a family, or the community as a whole.

The large and prominent *Noli me tangere* on the side of the pulpit facing the nave signals the influence of Angevin devotional practices on the Ravellese in the

83. *Noli me tangere* addition to the Bove pulpit, San Giovanni del Toro, Ravello, ca. 1340.

fourteenth century. In addition to the scene's basic Magdalene subject matter, its composition, iconographic details, and style further demonstrate an indebtedness to widespread cultural and artistic trends associated with the mendicant orders. As with the Amalfi Crucifixion, this work indicates the impact of Giotto and Pietro Cavallini on the coastal region, as the composition closely evokes versions of the scene in the Arena Chapel in Padua and the Brancaccio Chapel in San Domenico, Naples, both of the first decade of the fourteenth century.

The Toro fresco presents basic features found in these earlier works, including the general arrangement of the figures, the golden hem of Christ's white cloak, and the flag he clutches in his left hand. But the work in Ravello is not a close copy of any single version of the story; it reads as an amalgam working within these pictorial traditions. With its level horizon line and landscape interrupted by three trees, the painting is more aligned with Giotto's spare composition in Padua than Cavallini's busy one. Other details, however, such as Christ's tunic that falls in rigid V-shaped folds or the small piece of his cloak that rests precariously on his shoulder and outstretched arm, are unusual features that also appear in San Domenico (Fig. 84).

Other characteristics are without parallel, such as the fairly upright posture of the Toro Magdalen; she does not lunge toward the resurrected Christ or regain balance with her left arm, as at San Pietro a Maiella in Naples (ca. 1340). In fact her hands seem closer to forming a gesture of supplication or prayer than reaching in fear or desperation. The artist(s) seemingly adjusted the pose of Christ to suit her relatively composed stance. He is not turning energetically away from her, as at Padua, or gazing in her general direction but not at her, as at San Domenico. His extended hand, first angled toward hers and repainted in a more upright position, neither pushes her away nor reaches toward her. Her eyes focus on

84. Pietro Cavallini, *Noli me tangere*, San Domenico Maggiore, Naples, ca. 1308–10.

this ambiguous gesture. The scene does not emphasize disconnection, fear, and apprehension, but rather spiritual connection, in this case seemingly achieved through contemplation and prayer.

In contrast to the abstractions and motifs of the earlier pulpits, the emotional intensity and relative naturalism of the wall paintings were typical of the devotional focus of the early fourteenth century, as described earlier. Mary Magdalen was appreciated at that time for her perseverance and penitential capacity, which had, after all, enabled her to renounce her debauched past of money and men and to be the first person to see Jesus after his resurrection. "Magdalene, then, was very rich, and sensuous pleasure keeps company with great wealth," as Jacopo da Varagine wrote of her life before her conversion.[81] Her wealth and the risks it carried should be underscored in the context of this private church in the elite Toro district of Ravello. In addition to the *Golden Legend*, late medieval Dominican and Franciscan sermons on the Magdalen repeatedly emphasize her triumph over vanity as spiritual lessons for women of means in particular.[82]

In the Toro fresco, Mary Magdalen looks as if she is praying, not reaching; so the viewer too should pray for the recently deceased, who like Jesus may be resurrected. Rather than revealing the distress and uncertainty of the Christian community in the days following the Crucifixion, the Toro scene emphasizes connections to Christ and faith, and the access of all believers – even former prostitutes, vain women, and rich merchants of questionable ethics – to proper devotional practice and penance.[83]

THE GROTTO OF ST. CATHERINE OF ALEXANDRIA. In the corner of a side chamber or sacristy in San Giovanni del Toro is an unusual devotional space that leads to a relief sculpture of St. Catherine of Alexandria (Figs. 85 and 86). Uncovered in 1893, this space displays the materials and technique found in so many Amalfitan buildings: a thick layer of plaster molded into particular forms.[84] Here, however, the stucco does not articulate traditional architectural elements such as ribs or pendentives. Instead, its irregular protrusions and recessions describe the rough rocky surface of an inhabitable cave. The relief of St. Catherine is also rendered in stucco. No documents illuminate the date, artist, or patron of this unusual work. The few brief references the relief have dated it on the basis of style to the mid-1300s.[85]

Protruding about ten inches from the wall at the head, the Toro relief is one of the more sober and restrained stucco works in the South. Unlike the dramatic freestanding forms of the Spina pulpit, the work indicates that stucco technique

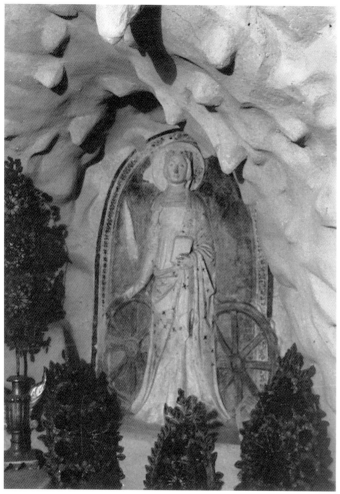

85. Stucco relief of St. Catherine of Alexandria, San Giovanni del Toro, Ravello, mid–fourteenth century.

related to the process of wall painting as well as to stone carving; the relief was generated from liquid forms built up from the wall that were then sculpted and painted. The Toro relief calls to mind the three-dimensional plasterwork described by Cennino Cennini, in which haloes or crowns protrude from the plane of a painted wall.[86]

Although the surface of the relief indicates that it has been reworked in places (the paint of the eyes, for instance, the form of the nose, hair on the right side, and palm frond), the polychromy appears to have been spare yet effective. The painted frame injects formality and order into the organic space of the cave, for it

features a band of intessellated star patterns akin to those found on twelfth- and thirteenth-century liturgical furnishings in the South, including the Bove pulpit in San Giovanni itself. The dark blue and red background serves to highlight the light cameolike body of the saint.

The figure of Catherine stands in a serene, frontal pose, one typical of full-length images of saints on the wings of fourteenth-century altarpieces or in wall paintings.[87] This stance seemingly befits her royal birth, intelligence, and keen sense of purpose that Jacopo da Varagine portrayed so vividly.[88] Delicate molded brocade and painted gold and red patterns on Catherine's dress denote her life in Alexandria, a textile emporium in the later Middle Ages.

This relief concentrates meaning by multiplying the attributes of hagiographic representation. Nestled between Catherine's body and the painted arch that frames the scene are the spiked wheels that Maxentius devised to torture her, but that were destroyed by angels before they did much damage to the martyr.[89] The Toro image is unusual in that there are two large wheels, unlike the single, miniaturized, and thus tamed attribute typical of medieval imagery. She holds a palm frond in her right hand and a closed book in her left one, the latter a reference to her adherence to the new Christian Word that also alludes to her Alexandrian education in "theoretical, practical, and logical philosophy" (*Golden Legend*) and "Grecian literatures, and . . . the languages of all nations" (*Menelogium Basilianum*).[90] Her learned eloquence was the weapon that converted, silenced, or outraged her contemporaries.

The Toro relief is one of many representations of St. Catherine that multiplied across Italy during the fourteenth century in fresco cycles, altarpiece wings, narrative reliefs, tombs, and single votive paintings. In the South, these works were in both high-profile settings under royal patronage and ones distant from the metropolis. The painted decoration of the Clarissan convent of Santa Maria Donna Regina incorporated at least four scenes from her life into its overarching Christological imagery, for instance.[91] A series of narrative relief sculptures were created for the choir of Santa Chiara in the 1340s.[92] One of Tino's devotional relief panels from his Neapolitan period depicts Catherine to the right of the Virgin and child; John the Baptist is on the opposite side.[93] Other works suggest royal efforts to disseminate the cult in places distant from the capital, such as Brindisi and Ottanà.[94] Many noble tombs from Naples to Gerace indicate the success of that effort.[95]

Because Catherine renounced her royal privileges and considerable wealth, was exceptionally learned, eloquent, a preacher (to the extent that women could

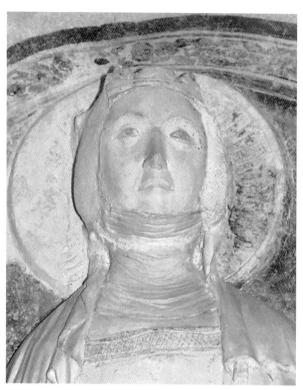

86. Detail of relief of St. Catherine of Alexandria, San Giovanni del Toro, mid–fourteenth century.

be), and was so pious that she earned the ire of her contemporaries, it is not surprising that representations of her proliferated during the reigns of Sancia and Robert. After all, these figures could be described in similar terms. The devout and articulate Robert was well known as a sermon writer, Sancia wished to abdicate and join the Clares, and both of them supported the heretical Spiritual wing of the Franciscans. Their affinities to that order were far from superficial. Robert was tertiary member, frequently donned the order's rough habit, and was buried in that garb. Sancia described herself as the "true mother of the order of blessed Francis."[96] Their extended families were also exceptionally pious.[97] Robert's mother founded the Clarissan convent of Santa Maria Donna Regina and participated in its liturgies in a limited way. The siblings of the queen and king, James, Fernando, and Philip of Mallorca and Louis of Toulouse, all rejected their royal responsibilities at some point to pursue monastic vocations. While the unusually fervent piety of the Angevins tends to be seen in terms of their devotion to Francis, Clare, Mary Magdalen, and their own Louis of

Toulouse, Catherine belongs within this matrix as well, albeit in a less prominent role.

Catherine's cult perhaps grew on account of Mary Magdalen's resurgence that followed the vision-dream of Charles II. Catherine's holy career loosely resembled that of her predecessor, as Jansen has observed.[98] Both were wealthy women who rejected the material comforts and privileges of their kin and embraced the risks and challenges of preaching Christianity in hostile settings. Both were effective as evangelizers, the Magdalen's charismatic authority stemming from her penitential about-face and its promise of salvation for all sinners, Catherine's from her intelligence, confidence, and commitment to virginity (in Tino's devotional relief mentioned above, the pairing of Catherine and John the Baptist reinforces this missionary association).[99] As pendant role models, particularly within the female monastic settings in Naples, together they would have appealed to a broad spectrum of believers of diverse social, economic, and religious experiences and personality types. In short, Catherine can be seen as the composed, well-educated, and thus "noble" equivalent of the Magdalen's emotionally fraught and once-fallen woman.

The Toro relief seemingly takes its cue from royal and other Southern projects. The degree of relief and proportions of Catherine resemble such French Gothic figures as Mary on the wall tomb of Isabelle of Aragon in the Cathedral of Cosenza. Completed by artists from the Île-de-France, this viscera tomb of the queen of France (d. 1271) is an early example of "imported" art during Angevin rule, but the style and effect of the Toro relief show a greater affinity to later works in Naples. Catherine's posture and confidence call to mind the caryatids of the tombs of Tino and figures sculpted by his successors, Pacio and Giovanni Bertini of Florence (e.g., personifications supporting the tomb chest of Mary of Valois in Santa Chiara; Prudence on the tomb of Robert in Santa Chiara, begun 1343).

In its aesthetic effect, the Toro sculpture is closely aligned with the reliefs at Santa Chiara (Fig. 87). Almost entirely destroyed in the bombardment and fire of 1943, the reliefs represented eleven key episodes from the life of Catherine. Consisting of a series of stage sets in light marble protruding from a dark background, the narratives conveyed the same cameolike aesthetic of the Ravello relief. Inscriptions along the bottom of the piece identified the scenes that unfolded above them, including a wealth of illuminating narrative details.[100] This work has been dated on the basis of style to the 1340s, although its precise attribution remains a matter of debate.[101]

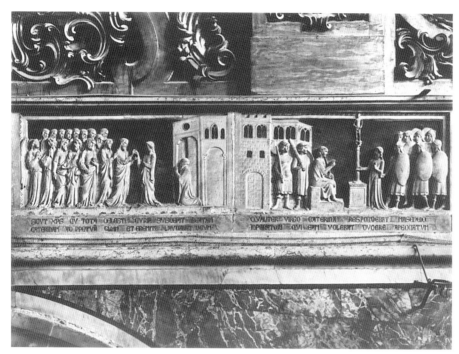

87. Generally attributed to Pacio and Giovanni Bertini, scenes from the life of St. Catherine of Alexandria, originally in Santa Chiara, Naples, 1340s (Copyright Alinari/Art Resource, NY).

As a single figure, the Toro Catherine displays formal affinities to a variety of small-scale objects and tomb sculptures that date from the 1270s through the 1340s. In its effect, it is most closely aligned with post-Tino Angevin works. Accordingly the Toro relief can be dated roughly to the period 1337 to 1350. Although it belongs to the same social and religious context that placed Catherine of Alexandria in favor at that time and shows receptiveness to authoritative works in royal settings, it does not replicate such works as the Santa Chiara reliefs. Rather, the relief appropriated aspects of those works and departed radically from them by working within a devotional ensemble that includes a fictive cave.

This larger setting of the St. Catherine relief reproduces one of the more unusual features of the Christianized landscape of Amalfi. Several caves were noted as shrines, healing sanctuaries, or hospitals in the later Middle Ages, in addition to housing hermitages and small monastic communities as at Santa Maria de Olearia outside Maiori.[102] The church of Sant'Angelo dell'Ospedale in Ravello was cut into the rock below the Toro church, and is first mentioned in documents of 1039 and 1107.[103] A grotto of St. Cosmas was

hollowed out of the southern face of the plateau of Ravello. First recorded in 1285 and dedicated to the saint who with his brother Damian offered free medical treatments in the early fourth century, the grotto was likely a healing site.[104]

Such foundations indicate the tenacity of cultural strata that did not require the tidy, regularized structures and ornamentation of official architecture and the institutional church. As alternative religious sites, they were physically and culturally local phenomena. The Toro ensemble was not unique in its efforts to recreate such organic settings; a grotto was constructed in a side aisle of Saints Cosmas and Damian in Amalfi, for instance. The Archbishop of Amalfi Andrea d'Alagno founded a *presepio* (or crèche) chapel there in 1324, following St. Francis's actions at Greccio and Arnolfo di Cambio's monumentalization of them in Santa Maria Maggiore in Rome.[105]

In the case of the Toro grotto, stucco was used to bridge the gap between natural and man-made architecture, to bring an artificial cave into a church interior. The material also blurs distinctions between sculpture, painting, and architectural enclosure by creating a unified surface comprised of a single material. Furthermore, it mediates between local cult practices and new images or styles of representation imported from central Italy via Angevin Naples. In other words, although the patrons at San Giovanni del Toro were clearly receptive to prestigious works of art in the capital and able to appropriate some aspects of them, they transformed those same works to suit their own cultural realities. Stucco played a fundamental role in this process of recontextualization.

New Arenas of Lay Patronage: Burial Practices and Funerary Art

As is well known, the liturgical technologies surrounding death – funerary masses, altars, tombs, and the like – were increasingly central to late medieval life, particularly after the codification of the doctrine of Purgatory.[106] This salvational economy was primarily fueled by the dying and their relatives who were anxious to secure eternal well-being. Various types of institutions also participated in this economic system and at times competed for the considerable resources involved.

An extreme case of friction between long-established authorities and the new mendicant orders occurred in Salerno. In 1288, a frail Florentine merchant who had joined the Franciscans wished to be buried in their Salernitan church.[107] During his funeral, the bishop of Salerno and a group of canons stormed the

church, attacked the friars, and kidnapped the corpse, which they buried in the cathedral cemetery. Later they returned to hurl rocks and abuse at the friars, destroy books and vestments, and even strip some of the friars naked. This battle of wills stopped only when Nicholas IV intervened and told the cathedral faction to behave. The episode reveals that while pious individuals, friars, or church officials could readily disapprove of greed, they could equally be seduced by the promise of money.

Amalfitan documents pertaining to the endowments of funerary chapels, masses, and burials testify to the shifting roles of various institutions in the care for the dead, from private foundations to mendicant houses and cathedrals. Although they are fragmentary and their language often generic, they also suggest the monumentalization of funerary art, as do many extant works of art.

Because one of the primary functions of private churches was eschatological, they were key burial sites during the heyday of lay patronage, as already seen at Sant'Eustachio in Pontone. In the fourteenth century, new foundations continued this tradition (SS. Annunziata, Ravello, Santa Maria Rotunda, Minori), and old ones often developed adjacent cemeteries (San Giovanni del Toro).[108] The effigy tomb slab of Filippo Spina (d. 1346) in San Giovanni, Pontone is one of the few surviving examples of monumental lay burials in private churches from this time. Of approximately the same date is the slab of Sapia de Vito, the widow of Giovanni Freccia, lieutenant and protonotary of the kingdom under Giovanna I (Fig. 88). Complete with a long inscription and heraldry of the de Vito and Freccia clans, this effigy of the opulently dressed woman lies in Santa Chiara in Ravello, where Sapia likely retired following the death of her husband. Her clan had provided the initial donation that established the convent in 1297.[109]

In the case of the private churches around Amalfi, bodies in graves belonged to the body of the church, and responsibility for them therefore partook of the share-based system of ownership. Leone Sclemati donated his *portione* of the church of Santa Maria Betrana in Minori to Sigimondo Biniolo in 1197, including houses, chestnut groves, codices, furnishings, and burials (*sepulturis*).[110] This *portione* entailed obligations for the new owner. In addition to gaining valuable agricultural resources and liturgical essentials, Sigimondo became responsible for the graves and caring for the souls of their inhabitants, who had likely endowed serial obsequies.

References to burials within cathedral churches are less common and follow the spatial conventions established in the previous chapter. Requests for burial within cathedral spaces increased markedly after the year 1300, but were also

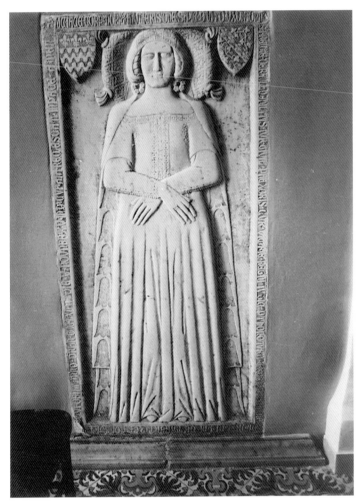

88. Tomb slab of Sapia de Vito, Santa Chiara, Ravello, 1340s (Ferdinando Serritiello).

present in earlier centuries.[111] Other sources indicate that cemeteries affiliated with the dioceses were sometimes located near the churches, and other times in distant locations.[112]

In contrast to the volatile situation in Salerno, financial support or patronal activities in one type of institution around Amalfi did not preclude comparable arrangements in another. The will of Mitula Rufolo (dated 1351) endowed weekly masses for her grandfather Nicola to be sung in the Cathedral of Ravello in the funerary chapel under the Rufolo lectern. She was to be buried, however, in the church of Trinity, a Benedictine convent.[113] In 1392, the widow Letitia Freccia donated a large, complex house and adjoining lands in Ravello to the Clarissan

convent in Ravello, but endowed funerary masses in chapel of San Giovanni a Ponticeto.[114] Similarly, in his will of 1394, Giovanni Rufolo was to be buried in the church of the Clares, along with his mother and sister. He endowed weekly masses there, as well as in the *Cappelle de Rufulis* under the pulpit in the Cathedral of Ravello.[115]

The Rufolo-Coppola Commissions in the Cathedral of Scala

The largest preserved sepulchral monument on the coast does not belong to a high-ranking ecclesiastical authority such as Landolfo Caracciolo or knight such as Pietro Sasso, but to a female member of the Rufolo family. This canopy tomb

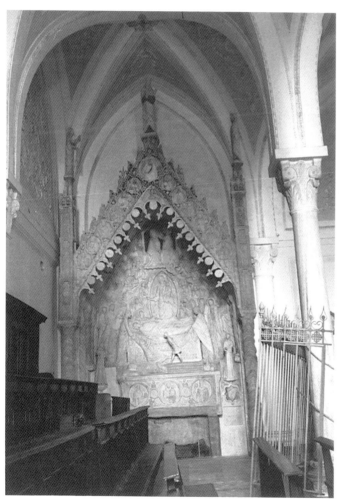

89. Tomb of Marinella Rufolo Coppola, crypt, Cathedral of Scala, 1332.

of Marinella Rufolo stands in the crypt of the Cathedral of Scala, a peripheral zone in the episcopal space[116] (Fig. 89). An inscription, now lost, recorded the identity of the deceased, and another refers to her husband, Antonio Coppola, as the founder of an adjacent chapel.[117] The second inscription provides the approximate date of the work, 1332.

Heraldry corroborates the epigraphic evidence. Located on the upper canopy and on the wall near the sarcophagus, a shield represents the Coppola coat of arms, with its distinctive cup (or *coppa*) and "A" for Antonio. A second device accommodates the Rufolo coat of arms, including the diagonal stripes and three fleurs-de-lis. Although the exact nature of Marinella's involvement in her tomb design cannot be determined, later documents attribute the Coppola name to the environment of the tomb.[118]

The site, scale, and elaborateness of the tomb are expressions of Marinella's social prestige following her marriage to Antonio Coppola, a nobleman from Scala. In their heyday, the Rufolos had consistently married members of other well-to-do families in Ravello, such as the Della Marra and Freccia clans, many of whom were similarly involved in *mercatantia* and the administration of the kingdom. After the Vespers affair and the execution of Lorenzo, the family's marriage alliances are harder to trace, for most apparently took place in the burgeoning capital of Naples. The unusual Coppola-Rufolo union undoubtedly brought renewed prestige to the beleaguered family in its homeland.

As one of the best preserved of the many stucco works in the South, the tomb of Marinella helps reconstruct the significance of this group of monuments. Adhering to a wooden skeleton, the stucco here is light, flexible, and emulates a variety of other materials and techniques. Blurring the material and aesthetic distinctions between wall painting and sculpture, it was painted and in places preserves its polychromy far better than other medieval works in marble or bronze.[119] Whereas stucco monuments in the South were worked to resemble various media, including architectural forms, freestanding sculpture, marble reliefs, or paintings, the forms of the Scala tomb partake of all of these genres.

The monument consists of three components, a raised sarcophagus with an effigy, a large canopy, and a background relief. The effigy is in poor condition, as the contours of the face are eroded – a drawback of this relatively soft material.[120] Marinella's hands are clasped, and two small dogs (now beheaded), common signs of courtesy and chivalry, rest at her feet. Connecting circular frames or medallions on the face of the tomb chest, another widespread motif, enclose half-figure reliefs of St. Anthony Abbot, the Virgin and Child, and St. Nicholas of

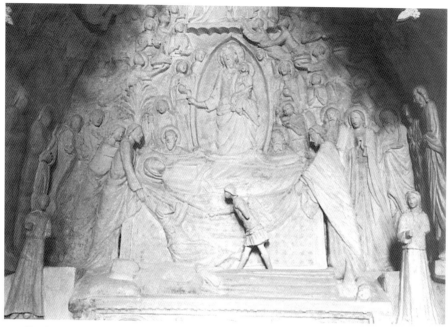

90. Background relief of the Dormition and Assumption of the Virgin, tomb of Marinella Rufolo Coppola, Cathedral of Scala, 1332.

Bari. Flanking the central medallion are small figures of Marinella and Anthony, who kneel in prayer. The piece emulates contemporary marble sarcophagi, with its smooth, bright surface and sober, symmetrical reliefs.

The baldachin explores the expressive potential of stucco with its intricate micro-architecture, busy ornament, and panoply of figures. The structural elements reduce local building traditions to a minute scale. The two columns supporting the baldachin bear bands of chevron ornament. Paired leonine column bases carry tiny twisted columns in the upper register of the pinnacles; their tower summits sport miniature windows, bells, and crenellation. Fleurs-de-lis pop up from the edges of the canopy. Vines with grape bunches meander along the face of the canopy and sprout crocketlike buds along its outer edge. Along with the miniature columns and leonine bases, these same vines appeared on the Spina pulpit in Minuto, indicating that the two works must have been created by the same workshop.

The back wall of the monument is carved in varying degrees of relief. The quintessential Marian themes of Gothic art, the Dormition, Assumption, and Coronation of the Virgin, are all represented, with the narration proceeding from the effigy up to the apex and pinnacles of the canopy (Fig. 90). Angels and

other heavenly figures are the attentive witnesses and create a single background that is appropriate for all three scenes. The figures vary from the freestanding archangel before the Virgin's bier to the choir of angels who fade into the wall.

This iconography was far from unusual in the twelfth and thirteenth centuries, constituting as it did the leitmotifs of Gothic portal design in France, Germany, and, to a lesser extent, Italy (e.g., Cathedrals of Florence and Orvieto). In Naples proper, a fresco cycle of the life of the Virgin in a chapel in the Franciscan church of San Lorenzo includes a Dormition scene; this work of the first decade of the fourteenth century is sober and spare relative to the crowded and populated scenes of Scala.[121] Other southern works, including the Farfa Casket and wall paintings of the Dormition in Rongolise near Sessa Aurunca and Santa Maria delle Cerrate near Lecce, express this iconography in the stylized, often Byzantine terms typical of earlier art in the *Regno*.[122]

The *Golden Legend* is a likely textual source for the Scala tomb in addition to many other Western images; most of the narrative details of the tomb correspond to those in Jacopo's account of the Dormition and Assumption.[123] Clusters of attentive apostles and angels appear as witness in both versions. Palm fronds, a recurring motif in the relief, have a multifaceted role in the text: an angel presents one to Mary when she first expresses her wish to join her son in heaven; the Virgin asks John to carry it next to her bier to protect her and the apostles from dissenting Jews; and the high priest cures the blindness of the new converts by waving the same palm before them.

This same account also informed the composition of another work of art created for this funerary environment, a large polyptych commissioned by Antonio Coppola for the chapel adjacent to Marinella's tomb[124] (Fig. 91). As with the tomb, the funeral bier of the Virgin anchors the painting, Christ hovers above the bier and holds the soul of Mary, and her Coronation unfolds in an aedicula borne by angels in the triangular central apex of the polyptych. Standing portraits of the saints Nicholas, James, Julian, and Anthony Abbot (to whom the Coppola chapel was dedicated) occupy the side panels. Its attribution to Roberto d'Oderisio on the basis of style is sound.

Although the Marian stories depicted on the tomb and polyptych are far from identical, the two works are contemporary and closely related. The same saints that are sculpted on the sarcophagus appear in the wings of the altarpiece, for example. Subsidiary figures such as the Annunciate Virgin appear in both works in comparably peripheral sites: the pinnacles of the canopy on the tomb and the

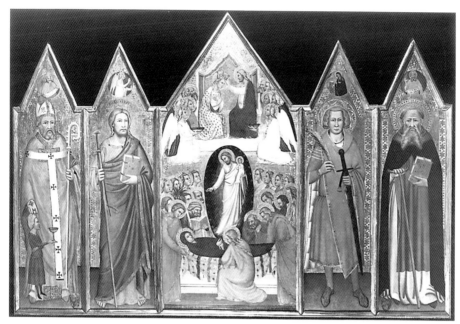

91. Roberto d'Oderisio. Coppola Polyptych, formerly in Scala, ca. 1330. Private Collection, Italy (courtesy Pierluigi Leone de Castris).

gable of a side panel on the altarpiece, for example. Furthermore, both works include an unusual amount of yellow and red. An inscription establishes that the polyptych was the fruit of Coppola patronage and secures the connection between the two works.[125]

Previous scholarly interest in the panel painting derived from the premise that it replicated a lost altarpiece by Giotto in Naples.[126] That work, referred to as a *pictura unius cone dipicte* in a document of 1331, was commissioned for the royal chapel dedicated to the Assumption in Castel Nuovo. Hence, Giotto's *cona* probably exhibited the same basic Marian imagery (or a part thereof) that appears on the Coppola works.[127] For these reasons, the Scala polyptych has been seen primarily as a substitute for a prestigious royal commission, a provincial reflection of a metropolitan ideal. Not surprisingly, then, the tomb itself has generated negligible interest, because it has been perceived as one step further removed from the originary Giotto.

It is plausible that Roberto d'Oderisio appropriated for the Scala polyptych the imagery of the Castel Nuovo *cona*, with the flanking panels replacing a wider audience of witnesses such as those painted by Giotto in the Berlin Dormition dossal and Coronation in Florence.[128] Some of the compositional and stylistic

similarities between the polyptych and these other altarpieces of approximately the same date are not merely formulaic details associated with this widespread iconography.[129] Such pictorial references to the royal commission in Naples help reconstruct the long career of Roberto d'Oderisio. As mentioned earlier, he likely was an apprentice in Giotto's large workshop and left Naples around 1332 for such projects as the Crucifixion for San Francesco, Eboli. But his familiarity with Cavallini's work in Naples was also formative, as the earlier discussion of the Amalfi Crucifixion established.

Although the threads linking Roberto d'Oderisio, Giotto, Scala, and Naples have brought the Coppola commissions out of obscurity, basic issues concerning the tomb and polyptych have not heretofore been studied in detail, including their individual features, circumstances and techniques of their production, and larger implications. One key point about the works that has been somewhat neglected is that Giotto's articulation in a courtly setting of this widespread Marian imagery was perceived as an appropriate starting point for the two monuments in the Scala crypt. The imagery was then fundamentally altered to suit this new funerary context.

The setting of the Coppola commissions renders such Marian iconography both surprising and surprisingly apt. Few late medieval tombs in Italy call on these iconographic themes to articulate the eschatological concerns of the dead and their families; images of the Crucifixion, Man of Sorrows, or Virgin and Child predominate instead. The use of Marian narrative in Scala is appropriate and intelligent, however, particularly in the case of the tomb, where an ascending hierarchy of literal and pictured bodies magnifies the hope of salvation. The lowest register of the monument is the tomb chest, which held the literal corpse of Marinella Rufolo Coppola; her recumbent effigy, the peaceful and permanent representation of the dead, lies on top of the chest. Immediately above the tomb and effigy is the funeral bier that supports the lifeless body of the Virgin in an identical pose, two visual parallels to the tomb and recumbent female figure below. Above this scene is Christ cradling Mary's soul, and above that, Mary reinhabits her body and sits enthroned next to Christ, ready to receive the crown of heaven. The structure of the tomb implies that Marinella will follow Mary, even partake of the Virgin's upward momentum, and attain heavenly salvation at the right hand of Jesus. The onomastic play between the names of the two women reinforces this parallel. The Coppola altarpiece, meanwhile, widens the community of witnesses and intercessors for Marinella and Antonio by incorporating the four attentive saints in the wings.

While Giotto's altarpiece in Castel Nuovo was likely a key referent in the Coppola commissions, the tomb of Marinella evokes a second Neapolitan workshop, one headed by the sculptor Tino di Camaino. During his early career in Tuscany, Tino produced a number of works that apparently impressed the royal family (for example, the altar of San Raniero in Pisa, 1306; the tomb of the bishop Antonio Orso in Florence, ca. 1321). King Robert invited Tino to Naples in 1323, where he created a series of canopy tombs for the Angevins and other high-ranking ecclesiastical and administrative officials.[130]

Tino's emphasis on canopies connected the Angevins to the burials of their predecessors in the South, including the Hautville and Hohenstaufen monuments in Venosa and Palermo, and of ecclesiastical authorities in Rome and environs.[131] They also helped diffuse the conventions of Gothic tomb design in the *Regno*, including narrative additions and caryatid personifications.[132] Thus Tino's works share basic design principles with Marinella's tomb: an elevated tomb chest with reliefs either in medallions or arcades, an effigy, large canopy with Gothic architectural motifs such as trefoils, crockets, and so on, and accompanying sculpted figures, such as clerics performing obsequies or angels.

The tombs of Tino and his workshop in Naples were largely produced in the mid-1320s and early 1330s – that is, in the last decade of Marinella's life. Three of the four early royal monuments were for Catherine of Austria (Fig. 92), Mary of Hungary, and Mary of Valois. These monuments did not necessarily define a tomb type specifically appropriate for women's burials, as there are considerable overlaps between them and the tomb of Charles of Calabria (d. 1332). But as an impressive corpus of work manufactured within a decade, they established a precedent for large-scale grave markers for women, a concept that previously had not been prominent in southwestern Italy. Naples thus presented to *regnicoli* a distinguished group of women's monuments, which were recognized as promising models by potential tomb patrons and artists alike.

The tomb in Scala deviates from the metropolitan corpus in its use of stucco. It is possible that Marinella and her family selected this more humble material for the creation of the large canopy tomb, which was probably the first of this design type in the region of Amalfi. Stucco offered a safer and less ostentatious alternative to traditional marble, a trait that would have been appealing given the widespread critiques of opulence and display.[133] Perhaps stucco also articulated a class distinction that expressed Marinella's difference from royals and nobles in Naples, thereby indicating a social hierarchy of funerary monument types akin to those discerned in Florence.[134]

Stucco, then, would have been somewhat less prone to the criticisms voiced in countless moralizing sermons that chastised the rich for their vanity, ostentation, and love of earthly beauty as opposed to spiritual sustenance. In late medieval retellings of the myth of Barlaam and Josaphat, a pious king tests his adversaries by making them choose between caskets made of gold and ones of haircloth and wood. The latter contain precious stones and perfumes, whereas the former are full of putrid matter. Seduced by opulence, they select the putrid, thereby demonstrating their failure to cultivate the notion of interior Christian beauty and focus on the inevitable end of Christian time.[135] By the fourteenth century, not all preachers equated displays of wealth with sin; in a funerary oration likely penned around 1309, the Dominican Giovanni Regina preached a modern concept in Naples: that visible wealth could be a positive spiritual force if manifest as charity or other Christian values.[136] But the ascetic preferences of Giordano of Pisa remained the norm.[137]

While less expensive than marble and thus suggestive of modesty, stucco was not always an austere medium. In the case of Marinella's tomb, it clearly facilitated varied representational strategies and aesthetic effects. Furthermore, it projects a unity derived from the fact its continuous surface is capable of easing transitions between architectural setting, sculptural elements, and painted surfaces. Uninterrupted fields of microarchitecture, figural sculpture, and color spread from the interior sides of the canopy across the background relief.

The integration of architecture, sculpture, and polychromy vividly contrasts with earlier canopy tombs of stone, which separate their constituent elements and materials and hold them apart. Tino's monuments consist of individual components with distinct structural or functional purposes and complementary aesthetic effects. This approach was widespread in Rome and the rest of Italy (e.g., the tombs of Cardinal Guglielmo Fieschi (d. 1256) in San Lorenzo fuori le Mura, Cardinal Matteo d'Acquasparta (d. 1302) in Santa Maria in Aracoeli, and even Bishop Giacomo Martono (d. 1360) in the Cathedral of Caserta Vecchia). Figural sculpture in high relief dominates stone tomb chests, architectural ornament in low relief adorns separate canopy structures, and flat devotional scenes in fresco or mosaic appear on walls above sarcophagi. Although many such works have traces of paint or gilding, colorful marble inlay, and an occasional narrative panel, the color and stories are limited and are generally placed within frames or grooves (a necessity and limitation of working in mosaic). In short, clear and distinct boundaries between parts, an emphasis on varied materials, and the controlled use of color characterize this more traditional tomb type.

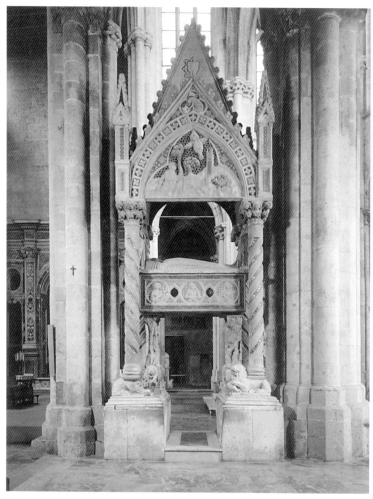

92. Tino di Camaino, tomb of Catherine of Austria, San Lorenzo Maggiore, Naples, ca. 1324 (Archivio Luciano Pedicini).

The unified design of Marinella's tomb derives from its unusually flexible material and testifies to the close collaboration of artists with many skills. This display of stucco required a diversified team that included carpenters able to build the skeletal framework of the canopy, builders familiar with local stucco techniques, sculptors with knowledge of Tino's tombs in Naples, and painters able to work in three dimensions and with wet plaster.

There was likely considerable overlap in the execution of these tasks, for artists did not necessarily limit themselves to one specific technique in this era of multimedia environments. Tino, after all, referred to himself as *Tini sculptoris de*

Senis arte coloris on the Pisa font of 1310, and polychromy survives on several of his works in marble, ivory, and wood.[138] He also supervised builders and masons at San Martino and painters at Castel Nuovo. Roberto d'Oderisio's formative years were spent in this ambience of multitasking; the artists who worked on Marinella's tomb were also likely trained in this setting.

The Tomb of Marinella, the Dormition, and Cultural Shifts in the Regno

Of all the figures on the tomb of Marinella, the angel perched between the effigy of the deceased and bier of Mary stands out. Dramatically carved in the round, this archangel lunges toward a man hovering at the side of the bier. With his sword outstretched, the archangel has severed the man's hands, which remain attached to the bier while the wounded fellow stumbles backward. The figure is not depicted in the Coppola polyptych or Giotto's Berlin Dormition, although traces of the same iconography are visible in a contemporary fresco in San Giovanni del Toro in Ravello.[139]

This apocryphal character appeared in Greek texts by the Pseudo-Melito of the fifth or sixth century and in the sermons of John, Archbishop of Thessoloniki (d. ca. 630).[140] In these versions of the *Koimesis*, a high priest (called Jephonias in some texts, Reuben in others) is urged by fellow Jews to upset the funeral bier of the Virgin. As he reaches up to do so, an angel swoops down and cuts off his hands. Jephonias then embraces Christianity, his hands are reattached miraculously, and he proceeds to convert the Jews who are present. Jephonias was incorporated into the *Golden Legend*, a key source for Dormition iconography in the *Regno* and elsewhere in the West.[141]

In the Scala tomb and the analogous fresco in Ravello, the dismembered body of Jephonias before the bier of the Virgin dramatically places the rejection of Christianity at the center of a scene of homage to Mary. The composition narrates that even in the presence of the Virgin, Christ, and apostles, Jephonias rejects the holiness of Jesus and his mother until the archangel inflicts its wrath. As in other representations of this tale, only the violent dismembering of Jephonias is represented; the subsequent miracles and conversions are not.[142] In suppressing the conversion, the tomb articulates the notion of Jews as eyewitnesses to the Incarnation who refuse to "see" its truths. Personifications of *Synagoga* as a blindfolded maiden are a more familiar representation of this same concept.[143]

The underpinnings of anti-Jewish sentiment that tinge the Jephonias story have echoes in other aspects of the tomb's iconography. Along the front of the canopy are medallions with busts of saints, most of whom carry prominent shields,

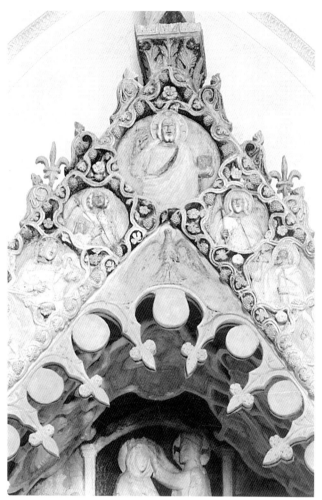

93. Upper canopy, tomb of Marinella Rufolo Coppola, crypt, Cathedral of Scala, 1332.

banners, or weapons, or stand before an identifiable convert or foe (Fig. 93). George appears with a dragon, for instance, and Eustachius with a stag. Lacking inscriptions or attributes, some of the figures cannot be identified, although their costumes and weaponry are differentiated somewhat. In the apex, the Holy Ghost and Christ as Pantokrater lead up to the God the Father, who towers over the entire ensemble and is carved in the round. The Trinity thus presides over saints on the front lines of conversion efforts and ever-vigilant archangels.

As celebrations of the aggressive facets of Christianity, the tomb and the apparent appeal of the Jephonias story belong to a new phase of southern Italian history, one that clashes vividly with the era of the art of *mercatantia*. The

unprecedented violence of the Scala tomb and Ravello fresco are part of the bur-
geoning discourse of intolerance in the South. The works articulate in forceful
language that the status of religious minorities changed in the decades after the
Vespers. Previously tolerated within the region's social, military, and economic
structures, both Jews and Muslims had helped forge the South's heterogeneity and
cultural openness. But these groups were increasingly excluded from mainstream
society by a variety of factors, both old and new, as historians of the less savory as-
pects of the thirteenth century have argued.[144] Repeated outbursts against usury,
for instance, proved deleterious to religious toleration; after the First Crusade
many such diatribes often singled out Jews as the guilty practitioners.[145] More ill
will was generated by Charles II's expulsion of Jews from Maine and Anjou in
1289.[146]

In the last decade of the thirteenth century, the structures of governance
instituted by Frederick II and developed by the Angevins were brought to bear
forcefully on religious minorities. While the bureaucratic network that so many
Amalfitans had staffed continued to exact punitive taxes and implement confisca-
tions, the Dominicans were instrumental in helping the crown institute less gentle
policies. The consolidation of the resources and power of king and monastic or-
der brought forth what R. I. Moore has called an "apparatus of persecution":[147]
inquisitorial investigations, violence, and mass conversions hit Jewish communi-
ties in the 1290s, and the Muslim community of Lucera was brutally Christianized
in 1300.

One of the Dominicans in Naples who led high-profile investigations into mat-
ters of faith was Bartolomeo dell'Aquila, who with the approval of King Charles
II pressured Jewish communities on the east and west coasts.[148] Bartolomeo's ac-
tivities fed on fears that neophyte converts to Christianity were luring Christians
to Judaism and desecrating Christian symbols. Such suspicions led to violence
in Trani and Salerno, two cities that had been centers of Jewish culture for
centuries.[149] In Trani, emotions flared after a crucifix was found in the trash
of a Jew; although allegedly placed there by a vengeful priest, the Jews were so
fearful of mob violence that they followed Bartolomeo's advice and converted to
Christianity. Riots erupted in Salerno in 1292 after Christian man was circum-
cised and another "baptized" in the synagogue there.[150] Bartolomeo ordered the
destruction of the building, but the next day the community as a whole agreed to
submit to Christian baptism if the proceeds from the sale of the building could
be directed toward the neophyte poor of the district. In a sermon of 1304, the
Dominican Giordano of Pisa preached his dramatic version of these events, in

which he claimed that more than eight thousand Jews were baptized in the *Regno* in those tumultuous years.[151]

Because the discourse of religious persecution that developed in the High Middle Ages perceived Jews and Muslims as comparable threats and characterized them in similar ways, it is not surprising that Muslim Lucera did not survive this era. In August 1300, with no warning of impending violence, the royal army under the leadership of Giovanni Pipino attacked the city. Most Lucerans were sold into slavery, although they had been technically *servi* already but effectively free. Although this sudden move has been interpreted as a short-sighted effort to salvage the perennially impoverished royal purse, it corresponded neatly to a larger pursuit of a unified Christian kingdom.

These outbursts of hostility were seen as shocking and dramatic in their time, as Giordano's sermon suggests, but they did not come out of the blue. The attitudes of sovereigns toward religious minorities were inconsistent throughout the thirteenth century, as Abulafia and others have emphasized, rendering Jews, Muslims, and their supporters vulnerable.[152] Pressure increased when the concept of a crusade against Lucera helped justify the Angevin conquest of the South in the 1260s.[153] Rhetoric emanating from Rome characterized the Lucerans in a variety of ways, some predictable (they were enemies of the cross), others more vivid and menacing (they were a noxious plague, or *pestis noxia*).[154] The Cardinal of Tusculum Eudes of Châteauroux utilized biblical and prophetic imagery in his pro-Angevin sermons, in which he cast Lucera as a pollutive "stench" that disturbs its surroundings, and Muslims as yeast that threatens to spread through the entire body of Christendom.[155] The new City of St. Mary that replaced the old "polluted" Lucera after 1300 saw monumental uses of Angevin heraldry, the construction of many new churches and monasteries, and royal donations of liturgical instruments that helped ensure the symbolic presence of the king and the city's "clean" identity.[156]

Even taking into account these earlier vacillations, the reign of Charles II marked a low point in the history of religious relations in the South. At first glance, this shift seems paradoxical, given that the Christian fringe, including the hermit-pope Celestine V, followers of Joachim of Fiore, and the emerging Spiritual Franciscan movement found support in Naples at that time.[157] But this very fracturing of the Christian community and related anxieties about the tenuous future of the faith likely helped spur attacks on outsiders.

The tomb of Marinella and related fresco in Ravello were created a few decades after these outbursts, during the reign of Robert and Sancia when

Christian-Jewish relations were only somewhat less volatile. Despite Robert's reputation as having been fair to minorities, violence against Jews continued to erupt across the South during his rule. Inquisitors were no longer the salient perpetrators, supplanted by tax collectors, church officials, and local mobs.[158] Hence the Jephonias imagery on Marinella's tomb was no less relevant in the 1330s. The prominence accorded to the mutilated figure must have resonated with Marinella and Antonio and affirmed their sense of how Marinella should be remembered because it does not appear on the Coppola polyptych or in related Marian works by Giotto.

It is clear that Marinella's monument worked both inside and outside the artistic paradigms of Naples in transforming metropolitan sepulchral designs and altarpiece iconography. But the addition of Jephonias also aggressively severed the tomb from its past, the age of *mercatantia*. This amputation can be seen as embodying layers of meaning beyond its literal expression of sanctioned violence against Jews. It represents intolerance, the cultural homogenization of the South, and Marinella's and Antonio's consenting to them; and it signifies the loss of the art of *mercatantia* and its rich array of materials, eclectic forms, and multicultural references. Hence, the tomb eloquently testifies to larger historical processes, including the absorption of the South into Christian Europe and the losses and violence that such a transition elicited.

As the tomb of Marinella makes clear, the art of the first half of the fourteenth century in Amalfi belongs to a new era. Patrons such as Antonio and Marinella were seduced by the new types of imagery made in Naples. Although their artistic heritage was of another tradition, they embraced the dominant artistic discourse by commissioning multiple works of art that evoked the new royal milieu. They were not alone: other works examined here, including the Amalfi Crucifixion, Toro *Noli me tangere*, and St. Catherine grotto, illustrate multiple episodes of appropriation in which metropolitan styles, designs, devotional ideas, and cult preferences reshaped the visual culture of the coast.

These monuments demonstrate that new works of art produced in Naples were physically and intellectually accessible to *regnicoli* soon after they were made. This was the case with public, commemorative structures such as tombs, many of which were located in the same monastic churches where Amalfitans endowed chapels or masses. But paintings within private environments, such as the royal chapel in Castel Nuovo, or off-limit sites of *clausura*, as at Santa Maria Donna Regina and Santa Chiara, were known as well. The dissemination

of metropolitan ideas thus derived in part from the artists who worked in such sites with Giotto, Tino, or Cavallini and then left the city for distant commissions.

These cultural shifts were naturally not as abrupt as the amputation performed on Marinella's tomb suggests. Rather, the works of the early fourteenth century testify to the slow loosening of connections to artistic and cultural traditions: of fewer long dedicatory inscriptions, less material variety, the absence of artists' signatures, a lack of works or ideas imported from beyond the Italian peninsula, and so on. And although cultural influence radiated from Naples throughout this period, the works of art around Amalfi articulated some creative localisms. Such inventiveness is particularly pronounced in two monuments, the Grotto of St. Catherine and tomb of Marinella. In those cases, the common building material of stucco recast sculptural prototypes in ways that broke down distinctions between reliefs, wall painting, and architecture while preserving local meanings and associations.

These works establish that art in fourteenth-century Amalfi was not simply a mirror image or pale reflection of art in Naples; it reworked metropolitan models within its own artistic, religious, institutional, economic, and social structures. Yet it must be emphasized that Naples was consistently the point of inspiration, an all-encompassing cultural force. Hence, the fourteenth-century commissions around Amalfi contrast dramatically with the more eclectic art of *mercatantia*, a fundamental feature of which is its lack of privileged style, material, or single source of inspiration.

Conclusions: Amalfi and the Art of *Mercatantia*

The decline of Amalfi's art of *mercatantia* engages larger issues and dynamics concerning the absorption of the South into the religious and cultural matrices of the West. This is multiple colonization, one that occurred in the later Middle Ages, again around 1860 with the Unification of Italy and repeatedly in centuries of scholarly traditions that are riddled with ambivalence and stereotypes. In part because of the threads of dissent and difference in the literature (including those codified around the Southern Question), this study has sought to identify and neutralize some particularly fraught issues. Whereas many earlier studies tend either to suppress difference by pulling the South into Western or central Italian paradigms (via classicism, for example, or the *grande arte* of the early fourteenth

century) or to resort to Orientalist projections and the binaries of the Southern Question, this work has tried to look at a local context on its own terms, offering critiques of these trends in order to move beyond them.

This study reconstructs a vital local setting in the multiethnic and monarchical South and traces its eventual decline. In its heyday, this locality developed a precocious tradition of lay patronage. During the late eleventh, twelfth, and thirteenth centuries, the resulting art of *mercatantia* was a cluster of features, sites, attitudes, and practices rooted in a culture enlivened and enriched by commerce. Patrons and artists in this creative network were not beholden to a single arena of cultural or artistic production, but negotiated several of them simultaneously while reifying their own social and economic structures, religious needs, and cultural values.

The concept of the art of *mercatantia* encompasses the ways that the tensions of nascent capitalism, including social competition and anxieties over wealth and salvation, shaped the built environment: how composite residential complexes took over whole districts of towns with increasingly elaborate layouts and ornamental displays, some of which followed Islamic architectural models; how private churches presented ambitious artistic programs, developed impressive collections of relics, and thereby created a decentralized topography of the sacred; and how in this urban dynamic, liturgical spaces in cathedrals came to be shaped by laypeople. Works of art created for all of these contexts emphasized material variety, genealogy, and lively juxtapositions of old and new, courtly and local, or Islamic and Western.

In encompassing a variety of monument types, styles, materials, and sites, the art of *mercatantia* helps uncover the thematic or ideological coherence of a group of monuments that might seem unrelated on the basis of style alone. But it also draws attention to the relationship of local to sovereign. In the twelfth and thirteenth centuries and even after 1300, Amalfitan art did not fully reject or accept artistic practices emanating from the courts in the South. Rather, the relationship of the local to the hegemonic was always in flux, and art and architecture articulated this ever-changing dynamic as several generations of Amalfitans realigned themselves within varying matrices of ecclesiastical, imperial, royal, monastic, and commercial power.

The region of Amalfi during the later Middle Ages can be characterized in various ways that resonate clearly after 800 years. In the ninth century, a Mediterranean-wide commercial network laid the foundations of lasting social

structures, including the share system of ownership, widespread literacy, and the genealogical obsession of the first Amalfitan elite. As trade expanded and a large proportion of the population participated in it – including the rich and not so rich, the laity and religious – *mercatantia* became the dominant cultural force and shaped art production, including Pantaleo's first set of bronze doors imported from Constantinople.

Yet in part because of its roots in earlier commercial practices, Amalfi's residual culture was also an unusual and autonomous one. The eclectic characteristics of the art, its spatial distribution, and types of lay patronage were established during the 1100s. By the mid–thirteenth century, the art of *mercatantia* was distinct in form and ideology from the central themes and preoccupations of early Angevin patronage, namely, the assertion and rearticulation of French cultural and political hegemony. Relative to the royal newcomers to the South, the Amalfitans and the art of *mercatantia* could be described as embodying an alternative culture.[159]

That is not to say that the "alternatives" were free of the Angevins. As the stories of the d'Afflitto, Spina, Sasso, and Rufolo families indicate, many denizens of the coast rose to prominence in the royal administration. Others who did not but continued to work in commerce still felt the impact of the Angevins on their livelihoods, as the taxes that the kings exacted, treaties they signed, and crusades they fought naturally had a direct impact on long-distance trade, often facilitating it. Amalfi's alternative culture, then, at times intersected with larger hegemonic ones and derived some its momentum from them.

By 1270, the conventions of private patronage that paved the way for the Rufolos were challenged by Angevin rule and the region's increasing economic distress. In the case of the Rufolos, the immensity of their wealth and public manifestations of it rendered the family and its cultural practices threatening to a vulnerable king. In light of varied contemporary conflicts – the Vespers, the king's political and French cultural agendas, theological debates regarding the sins of commerce, and moralizing curbs on public and private display – this tradition could not continue. The Rufolos and their monuments were the swansong of the art of *mercatantia* and its Mediterranean roots, which, along with the Rufolos themselves, did not survive the struggle for cultural and political hegemony in the South.

Indebted to prestigious and up-to-date examples of royal patronage, the works of art of the first half of the fourteenth century signal the triumph of central Italian forms in the small towns of the South. The monuments testify to the

region's gradual loss of cultural autonomy and to its surrender to the sway of the burgeoning capital of Naples. This fundamental shift, from a culture steeped in Mediterranean traditions to one that looked hopefully to the modern ideals of the court, helped relegate places like Amalfi to the status of depopulated provinces. Ironically, then, the same forces that generated renewal in other regions enervated the long-standing vitality of Amalfitan art and culture.

NOTES

⁓

INTRODUCTION: THE ART OF *MERCATANTIA*

1. "Credesi che la marina da Reggio a Gaeta sia quasi la più dilettevole parte d'Italia: nella quale assai presso a Salerno è una costa sopra 'l mare riguardante, la quale gli abitanti chiamano la costa d'Amalfi, piena di picciole città, di giardini e di fontane, e d'uomini ricchi e procaccianti in atto di mercatantia, sì come alcuni altri." Giovanni Boccaccio, *Decameron*, ed. Antonio Enzo Quaglio (Milan, 1974), 118–19. English translations my own.

2. On the preexisting dedication to St. Andrew in Amalfi and translation of relics, Werner Maleczek, *Petrus Capuanus: Kardinal, Legat am vierten Kreuzzug, Theologe* (Vienna, 1988), ch. 5; and Ulrich Schwarz, *Amalfi im frühen Mittelalter (9.–11. Jahrhundert)* (Tübingen, 1978). On the fabric of the cathedral, Mario d'Onofrio and Valentino Pace, *La Campania*. Italia romanica, vol. 4 (Milan, 1981), 274–81; Pietro Pirri, *Il Duomo di Amalfi e il Chiostro del Paradiso* (Rome, 1941). Also, Jill Caskey, "Una fonte cinquecentesca per la storia dell'arte medievale ad Amalfi," *RCCSA* 12 (1992): 71–81.

3. G. Boccaccio, *Decameron*, 118–19.

4. To clarify, I use "merchant patronage" if documentation, inscriptions, or other sources indicate that the patron was involved in *mercatantia*; "lay patronage" if a patron was not affiliated with religious institutions or organizations; and "private patronage" if a monument was for family use and not located in a public or episcopal setting. These labels are not mutually exclusive. For example, all three apply to the twelfth-century church of San Michele Arcangelo in Pogerola.

5. Boccaccio likely encountered stories about Lorenzo during his first Neapolitan sojourn from 1327 to 1341. It is possible that he personally met Lorenzo's descendents in the *Studium* in Naples because many of them were studying law there at approximately the same time that he was. On Boccaccio in Naples, Vittore Branca, *Boccaccio, the Man and His Works*, trans. Richard Monges (New York, 1976), chapters 2 and 3.

6. Amalfitan sources are scattered among archives in Naples, Amalfi, Ravello, Minori, and Cava. These primarily notarial documents deal with local activities, such as exchanges of property, wills, donations to churches, and so on. Indices and transcriptions (often partial) have been published and are as follows: Riccardo Filangieri, ed., *Codice diplomatico amalfitano* (Naples, 1917) (hereafter *CDA*); Ulrich Schwarz, "Regesta amalfitana. Die älteren Urkunden Amalfis in ihrer Überlieferung," *QFIAB* 58 (1978): 1–136, 59 (1979): 1–157, and 60 (1980): 1–156; *Le Pergamene degli archivi vescovili di Amalfi e Ravello* series (Amalfi, 1972–9) (hereafter *PAVAR*), edited by Jole Mazzoleni and others (see bibliography for complete citations); Jole Mazzoleni

and Renata Orefice, eds., *Il Codice Perris, Cartulario amalfitano, X–XV secolo* (Amalfi, 1985–9) (hereafter *CP*). Smaller collections have variously been published, catalogued, and transcribed, as noted later. The Fondo Mansi in the Abbazia della Badia della Trinità, Cava de' Tirreni, consists of eighteenth-century copies of many lost documents. Another key manuscript source for the history of art is the first vernacular history of Amalfi, written in the 1580s by Giovanni Battista Bolvito and housed in the Biblioteca Nazionale, Naples, as Ms. Fondo San Martino 101–2.

Royal sources supplement local charters with information about Amalfitan activities away from home. Having suffered serious losses in the Second World War, these Hohenstaufen and Angevin sources have been reconstructed in part from prewar transcriptions and appear in the multivolume and ongoing *Registri della Cancelleria angioina* (Naples, 1963–present) (hereafter *RCA*), another project overseen by Filangieri and Mazzoleni. Earlier transcriptions are Alain de Boüard and Paul Durrieu, eds., *Documents en français des archives angevines de Naples* (Paris, 1933 and 1935); and Evelyn Jamison, ed., *Documents from the Angevin Registers of Naples, Charles I* (Rome, 1949).

7. Eugenio Maria Beranger, "Presenze ed influenze saracene nel medio e basso Liri (IX–XII sec.)," in *Presenza araba e islamica in Campania, Atti del convegno sul tema, 1989*, ed. Agostino Cilardo (Naples, 1992), 55–117; Bruno Figliuolo, "Gli amalfitani a Cetara: Vicende patrimoniale e attività economiche (secoli X–XI)," *Annali dell'Istituto italiano per gli studi storiche* 6 (1979–80): 33–4. See Chapter 2.

8. The only serious assessment of the family's fall remains Eduard Sthamer, "Der Sturz der Familien Rufolo und Della Marra nach der sizilischen Vesper," in *Abhandlungen der Preußischen Akademie der Wissenschaften* (1937): 1–68. On Charles and the Vespers, see Chapter 1.

9. My use of the term *capitalism* with qualifiers such as *proto* or *nascent* derives from the fact that many of the constituent elements of capitalism were part of Amalfi's economy in the high and late Middle Ages: credit, interest, investment in shares, elite control of ships and mills. Yet Amalfi's international economy, despite its precocious complexity, was small in scale and cannot be defined as capitalism in the classical sense. For the debates regarding the precise place and time of capitalism's birth in late medieval Italy, now largely stalled or dismissed as moot, see works cited in Chapter 1.

10. On the imposition of French architectural forms, see Caroline Bruzelius, "Charles I, Charles II, and the Development of an Angevin Style in the Kingdom of Sicily," in *L'état angevin. Pouvoir, culture et société entre XIIIe et XIVe siècle* (Rome, 1998), 99–114, as well as her other studies noted later.

11. This tale is set in an earlier era, one that predates Florentine supremacy, although as is typical of the *Decameron*, Boccaccio introduced the tale in the present tense. See subsequent discussions of the status of Tuscany in history and historiography.

12. Mario Del Treppo's study of 1977 helped correct the entrenched tendency in the literature to mythologize, heroicize, and even exaggerate Amalfi's early commercial prowess. Del Treppo emphasized the small scale of Amalfi's international trade, and reconstructed a narrative of the coastal economy in which local investment in natural resources and agriculture was vital to prosperity. Although his work is a brilliant corrective, the reality of long-distance trade and its impact on Amalfitan culture – for which works of art offer clear, material evidence – must still be taken into account. The proverbial pendulum swings back toward the center in my research, which accepts that both local and distant investment contributed to the prosperity that facilitated merchant patronage. M. Del Treppo, *Amalfi medioevale*.

13. Privileges accorded the Amalfitans in the *Pactum Sicardi* discussed in Barbara Kreutz, *Before the Normans* (Philadelphia, 1991), 21.

14. Key sources on this early commercial network include Michel Balard, "Notes sur le commerce entre l'Italie et l'Égypte sous les Fatimides," in *L'Égypte fatimide, son art et son histoire*. Actes du colloque organisé à Paris, 1998, ed. Marianne Barrucand (Paris, 1999), 627–33; Barbara M. Kreutz, "Ghost Ships and Phantom Cargoes: Reconstructing Early Amalfitan Trade," *Journal of Medieval History* 20 (1994): 347–57; Bruno Figliuolo, "Longobardi e Normanni," in *Storia e civiltà della Campania: Il Medioevo*, ed. Giovanni Pugliese Carratelli (Naples, 1992), 37–86; idem, "Amalfi e il Levante nel Medioevo," in *I comuni italiani nel Regno crociato di Gerusalemme*, ed. Gabriella Airaldi and Benjamin Z. Kedar (Genoa, 1986), 571–664; David Abulafia, *Le due Italie, relazioni economiche fra il Regno normanno di Sicilia e i comuni settentrionali*, expanded version of *The Two Italies. Economic Relations between the Norman Kingdom of Sicily and the Northern Communes* (Cambridge, 1977), trans. Cosima Campagnolo (Naples, 1991); U. Schwarz, *Amalfi im frühen Mittelalter*; Armando Citarella, "Patterns in Medieval Trade: The Commerce of Amalfi before the Crusades," *Journal of Economic History* 28 (1968): 531–55; idem, "The Relations of Amalfi with the Arab World before the Crusades," *Speculum* 42 (1967): 299–312; Marius Canard, "Une lettre du calife fatimite al-Hafiz (524–544/1130–1149) à Roger II," in *Atti del convegno internazionale di studi ruggeriani, 1954* (Palermo, 1955), 125–46; S. N. Stern, "An Original Document from the Fatimid Chancery Concerning Italian Merchants," *Studi in onore di Giorgio Levi della Vida*, vol. 2 (Rome, 1956), 529–38; Horatio Brown, "The Venetians and the Venetian Quarter in Constantinople to the Close of the Twelfth Century," *Journal of Hellenic Studies* 40 (1920): 68–88; Wilhelm Heyd, *Histoire du commerce du Levant au Moyen Âge* (Leipzig, 1923); idem, *Le colonie commerciali degli italiani in Oriente nel Medioevo* (Venice, 1866–8); Matteo Camera, *Memorie storico-diplomatiche dell'antica città e ducato di Amalfi* (Salerno, 1876 and 1881; reprint, Salerno, 1972) (hereafter *Memorie*).

15. E.g., Fatimid currency in Ulrich Schwarz, "Regesta amalfitana 3," *QFIAB* 60 (1980): 22, doc. 10 (dated 974); Byzantine in *PAVM*, 21–2, doc. 22 (dated ca. 1063).

16. "Urbs haec dives opum, populoque referta videtur./Nulla magis locuples argento, vestibus, auro./Partibus innumeris. Hac lurimus urbe moratur/Nauta, maris coelique vias aperire peritus./Huc et Alexandri diversa feruntur ab urbe, /Regis et Antiochi; gens haec freta plurima transit:/His Arabes, Libi, Siculi noscuntur et Afri/Haec gens est tutum notissima paene per orbem/Et mercanda ferens et amans mercata referre." Guillaume de Pouille, *La Geste de Robert Guiscard*, ed. Marguerite Mathieu (Palermo, 1961), III, 67, p. 190, lines 476–85.

17. From the "Surat al-ard" (Configuration of the Earth), in *Italia euro-mediterranea nel Medioevo: Testimonianze di scrittori arabi*, Antologia di saggi, ed. and trans. Maria Giovanna Stasolla (Bologna, 1983), 247–8.

18. E.g., series of documents from 1169 to 1259 (the *tarì* ceased to be minted in 1222). Jole Mazzoleni, ed., *Le Pergamene di Capua*, vol. 1 (Naples, 1957), 86–9, doc. XXXVI (1169); 120–2, doc. LVIII (1232); 137–40, doc. LXVII (1241); 160–2, doc. LXXX (1249).

19. Given the fact that the inhabitants of the towns of the former Duchy of Amalfi shared artistic, economic and social histories, I use the term "Amalfitan" in a general sense, applicable to the region of Amalfi with its outlying towns, unless I specify that I am referring to Amalfi proper (or its inhabitants). In cases where differences in attitudes and customs make that move problematic (primarily in the context of twelfth-century politics), I refrain from using the term inclusively.

20. With its variant *mercatanzia*, this term, derived from the Latin *mercadantia* or *mercadandia*, appears throughout the *Decameron* and other early vernacular works such as *The Book of Marco Polo*, sermon *exempla*, chronicles, and translations of Jacopo da Varagine's *Golden Legend*. Detailed etymologies in Salvatore Battaglia, ed., *Grande dizionario della lingua*

italiana, vol. 10 (Turin, 1978), 131–2; Charles Du Fresne Du Cange, *Glossarium mediae et infimae latinitatis*, vol. 5 (Niort, 1885), 348, 350; exempla in *Racconti esemplari di predicatori del Due e Trecento*, vol. 3, ed. Giorgio Varanini and Guido Baldassari (Rome, 1993), 47 (Domenico Cavalca).

21. M. Del Treppo, *Amalfi medioevale*; and Romeo Pavoni, "Il mercante," in *Condizione umana e ruoli sociali nel Mezzogiorno normanno-svevo*, ed. Giosuè Musca (Bari, 1991), esp. 231–4. Further discussion of this problem is found in Chapter 1.

22. My adjectival construction of "merchant art" (rather than "art of merchants") is intended to evoke Boccaccio's usage.

23. "Trade" and "exchange" are not necessarily incorrect translations, but merely too specific, and similarly "commerce" is somewhat abstract and passive.

24. In these respects my use of *mercatantia* bears a resemblance to Gramsci's conception of ideology. Emphasizing the material manifestations of a system of beliefs, rather than purely intellectual abstractions, Gramsci saw ideology as an entrenched system of conduct and behavior resembling a "religion understood in the secular sense of a unity of faith between a conception of the world and a corresponding norm of conduct." Antonio Gramsci, *Selections from the Prison Notebooks*, ed. and trans. Quinton Hoare and Geoffrey Nowell Smith (London, 1971), 326.

I evoke Gramsci here not because his work provides any clear answers to questions concerning merchant art in the later Middle Ages, but because his theoretical framework raises questions that illuminate relations among contemporary centers of cultural activity (e.g., coastal Campania, North Africa, the court of Naples, nearby monastic settings). See subsequent discussion. On the value of Gramsci to historians of all political stripes, see T. J. Jackson Lears, "The Concept of Cultural Hegemony: Problems and Possibilities," *American Historical Review* 90 (1985): 567–93; on Gramsci's relevance for historians of southern Italy, see Pasquale Verdiccio, "Reclaiming Gramsci: A Brief Survey of Current and Potential Uses of the Work of Antonio Gramsci," *Symposium* 49 (1995): 169–76. For a poetic yet forceful take on Gramsci and the postwar South, Pier Paolo Pasolini, *Volgar'eloquio* (1975; Rome, 1987).

25. Its varied and composite forms perhaps determined the limited parameters of earlier writings on the house. Most of the scholarly publications that treat it isolate single details – a type of vault, for instance – and place it within formal taxonomies established for a specific subject, problem, or region. Salient examples are Luigi Kalby, *Tarsie ed archi intrecciati nel romanico meridionale* (Salerno, 1971); Joselita Raspi Serra, "L'architettura degli ordini mendicanti nel Principato salernitano," *MÉFR* 93 (1981): 605–81.

26. This starkly contrasts with most writings on thirteenth-century Amalfitan art, which isolate works of art and thus avoid analytic synthesis; discussions follow.

27. Sources on Pantaleo and Maurus Comite include the following: Maria Vittoria Marini Clarelli, "Pantaleone d'Amalfi e le porte bizantine in Italia meridionale," in *Arte profana e arte sacra a Bisanzio*, ed. Antonio Iacobini and Enrico Zanini (Rome, 1995), 641–52; Herbert Bloch, *Monte Cassino in the Middle Ages* (Cambridge, MA, 1986); Robert Bergman, *The Salerno Ivories: Ars sacra from Medieval Amalfi* (Cambridge, MA, 1980), esp. 128–30; idem, "A School of Romanesque Ivory Carving in Amalfi," *Metropolitan Museum Journal* 9 (1974): 163–85; Margaret Frazer, "Church Doors and the Gates of Paradise: Byzantine Bronze Doors in Italy," *DOP* 27 (1973): 147–62; Adolf Hofmeister, "Maurus von Amalfi und die Elfenbeinkassette von Farfa aus dem 11. Jahrhundert," *QFIAB* 24 (1932): 273–83; idem, "Der Übersetzer Johannes und das Geschlecht Comitis Mauronis in Amalfi," *Historische Vierteljahrschrift* 27 (1932): 225–84, 493–508.

28. This summary is based on the following key works, which address various contexts of eclecticism in the South. With the notable exception of Tronzo's book, they tend to focus on

a single cultural presence rather than on a series of overlapping ones. William Tronzo, *The Cultures of His Kingdom. Roger II and the Cappella Palatina in Palermo* (Princeton, 1997); Robert Bergman, "Byzantine Influence and Private Patronage in a Newly Discovered Medieval Church in Amalfi: S. Michele Arcangelo in Pogerola," *JSAH* 50 (1991): 421–45; idem, *Salerno Ivories*; Dorothy Glass, *Romanesque Sculpture in Campania: Patrons, Programs, and Style* (University Park, PA, 1991); Lucia Travaini, "I tarì di Salerno e di Amalfi," *RCCSA* 10 (1990): 7–71; Glenn Lowry, "Islam and the Medieval West: Southern Italy in the Eleventh and Twelfth Centuries," *RCCSA* 3 (1983): 5–59; Arnaldo Schiavo, *Monumenti della Costa di Amalfi* (Milan, 1941).

29. When a relationship between the visual arts and merchant culture is noted, the nature, impact, and implications of that relationship, and its connections to emerging commodity culture, are rarely explored. Thus Francesco di Marco's artistic patronage in Prato is rarely evaluated in conjunction with his status as "art dealer" or with generalized merchant culture. On Francesco di Marco, apt but brief remarks in Creighton Gilbert, "What Did the Renaissance Patron Buy?" *Renaissance Quarterly* 51 (1998), esp. 402–4. Later context: Jean Wilson, *Painting in Bruges at the Close of the Middle Ages: Studies in Society and Visual Culture* (University Park, PA, 1998).

30. Deborah Howard, *Venice & the East* (New Haven, 2000).

31. Lopez for one asserted that the late medieval urban landscape is the product of merchant culture and its interests; Goldthwaite refers to teachers of commerce (*maestri d'abbaco*) assisting in large-scale architectural calculations and measurements. Robert Lopez, "The Culture of the Medieval Merchant," *Medieval and Renaissance Studies*, ed. D. Randall (Raleigh, NC, 1979), 52–73; Richard Goldthwaite, "Schools and Teachers of Arithmetic in Renaissance Florence," *Journal of European Economic History* 1 (1972): 418–33. Goldthwaite's characterization of Florentine culture as fundamentally geometric presaged recent studies of Trecento urbanism, such as David Friedman, *Florentine New Towns. Urban Design in the Late Middle Ages* (Cambridge, MA, 1988); Marvin Trachtenberg, *Dominion of the Eye: Urbanism, Art, and Power in Early Modern Florence* (Cambridge and New York, 1998).

32. Alexander Murray, *Reason and Society in the Middle Ages* (Oxford, 1978); Y. Renouard, *Hommes d'affaires*; R. Goldthwaite, "Schools and Teachers of Arithmetic"; D. Friedman, *Florentine New Towns*, esp. ch. 4. Deborah Howard's recent work on Venice (*Venice & the East*) breaks this mold by looking broadly at merchant culture, including its subjective impact on visual culture.

33. Key works consulted for this passage include Christian Bec, *Les marchands écrivains à Florence (1275–1434)* (Paris, 1967); Emilio Pasquini, *La letteratura didattica e la poesia popolare del Duecento* (Bari, 1971); Manlio Cortelazzo, "La cultura mercantile e marinaresca," in *Storia della cultura veneta*, Vol. 1: *Dalle origini al Trecento* (Vicenza, 1976), 671–91; Vittore Branca, ed., *Mercanti scrittori. Ricordi nella Firenze tra Medioevo e Rinascimento* (Milan, 1986). On cursive, Henri Pirenne, "L'instruction des marchands au moyen âge," *Annales d'histoire économique et sociale* 1 (1929): 13–28; on perceptions of being busy and lacking time, A. Murray, *Reason and Society*, 105–7.

34. Sombart hypothesized that the development of capitalism was dependent of moneyed court societies rife with greed, frivolous waste, and exploitation. The resulting culture, deemed intellectually and morally impoverished by Sombart and his followers, was adopted and disseminated by an imitative bourgeoisie. Thus the roots of middle-class culture are in the early capitalism of the fourteenth century, an era of Western market expansion, great Florentine banks, and so on. Werner Sombart, *Luxury and Capitalism* (1913), trans. W. R. Dittmar (Ann Arbor, MI, 1967); and *Der Moderne Kapitalismus* (Munich, 1919–21). For a discussion of Sombart's ambivalence toward Marx and his debates with Max Weber on religion and economics, see Philip Siegelman's introduction to Dittmar's translation.

35. Key works consulted for this passage include David Herlihy, "The Florentine Merchant Family of the Middle Ages," in *Studi di storia economica toscana nel Medioevo e nel Rinascimento in memoria di Federigo Melis* (Pisa, 1987), 179–201; idem, *Pisa in the Early Renaissance. A Study of Urban Growth* (New Haven, 1958); Jacques Heers, "Urbanisme et structure sociale à Gênes au Moyen-Âge," in *Studi in onore di Amintore Fanfani*, vol. 1 (Milan, 1962), 371–412; Amintore Fanfani, "La préparation intellectuelle et professionnelle à l'activité économique en Italie du XVe au XVe siècle," *Le Moyen Âge* 57 (1951): 327–46; idem, *Le origini dello spirito capitalistico in Italia* (Milan, 1933); Armando Sapori, *Studi di storia economica medievale* (Florence, 1946). See also n. 31.

36. É. Bertaux, *AIM*. The same can be said of the "updating" of Bertaux, *L'art dans l'Italie méridionale: L'aggiornamento dell'opera di Émile Bertaux*, ed./dir. Adriano Prandi (Rome, 1978). A gloss on Bertaux's work, the *Aggiornamento* maintains the basic structure and parameters of the 1903 study. Abbate's recent volume breaks from this tradition and underlines instead the polycentrism of southern Italy and related center and periphery issues. Francesco Abbate, *Storia dell'arte nell'Italia meridionale. Dai longobardi agli svevi* (Rome, 1997), and *Storia dell'arte nell'Italia meridionale. Il Sud angioino e aragonese* (Rome, 1998).

37. Benedetto Croce's model resonates here, despite the problems concerning a monolithic characterization of "indigenous" versus "imported" cultures. "Storia, a ben considerare, distinta da quella dei sovrani e altresì da quella del Regno." Benedetto Croce, *Storia del Regno di Napoli*, 1925, ed. Giuseppe Galasso (Milan, 1992), 83.

38. "We have here a history that is no history, a development that does not develop. Its notorious characteristic is to be at every step upset and interrupted, whereas the history of other parts of Italy is characterized by the impetus of their political bodies, their struggles for liberty and power, their trade and industries, their seafaring prowess and colonies, their poetry and art.... Hence the telling of this history is a thankless and even difficult task as compared to the relative ease of narrating a history of greater importance, with a definite line of development, a beginning, middle, and end, a logic which the mind can follow and understand and depend upon." Benedetto Croce, *History of the Kingdom of Naples*, trans. Frances Frenaye (Chicago, 1970), p. 233 (also B. Croce, *Storia del Regno di Napoli*, 1992 edition, 336–7). In discerning distinct cultural traditions within contexts that elude sequential ordering, Croce validates subjects outside conventional narratives, making space for historiographical concepts such as the art of *mercatantia*.

39. Annabel Jane Wharton, *Art of Empire. Painting and Architecture of the Byzantine Periphery* (University Park, PA, 1988). In assessing the "provincial," Wharton is alert to how traditional studies privilege metropolitan art and denigrate the periphery.

40. For example, Croce-inflected historiographical remarks in Giuliana Vitale, "Nobiltà napoletana della prima età angioina. Elite burocratica e famiglia," in *Ricerche sul Medioevo napoletano: Aspetti e momenti della vita economica e sociale a Napoli tra decimo e quindicesimo secolo*, ed. Alfonso Leone (Naples, 1996), 187–223; grand syntheses of Giuseppe Galasso, *Storia d'Italia*, vol. 15: *Il Regno di Napoli* (Turin, 1992); Giovanni Vitolo, *Città e coscienza cittadina nel Mezzogiorno medievale* (sec. XI–XIII) (Salerno, 1990).

41. Dorothy Glass is one of the few to examine local art production, albeit from a synchronic rather than diachronic perspective, in her study of Romanesque sculpture in Campania. She characterizes the art as "very much a local phenomenon, for it evolved from a close study of local antiquity and the selective adaptation of elements from neighboring provinces." D. Glass, *Romanesque Sculpture in Campania*, 9. Glass is interested in cultural continuity, in seeing the classicizing sculpture of Campania as a bridge between renascences of Monte Cassino and Frederick II.

42. For example, Glass's description of a "the long-lived but sporadic and inconsistent substratum of a rather crude, local style" and Bloch's take on the self-referential apes on the pyxis of Desiderius at SS. Cosmas and Damian in Rome and the lintel of the Cathedral of

Salerno. H. Bloch, *Monte Cassino in the Middle Ages*, 82–8; D. Glass, *Romanesque Sculpture in Campania*, 21, 26, critiques in note 44.

43. Bertaux likely recognized this as well, for his 1903 work avoids traditional categories (e.g., Gothic, Romanesque) and follows Croce's geographically based organization. Croce's work is an early take on the South's polycentrism, published in the journal he founded with S. Di Giacomo in 1892. Benedetto Croce, "Sommario critico della storia dell'arte nel Napoletano," *NN* 2 (1893): 6–10, 23–7, 35–41, 55–61, 85–9, 130–4, 152–6, 164–7, 179–85; 3 (1894): 39–41, 56–60, 70–2. Bertaux's tomes are organized by region, dynasty, institution, and medium, rather than, say, by formal characteristics, although there are some stylistic groupings within those categories.

44. New scholarship on the *Questione del Mezzogiorno* emphasizes its codification in the exigencies of Unification and traces its permutations in generations of scholarship and policy. Key works are Nelson Moe, *The View from Vesuvius. Italian Culture and the Southern Question* (Berkeley, 2002); Lucy Riall, "Which Road to the South: Revisionists Revisit the Mezzogiorno," *Journal of Modern Italian Studies* 5 (2000): 89–100; John Dickie, *Darkest Italy. The Nation and Stereotypes of the Mezzogiorno, 1860–1900* (New York, 1999); Jonathan Morris, "Challenging *Meridionalismo*: Constructing a New History for Southern Italy," in *The New History of the Italian South: The Mezzogiorno Revisited*, ed. Robert Lumley and Jonathan Morris (Exeter, 1997), 1–19. Fundamental to this wave of revisionism is the earlier questioning of paradigms in Giuseppe Galasso, *L'altra Europa: Per un'antropologia storica del Mezzogiorno d'Italia* (Milan, 1982).

45. A survey of introductory literature uncovers attitudes redolent of the Question's negative views. See, for example, John White's *Art and Architecture in Italy, 1250–1400* (orig. 1966) and John Pope-Hennessy's *Italian Gothic Sculpture* (orig. 1955). White's handbook is emblematic of conventional views, with its voluminous assessments of works of art in northern and central Italy interspersed with spare descriptions of the South. One wonders if his treatment and language – for example, "There is an almost democratic air about the growing local despotisms of Northern Italy when compared with the entrenched autocracy of the south" – would inspire new students of art history to strike out for southern destinations. One suspects not. In a comparable vein, Pope-Hennessy praises the early works of Tino di Camaino and dismisses his Neapolitan ones, claiming that the sculptor "would have developed into a great large-scale sculptor" had he not left Tuscany for "enervating" Naples (see Chapter 4, this volume). John White, *Art and Architecture in Italy, 1250–1400*, 2d ed. (New Haven, 1987), 280; John Pope-Hennessy, *Italian Gothic Sculpture. An Introduction to Italian Sculpture*, 2d ed. (New York, 1970; reprint, New York, 1985), 17.

46. For example, Bertaux's conceptualization of the art of the medieval South as extended "prequel" to the Tuscan Renaissance. See Chapters 2 and 4, this volume.

47. For example, discussions of Norman art in Sicily, specifically early ones published around the time of Unification: Gioacchino Di Marzo, *Delle belle arti in Sicilia dai normanni sino all fine del secolo XIV* (Palermo, 1858; reprint, Catania, 1988), vol. 1, 97–8, 197–202, etc.; on the racist discourse of hybridity rooted in the Civil War and Emancipation, Robert J. C. Young, *Colonial Desire: Hybridity in Theory, Culture, and Race* (London, 1995). On the methodological shortcomings of hybridity, as conventionally (versus theoretically) understood, W. Tronzo, *Cultures of His Kingdom*, 13–14.

48. For example, Bertaux characterized the Rufolo House as the "palace of an Oriental despot"; he did not develop or substantiate this impressionistic observation. Subsequent local historians continue in this vein, describing the house as a backdrop to sensuous banquets complete with dancing girls. This classic Orientalist formulation precludes analysis and interpretation, as I argue in Chapter 2. É. Bertaux, *AIM*, 627.

49. This is not to say that the art and architecture of the late thirteenth century are conservative, reactionary, or retarditaire; they are not – they are daring and compellingly modern.

But the concept of private patronage and the social customs that propelled it were grounded in that earlier era. The vocabulary used here to describe coexisting and even competing cultures (alternative, residual, dominant) derives from the work of Raymond Williams, whose elaborations of Gramsci's theories of hegemony are remarkably well suited to case of Ravello in the thirteenth century. Raymond Williams, "Base and Superstructure in Marxist Cultural Theory" (1973), reprinted in *Problems in Materialism and Culture. Selected Essays* (London, 1982 and 1989), 31–49; idem, *The Sociology of Culture* (Chicago, 1981).

50. On private churches, see Chapter 3; on the culture of bathing, Jill Caskey, "Steam and *sanitas* in the Domestic Realm: Baths and Bathing in Medieval Southern Italy," *JSAH* 58 (1999): 170–95.

51. "We abolish completely the style of writing which was preserved until the present in the city of Naples, the Duchy of Amalfi, and Sorrento, and the areas belonging to them. Therefore, we decree that public documents and bonds of any kind ought to be written in common and legible letters by the notaries appointed by us. We also desire and decree that the aforementioned public documents should be written in the future only on parchment. . . . Moreover, those which are drawn up on the aforementioned cotton paper (*charta bombacyna*) and written in the aforesaid places, Naples, Amalfi, and Sorrento, should be drawn up again in common and legible writing within two years from the day of the promulgation of this law." The legislation also banned the practice of privately appointed judges in Amalfi, Sorrento, and Naples. Quotation from *The Liber Augustalis, or Constitutions of Melfi, Promulgated by the Emperor Frederick II for the Kingdom of Sicily in 1231*, ed. and trans. James M. Powell (Syracuse, 1971), Title LXXX (63), p. 50; judges discussed in Title LXXXI (64), p. 51.

52. Caroline Bruzelius, " '*ad modum franciae.*' Charles of Anjou and Gothic Architecture in the Kingdom of Sicily," *JSAH* 50 (1991): 402–20.

53. Adam de la Halle's landmark of early music, "Li Gieus de Robin et Marion," was performed for the first time in Naples in 1275 or 1285. On the multilingual culture of Frederick II, Roberto Weiss, "The Greek Culture of Southern Italy in the Later Middle Ages," *Proceedings of the British Academy* 37 (1951): 23–50, esp. 28. On Charles I and vernacular poetry, Stefano Asperti, *Carlo I d'Angiò e i trovatori* (Ravenna, 1995).

54. A few transfers result from marriage or inheritance, but the majority are confiscations. Land transfer documents in Luciano Catalioto, *Terre, baroni e città in Sicilia nell'età di Carlo I d'Angiò* (Messina, 1992), Appendix 2.

55. Sylvie Pollastri, "La noblesse provençale dans le Royaume de Sicile," *Annales du Midi* 100 (1988): 405–29.

56. Only a few notaries were not Sicilians, and few Sicilians penetrated the upper echelons of the administration. L. Catalioto, *Terre, baroni e città*, Appendix 4.

57. Fundamental assessments of Desiderius's visit to Amalfi are H. Bloch, *Monte Cassino in the Middle Ages*; idem, "Origin and Fate of the Bronze Doors of Abbot Desiderius of Monte Cassino," *DOP* 41 (1987): 89–102; Joselita Raspi Serra, *Amalfi, Montecassino, Salerno. Un corso fondamentale nella strutturazione e nel lessico dell'architettura 'romanica'* (Salerno, 1979).

58. Leo Marsicanus, *Chronica Monasterii Casinensis*, ed. Harmut Hoffmann (Hannover, 1980), III.18, 385.

59. "Tandem igitur totius basilice preter aditum cum difficultate non parva spatio complanato et necessariis omnibus abundantissime apparatis, conductis protinus peritissimis artificibus tam Amalfitanis quam et Lambardis." Leo Marsicanus, *Chronica*, III.26, 394. Variant regarding Amalfitans in Montecassino Cod. 450, dated ca. 1140–50.

60. During his sojourn in Amalfi, Desiderius would have observed the ducal church of Santa Maria Maggiore, constructed after 986, and the original cathedral of Saints Cosmas and Damian. Dating from before 987, the latter contains *spolia* arcades, pointed arches, and lancet windows. For theories regarding the dissemination of pointed arches from Amalfi to Monte Cassino, Sant'Angelo in Formis, Cluny, and beyond, see the seminal article by Kenneth

Conant and Henry Willard, "Early Examples of the Pointed Arch and Vault in Romanesque Architecture," *Viator, Medieval and Renaissance Studies* 2 (1971): 203–9. Revision of the meaning of "fornices spiculos" and the late-twelfth-century dating of the porch with pointed arches at Sant'Angelo in Formis, H. Bloch, *Monte Cassino in the Middle Ages*, vol. 2, 63, note 2. North African antecedents in Alexandre Lézine, *Mahdiya, recherches d'archéologie islamique* (Paris, 1965).

61. Jacques Le Goff, *Marchands et banquiers au Moyen Âge* (Paris, 1956), 110–11.

62. Oleg Grabar, "Trade with the East and the Influence of Islamic Art on the 'Luxury Arts' in the West," in *Medio Oriente e l'Occidente nell'arte del XIII secolo*, Atti del XXIV Convegno internazionale di storia dell'arte, ed. Hans Belting (Bologna, 1982), 29.

63. Antal posits, for example, that the humanization of the divine characteristic of fourteenth-century art renders it "pronouncedly upper-middle-class," whereas the "greater primitiveness and lack of naturalism" of symbolic or hieratic works appealed to lower classes. Frederick Antal, *Florentine Painting and its Social Background. The Bourgeois Republic before Cosimo de Medici's Advent to Power* (London, 1948) (written 1932–8). Also subsequent work in this vein by Arnold Hauser, "The Middle-Class Art of the Late Gothic Period," Chapter 11 in *The Social History of Art* (1951), 3d paperback ed., vol. 1 (London, 1999). Despite its appealing challenge to the status quo of art history, Antal's study is rarely cited and oddly finds little space in new scholarship attentive to the social roots of cultural expression.

64. The ghost of Veblen seemingly haunts most narratives of medieval art. Thorstein Veblen, *The Theory of the Leisure Class. An Economic Study of Institutions* (New York, 1899; reprint, New York, 1965).

65. For example, Georges Duby, *Hommes et structures du moyen âge: Recueil d'articles*, École practique des hautes études, VIe section: *La savoir historique*, 1 (Paris, 1973).

66. The studies of cultural production of particular relevance to this project include Alan Hunt, *Governance of the Consuming Passions: A History of Sumptuary Law* (New York, 1996); Homi Bhabha, *The Location of Culture* (New York, 1994); Edward Said, *Culture and Imperialism* (New York, 1994); Raymond Williams, "Base and Superstructure in Marxist Cultural Theory"; Norbert Elias, *The Court Society* (1969), trans. Edmund Jephcott (Oxford, 1983).

CHAPTER ONE

1. "Tra le quali cittadette n'è una chiamata Ravello, nella quale, come che oggi v'abbia di ricchi uomini, ve n'ebbe già uno il quale fu ricchissimo, chiamato Landolfo Rufolo; al quale non bastando la sua ricchezza, disiderando di raddoppiarla, venne presso che fatto di perder con tutta quella se stesso." Giovanni Boccaccio, *Decameron*, ed. Antonio Enzo Quaglio (Milan, 1974), 118–19.

2. "Solit enim studiosus agricola de sui laboris agro spinas frequenter evellere, ut de futuro semine fructum capiat exspectatum." Full of rhetorical flourishes and biblical allusions, this document has been attributed to the jurist Bartolomeo of Capua (d. 1328), who exerted considerable influence on Charles of Salerno for decades. Document transcription and discussion in Eduard Sthamer, "Der Sturz der Familien Rufolo und Della Marra nach der sizilischen Vesper," *Abhandlungen der Preußischen Akademie der Wissenschaften* (1937): 28–30. Also, I. Walter and M. Piccialuti, s.v. "Bartolomeo da Capua," *DBI* vol. 6 (Rome, 1964), 697–704.

3. Sources for this passage include Jenny Kermode, *Medieval Merchants: York, Beverley and Hull in the Later Middle Ages* (Cambridge, 1998); Olivia Remie Constable, *Trade and Traders in Muslim Spain. The Commercial Realignment of the Iberian Peninsula, 900–1500* (Cambridge, 1994); S. D. Goitein, *A Mediterranean Society: The Jewish Communities of the Arab World as Portrayed in the Documents of the Cairo Geniza*, 6 vols. (Berkeley, 1967–1988); Richard D. Face, "Symon de Gualterio: A Brief Portrait of a Thirteenth-Century Man of Affairs," in *Economy, Society, and Government in Medieval Italy. Essays in Memory of*

Robert Reynolds, ed. David Herlihy, Robert Lopez, and Vsevolod Slessarev (Kent, OH, 1969), 76–94; Robert Lopez, "Le marchand génois: Un profil collectif," *Annales: Economies, sociétés, civilisations* 13 (1958): 501–15; Iris Origo, *The Merchant of Prato* (London, 1957).

4. Vera von Falkenhausen, "Il Ducato di Amalfi," in *Storia d'Italia*, vol. 3: *Il Mezzogiorno dai Bizantini a Federico II*, dir. Giuseppe Galasso (Turin, 1983), 339–46.

5. On the early Amalfitan nobility, see M. Del Treppo, *Amalfi medioevale*, ch. 6. Also Gerardo Sangermano, *Caratteri e momenti di Amalfi medievale e del suo territorio* (Amalfi, 1981); Ulrich Schwarz, "Alle origini della nobiltà amalfitana: I *comites* di Amalfi e loro discendenza," in *Amalfi nel Medioevo*, Atti del convengo internazionale, Amalfi (Amalfi, 1973), 369–79.

6. Ulrich Schwarz, "Regesta amalfitana. Die älteren Urkunden Amalfis in ihrer Überlieferung." *QFIAB* 58 (1978): 27–52.

7. Robert Brentano, *Two Churches. England and Italy in the Thirteenth Century* (Princeton, 1968), 298; idem, "Sealed Documents of the Mediaeval Archbishops at Amalfi," *Mediaeval Studies* 23 (1961): 21–46.

8. For the problematics of genealogy, see Patricia Skinner, *Family Power in Southern Italy. The Duchy of Gaeta and Its Neighbours, 850–1139* (Cambridge, 1995), 15; Alexander Murray, *Reason and Society in the Middle Ages* (Oxford, 1978), 90–2. On the evidentiary and falsification, Armando Petrucci, "The Illusion of Authentic History: Documentary Evidence," orig. 1984, in *Writers and Readers in Medieval Italy. Studies in the History of Written Culture*, trans. and ed. Charles Radding (New Haven, 1995), 236–50.

9. P. Skinner, *Family Power in Southern Italy*, 106.

10. Local writers from Bolvito to recent times have designated a distinguished ancient Roman tribune, the Publius Rutilius Rufus, as the family's lofty ancestor. A sarcophagus inscribed *quintus fabritius rufus* in the Cathedral of Amalfi has fueled that theory for centuries. J. Caskey, "Rufolo Palace," ch. 1; Giuseppe Imperato, *Villa Rufolo nella letteratura nella storia nell'arte* (Salerno, 1979), 57; Ferrante Della Marra, *Discorsi delle famiglie estinte, forastieri, o non comprese ne' Seggi di Napoli; Imparentate colla Casa della Marra* (Naples, 1641), 347; G. B. Bolvito, "Registri," BNN, FSM 101, p. 264.

11. Freccia wrote that ninety Rufolo horsemen fought on behalf of Duke Roger Guiscard, earning one Nicola Rufolo the title duke of Sora. But Sora maintained Lombard rule until relatively late, joining the Norman Kingdom only in 1140 after Roger and Anfuso, sons of Roger II, occupied the town. It was then enfiefed to Simone, a baron of Aversa, and the twenty-four knights who served Simone were all from Aversa. Freccia's vernacular successor Bolvito repeated this story, as did later genealogists. Walter Schütz, *Catalogus Comitum. Versuch einer Territorialgliederung Kampaniens unter den Normannen von 1000 bis 1140 von Benevent bis Salerno* (Frankfurt-am-Main, 1995); Errico Cuozzo, *"Quei maladetti Normanni:" Cavalieri e organizzazione militare nel Mezzogiorno normanno* (Naples, 1989), 45–6. Early mythologizing sources: Marino Freccia, *De Subfeudis Baronum et investituris Feudorum* (Venice, 1579), 78; F. Della Marra, *Discorsi delle famiglie estinte*; Berardo Filangieri di Candida Gonzaga, *Memorie delle famiglie nobili delle province meridionali d'Italia* (Naples, 1879).

12. *PAVAR* vol. 2, 101, doc. CIV.

13. *PAVAR* vol. 1, 6–8, doc. V. The location of "alla pumece" is probably in the *retroterra* of Minori, near the summit of Santa Maria della Pomice. Also, Leone Rufolo owned a large parcel of land "alla pumece" in 1038. *CP* vol. 1, 53, doc. XXXVII.

14. Debates surrounding the use of the term "patrician" for medieval contexts and problems of class definitions in Janet Abu-Lughod, *Before European Hegemony. The World System A.D. 1250–1350* (New York and Oxford, 1989), 100, n. 14.

15. This creation of surnames suggests a desire for definite identification, perhaps resulting from social, legal, or economic opportunities and needs, as Skinner has hypothesized for Gaeta.

P. Skinner, *Family Power in Southern Italy*, 131–2. Also M. Del Treppo, *Amalfi medioevale*, ch. 6; G. Sangermano, *Caratteri e momenti di Amalfi*.

16. On the rivalry between Amalfitan and Ravellese elites that erupted with the Norman conquest and the rise of many Ravellese families at that time, François Widemann, "Les Rufolo. Les voies de l'anoblissement d'une famille de marchands en Italie méridionale," in *La noblesse dans les territoires angevins à la fin du Moyen Âge*, Actes du colloque international organisé par l'Université d'Angers, 1998 (Rome, 2000), 115–30.

17. *PAVAR* vol. 2, 22–24, doc. XXXIX, dated 1139.

18. The sons were noted as being "away" in 1179; see observations of M. Del Treppo, *Amalfi medioevale*, 132, and discussion later in this chapter.

19. Widemann emphasizes that the investiture of the apparently exceptionally young Giovanni must be read as a reflection of the Rufolos' power in the aftermath of the Pisan invasions. F. Widemann, "Les Rufolo," 121.

20. Rhetorical conventions lend these donations a uniform tone. Most read "donat Dom. Johannis Episcopo...e per eu ecclesia sui episcopii." Cava, Fondo Mansi 13, doc. 192, dated 1171.

21. *PAVAR* vol. 1, 87–9, doc. LVII; land "in campo at ora Maiuri."

22. *PAVAR* vol. 2, 93–4, doc. XCIV.

23. Giovanni acquired shares amounting to one-third of the properties in what is now the Piazza della Fontana. In 1280 Nicola gave to Iacopo a workshop in that same busy commercial location. *PAVAR* vol. 5, 53, doc. LXIX.

24. A. Murray, *Reason and Society*, 84–91.

25. Despite their wealth and influence, the Rufolos were probably not members of the feudal nobility; the early modern sources that make that claim cannot be substantiated. A few Amalfitan families received fiefs in the second half of the thirteenth century, such as the Sasso and Spina in Scala or Freccia in Ravello; but for the most part, elite Amalfitan families were not recognized as such by the crown. To maintain distinctions between the old and new elites around Amalfi as well as between local and feudal groups, I use the term "noble" only in conjunction with the feudal elite. For the latter, elaborate procedures were in place that guaranteed their separate status. See, for instance, feudal rights bestowed on Guillelmus de Lagonessa in 1278, as described at length in *CDCapua*, vol. 2, 25–8, doc. 119; references to Cesare d'Alagno *milite* (*PAVAR* vol. 6, 18, doc. XVII, dated 1318), *Nobilis dominus Bartholomeis Caraczulus dictus Carrafa de Napoli milites* (*AMA*, 150, doc. 4, dated 1320), and so on. M. Del Treppo, *Amalfi medioevale*, ch. 6; F. Widemann, "Les Rufolo," who emphasizes the noble status of the Rufolos in part on the basis of the problematic reference to the duke of Sora (see n. 10). On the fief held by Nicola Freccia in San Marzano for four years, see N. Kamp, s.v. "Freccia, Nicola," *DBI* vol. 50 (Rome, 1998), 351.

26. There is the case of Rabello Rufolo, son of Leonis and brother of the bishop Giovanni, who helped to endow the church of Saints Vito, Modesta, and Crescentia in Sambuco with the donation of a fraction of a chestnut grove. This is rather limited involvement, though, compared with what is documented for other private foundations, as explored in Chapter 3. Cava, Fondo Mansi 13, docs. 253–5, dated 1167–81.

27. *PAVAR* vol. 1, 6–8, doc. V; *PAVAR* vol. 1, 76–8, doc. L, and *PAVAR* vol. 2, 114–116, doc. CXVI, etc. Chestnut wood was a valuable commodity because it was used in the construction of ships.

28. For example, Orso as merchant in *RCA* vol. 23, p. 246 (dated 1280–1); merchant ship named *Rufula* in *RCA* vol. 14, doc. 251 (dated 1276). On the alleged use of the Rufolo fleet against the Amalfitans in the Norman assault of 1082, F. Widemann, "Les Rufolo," 118.

29. For example, "Iohannes Capuanus de Amalphia mercator," in 1354 (*AMA* p. 151, doc. 7); "Georgious filius quondam Angeli mercator," in 1308 in Salvatore Santeramo, ed.,

Codice diplomatico barlettano vol. 1 (Barletta, 1924) (hereafter *CDBarlettano*), 325–7, doc. 133.

30. For example, *CDC* doc. 300 (dated 978), "quando ego eram Babilonia ad navigandum;" *PAVM* 7, doc. 7 (ca. 1011); U. Schwarz, "Regesta amalfitana," *QFIAB* 59 (1979), 87, doc. 41 (1007). This was a frequent enough situation that the legal rights of women were delineated in the *Consuetudines civitatis amalfie*. This code developed as a negotiation of dowry law as Amalfi broke free from the Duchy of Naples in 839, although the earliest surviving redaction is from 1274. Alfonso Leone and Alessandro Piccirillo, eds., *Consuetudines Civitatis Amalfie* (Cava, 1970).

31. Scholarly constructs of the medieval merchant tend to derive from the more specialized economy of late medieval and early Renaissance Tuscany. Figures such as Francesco di Marco Datini, Francesco Pegolotti, and Giovanni Morelli left abundant records of their daily engagement in trade, which convey the all-consuming nature of their profession as well as a lively sense of their personalities.

32. M. Del Treppo, *Amalfi medioevale*; Romeo Pavoni, "Il mercante," in *Condizione umana e ruoli sociali nel Mezzogiorno normanno-svevo*, ed. Giosuè Musca (Bari, 1991), 231–4. For similarities to Genoa, R. Lopez, "Marchand génois."

33. The diversity of the South's mercantile community reveals that predominant medieval systems of social classification are, like the prevailing scholarly views of merchants, also ill suited to the Amalfitans. Even as theorists such as Peter the Venerable, John of Salisbury, and Bernard of Clairvaux reimagined social hierarchy to accommodate new skills and professions rather than simply defining status by birth, their idealized visions of a unified Christian society clash with southern Italy's unique cultural configuration, where diverse religious communities worked together in the same professions. For accounts of the diversity of merchant communities, Cosimo Damiano Fonseca, "'Ordines' istituzionali e ruoli sociali," in *Condizione umana e ruoli sociali nel Mezzogiorno*, 15; and R. Pavoni, "Il mercante;" S. D. Goitein, "Sicily and Southern Italy in the Cairo Geniza Documents," *ASPN* 67 (1971): 9–33.

34. O. R. Constable, *Trade and Traders in Muslim Spain*, 54–9.

35. On early external sources referring to Amalfitans abroad, see Introduction, n. 6.

36. References to Amalfitan merchant families appear throughout the extensive *Codice diplomatico barese*, including vol. 5, doc. 31 (1099) and doc. 117 (1159), and vol. 3, doc. 283 (1266); and the Angevin chancery, including *RCA* vol. 23, p. 246 (dated 1280–1). For Amalfitan colonies in Italy, P. Natella, "Clan amalfitani fuori d'Amalfi e la nascita dell'emigrazione displuviale," *RCCSA* 9 (1989): 89–101; M. Camera, *Memorie*.

37. Errico Cuozzo, "La nascita della diocesi di Ravello: Un episodio della ristrutturazione diocesana nel Mezzogiorno dell' XI secolo," in *Atti della giornata di studio per il IX Centenario della fondazione della Diocesi di Ravello, 1986* (Ravello, 1987), 45–52.

38. For immigration in the 1230s, see M. Camera, *Memorie*, 343–5. On Monopoli: of disputed date, Santa Maria was perhaps founded as an *ex voto* after a shipwreck in the eleventh century. Pina Belli D'Elia, *La Puglia*. Italia romanica, vol. 8 (Milan, 1987), 444–5. On Barletta: undated document; possibly dated before 1283 (*CDBarlettano*, vol. 1, doc. 36); also, papal permission for repairs and beautification ("ampliari et dilatari procuret opere sumptuose"), 1307 (*CDBarlettano*, vol. 1, doc. 131). Discussion of monument and lay participation in Caroline Bruzelius, "'A Torchlight Procession of One.' Le choeur de Santa Maria Maggiore de Barletta," *Revue de l'art* 125 (1999): 9–19.

39. Cava, Fondo Mansi 13, fol. 16r, doc. 58, 1288. For the theory that an extant *masseria* (large farm or estate) between Giovinazzo and Terlizzi belonged to the Rufolos, see Horst Schäfer-Schuchardt, "Trapetti in Terra di Bari in età sveva e protoangioina," in *Cultura e società in Puglia in età sveva e angioina*, ed. Felice Moretti (Bitonto, 1989), 187–98. Other Apulian hypotheses in François Widemann, "Giacomo Rufolo. Rôles et fonctions dans une famille patricienne de Ravello au XIIIe siècle," *Apollo* 12 (1996): 73–100.

40. For the importance of Apulian ports and of Angevin support for these isolated communities, see John Pryor, "*In subsidium Terrae Sanctae*: Exports of Foodstuffs and War Materials from the Kingdom of Jerusalem, 1265–1284," *Asian and African Studies* 22 (1988): 127–46.

41. For a similar situation in Tuscany, David Herlihy, *Pisa in the Early Renaissance. A Study of Urban Growth* (New Haven, 1958); or the *commenda* of Liguria, R. Lopez, "Marchand génois."

42. The *magister cameraris* served as a liaison between chamberlains of the districts and the court itself. His responsibilities were both juridical and financial. For administrative matters, Luciano Catalioto, *Terre, baroni e città in Sicilia nell'età di Carlo I d'Angiò*, Collana di Testi e studi storici 7 (Messina, 1995); Enrico Pispisa, *Il Regno di Manfredi. Proposte di interpretazione* (Messina, 1991); Norbert Kamp, "Vom Kämmerer zum Sekreten: Wirtschaftsreformen und Finanzverwaltung im staufischen Königreich Sizilien," in *Probleme um Friedrich II.*, ed. Josef Fleckenstein (Sigmaringen, 1974), 43–92; Léon Cadier, *Essai sur l'administration du royaume de Sicile sous Charles Ier et Charles II d'Anjou* (Paris, 1891).

43. Angelo, the son of the merchant banker Giovanni di Giozzo Della Marra of Ravello, was noted as the "familiare" of the emperor in 1234 and occupied various prestigious positions in the administration, including curator of the royal treasury. E. Sthamer, "Sturz," and M. Caravalle, s.v. "Angelo Della Marra," in *DBI* vol. 37 (Rome, 1989), 89–91.

44. Alfonso Leone, "La politica filoangioina degli Amalfitani," in *Ricerche sull'economia meridionale dei secoli XII–XV* (Naples, 1994), 7–13.

45. Norbert Kamp, "Vom Kämmerer zum Sekreten;" S. Manzi, "Amalfitani funzionari del Regno di Napoli dal periodo normanno alla fine del XIII secolo," *RCCSA* 4 (1984): 87–114.

46. *PAVAR* vol. 4, 86–7, doc. XXX.

47. Mid-thirteenth-century work, the Hamilton Codex 396, discussed in G. Sangermano, *Caratteri e momenti di Amalfi*. Amalfi appears in the Pisan navigational *Liber de existencia riveriarum* of ca. 1200. Patrick Gautier Dalché, *Carte marine et portulan au XIIe siècle*, Collection de l'École française de Rome, vol. 203 (Rome, 1995), 159.

48. G. Coniglio, "Amalfi e suo commercio nel Medioevo," *Nuova rivista storica* 18–19 (1944/45).

49. On the small *sagenis* vessels with sails used by the Amalfitans in the early Middle Ages, Barbara M. Kreutz, "Ghost Ships and Phantom Cargoes: Reconstructing Early Amalfitan Trade," *Journal of Medieval History* 20 (1994): 347–57; Mario Del Treppo, "La marina napoletana nel Medioevo: Porti, navi, equipaggi," in *La fabbrica delle navi. Storia della cantieristica nel Mezzogiorno d'Italia*, ed. Arturo Fratta (Naples, 1990), 31–46.

50. The most thorough treatment of Amalfi's decline is Abulafia's introduction to the Italian translation of *The Two Italies* (1977). David Abulafia, "Il Mezzogiorno italiano in rapporto con i suoi vicini verso il 1200," in *Le Due Italie: Relazioni economiche fra il Regno normanno di Sicilia e i comuni settentrionali*, trans. Cosima Campagnolo (Naples, 1991), 7–32; also Giuseppe Galasso, "Il commercio amalfitano nel periodo normanno," in *Studi in onore di Riccardo Filangieri*, vol. 1 (Naples, 1959), 81–103. The long-term effects of Tuscan and northern investment in the South were particularly deleterious in Sicily, where their actions stunted local industrial development and widened the rifts between various social and ethnic strata that fueled the Vespers rebellion. Enrico Pispisa, *Medioevo meridionale. Studi e ricerche* (Messina, 1994), 229–30.

51. *RCA* vol. 3, 30. He also served in this position in 1280–1 (*RCA* vol. 23, 246). Scarcities discussed in Michel De Boüard, "Problèmes de subsistances dans un état médiéval: Le marché et les prix des céréales au royaume angevin de Sicile (1266–1282)," *Annales d'histoire économique et sociale* 10 (1938): 483–501.

52. *RCA* vol. 5, 237; also vol. 8, 194 and 301. On the prestige of mint administration in general, A. Murray, *Reason and Society*, 86. Given the fierce taxation policies of the Angevins, these positions could be quite lucrative: towns were required to return old currency to the

mint administrators and then were taxed on the new they received. This occurred more or less annually during the years of financial crisis. Giuseppe Del Giudice, *Una legge suntuaria inedita del 1290* (Naples, 1887), 35.

53. *RCA* vol. 6, 32, 158, etc; G. Del Giudice, *Legge suntuaria*, 29, etc.; royal accusations of negligence concerning shipments of supplies reprinted in F. Widemann, "Giacomo Rufolo," 87–8.

54. L. Cadier, *Administration du royaume de Sicile*, 23.

55. Pietro Corrao, "L'ufficio del Maestro Portulano in Sicilia fra angioini ad aragonesi," in *La società mediterranea all'epoca del Vespro.* XI Congresso di storia della Corona d'Aragona, ed. Francesco Giunta and Pietro Corrao, vol. 2 (Palermo, 1983), 419–31; Del Giudice, *Legge suntuaria*, 29.

56. *RCA* vol. 24, 137.

57. *RCA* vol. 26, 176.

58. *RCA* vol. 6, 347–50; *RCA* vol. 7, 134.

59. David Abulafia, "The Pisan *Bacini* and the Medieval Mediterranean Economy: A Historian's Viewpoint," *Papers in Italian Archaeology* 4 (Oxford, 1985), 294.

60. *RCA* vol. 13, 58–9, doc. 78.

61. Quotations from Luke 6:35, Matt. 6:24, First Rule of Francis, 1221, in Marion Habig, ed., *St. Francis of Assisi, English Omnibus of Sources for the Life of St. Francis*, vol. 1 (Quincy, IL, 1991), 38.

62. "scilicet facite vobis amicos de mammona inquitatis de inquitate tua.... O felix sapientis mercatoris commercium pro terrenis celestia pro perituris eterna commutavit." *Arenga* of the foundation of San Michele in Pogerola, transcribed in Robert Bergman, "Byzantine Influence and Private Patronage in a Newly Discovered Medieval Church in Amalfi: S. Michele Archangelo in Pogerola," *JSAH* 50 (1991): 445, doc. 12, dated 1181.

63. Iacopo was active in the second half of the thirteenth century. Iacopo de Benevento, "Viridarium consolationis," in *Florilegium casinense* 4 (1880): 268.

64. This discussion is based on the following seminal studies: Odd Langholm, *Economics in Medieval Schools. Wealth, Exchange, Value, Money and Usury according to the Paris Theological Tradition, 1200–1350* (Leiden, 1992); Jacques Le Goff, *Your Money or Your Life, Economy and Religion in the Middle Ages*, trans. P. Ranum (New York and Cambridge, MA, 1989); Lester Little, *Religious Poverty and the Profit Economy in Medieval Europe* (Ithaca, 1978); Raymond de Roover, "The Scholastic Attitude toward Trade and Enterpreneurship," in *Business, Banking, and Economic Thought in Late Medieval and Early Modern Europe*, ed. Julius Kirschner (Chicago, 1974), 336–45; John Baldwin, *Masters, Princes, and Merchants: The Social Views of Peter the Chanter and His Circle* (Princeton, 1970); Benjamin Nelson, "The Usurer and the Merchant Prince: Italian Businessmen and the Ecclesiastical Law of Restitution, 1100–1550," *Journal of Economic History*, suppl. VII: *Economic Growth* (1947): 104–22; Amintore Fanfani, *Le origini dello spirito capitalistico in Italia* (Milan, 1933).

65. In 1179, the Third Lateran Council promised excommunication for usurers who practiced their trade openly and denied them Christian burials. The Council of Lyon strengthened these rulings in 1274, leading to statutes such as the one adopted by Pisa in 1286 that banned usurers from the city and its law courts. Jacques Le Goff, "The Usurer and Purgatory," in *The Dawn of Modern Banking* (New Haven, 1979), 25–52.

66. *The Liber Augustalis, or Constitutions of Melfi, Promulgated by the Emperor Frederick II for the Kingdom of Sicily in 1231*, ed. and trans. James M. Powell (Syracuse, 1971), Title VI, p. 12.

67. In light of Max Weber's theories regarding the dependence of capitalism on Protestantism and its "work ethic," and subsequent debates on how Christian prohibitions shaped, fueled, and retarded economic growth, see sources in n. 64.

68. J. Le Goff, *Your Money or Your Life* (New York, 1989); L. Little, *Religious Poverty*; Leonard Boyle, "The *Summa Confessorum* of John of Freiburg and the Popularization of the Moral Teaching of St. Thomas and of some of his Contemporaries," in *St. Thomas Aquinas, 1274–1974: Commemorative Studies* (Toronto, 1974), vol. 2, 245–68; Armando Sapori, "Il 'giusto prezzo' nella dottrina di San Tommaso e nella pratica del suo tempo," in *Studi di storia economica medievale* (Florence, 1940), 189–227.

69. On John Duns Scotus, R. de Roover, "Scholastic Attitude," 339.

70. "The inhabitants of the place are merchants engaged in trade, who do not sow or reap, because they dwell upon high hills and lofty crags, but buy everything for money." *The Itinerary of Benjamin of Tudela*, ed. and trans. Marcus Nathan Adler (London, 1907), 9. Many foodstuffs were imported from the fertile interior of Campania and Apulia.

71. Lester Little, "Pride goes before Avarice: Social Change and the Vices in Latin Christendom," *American Historical Review* 76 (1971): 31; J. Le Goff, *Your Money or Your Life*.

72. Remigius, quoted in Alexander Murray, "Piety and Impiety in Thirteenth-Century Italy," *Studies in Church History*, Popular Belief and Practice 8 (1972): 90.

73. For example, quantity of *exempla* dealing with financial issues and usury by the Dominican preachers Giordano of Pisa (d. 1311), Iacobo Passavanti (d. ca. 1350), Domenico Cavalca (d. ca. 1342), and Filippo degli Agazzari (d. ca. 1422). Texts in *Racconti esemplari di predicatori del Due e Trecento*, vol. 2, ed. Giorgio Varanini and Guido Baldassarri (Rome, 1993).

74. Giovanni Villani, himself a merchant, recounts this episode in his *Nuova cronica*, ed. G. Porta (Parma, 1990), vol. 1, book 8, part 53, p. 494. Akin to the arrest of Jews in England as well, who were under the king's special protection until he desired their money.

75. Giovanni Vitolo and Alfonso Leone, "Riflessi della guerra del Vespro sull'economia della Campania," in *Società mediterranea all'epoca del Vespro*, vol. 4, 433–42; immigration of laborers from France in 1273, Émile Léonard, *Les Angevins de Naples* (Paris, 1954), 94–6; sumptuary laws, G. Del Giudice, *Legge suntuaria*, 162–4.

76. Ravellese who settled in Barletta in the 1230s, the Della Marra family had roots in coastal Campania. See earlier discussion. This account of the chronology of the arrests and executions derived largely from E. Sthamer, "Sturz."

77. Whether these activities were tied to an administrative appointment or whether Matteo was working on his own for the crown is not clear. Evelyn Jamison, ed., *Documents from the Angevin Registries of Naples, Charles I* (Rome, 1949), docs. 189, 190, 192, 204, etc.

78. E. Sthamer, "Sturz;" M. Caravale, s.v. "Della Marra, Galgano," in *DBI* vol. 37 (Rome, 1989), 95.

79. Iacopo, who was *secretus* of Sicily in 1281 and salt minister in Apulia throughout the 1270s, was not arrested; neither was Orso Rufolo, active in the *secretia* of Apulia from 1270 to 1281 and noted as a merchant. Widemann has pointed out that Iacopo was the one family member whose financial dealings appear corrupt, as local documentation regarding questionable property confiscations suggest. F. Widemann, "Giacomo Rufolo," 84.

80. E. Sthamer, "Sturz," 46, doc. 51 (January 1284), etc.

81. The Rufolo and Della Marra scandal is mentioned in studies of the Angevin administration, where it is discussed primarily in conjunction with the Sicilian Vespers. Early histories of the Vespers rebellion seem to reinforce the biased language of medieval accounts. Some Italian scholarship portrays the accused as victims of an avaricious and cruel sovereign (Amari, Del Giudice). In contrast, French scholars adopting a nearly apologetic tone tend to accuse the administrators of taking advantage of a king who was ill prepared to rule the South; thus the purported cruelty of the king is deflected onto the accused administrators (Léonard and to some degree Bresc). As more complex views on the Vespers emerge, so the Rufolos and Della Marras receive nuanced (albeit brief) treatment, as with Andreas Kiesewetter, *Die Anfänge der Regierung König Karls II. von Anjou (1278–1295)* (Husum, 1999); Peter Herde, "Carlo

I d'Angiò nella storia del Mezzogiorno," in *Unità politica e differenze regionali nel Regno di Sicilia*, ed. Cosimo Damiano Fonseca, Hubert Houben, and Benedetto Vetere (Galatina, 1992), 181–204; and N. Kamp, "Vom Kämmerer zum Sekreten." Earlier works: Henri Bresc, "1282: Classes sociales et révolution nationale," in *Società mediterranea di epoca del Vespro*, vol. 2, 241–58; É. Léonard, *Angevins de Naples*; G. Del Giudice, *Legge suntuaria*; Michele Amari, *La guerra del Vespro siciliano* (Palermo, 1841), ed. Francesco Giunta (Palermo, 1969).

82. Carlo Carucci, ed., *Codice diplomatico salernitano* (Subiaco, 1931+) (hereafter *CDSalernitano*), vol. 2, doc. 1.

83. *Pace* Bresc, who interprets the Vespers as an anti-Amalfitan outburst. H. Bresc, "1282."

84. Amari's seminal *Guerra del Vespro* depicted French rule as oppressive, spontaneous, and bloody rebellion as liberating, thus provoking the ruling Bourbons to ban it. He had initially used the bland title *Un periodo delle istorie siciliane del secolo XIII* to get his first edition past the royal censors. The the book was approved but banned soon after, and Amari left for Paris, where the work was published again in 1842 and 1843 with its current title. On the politics and circumstances surrounding the various editions of Amari's work, see Romualdo Giuffrida, "Premessa," in Michele Amari, *Un periodo delle istorie siciliane del secolo XIII* (1841; reprint Palermo, 1988), iii–xii.

In contrast to this heroic interpretation, Steven Runciman's classic study saw the rebellion as an example of the Sicilians' penchant for secrecy, violence, and bloodshed; its essentializing tone alienated generations of Sicilian intellectuals. Recent literature tends to place to rebellion within broader political and economic matrices, in which attention shifts to the chaos of the final years of Hohenstaufen rule, when the dominance of Tuscan and Catalan merchants weakened the barons and their connections to sovereign authority, and Catalan and Palaeologan aspirations and concerns are magnified. Steven Runciman, *The Sicilian Vespers. A History of the Mediterranean World in the Later Thirteenth Century* (Cambridge, 1958); Leonardo Sciascia, "Le mythe des Vêpres siciliennes," in *Palerme 1070–1492. Mosaïque de peuples, nation rebelle: La naissance violente de l'identité sicilienne*, ed. Henri Bresc and Geneviève Bresc-Bautier (Paris, 1993), 229–39. Broader views of Mediterranean and feudal politics: A. Kiesewetter, *Karls II. von Anjou*; E. Pispisa, "Il problema storico del Vespro," in *Medioevo meridionale*; Salvatore Tramontana, *Gli anni del Vespro, L'immaginario, la cronaca, la storia* (Bari, 1989); Norman Housley, *The Italian Crusades. The Papal-Angevin Alliance and the Crusades against Christian Lay Powers, 1254–1343* (Oxford, 1982, 1999).

85. Principal sources consulted for this passage are Jean Dunbabin, *Charles I of Anjou. Power, Kingship, and State-Making in Thirteenth-Century Europe* (London, 1998); A. Kiesewetter, *Karls II. von Anjou*; David Abulafia, *The Western Mediterranean Kingdoms, 1200–1500* (London, 1997); L. Cadier, *Administration du royaume de Sicile*; Benedetto Croce, *Storia del Regno di Napoli* (Bari, 1925; Milan, 1992). See also n. 84.

86. On the severity of this tax relative to that of other contemporary sovereigns, P. Herde, "Carlo I d'Angiò," 197–8.

87. H. Bresc, "1282," 250–1.

88. Saba Malaspina, "Rerum sicularum historia," in *Cronisti e scrittori sincroni napoletani editi e inediti*, vol. 2: *Storia della monarchia, Svevi*, ed. Giuseppe Del Re (Naples, 1868; reprint Darmstadt, 1975), 286–7, 302–3, 330–1, etc.

89. E. Sthamer, "Sturz," docs. 2, 20, 58, 107, etc. My view of the generic accusations derives from this critical study.

90. The mob's shouts of "Die, Frenchmen" appear in most accounts of the rebellion, including Bartholomeus de Neocastro, "Historia Sicula," in *Rerum Italicarum scriptores*, n.s. vol. 13, ed. Giuseppe Paladino (Bologna, 1921–22), 11–12; the fourteenth century "Liber Jani de Procida et Palialoco," in *Due Cronache del Vespro in volgare siciliano del XIII*, eds. E. Sicard, G. Carducci and V. Fiorini, *RIS*, vol. 34 (Bologna, 1917), 57; and even Dante: "se mala

segnoria, che sempre accora/li popoli suggetti, non avesse/mosso Palermo a gridar: 'Mora, mora!'" (*Paradiso* VIII, 73–5). Also S. Runciman, *Sicilian Vespers*, 215.

91. If this myth has any basis in reality, then the mob chose an eloquent legume for its test of cultural difference. By the thirteenth century, chickpeas were fundamental to the diet of *regnicolo* and Mediterranean merchant alike. Easily dried and thus preserved for long periods of time, chickpeas were a common source of protein, and often the only source taken on long sea voyages. From the cuisine of courtly Baghdad to the mundane grocery lists of Jewish merchants in Cairo, chickpeas appear in a variety of southern and eastern Mediterranean contexts in the high Middle Ages. Although not unknown above the Alps, they were less fundamental to northern European cuisine. Although the consequences of failing the *ciciru* test were grave, the ideological charge of medieval cookery fully emerged only in the wake of the Vespers rebellion. In an episode of stove-top imperialism akin to Charles I's aggressive insistence on the French style in architecture, Charles II established in law the proper way to make soup: with meat prepared in *more ultramontano*. Soup: G. Del Giudice, *Legge suntuaria*, 158. Chickpeas: J. Pryor, "Exports of Foodstuffs"; S. D. Goitein, *Mediterranean Society*, vol. 4, 232; C. Anne Wilson, "The Saracen Connection: Arab Cuisine and the Mediaeval West," *Petits propos culinaires* 7 (March 1981): 13–22, 8 (June 1981): 19–28; A. J. Arbery, ed. and trans., "A Baghdad Cookery Book (1226)," *Islamic Culture: The Hyderabad Quarterly Review* 13 (1939): 21–47. Architecture: Caroline Bruzelius, "*ad modum franciae*. Charles of Anjou and Gothic Architecture in the Kingdom of Sicily," *JSAH* 50 (1991): 402–20.

92. "French" newcomers of the 1260s and 70s were themselves a diverse group, arriving from Provence and also central and western France – Albi, Marseilles, Aix, Nice, and Sens count among their varied provenances. Thus the meaning of "French" and "Sicilian" are difficult to conceptualize for this period and were far from rigidly applied in the rebellion, as a few men from Provence were noted among the rebels, and the *regnicolo* administrator Enrico Rossi was murdered by the mob. That being said, the raid began as a response to a "French" general molesting a Palermitan woman, and anti-French sentiment dominates accounts of the rebellion. On the diversity of the Northern settlers, L. Catalioto, *Terre, baroni, e città*, and Sylvie Pollastri, "La noblesse provençale dans le Royaume de Sicile (1265–1282)," *Annales du Midi* 100 (1988): 405–29.

93. Here I side with Kiesewetter, who places the Rufolo and Della Marra story within the framework of Charles II's reformist agenda. But in attempting to recuperate flagging support in so violent a way, the arrests and executions also are part of the crown's consolidation of (oppressive) monarchical power. A. Kiesewetter, *Karls II. von Anjou*, ch. 9. On such uses of royal power, R. I. Moore, *The Formation of a Persecuting Society. Power and Deviance in Western Europe, 950–1250* (Oxford, 1987, 2000).

94. Kiesewetter and Nitschke have noted that the Rufolo–Della Marra case marked the first active and autonomous move of the prince, whom Charles I had left in charge when in France from January 1283 to June 1284. Charles of Salerno's actions diverged from his father's less sympathetic stature toward complaints of *regnicoli*; indeed Charles I was apparently displeased with his son's treatment of the Rufolo and Della Marra men and sought to distance himself from the prince's actions. The judge who supervised the trials and executions, Tommaso of Brindisi, was arrested and executed when the king returned to the *Regno*. A. Kiesewetter, *Karls II. von Anjou*; August Nitschke, "Karl II. als Fürst von Salerno," *QFIAB* 36 (1956): 188–204.

95. If the king perceived a delay in fulfilling his orders, threats grew more specific, as in the case of the judicial secretary of the Basilicata's order to hand over the collected hearth taxes or be subjected to "pain to the eyes." Documents dated 1272. G. Del Giudice, *Legge suntuaria*, 192–4.

96. See A. Kiesewetter, *Karls II. von Anjou*, ch. 9; S. Runicman, *Sicilian Vespers*; and A. Nitschke, "Karl II. als Fürst."

97. On the Franciscan forms of San Lorenzo and the possibility of an onomastic dedication there in Lorenzo Rufolo's memory, Caroline Bruzelius, "Il coro di San Lorenzo Maggiore e la ricezione dell'arte gotica nella Napoli angioina," in *Il Gotico europeo nell'Italia*, ed. Valentino Pace and Martina Bagnoli (Naples, 1994), 265–77; document transcription in E. Sthamer, "Sturz," doc. 55.

98. Loan of twenty silver *once* to the bishop Ptolomeo of Ravello noted in *PAVAR* vol. 5, 59, doc. LXXXIII.

99. Cava, Fondo Mansi 13, doc. 581. For a Nicola Rufolo, doctor of law, active in 1290, see R. Brentano, *Two Churches*, 160–5.

100. Cava, Fondo Mansi 13, docs. 68, 513.

101. Cava, Fondo Mansi 13, doc. 635. Paid for weekly masses both in the Rufolo chapel in the cathedral and also at Santa Chiara.

102. Cava, Fondo Mansi 13, doc. 534; also Tommaso Kaeppeli, "Dalle pergamene di San Domenico di Napoli. Rilievo dei domenicani ivi menzionati con due appendici sui priori conventuali e provinciali fino al 1500," *Archivum Fratrum Praedicatorum* 32 (1962): 297, doc. 19, doc. 20. See Ch. 4.

103. ASN, Monasteri soppressi 425 (San Domenico Maggiore), p. 83. See Chapter 4.

104. Mariotto is referred to as "preculature generare de la maiore ecclesia piscopato de Ravello." *PAVAR* vol. 6, 218–19, App. doc. III.

105. ASN, Frammenti di fuochi, ms. 232 and 246, dating from 1593, 1596, and 1666.

CHAPTER TWO

1. G. B. Bolvito, "Registri," BNN, FSM 101, p. 267. Transcription and analysis of passage in Jill Caskey, "An Early Description of the Villa Rufolo in Ravello," *Apollo* 11 (1995): 123–8.

2. Marino Freccia, *De Subfeudis Baronum et investituris Feudorum* (Venice, 1579), 78.

3. For Cassiodorus on Theodoric's palace in Ravenna, see Gary Radke, "The Palaces of Frederick II," in *Intellectual Life at the Court of Frederick II Hohenstaufen*, ed. William Tronzo (Washington, DC, 1994), 180.

4. A new census of vaulted houses focuses on more modest structures to the west of Amalfi and is exceptional in its attentiveness to context. Giuseppe Fiengo and Gianni Abbate, *Case a volta della costa di Amalfi* (Amalfi, 2001).

5. The first detailed analysis of the house and its place in scholarly and local literature is J. Caskey, "Rufolo Palace," ch. 3. Subsequent archaeological studies noted below. Earlier references: Heinrich Wilhelm Schulz, *Denkmaeler der Kunst des Mittelalters in Unteritalien* (Dresden, 1860), vol. 2, 278–9; É. Bertaux, *AIM*, 626–8; Antonio Cadei in *Aggiornamento AIM*, 781–4; Armando Schiavo, "Villa Rufolo," *Le vie d'Italia* (1940): 478–90; brief remarks on Islamic influence in Francesco Gabrieli and Umberto Scerrato, *Gli arabi in Italia. Cultura, contatti e tradizioni* (Milan, 1985), 333.

6. For example, Jean-Marie Martin, "Palais princiers et impériaux en Italie méridionale et en Sicile (VIIIe–XIVe siècles)," in *Palais royaux et princiers au Moyen Âge*. Actes du colloque international tenu au Mans, 1994, ed. Annie Renoux (Le Mans, 1996), 173–80; Joselita Raspi Serra, "L'architettura degli ordini mendicanti nel Principato salernitano," *MÉFR* 93 (1981): 605–81. A more broad-based study is the foundational work on Salerno, Paolo Delogu, *Mito di una città meridionale (Salerno, secoli VIII–XI)* (Naples, 1977), esp. ch. 3.

7. Not only have extant houses of medieval origin inevitably been reconfigured over the centuries, but the types of sources that help establish the chronologies of religious buildings (inscriptions, records of donations, list of office holders, and so on) are few and far between.

Hence the importance of excavated evidence. Various debates in Ross Samson, ed., *The Social Archaeology of Houses* (Edinburgh, 1990).

8. He refers to the "hodgepodge" of pre-fifteenth-century elite housing in Florence. Richard Goldthwaite, "The Florentine Palace as Domestic Architecture," *The American Historical Review* 77 (1972): 983.

9. The general themes mentioned here evoke the following key studies: Maureen C. Miller, *The Bishop's Palace. Architecture & Authority in Medieval Italy* (Ithaca, 2000); Mary Whiteley, "Royal and Ducal Palaces in France in the Fourteenth and Fifteenth Centuries: Interior, Ceremony, and Function," in *Architecture et vie sociale. L'organisation intérieure des grandes demeures à la fin du Moyen Âge et à la Renaissance*, Actes du colloque tenu à Tours, 1988, ed. Jean Guillaume (Paris, 1994), 47–64; Michael Thompson, *The Medieval Hall. The Basis of Secular Domestic Life, 600 A.D.–1600 A.D.* (Aldershot, 1995); Karl Swoboda, "The Problem of Iconography of Late Antique and Early Medieval Palaces," *JSAH* 20 (1961): 78–89.

10. Because the houses are occupied, such a comprehensive project would require sustained cooperation from scores of homeowners. Not many of them are interested in allowing their house to be visited, photographed, and measured for architectural drawings. My work focuses on the houses that I have had the privilege of visiting. I extend my gratitude to those individuals who welcomed me into their homes.

11. Objects discussed in Paolo Peduto, "La ceramica maghrebina nella costa di Amalfi," *Apollo* 11 (1995): 116–22, and idem, "Un giardino-palazzo islamico del secolo XIII: L'artificio di Villa Rufolo a Ravello," *Apollo* 12 (1996): 57–72.

12. Theories of medieval cross-cultural exchange have ranged from the traditional notion of "influence" as a passive phenomenon to recent emphases on the active, informed, and participatory nature of aesthetic choice. Intermediate models such as Goss's are helpful in charting the mechanisms of transmission over geographical or cultural divides, but they are less able to illuminate Amalfitan housing, where cultural proximity rather than distance is in play. Vladimir Goss, "Western Architecture and the World of Islam in the Twelfth Century," in *The Meeting of Two Worlds, Cultural Exchange between East and West in the Period of the Crusades*, ed. V. Goss (Kalamazoo, 1986), 361–75. Also in this tradition: Deborah Howard, *Venice & the East* (New Haven, 2000); Glenn Lowry, "Islam and the Medieval West. Southern Italy in the Twelfth Century," *RCCSA* 3 (1983): 5–58. "Active" models: Anthony Cutler, "The Parallel Universes of Arab and Byzantine Art (with Special Reference to the Fatimid Era)," in *L'Égypte fatimide, son art et son histoire*, ed. Marianne Barrucand (Paris, 1999), 635–48; Robert Nelson, "Appropriation," in *Critical Terms for Art History*, ed. Robert Nelson and Richard Shiff (Chicago, 1996), 116–28.

13. David Abulafia, "A Tyrrhenian Triangle: Tuscany, Sicily, Tunis, 1276–1300," in *Studi di storia economica toscana nel Medioevo e nel Rinascimento in memoria di Federigo Melis* (Pisa, 1987), 53–75; S. D. Goitein, "Medieval Tunisia, the Hub of the Mediterranean," reprinted in *Studies in Islamic History and Institutions* (Leiden, 1968), 308–28.

14. S. D. Goitein, "Medieval Tunisia," 311.

15. Mounira Chapoutot-Remadi, "Tunis," in *Grandes villes méditerranéennes du monde musulman*, ed. Jean-Claude Garcin (Rome, 2000), 240–2; also Geo Pistarino, *Notai genovesi in Oltremare. Atti rogati a Tunisi da Pietro Battifoglio (1288–1289)* (Genoa, 1986).

16. Norman Housley, *The Italian Crusades* (Oxford, 1982, 1999), ch. 5.ii; William Chester Jordan, *Louis IX and the Challenge of the Crusade. A Study in Rulership* (Princeton, 1979), ch. 8; Joseph Strayer, "The Crusades of Louis IX," in *A History of the Crusades*, vol. 2: *The Later Crusades*, ed. Robert Lee Wolff and Harry W. Hazzard (Madison, 1969), 487–518.

17. Recent views of Frederick's eclecticism, particularly in castles, Valentino Pace, "Presenze europee dell'arte meridionale. Aspetti della scultura nel 'Regnum' nella prima metà del XIII secolo," in *Il Gotico europeo in Italia*, ed. Valentino Pace and Martina Bagnoli (Naples,

1995), 221–37; Ferdinando Bologna, "Momenti della cultura figurativa nella Campania medievale," in *Storia e civiltà della Campania: Il Medioevo*, ed. Giovanni Pugliese Carratelli (Naples, 1992), 171–275.

18. My remarks here are based on personal inspection of the sites and not firsthand archaeological analysis. Although the intact structures provide solid ground for interpretation, the intervention of archaeologists has been fruitful on the site of the Rufolo House and would no doubt further elucidate many details concerning chronology and building techniques there and elsewhere.

19. As legal documents rather than letters or diaries, these sources are reticent regarding personal perceptions of medieval housing. Hence this study does not follow Howard's view of houses as subjective expressions of conceptions of the home. D. Howard, *Venice & the East.*

20. On etymology and terminology, see M. Miller, *Bishop's Palace*, Appendix; P. d'Achille, s.v. "Palazzo," in *EAM* vol. 9 (Rome, 1998), 78; Jacques Gardelles, "Le palais dans l'Europe occidentale chrétienne du Xe au XIIe siècle," *Cahiers de civilization médiévale* 19 (1976): 115–34.

21. Emblematic of the problem is the residence of the Rufolos, which has been called at various times a *domus, casa, palazzo,* and *villa.* Around Amalfi, the term *palatium* first referred to ducal residences (*PAVM*, 6, doc. 5, dated 984; *PAVM*, 13, doc. 13, dated 1033); then episcopal ones, first in 1047 (*PAVM*, 15, doc. 16). Reference to Anna Rufolo *ad domum suam* in *RCA* vol. 26, 186, doc. 577 (1282–3). Unusual reference to a *palatium* of townsperson in 1287 (*PAVM*, 178, doc. 178).

22. For example, M. Thompson, *Medieval Hall*, 134; Maurice Barley, *Houses and History* (London, 1986), ch. 5. Also, Victor Mortet, "Hughe de Fouilloi, Pierre le Chantre, Alexandre Neckam et les critiques dirigées au douzième siècle contre le luxe des constructions," in *Mélanges d'histoire offerts à M. Charles Bémont par ses amis et ses élèves à l'occasion de la XXVe année de son enseignement à l'École Pratique des Hautes Études* (Paris, 1913), 105–37.

23. Ulrich Schwarz, *Amalfi im frühen Mittelalter (9.–11. Jahrhundert)* (Tübingen, 1978), 113–15.

24. Roman Amalfi: Matilde Romito, "Il commercio anforario in età romana sulla costiera amalfitana," in *Amphores romaines et histoire économique: Dix ans de recherche.* Actes du colloque de Siene, 1986 (Rome, 1989), 626–7; Nicola Franciosa, *La Villa Romana di Minori* (Salerno, 1976).

25. The earliest source mentioning Amalfi is a letter from Gregory the Great dated 598. The community must have been sizable, for Gregory refers to a bishop in town. While some of the elevated towns were viable in the comital period and critical parts of a network of fortifications, their heyday came later, with the rise of families previously wedded to the land. For early history and sixth-century documents, see U. Schwarz, *Amalfi im frühen Mittelalter*, 14–15.

26. The availability of fresh running water, with its industrial potential for milling and logging, combined with the advantages of a marine locale (fishing, trade), rendered the valleys promising sites for economic developments. These resources facilitated the manufacture of ships that then allowed the Amalfitans to sell raw materials in North Africa.

27. The town plans presented in this book derive from a number of sources. Robert Bergman kindly gave me a series of maps with topographical and architectural evidence that were part of his Harvard-based research project in the early 1980s. These maps were my starting point. In addition to reducing the number of modern structures and roads as much as possible, I have rendered salient buildings in plan, including private churches, cathedrals, and the Rufolo House. Some of the church plans in my maps show medieval reconstructions, rather than the buildings in their current state (e.g., Cathedrals of Scala and Ravello). Many inserted plans derive from canonical sources on Amalfi, such as those by Venditti and Schiavo (see

bibliography). Others are based on my own measurements and drawings. Some are blended versions of both. I am grateful to Danielle Lam-Kulczak for her expert work on this mapping project, to Lino Losanno for his assistance on site, and to Robert Bergman for his initial act of generosity.

28. Andrea De Leone and Alessandro Piccirillo, eds., *Consuetudines civitatis amalfie* (Cava, 1970), 84.

29. Agreement to limit construction "pro lumine et claritate omnium predicatarum fabricarum" of the bishop. *PAVM*, 177–8, doc. 178 (1287).

30. For example, Salvatore Santeramo, ed., *Codice diplomatico barlettano*, vol. 1 (Barletta, 1924) (hereafter abbr. *CDBarlettano*), 97–8, doc. 37 (1282); 173–4, doc. 60 (1290); vineyard in Canne, 26–7, doc. 7 (1186); donation of "domum unam nostram oreatam cum Gayfu," 139–40, doc. 47 (1287); also 74–6, doc. 28 (1249); 224–6, doc. 83 (1298).

31. For example, *CDBarlettano*, vol. 1, 91–2, doc. 34 (1279); two houses purchased by Risone della Marra.

32. Other contexts discussed in D. Howard, *Venice & the East*, 159–62; David Andrews, "Medieval Domestic Architecture in Northern Lazio," in *Medieval Lazio: Studies in Architecture, Painting, and Ceramics*, ed. John Osborne, David Andrews, and David Whitehouse (Oxford, 1982), 10.

33. Jean-Marie Martin, "Quelques données textuelles sur la maison en Campanie et en Pouille (Xe–XIIe siècle)," in *Maisons et espaces domestiques dans le monde méditerranéen au Moyen Âge.* Castrum 6 (Collection de l'ÉFR 105/6), ed. André Bazzana and Étienne Hubert (Rome and Madrid, 2000), 74–87; G. Gargano, "Casa medievale amalfitana."

34. Margaret Wood, *The English Mediaeval House* (London, 1965), 6. Also, M. Barley, *Houses and History*, 67–72.

35. Luigi Kalby, *Tarsie ed archi intrecciati nel romanico meridionale* (Salerno, 1971), 33–6; Francesco Aceto, s.v. "Salerno," in *EAM*, vol. 10 (1999): 254–61.

36. More common in ecclesiastical settings, two-tone insets enliven the upper registers and domes of many twelfth- and thirteenth-century churches in southern Italy and Sicily, including the Cathedrals of Caserta Vecchia, Melfi, Messina, Palermo, and Monreale. For debates initiated by Bertaux regarding the chronology of intarsia motifs and their place(s) of origin, see J. Caskey, "Rufolo Palace," 10–11, 115–17; Antonio Cadei, "Il colore nell'architettura. Riflessioni sulla diffusione della tarsia policromia in Italia meridionale e Sicilia durante età normanna," in *L'architettura medievale in Sicilia: La Cattedrale di Palermo*, ed. Angiola Maria Romanini and Antonio Cadei (Rome, 1994), 183–204.

37. Antonio Forcellino and Ruggero Martines, "I recenti restauri a Villa Rufolo: Nuove acquisizioni sulla Villa e sulla sua genesi," *I Beni culturali: Tutela e valorizzazione. Rivista bimestrale a carattere scientifico* 6 (1999): 28–33. Comparable sketches for stucco patterns survive in the minaret of the Kutubiyya mosque in Marrakesh (mid–twelfth century). G. Marçais, *L'architecture musulmane d'occident* (Paris, 1954), 228.

38. U. Schwarz, "Regesta amalfitana," *QFIAB* 60 (1980): 110, doc. 36.

39. *PAVM*, 28–30, doc. 29.

40. Passage transcribed and analyzed in J. Caskey, "Early Description."

41. Note here the unlikely dates. Charles II was not yet the king and Robert was five years old at the *terminus ante quem* of this banquet, 1283, the year the Rufolo and Della Marra men were arrested.

42. Passage in G. B. Bolvito, "Registri," BNN, FSM 101, 421–2. Repeated in Camera, for whom Bolvito was a key (but unnamed) source. "Scalenses et Ravellenses effeminati viribus, sed fraudibus infruniti operam dabunt spoliis aliorum, sed accuret nimis dies illa velociter in qua scelestos, et cupidos, ac si stipulam aridam flammei clibanus furoris involvet, alterorum situs novorum patebit in curribus Caldeorum." M. Camera, *Memorie*, vol. 1, 360 (attributed to

Joachim). Circle of Joachim attribution in Gerardo Sangermano, "La storiografia," in *Scala nel Medioevo*. Atti del Convegno di Studi, 1995 (Amalfi, 1996), 28.

43. Joachite influence on Robert the Wise and Sancia of Mallorca merits further study, as noted in Ronald Musto, "Franciscan Joachimism at the Court of Naples, 1309–1345: A New Appraisal," *Archivum Franciscanum Historicum* 90 (1997): 419–86; pursuing line of inquiry begun in Caroline Bruzelius, "Queen Sancia of Mallorca and the Convent Church of Santa Chiara in Naples," *Memoirs of the American Academy in Rome* 50 (1995): 69–100.

44. With their formalist focus, studies of the mid-nineteenth century provide a transition between the moralizing and Orientalist traditions. For instance, H. W. Schulz's ground breaking *Denkmaeler* (published in 1860, five years after Schulz's death) related structures and ornament in the Rufolo House to the Cathedral of Caserta Vecchia, an apt comparison. But he also remarked on the house's rare and "fantastic" courtyard. Echoes of Schulz and indeed Bolvito appear in Volpicella's *Delle antichità d'Amalfi e ditorni* (1859), which singles out the courtyard of the Rufolo House as "sumptuous" without reference to comparanda or antecedents. H. W. Schulz, *Denkmaeler*, vol. 2, 279; Scipione Volpicella, *Delle antichità d'Amalfi e ditorni* (Naples, 1859), 78.

45. Adolfo Venturi, *Storia dell'arte italiana*, vol. 3 (Rome, 1904), 510.

46. É. Bertaux, *AIM*, 627. Note similar remark about the dome at the Cathedral of Caserta Vecchia, cited as a comparison with the Rufolo House: it is "digne de surmonter le tombeau d'un calife" – again, without specifics. É. Bertaux, *AIM*, 625.

47. A. Schiavo, "Villa Rufolo."

48. Quotations from François Widemann, "La Villa Rufolo de Ravello et ses propriétaires avant Nicola," *Apollo* 13 (1997): 93–110; P. Peduto, "Giardino-palazzo islamico."

49. Girault de Prangey, *Essai sur l'architecture des arabes et des mores, en Espagne, en Sicile, et en Barbarie* (Paris, 1841); *Description de l'Égypte* (Paris, 1808–28).

50. For instance, there is no equation of Islamic domestic architecture with the feminine that is in so many studies of the South. In fact the work insists on the elegance, tastefulness, variety, and richness of works such as the Alhambra – all used as positive characterizations. G. De Prangey, *Essai sur l'architecture des arabes*, 189, 197, etc.

51. Gioacchino Di Marzo, *Delle Belle Arti in Sicilia*, vol. 1: *Dai Normanni sino alla fine del secolo XIV* (Palermo, 1858; reprint, Catania, 1988), 40, 84–6.

52. Guido di Stefano, *Monumenti nella Sicilia normanna* (Palermo, 1955, 1979), xxv.

53. Fundamental critique of the premise that Islamic art is fundamentally decorative as opposed to figural and thus meaningful, Gülru Necipoğlu, *The Topkapi Scroll – Geometry and Ornament in Islamic Architecture* (Santa Monica, 1995), chs. 4 and 5.

54. On the relevance of such disparate discourses as Montesquieu's theories of climate to the picturesque in nineteenth-century literature, Nelson Moe, *The View from Vesuvius. Italian Culture and the Southern Question* (Berkeley, 2002); John Dickie, *Darkest Italy. The Nation and Stereotypes of the Mezzogiorno, 1860–1900* (New York, 1999). Fundamental overview of the Question in this revisionist mode in Piero Bevilacqua, *Breve storia del Mezzogiorno d'Italia* (Rome, 1993). Key primary sources: Leopoldo Franchetti, *Condizioni economiche amministratrice delle province napoletane, Abruzzi e Molise, Calabrie e Basilicata* (Florence, 1875), Antonio Gramsci, *Disgregazione sociale e rivoluzione. Scritti sul Mezzogiorno*, ed. Francesco Biscione (Naples, 1995); Giuseppe Massari, "Il Brigantaggio," 1863, in *Il Sud nella storia d'Italia. Antologia della questione meridionale*, ed. Rosario Villari, vol. 1 (Bari, 1972), 89–102.

55. For example, Nelson Moe, "The Emergence of the Southern Question in Villari, Franchetti, and Sonnino," in *Italy's 'Southern Question': Orientalism in One Country*, ed. Jane Schneider (New York, 1998), 51–77; and Nadia Urbinati, "The Souths of Antonio Gramsci and the Concept of Hegemony," in *Italy's 'Southern Question,'* 135–56.

56. See the typical remarks of Brühl: "i numerosi palazzi communali giunti fino ai tempi nostri testimoniano ancora della lotta sostenuta dai Comuni italiani per la libertà cittadina" and "un valore essenziale dell'età comunale, la libertà cittadina." Carl Richard Brühl, "Il 'palazzo' nelle città italiane," in *La coscienza cittadina nei comuni italiani del Duecento*, Convegni del Centro di studi sulla spiritualità medievale, Todi, 1970 (Todi, 1972), 202.

57. On the magazine *Illustrazione italiana*, which helped popularize the notion that monuments of historicocultural value were in the North and that landscape was the South's attraction, N. Moe, *View from Vesuvius*, ch. 6.

58. For example, range of visitors' accounts and guidebooks, from the learned Hippolyte Taine's *Voyages en Italie*, vol. 1, *Naples et Rome* (Paris, 1866; reprint, Paris, 1965), to the more popular Caroline Atwater Mason, *The Spell of Italy* (Boston, 1909).

59. C. A. Mason, *Spell of Italy*, 67.

60. For example, the erudite guidebook with a marked artistic bent that presages Croce's anxieties: Sybil Fitzgerald, with illustrations by Augustine Fitzgerald, *Naples* (London, 1904), 62–3.

61. Bertaux inserted the Hohenstaufen into Burckhardt's model of "the State as a work of art." Widely circulated translations of *Civilization* include photographs of Castel del Monte, the castle at Lucera, and the gold *augustalis*, although the works of art themselves are not mentioned in the text. Jacob Burckhardt, *The Civilization of the Renaissance in Italy*, vol. 1 (New York, 1929, 1975), 22.

62. His research began in 1894 and thus spanned years when rampant famine, malaria, violent rebellion, and a lack of infrastructure made the region so inhospitable that the first leader of Italy to make an official tour of the South did so only in 1902 (Giuseppe Zanardelli, the newly elected Presidente del Consiglio). Mario Dilio, *Il viaggio di Zanardelli in Basilicata* (Bari, 1970), 23. See Bertaux's remarks on the challenges of research, spurred by his sense of "filial devotion" to the South: "En verité, lorsque je défendais l'Italie du Sud contre les calomnies et les erreurs dont elle est encore victime, je croyais accomplir un devoir filial." É. Bertaux, "Préface," *AIM*, i–xiv; esp. xii.

63. In 1931, for instance, Sangermano wrote that his volume of medieval documents was intended "a mettere in evidenza la virtù di questo lembo di terra a torto accusato, come terra di conquista, terra vuota di ogni politico e civile avvenimento." *CDBarlettano*, vol. 2, v.

64. Sicardi's 1917 edition of two vernacular chronicles of the Vespers begins with the following dedication: "Alla cara memoria dei'miei buoni genitori Paolo Sicardi e Maria Agostina Rivarola che dormono ora insieme il sonno sereno della morte all'ombra della chiesetta di Santo Spirito in quel suolo sempre benedetto sacro alla libertà de'popoli che prima fu bagnato dal sangue redentore de'Vespri." The church of Santo Spirito is where the riot began. In *Due Cronache del Vespro in volgare siciliano del XIII*, ed. Enrico Sicardi, G. Carducci and V. Fiorini, *Rerum Italicarum scriptores*, vol. 34 (Bologna, 1917), dedication page.

65. S. Volpicella, *Antichità d'Amalfi*, 6–8, 25, 63–4, etc. The religious tone of this work vividly contrasts with his more measured and scholarly tome, *Storia dei monumenti del Reame delle Due Sicilie*, vol. 2: *Principali edificii della città di Napoli descritti da Scipione Volpicella*, part 2 (Naples, 1847).

66. "Et quei Palazi che vi sono ancora hoggi in di rimasti in piede; sono veramente di notabile grandeza, et di sontuosa manifattura;... Et sono vi in gran copia; perchè oltre di quello stupendo de' Rufuli...vi sono degli altri magnificentissimi, come à dire quei dei Frezi, Castaldi, Muscettoli, et quello di Casa dela Marra, dove è una sala di meravigliosa grandeza;...de Rogadei; Grisone; Acconciaiochi; et altrii. Et non è dubbio che in Ravello et in Scala ancò; non vi sia maggior copia; et molto più magnifica de Palazi, airosiβimi, et di vaghissima prospettiva da ogni lor parte." G. B. Bolvito, "Registri," *FSM* 101, p. 257.

67. "Et certo,...assai più amplitudine, et magnificenza, et vagheza de Palazi, è in Scala, di quella che di tal cose è, in Amalfe; et oltre di quei degli Afflitti, i quali sono veramente

meravigliosii vi ne sono infiniti altri; che ad quei predetti di Ravello non cedono un punto; essendonovi i medesimi archati; et colonnati; et ordini de inclaustri marmorei; et altri freggi; et delicature; che in quelli sono; Talmente che dala loro sontuosa edificacione; manifestamente si appalesano la nobilità, et richeza de i Frisari; Trari; Sarcani; Spini; Imperatori; Sandelli; Coppuli; Boniti; Sazi; et altri fundatori di detti gran palazi." G. B. Bolvito, "Registri," BNN, FSM 101, p. 288.

68. See n. 67.

69. J. Caskey, "Rufolo Palace," 120–5. See also F. Widemann, "Villa Rufolo."

70. Trara references in Norbert Kamp, "Ascesa, funzione e fortuna dei funzionari scalesi nel Regno meriodionale del sec. XIII," in *Scala nel Medioevo*, 43.

71. Dates and positions held by Bartolomeo and Iacobo in Norbert Kamp, "Vom Kämmerer zum Sekreten. Wirtschaftsreformen und Finanzverwaltung im staufischen Königsreich Sizilien," in *Probleme um Friedrich II.*, ed. Josef Fleckenstein (Sigmaringen, 1974), 79, 80, 91, 92; Benedetto, in *PAVAR* vol. 5, 28–30, doc. XXVI. Rogadeo agricultural holdings included vineyards in Tramonti (1165) and Traversa (1203). *FM*, 16–18, doc. 9 (1165) and 24, doc. 13 (1203).

72. N. Kamp, "Vom Kämmerer zum Sekreten," 73, 75, 80, 85, etc. Stefano as judge in 1244, *PAVAR* vol. 5, 33–4, doc. XXVIII; Leo in *FM*, 50–2, doc. 27 (1271); Rigorius in *FM*, 37–9, doc. 20 (1242).

73. On the involvement of Bartolomeo *protonotarius* in the arrests of the Rufolos and Della Marras, see Ch. 1. On Nicola, *CDBarlettano*, vol. 1, 315, doc. 128; oration *carissimi amici nostri* in Johannes Baptist Schneyer, *Repertorium der lateinischen Sermones des Mittelalters*, vol. 1 (Münster, 1969), 424 (Vienna, Bib. Nat. 2132, #53). Also, N. Kamp, s.v. "Freccia, Nicola," in *DBI* vol. 50 (Rome, 1998), 350–4 (separate entries for the two Nicolas).

74. Peduto, following Bolvito, takes up the notion of a southern extension to Marmorata. P. Peduto, "Giardino-palazzo islamico."

75. Post-Rufolo history of site in J. Caskey, "Rufolo Palace," ch. 3.

76. J. Caskey, "Rufolo Palace," ch. 3.

77. Matilde Romito, Paolo Peduto, François Widemann, Sergio Vitolo and Prisca Giovannini, "Villa Rufolo di Ravello: Le campagne di scavo del 1988–89," *RSS* 14 (1990): 253–87; P. Peduto, "Giardino-palazzo islamico;" F. Widemann, "Villa Rufolo."

78. G. B. Bolvito, "Registri," BNN, FSM vol. 101, p. 291. Upon converting to Christianity, Eustachius experienced Job-like tragedies with the apparent loss of his wife and two sons. After reuniting, the family returned to Rome only to face persecution. As the *Golden Legend* recounts, "the emperor had a brazen bull heated and ordered the four saints enclosed in it alive. Praying and commending themselves to the Lord, they entered the bull and so rendered their souls to the Lord. Three days later their bodies were taken out of the bull in the emperor's presence. The bodies were intact, nor had the heat of the fire touched the hair or any other part of them." Bolvito clarifies that the d'Afflittos were not direct descendants of Eustachius because he and his children were all *fritti* in the brazen bull. Jacobus de Voragine, *The Golden Legend, Readings on the Saints*, trans. William Granger Ryan (Princeton, 1993), vol. 2, 271, doc. 161.

79. *CP* vol. 1, 119–22, doc. LXXX (dated 998); Salvatore Amici, "Aradica medievale scalese," in *Scala nel Medioevo*, 309.

80. N. Kamp, "Ascesa, funzione e fortuna," 45–6; S. Amici, "Araldica," 309; Ferdinando Ughelli, *Italia sacra* (Venice, 1720, reprint, Lichtenstein, 1970), vol. 7, cols. 328–33.

81. Jill Caskey, "Baths and Bathing." Also Arnaldo Venditti, "Scala e i suoi borghi, ii: Un villaggio rudere: Pontone d'Amalfi," *NN* (1963): 167–8; A. Schiavo, *Monumenti della Costa di Amalfi*, 141.

82. For example, more than a century after the death of Gerardo. A. Schiavo, *Monumenti*, 132; P. Peduto, "Giardino-palazzo islamico."

83. Summary of historiographical debates in Franco Cardini, "L'Ordine gerosolimitano e la figura di fra Gerardo Sasso," in *Scala nel Medioevo*, 85–90; M. Camera, *Memorie*, vol. 2, 279–81.

84. Conference proceedings forthcoming from the Centro di cultura e storia amalfitana. Cinzia dal Maso, "Il cavaliere di Malta torna a casa: Amalfi," *Venerdì della Repubblica*, 13 December 2002, 59–60.

85. On Pietro Sasso, M. Camera, *Memorie*, vol. 2, 281; M. Del Treppo, *Amalfi medioevale*, 90.

86. Giacomo is noted in Angevin sources as living in Palermo. It is unclear if his family emigrated from Amalfi to Sicily, as so many other families from the region did. On Giacomo, N. Kamp, "Ascesa, funzione e fortuna," 48.

87. S. Volpicella, *Antichità d'Amalfi*, 43.

88. G. B. Bolvito, "Registri," BNN, FSM 101, pp. 288–9.

89. Description in M. Camera, *Memorie*, vol. 2, 281–2; A. Venditti, "Scala e i suoi borghi, iii," *NN* (1963): 224–5, n. 30.

90. Albert Vogt, ed. and trans., *Le livre des cérémonies* (Paris, 1935); Averil Cameron, "The Construction of Court Ritual: The Byzantine Book of Ceremonies," in *Rituals of Royalty: Power and Ceremonial in Traditional Societies*, ed. David Cannadine and Simon Price (Cambridge, 1987), 106–36.

91. André Grabar and Oleg Grabar, "L'essor des arts inspirés par les cours princières à la fin du premier millénaire: Princes musulmans et princes chrétiens," in André Grabar, *L'art de la fin de l'antiquité et du Moyen Âge*, vol. 1 (Paris, 1968), 121–44. Specific sites: Nasser Rabbat, *The Citadel of Cairo. A New Interpretation of Royal Mamluk Architecture* (Leiden, 1996); Darío Cabanelas Rodríguez, James Dickie, Jesús Bermúdez López, and D. Fairchild Ruggles, "The Alhambra," in *Al-Andalus, the Art of Islamic Spain*, ed. Jerrilynn Dodds (New York, 1992), 127–73; Oleg Grabar, *The Alhambra* (London, 1978).

92. Efforts to carve out private space within a larger public domain drove some aspects of the diversification of residential architecture for Western rulers in the later Middle Ages, however. The Palace of the Popes in Avignon developed new semiprivate chambers for the pontiff that were contiguous with public space but secured within fortified towers. Similarly, urban palaces of the fourteenth century inserted pockets of private space within larger ceremonial stage sets. Bernhard Schimmelpfennig, "'Ad maiorem Pape gloriam.' La fonction des pièces dans le palais des Papes d'Avignon," in *Architecture et vie sociale*, 25–46; G. Radke, "Form and Function in Thirteenth-Century Papal Palaces," in *Architecture et vie sociale*, 11–24; Mary Whiteley, "Public and Private Space in Royal and Princeley Chateaux in Late Medieval France," in *Palais royaux et princiers*, 71–5.

93. For Genoa, Ennio Poleggi, "Le contrade delle consorterie nobiliari a Genova tra il XII e il XIII secolo." *Urbanistica* 42–3 (1965): 15–20. For Tuscany, D. Andrews, "Medieval Domestic Architecture."

94. Detailed assessment of sculpture and ornament in J. Caskey, "Rufolo Palace," ch. 3.

95. Further discussion of the Rufolo pavilion tower and related debates in Jill Caskey, "The House of the Rufolos in Ravello: Lay Patronage and Diversification of Domestic Space in Southern Italy," in *The Christian Household in Medieval Europe, ca. 850–c. 1550: Managing Power, Wealth, and the Body*, ed. Cordelia Beattie, Anna Maslakovic, and Sarah Rees Jones (Turnhout, 2003), 315–34.

96. Vincenzo Sebastiano, "Rovine e ruderi nel borgo di Campoleone a Scala," *RCCSA* 7 (1997): 181–98.

97. "...ingresso, era di forma quadrata di palmi trecento, riguardando alle quattro parti del mondo...Nell'ingresso non s'alza l'occhio senza inarcarsi il ciglio: havendo il portico una cupula scanellata che scopre solcato il suo cielo, et in forma di tante attorcigliate serpi una moltitudine di colonnette di creta di faenza con base e capitelli e con fascia di pietre nere scorniciate; e di sopra delicatissimi archetti intrecciati tra due cornicioni che la sostengono." M. Camera, *Memorie*, vol. 2, 281.

98. Paolo Cuneo, *Storia dell'urbanistica. Il mondo islamico* (Rome and Bari, 1986), ch. 5; G. Marçais, *Architecture musulmane d'Occident*. Also Mondher Sakly, "Kairouan," in *Grandes villes méditerranéennes*, 57–85.

99. The Maghrebi sources of Norman palace architecture include the Qal'ah of the Beni Hammad, a cultural center founded by the Hammadid dynasty in 1108–9 as a fortified outpost between Qayrawan and Achir. It was abandoned in the mid–twelfth century after the Hammadids moved to Bougie. Jeremy Johns, "The Norman Kings of Sicily and the Fatimid Caliphate," *Anglo-Norman Studies* XV, Proceedings of the Battle Conference (1993), 133–59; Ursula Staacke, *Un palazzo normanno a Palermo, la Zisa: La cultura musulmana negli edifici dei Re* (Palermo, 1991); Lucien Golvin, *Recherches archeologiques à la Qal'a des Benû Hammâd* (Paris, 1965); Francesco Gabrieli, "Il palazzo hammadita di Bigaya, descritto da Ibn Hamdis," in *Aus der Welt der islamischen Kunst, Festschrift für Ernst Kühnel zum 75. Geburtstag am 26.10.1957* (Berlin, 1957), 54–8; G. Marçais, *Architecture musulmane d'Occident*. On broader questions of Fatimid influence beyond palace architecture, see William Tronzo, *The Cultures of His Kingdom. Roger II and the Cappella Palatina in Palermo* (Princeton, 1997).

100. Some were vaulted, for as domed structures gained a funereal association in North Africa, official audience chambers preferred the form of the vaulted *iwan*. Jonathan Bloom, "The *Qubbat al-Khadra* and the Iconography of Height in Early Islamic Architecture," *Ars orientalis* 23 (1993): 135–41; Nasser Rabbat, "Mamluk Throne Halls: *Qubba* or *Iwan*?" *Ars orientalis* 23 (1993): 201–18.

101. Ali ibn Muhammad al-Iyadi, court poet to al-Mansur and al-Mu'izz. Jonathan Bloom, "The Origins of Fatimid Art," *Muqarnas* 3 (1985): 29.

102. Naser-i Khosraw described twelve garden pavilions there. Gulrü Necipoğlu, *Architecture, Ceremonial, and Power. The Topkapi Palace in the Fifteenth and Sixteenth Centuries* (Cambridge, MA, 1991), 245.

103. N. Rabbat, "Mamluk Throne Halls"; idem, *Citadel of Cairo*.

104. Recent excavations have revealed two chambers between the entrance tower and chapel. P. Peduto, "Palazzo-giardino islamico," 70.

105. This wall is where sinopia sketches were recently discovered under the inlaid materials. A. Forcellino and R. Martines, "Recenti restauri a Villa Rufolo."

106. On the Hohenstaufen revival of the *palatium* as imperial privilege, Thomas Zotz, "Palatium et curtis. Aspects de la terminologie palatiale au Moyen Âge," in *Palais royaux et princiers*, 13. Also, G. Radke, "Palaces of Frederick II."

107. Taranto (revaulting of the Great Hall): H. W. Schulz, *Denkmaeler*, vol. 4, 40–1, doc. XCVIII; Melfi: Rosa Corrado, "Il Castello di Melfi: Un cantiere militare angioino," *Arte medievale* 11 (1997): 133–44; Naples: Francesco Aceto, "Il 'Castrum novum' angioino di Napoli," in *Cantieri medievali*, ed. Roberto Cassanelli (Milan, 1995), 251–67; Leonardo Di Mauro, "Castel Nuovo. L'architettura, il rilievo urbanistico, l'iconografia," in *Castel Nuovo. Il Museo Civico*, ed. Pierluigi Leone de Castris (Naples, 1990), 15–33.

108. Bari (1278, for windows): H. W. Schulz, *Denkmaeler* vol. 4, 67, doc. CLXXVI; Melfi: R. Corrado, "Castello di Melfi"; Naples: F. Aceto, "'Castrum novum'"; Trani: Antonio Cadei and P. F. P., "Castello di Trani," in *Federico II e l'Italia. Percorsi, luoghi, segni e strumenti* (Rome, 1996), 224–7.

109. F. Aceto, "'Castrum novum'"; G. De Blasiis, "Le case dei principi angioini nella Piazza di Castelnuovo," *ASPN* 11 (1886): 442–81, and 12 (1887): 289–435. On the treaty and steps leading up to it, N. Housley, *Italian Crusades*, ch. 1.

110. Impact of this aspect of the Roman *domus* on medieval housing: Norbert Schoenauer, *6,000 Years of Housing* (New York, 1981, 2000); Simon Ellis, "The End of the Roman House," *American Journal of Archaeology* 92 (1988): 565–76; Elizabeth Fentress, "The House of the Prophet: North African Islamic Housing," *Archeologia medievale* 14 (1987): 47–68; idem, "Social Relations and Domestic Space in the Maghreb," in *Maisons et espaces domestiques*, 15–26; S. D. Goitein, "A Mansion in Fustat. A Twelfth-Century Description of a Domestic Compound in the Ancient Capital of Egypt," in *The Medieval City. Essays in Honor of Robert S. Lopez*, ed. David Herlihy, Harry Miskimin, and A. L. Udovitch (New Haven, 1977), 163–78; Jacques Revault, *Palais et demeures de Tunis, XVIII–XIX siècles* (Paris, 1971), 44–74.

111. The idea of *curtis* as the core of private property emerges in the Germanic law code of Rothair of 643. Applicable to Lombard territories in northern and southern Italy, Rothair's Edict designates the courtyard as a legally protected site that must not be violated by trespassers or thieves. Such notions of private property rights as centered on freedom from trespass and the nuisance of neighbors were articulated again in the late Middle Ages and of course remain fundamental to the philosophy of law in the West. Katherine Fischer Drew, ed. and trans., *The Lombard Laws* (Philadelphia, 1973), 108.

112. For example, *PAVAR* vol. 5, 31–3, doc. XXVII (1243), Ravello; also *PAVAR* vol. 5, 21–3, doc. XXI (1236), Lacco district of Ravello.

113. Faouzi Mahfoudh, "La grande mosquée de Mahdiya et son influence sur l'architecture médiévale ifriqiyenne," in *Égypte fatimide*, 118–40; G. Marçais, *Architecture musulmane d'Occident*; Alexandre Lézine, *Architecture de l'Ifrikiya: Recherches sur les monuments aghlabides* (Paris, 1966).

114. Although there is no clear evidence regarding the character of Sicilian architecture during the rule of either the Aghlabids or their Kalbid successors who operated as adjuncts to Fatimid authority, the recent excavation of a mosque at Segesta has begun to illuminate this problem. Alessandra Molinari, "Edilizia pubblica e privata nella Segesta medievale," in *Maisons et espaces domestiques*, 183.

115. Overview of toponymy and description of surviving medieval houses in G. Gargano, "Casa medievale amalfitana."

116. A. Cadei in *Aggiornamento*, 781–4; also J. Raspi Serra, "Architettura degli ordini mendicanti," 605–81.

117. G. B. Bolvito, "Registri," BNN, FSM 101, p. 287.

118. On the Andalousian revival in thirteenth-century Tunis, of which little survives in residential architecture, Jacques Revault, *Palais et résidences d'été de la région de Tunis* (Paris, 1974), 21–6; Robert Brunschvig, *La Berbérie orientale sous les Hafsides dès origines à la fin du XVe siècle* (Paris, 1940), vol. 1, esp. 338–57; on immigration from Spain and the material "decadence" of the Hafsid elite, Ibn Khaldun, *The Muqaddimah. An Introduction to History*, trans. Franz Rosenthal, ed. N. J. Dawood (Princeton, 1967; paperback ed., 1969), 200, 293.

119. According to Camera, Manfred resented Atrani's Guelph leanings and placed a community of 1000 Saracens there as punishment. They remained until the archbishop of Amalfi Filippo Augustariccio removed them in 1269. M. Camera, *Memorie*, vol. 2, 237–8; Giuseppe Imperato, *Amalfi nella storia religiosa e civile* (Amalfi, 1987), 265. Flagella, the Frederician "new town" founded in 1241 near the Liri River, was noted in its foundation document as located near "where the infidels lived." Medieval sources quoted and discussed in G. Colasanti, "Il passo di Ceprano sotto gli ultimi Hohenstaufen," *Archivio della Reale Deputazione romana di storia patria* 35 (1912): 38 (thanks to Kathy van Driel for this reference). On Muslims in this region in general, Eugenio Maria Beranger, "Presenze ed influenze saracene nel medio

e basso Liri (IX–XII sec.)," in *Presenza araba e islamica*, Atti del Convegno sul tema, 1989, ed. Agostino Cilardo (Naples, 1992), 55–117.

120. Mauro Ferracuti, "La presenza saracena all'interno dell'area campana nel XIII secolo," in *Presenza araba e islamica in Campania*, 265.

121. As posited for Venice, portable goods such as ivories and rock crystals readily transmitted architectural motifs from the Middle East to the West, particularly before architectural drawings on paper became widespread. D. Howard, *Venice & the East*, 59–62. Builds upon theories of transmission by V. Goss, "Western Architecture and the World of Islam."

122. A. Shalem attributes a group of oliphants with "lace-like" surfaces suggestive of Fatimid influence to Amalfi or Salerno, refining Kühnel's fundamental work. Avinoam Shalem, *Islam Christianized: Islamic Portable Objects in the Medieval Church Treasuries of the Latin West* (Frankfurt am Main, 1996), esp. ch. 5; Ernst Kühnel, "Die sarazenischen Olifanthörner," *Jahrbuch der Berliner Museen* 1 (1959): 33–50; and idem, *Die islamischen Elfenbeinskulpturen* (Berlin, 1971), cat. 52, ill. 44.

123. Stelai discovered in Pozzuoli and Chiaia district of Naples, now in the Archaeological Museum in Naples. Vincenza Grassi, "Iscrizioni funerarie arabe nel Napoletano," in *Presenza araba e islamica*, 337–64.

124. The pyxis of Sayf al-Dawla, dated 1004–8, in J. Dodds, ed., *Al-Andalus*, 202, cat. 5. The casket from the cathedral treasury in Valencia now in the National Archaeological Museum, Madrid (inv. 7.371), made in 1049–50 for the governor of Cuenca in A. Shalem, *Islam Christianized*, cat. 136; and J. Dodds, ed., *Al-Andalus*, cat. 7; E. Kühnel, *Islamischen Elfenbeinskulpturen*, cat. 42, table 38.

125. A. Shalem, *Islam Christianized*, ch. 5.

126. Iacopo Rufolo, for instance, oversaw shipments of grain to Bougie in 1275, as did Matteo in 1279 and 1281. *RCA* vol. 13, 91; *RCA* vol. 23, 310; Giuseppe Del Giudice, *Una legge suntuaria inedita del 1290* (Naples, 1887), 216–19, doc. 16. Also G. Pistarino, *Notai genovesi in Oltremare*.

127. Fuller treatment of the baths in Jill Caskey, "Steam and *sanitas* in the Domestic Realm: Baths and Bathing in Southern Italy in the Middle Ages," *JSAH* 58 (1999): 170–95. Also, Paul Arthur, "The Byzantine Baths at Santa Chiara, Naples," in *Journal of Roman Archaeology*, suppl. seri. 37, 1999, *Roman Baths and Bathing*, Part 1: *Bathing and Society*, ed. J. DeLaine and D. E. Johnston, 135–46; V. Sebastiano, "Rovine e ruderi."

128. The Pontone bath was first published by Arnaldo Venditti, "Scala e suoi borghi, ii," 167–8; Paolo Peduto, "Materiali arabo-islamici nella Ravello del secolo XIII. Eredità o moda?" in *Presenza araba e islamica*, 467–72; and idem, "Giardino-palazzo islamico." J. Caskey, "Baths and Bathing."

129. Ulrich Schwarz, "Regesta amalfitana," *QFIAB* 59 (1979): no. 14.

130. Arnaldo Venditti, *Architettura bizantina nell'Italia meridionale* (Naples, 1969), 635–6. For a more detailed discussion of Byzantine connections, J. Caskey, "Baths and Bathing," 184–5.

131. Lucien Golvin and Derek Hill, *Islamic Architecture in North Africa* (Hamden, Conn., 1976); A. Lézine, *Architecture de l'Ifriqiya*; Slimane-Mostafa Zbiss, "Documents d'architecture fatimite d'Occident," *Ars orientalis* 3 (1959): 27–31.

132. For example, Matthew Paris on Frederick II. J. Caskey, "Baths and Bathing," 186–7.

133. Present-day parallels and their implications for a history of private life in Stuart Shapiro, "Places and Spaces: The Historical Interaction of Technology, the Home, and Privacy," *The Information Society* 14, no. 4 (1998): 275–84.

134. It has been posited that Muslims were brought to Ravello to construct the Rufolo House, although this idea must remain hypothetical. M. Ferracuti, "Presenza saracena," 284; following suggestions of L. Kalby, *Tarsie ed archi intrecciate*, 71.

135. Lentini and Syracuse: H. W. Schulz, *Denkmaeler*, vol. 4, 4, doc. IX; 4–5, doc. X; 5, doc. XI.

136. M. Ferracuti, "Presenza saracena," 264.

137. P. Peduto, "Giardino-palazzo islamico."

138. For uses of ornament as spatial and social differentiation in the early modern North, see Ethan Matt Kavaler, "Renaissance Gothic in the Netherlands: The Uses of Ornament," *AB* 82 (2000): 226–51; versus Oleg Grabar, *The Mediation of Ornament* (Princeton, 1992).

139. On the juridical significance of Tuscan loggias as liminal spaces, see Charles Burroughs, "Spaces of Arbitration and the Organization of Space in Late Medieval Italian Cities," in *Medieval Practices of Space*, ed. Barbara Hanawalt and Michal Kobialka (Minneapolis, 2000), 64–100; R. Goldthwaite, "Florentine Palace."

140. Peduto has rightly linked this type of blurred interior-exterior to Islamic palace sources. P. Peduto, "Giardino-palazzo islamico."

141. F. Mahfoudh, "Grande mosquée de Mahdiya;" S. M. Zbiss, "Documents d'architecture fatimide," 27–8. Also G. Marçais, *Architecture musulmane d'Occident*, 106–10; A. Lézine, *Architecture de l'Ifrikiya*.

142. This selective and limited appropriation of Gothic forms coincides with Trachtenburg's views of Italian Gothic. Marvin Trachtenberg, "Gothic/Italian 'Gothic': Toward a Redefinition," *JSAH* 50 (1991): 22–37. Pastena ribs in G. Fiengo and G. Abbate, *Case a volta*, fig. 31.

143. *PAVAR* vol. 1, 60–3, doc. XLI.

144. *PAVAR* vol. 5, 1–3, doc. II (1222). Comparable detail and elaboration in: *PAVAR* vol. 5, 10–13, doc. IX (1225) (Ravello); *PAVAR* vol. 5, 21–3, doc. XXI (1236) (Ravello); later and slightly less complex, *SNSP* 28–32, doc. XI, 1378 (Lone).

145. For the Castellomatas, Robert Bergman, "Byzantine Influence and Private Patronage in a Newly Discovered Medieval Church in Amalfi: San Michele Arcangelo in Pogerola," *JSAH* 50 (1991): 421–45. For the Rufolos, J. Caskey, "Rufolo Palace," ch. 3.

146. M. Miller, *Bishop's Palace*, chs. 1 and 2; on the impact of the Roman composite mode on later housing, see A. Grabar and O. Grabar, "Princes musulmans et princes chrétiens."

147. To probe a range of possibilities, I chose two maritime centers and an inland town for which similar types of documentation survive. Sources include: Salvatore Santeramo, ed., *CDBarlettano*, vols. 1 and 2; Jole Mazzoleni, ed., *Le Pergamene di Capua* (Naples, 1957, 1959; hereafter abbr. *PCapua*); Natale Caturegli, ed., *Regesta Chartarum Italiae. Le carte arcivescovili pisane del secolo XIII* (Rome, 1974; hereafter abbr. *CAPisane*). Venice shows a similar specificity in its descriptions of domestic architecture, as Deborah Howard has recently shown, *Venice & the East*, ch. 5.

148. "Capital": for example, for Capua; "casa que est apoteca" (1229; *PCapua*, vol. 1, 115–17, doc. 55); "casa . . . cum arboribus et fructoras suas et cum introytu suo" (1252; *PCapua*, vol. 1, doc. 87); for Pisa (Avane), "omnes terras, cultas et incultas et vineatas, agrestes et dimesticas" (*CAPisane* vol. 1, 144–8, doc. 68, dated 1215); Barletta: *CDBarlettano*, vol. 1, 18–20, doc. 5 (dated 1172); vol. 1, 330–3, doc. 136 (dated 1308). "Repairs:" for Barletta, *CDBarlettano*, vol. 1, 262–3, doc. 101 (dated 1301); vol. 1, 297–9, doc. 120 (dated 1304).

149. *CDBarlettano*, vol. 1, 228–30, doc. 85 (dated 1299); also vol. 1, 330–3, doc. 136 (dated 1308); vol. 2, 64–5, doc. 41 (dated 1313); vol. 2, 257–8, doc. 172 (dated 1341).

150. For example, charter dated 1217 from Pisa, sale of "unam petium terre . . . cum vinea et arboribus super se et terra campia et cum omni hedificio quod super se habet" (*CAPisane*, 154–7, doc. 72); similarly, charter from Cagliari (dated 1218), *CAPisane*, vol. 1, 158–61, doc. 74; from Pontasserchio, *CAPisane*, 75–7, doc. 44 (dated 1297), and 232–3, doc. 97 (dated 1223). Pisa document of 1222 concerns the future condition of a house but without references to what comprised the *domus*, *CAPisane*, vol. 1, 208, doc. 93.

151. Will of Egidia, *CDBarlettano*, vol. 1, 287–81, doc. 109 (dated 1302); comparable references to clothing, blankets, and furnishings, followed by references to vineyards in *CDBarlettano*, vol. 1, 43–5, doc. 15 (dowry restitution dated 1215).

152. Will of Mabilia, *mantellettum meum de Kamellotto* and all, *CDBarlettano*, vol. 1, 264–6, doc. 102 (dated 1301).

153. On luxury as a concept derived from the political morality of each society, and thus in the Christian Middle Ages as a composite of other sins (from St. Augustine), see Christopher Berry, *The Idea of Luxury. A Conceptual and Historical Investigation* (Cambridge, 1994). On excessive architecture, including an elision of lust and luxury, Alexander Neckam, *De naturis rerum*, ed. Thomas Wright (London, 1863), esp. CLXXII ("De aedificiis") and CXCII ("De luxu").

154. For example, Hugonis de Folieto's remark, "in superfluitate vero amor seculi, non amor Dei, amor palatii, non amor paradise notantur." Also, "Aedificia fratrum non superflua sint, sed humilia: non voluptuosa, sed honesta." From "De claustro animae," in J.-P. Migne, ed., *Patrologia Latina* vol. 176, no. 2 (Paris, 1880), cols. 1056, 1053. Discussion in Victor Mortet, "Hughe de Fouilloi, Pierre le Chantre, Alexandre Neckam;" John Baldwin, *Masters, Princes, and Merchants: The Social Views of Peter the Chanter and his Circle* (Princeton, 1970).

155. Hugonis's *De claustro animae* is cited in Iacopo of Benevento's sermon "On Discretion" in the *Viridarium consolationis*, second half of the thirteenth century. *Florilegium casinense* 4 (1880): 200.

156. Daniel Lesnick, "Dominican Preaching and the Creation of Capitalist Ideology in Late-Medieval Florence," *Memorie domenicane* 8/9 (1977–8): 199–247. For the formation and distribution of this ideology, Jean-Claude Schmitt, "Recueils franciscains d'exempla et perfectionnement des techniques intellectuelles du XIIIe au XIVe siècle," *Bibliotèque de l'École des chartes* 135 (1977): 5–21.

157. Giordano presumably refers to the catastrophic fire of 1304. Echoing Jerome's critiques of the lavishness of Christian art, Giordano railed against the fact that such expenditures occurred while people remained hungry. Sermon in *Racconti esemplari di predicatori del Due e Trecento*, ed. Giorgio Varanini and Guido Baldassarri, vol. 2 (Rome, 1993), 375, no. 201. In the *Commedia*, Dante also characterized hair pieces and other fashions as emblematic of Florence's moral failure, in contrast to the city's Golden Age of the twelfth century, when "si stava in *pace*, sobria e pudica" (*Paradiso* XV. 97–148).

158. Commodities sermon in *Racconti esemplari*, vol. 2, 417–20, no. 229.

159. Essential works on sumptuary law include: Alan Hunt, *Governance of the Consuming Passions: A History of Sumptuary Law* (New York, 1996); Catherine Killerby, "Practical Problems in the Enforcement of Italian Sumptuary Law, 1200–1500," in *Crime, Society, and the Law in Renaissance Italy*, ed. Trevor Dean and K. J. P. Lowe (Cambridge, 1994), 99–120; Diane Owen Hughes, "Distinguishing Signs: Ear-Rings, Jews, and Franciscan Rhetoric in the Italian Renaissance City," *Past & Present* 112 (1986): 3–59; idem, "Sumptuary Law and Social Relations in Renaissance Italy," in *Disputes and Settlements. Law and Human Relations in the West*, ed. John Bossy (Cambridge, 1983), 69–99; Cecil Roth, "Sumptuary Laws of the Community of Carpentras," *Jewish Quarterly Review*, new series, 18 (1927–8): 357–73.

160. Figural ornament outlawed in 1343 law in Siena and Bologna in 1398: E. Casanova, "La donna senese del Quattrocento nella vita privata," *Bollettino senese di storia patria* 8 (1901): 62. Precious hairnets, Bologna in 1289 and 1294: Lodovico Frati, *La vita privata in Bologna* (Bologna, 1928), 27, 244, etc.

161. Also for Messina, Salvatore Salomone-Marino, "Le pompe nuziali e il corredo delle donne siciliane ne' secoli XIV, XV, e XVI," *Archivio storico siciliano* 1 (1876): 209–40.

162. For example, 1298: no colored cloth could be worn by knights in *privato* or *occulto*. G. Del Giudice, *Legge suntuaria*, 127.

163. Besides preserving the dynasty's ultimate authority, that is, as members of the royal family were naturally exempted from the law.

164. For example, variety of sites and commodities mentioned in documents in G. Pistarino, *Notai genovesi in Oltremare*; D. Abulafia, "Tyrrhenian Triangle."

165. Lucy-Anne Hunt, "Comnenian Aristocratic Palace Decoration: Descriptions and Islamic Connections," in *The Byzantine Aristocracy, IX to XIII Centuries*, BAR International Series 221, ed. Michael Angold (Oxford, 1984), 138–56.

166. Soon after the victory of Charles I, "al re non piacque d'abitare nel castello di Capova, perch'era abitato al modo tedesco; ordinò che si facesse castello nuovo presso a San Pietro in Castello da l'altra parte di Napoli." Di Mauro hypothesizes that the "German" features were its square towers, unlike the towers of Castel Nuovo, which generally were represented as round. L. Di Mauro, "Castel Nuovo;" Giovanni Villani, *Nuova Cronica*, ed. Giuseppe Porta (Rome, 1990), lib. 8, ch. 10, 426. Also Caroline Bruzelius, "*Il gran rifiuto*. French Gothic in Central and Southern Italy in the Last Quarter of the Thirteenth Century," in *Architecture and Language: Constructing Identity in European Architecture, ca. 1000–1650*, ed. Georgia Clarke and Paul Crossley (Cambridge and New York, 2000), 39.

167. On palaces in the Hafsid period, see n. 118, and G. Marçais, *Architecture musulmane d'occident*, 262–4.

CHAPTER THREE

1. Important studies of private religious foundations include, for Byzantium, John P. Thomas, *Private Religious Foundations in the Byzantine Empire* (Washington, DC, 1987); Emil Herman, "'Chiese private' e diritto di fondazione negli ultimi secoli dell'impero bizantino," *Orientalia christiana periodica* 12 (1946): 302–21. For southwest Italy, Huguette Taviani-Carozzi, *La Principauté lombarde de Salerne, IX–XI siècle. Pouvoir et société en Italie lombarde méridionale*, 2 vols. (Rome, 1991), 657–67; Paolo Delogu, *Mito di una città meridionale (Salerno, secoli VIII–XI)* (Naples, 1977); M. Del Treppo, *Amalfi medioevale*, ch. 9; Bruno Ruggiero, *Principi, nobiltà e chiesa nel Mezzogiorno longobardo. L'esempio di S. Massimo di Salerno* (Naples, 1973). See also n. 7, this chapter.

2. For art historical overviews and case studies, which are far more numerous for Byzantine contexts due to the prominence of private monasteries there, see Linda Safran, *San Pietro at Otranto: Byzantine Art in South Italy* (Rome, 1992), ch. 4; Robert Bergman, "Byzantine Influence and Private Patronage in a Newly Discovered Medieval Church in Amalfi: S. Michele Arcangelo in Pogerola," *JSAH* 50 (1991): 421–45; Thomas Mathews, "'Private' Liturgy in Byzantine Architecture," *Cahiers archéologiques* 30 (1982): 125–37; Anthony Cutler, "Art in Byzantine Society: The Motive Forces of Byzantine Patronage" (1981), in *Imagery and Ideology in Byzantine Art* (London, 1992), XI; Robin Cormack, "Aristocratic Patronage of the Arts in 11th- and 12th-century Byzantium," in *The Byzantine Aristocracy, IX–XIII Centuries*, BAR International Series 221, ed. Michael Angold (Oxford, 1984), 158–72.

3. Lay participation and patronage were of course not new at this time; what is significant about Amalfi is the sustained presence of lay patrons in both large and small institutions and contexts. For important but generally singular (rather than sustained) cases of lay patronage in Italy, see Hans Belting, "Eine Privatkapelle im frühmittelalterlichen Rom," *DOP* 41 (1987): 55–69, and Kirstin Noreen, "Lay Patronage and the Creation of Papal Sanctity during the Gregorian Reform: The Case of Sant'Urbano alla Caffarella, Rome," *Gesta* 40 (2001), 35–59; for financial contributions to monasteries, Giovanni Vitolo, "'Vecchio' e 'nuovo' monachesimo nel Regno svevo di Sicilia," in *Friedrich II. Tagung des Deutschen historischen Instituts in*

Rom im Gedenkjahr 1994, ed. Arnold Esch and Norbert Kamp (Tübingen, 1996), 182–200. For a historiographic overview of patronage in northern Europe, see Jill Caskey, "Whodunnit? Patronage, the Canon, and the Problematics of Agency in Romanesque and Gothic Art," in *A Companion to Medieval Art: Romanesque and Gothic in Northern Europe*, ed. Conrad Rudolph (Oxford, forthcoming).

4. M. Del Treppo, *Amalfi medioevale*, 151–64. His preliminary census of private foundations of the ninth through the twelfth centuries notes twenty-one such churches, located in most littoral and hill towns.

5. For example, Laws of the Lombard King Aistulf (775) updated the legal rights of lay owners of church property. Katherine Fischer Drew, ed. and trans., *The Lombard Laws* (Philadelphia, 1973), 236.

6. As Brentano put it, "One cannot walk two kilometers in any direction without leaving the diocese of Ravello, nor three without leaving those of Scala and Minori. . . . It is hard to walk at all and stay within their thirteenth-century borders." Robert Brentano, *Two Churches, England and Italy in the Thirteenth Century* (Princeton, 1968; paperback ed., Berkeley, 1988), 63.

7. Closely resembling the rights of the Byzantine *ktistes* (founder), the *ius patronatus* marks a dilution of the Germanic *ius proprietatis*, which entailed full property rights, from foregoing tithes to limiting the power of priests appointed by the laity. On founders' rights as established in Germanic law and ecclesiastical attempts to curtail them during Reform, see Ulrich Stutz, "The Proprietary Church as an Element of Mediaeval Germanic Ecclesiastical Law" (1895), in *Mediaeval Germany, 911–1250. Essays by German Historians*, ed. and trans. Geoffrey Barraclough (Oxford, 1938), vol. 2, 35–70; on the reduced autonomy of private churches in ecclesiastical law of the twelfth century, see Ulrich Stutz, "Gratian und die Eigenkirchen," *Zeitschrift der Savigny-Stiftung für Rechtsgeschichte* 1 (1911): 1–33; versus separating the problem of proprietary churches from Investiture, see G. Mollat, "La restitution des églises privées au patrimoine ecclésiastique en France du IXe au XIe siècle," *Revue historique du droit français et étranger* 27 (1949): 399–423. For analogous constraints of founders' rights in Byzantium, see E. Herman, " 'Chiese private' "; J. P. Thomas, *Private Religious Foundations*. For the *ius patronatus* in Amalfi, Andrea de Leone and Alessandro Piccirillo, eds., *Consuetudines civitatis Amalfie* (Cava de' Tirreni, 1970), section 36, 88.

8. A *portionarius* (shareholder) could sell, lease, or donate his or her shares of a church. For instance, the widow Zucza Gattula and her son Musco donated their "totam ipsam portionem" of the Church of Sts. Erasmus and Nicholas to the bishop of Minori in 1189, for the health of their souls. *PAVM*, 77–8, doc. 75.

9. In the case of Salerno, a similar, tacit acceptance of new foundations perhaps reflected the politics of the new Norman era, in which bishops sought to please the nobility and bolster its political clout in part to keep monastic power in check. That being said, episcopal control over the clergy in private churches occurred in this period, although subsequent attempts at reform were more successful. The archbishop of Amalfi Filippo Augustariccio (in office 1266–92) managed to fold many family foundations into the holdings of public institutions, thereby creating large and wealthy monasteries in Amalfi itself. On the impact of reform on Salerno's private churches, H. Taviani-Carozzi, *Principauté lombarde de Salerne*, 1015–17; on Amalfi, M. Del Treppo, *Amalfi medioevale*, 159. Contrast with reformist zeal in Gaeta, Patricia Skinner, *Family Power in Southern Italy. The Duchy of Gaeta and its Neighbors, 850–1139* (Cambridge, 1995), 234.

10. The sisters are described as *fundatores* of the church. *PAVM*, 100, doc. 97.

11. His figures, even if exaggerated, indicate that private churches were a prominent feature of the urban landscape. G. B. Bolvito, "Registri," BNN, FSM 101, pp. 288–90.

12. Benjamin Nelson, "The Usurer and the Merchant Prince: Italian Businessmen and the Ecclesiastical Law of Restitution, 1100–1550," *Journal of Economic History*, suppl. VII, *Economic Growth* (1947): 104–22.

13. The situation of the Amalfitan merchants resembles other crises of affluence in the Christian West. Vast land holdings enriched Early Christian bishops to such an extent that they needed to develop new ways to spend their wealth that would not clash with the faith's principles, as Peter Brown has argued; constructing impressive liturgical spaces for the flock provided one clear way to do so and could be readily justified as an evangelizing venture. Similarly the wealth of monasteries around 1100 provoked waves of critique and precipitated new forms of asceticism and charity. Conrad Rudolph, *The "Things of Greater Importance": Bernard of Clairvaux's Apologia and the Medieval Attitude Toward Art* (Philadelphia, 1990); Peter Brown, *The Cult of Saints: Its Rise and Function in Early Christianity* (Chicago, 1981), 39–40; Jean Leclercq, "The Monastic Crisis of the Eleventh and Twelfth Centuries," in *Cluniac Monasticism in the Central Middle Ages*, ed. Noreen Hunt (London, 1971), 217–37.

14. The episcopal *arenga* or pious statement attached to a document of 1181 states: "O felix sapientis mercatoris commercium pro terrenis celestia pro perituris eterna commutavit." R. Bergman, "S. Michele Arcangelo," 425–6.

15. Key studies include Jean-Christophe Agnew, "Coming up for Air: Consumer Culture in Historical Perspective," in *Consumption and the World of Goods*, ed. John Brewer and Roy Porter (London, 1993), 19–39; Mary Douglas and Baron Isherwood, *The World of Goods* (New York, 1979); also, Patrick Geary, "Sacred Commodities: The Circulation of Medieval Relics," in *Commodities and Culture*, ed. Arjun Appandurai (Cambridge, 1986), 169–91. These studies acknowledge that commodity culture is a modern phenomenon, but that isolated goods in the premodern era were envisioned or characterized in similar ways and are thus justifiably analyzed through the lens of consumer theory.

16. See Chapter 2, n. 145.

17. Lombard chapels in southern Italy provide local analogues to well-known foundations in Aachen, Palermo, Paris, and so on. For the palace chapels of Lombard princes in Salerno and Benevento and their relations to those in Pavia, see Mariano Grieco, ed., *San Pietro a Corte. Ricupero di una memoria nella città di Salerno* (Naples, 2000); P. Delogu, *Mito di una città*, ch. 1.

18. *CDA* vol. 1, 49–52, doc. XXXIV. Preexisting foundation theory: Mario D'Onofrio and Valentino Pace, *La Campania*. Italia romanica, vol. 4 (Milan, 1981), 301.

19. The lack of clear evidence concerning the earlier church on the site, a seemingly late consecration date (1276), and a scholarly tradition that sought to define "Campanian Romanesque" as indebted to Sicily, fueled divergent theories of San Giovanni's date since the work of Bertaux. Summary of scholarship in M. D'Onofrio and V. Pace, *Campania*, 301–4.

20. Francesco Pansa, *Istoria dell'antica repubblica d'Amalfi* (Naples, 1724; reprint, Bologna, 1989), vol. 2, 86. This Bove attribution stems from local tradition and is not confirmed in primary sources. No dedicatory inscription appears on the pulpit. This is surprising because long inscriptions were key to Amalfitan conventions of private patronage, as discussed later in the chapter. Perhaps this lack of familial marking stems from the shared nature of the foundation.

21. Francesco Gandolfo, *La scultura normanno-sveva in Campania. Botteghe e modelli* (Rome and Bari, 1999), 96–100; Dorothy Glass, *Romanesque Sculpture in Campania: Patrons, Programs, and Style* (University Park, PA, 1991), ch. 4. On earlier scholarly debates, Francesco Aceto, "I pulpiti di Salerno e la scultura romanica della costiera di Amalfi," *NN* 18 (1979): 169–94.

22. Paolo Peduto, "L'ambone della chiesa di San Giovanni a Toro di Ravello. L'uso della ceramica nei mosaici," *Apollo* 7 (1991): 103–9; Glenn Lowry, "Islam and the Medieval West:

Southern Italy in the Eleventh and Twefth Centuries," *RCCSA* 3 (1983): 5–58; Gaetano Bal-lardini, "'Bacini' orientali a Ravello," *BA* 27 (1934): 391–400.

23. Cava, Fondo Mansi 13, fol. 106v, doc. 473, dated 20 September 1283.

24. Luciano Catalioto, *Terre, baroni, e città in Sicilia nell'età di Carlo I d'Angiò* (Messina, 1995), apps. 2 and 4.

25. The "sepultura di esso Sergio; che giace nela sua cappella sita appresso la d(et)ta porta, dala parte sinistra. Et le l(ette)re che sono in d(ett)a sepultura, dicono così: Hic iacet d(omi)nus Sergius Muscpetula Peccator." G. B. Bolvito, "Registri," BNN, FSM 101, pp. 257–8.

26. A now-lost inscription on the bell tower was dated 1187 and named the two sons of the founder Matteo as co-owners. Antonio Cadei, in *Aggiornamento AIM*, 773.

27. On the Eustachius myth and d'Afflitto family, see Chapter 2.

28. The intersecting arches contain colorful inlay in faux *opus reticulatum*, about fifty years before the trumpeted revival of them at Frederick II's Castel del Monte in Apulia. Much of the ornamental detail observed by earlier scholars was replaced in 2002 in a restoration that has saved the remains from collapse. On the ornament, see Arnaldo Venditti, "Scala e i suoi borghi, ii: Un villaggio rudere: Pontone d'Amalfi," *NN* (1963): 163–76; Stefano Bottari, "I rapporti tra l'architettura siciliana e quella campana del Medioevo," *Palladio* 5 (1955): 7–28; Benedetto Croce, "Sommario critico della storia dell'arte napoletana," *NN* 2 (1893): 88.

29. Connections between artisans at Monreale and Amalfi were intimate in those years, for Barisano of Trani probably cast the bronze doors of Monreale after those of Ravello (1179). The prominence of Eustachius on Barisano's bronze doors on the north portal of Monreale may relate to William II's love of the hunt and his dream that justified the foundation of Monreale. But the possibility of a Ravello-Pontone-Monreale axis is tantalizing and should be considered. Could it be that the d'Afflitto doors were made by Barisano? A capital in the cloister of Monreale depicts the saint as well, drawing the two monuments more tightly together. On connections to Sicily in architecture and sculpture, D. Glass, *Romanesque Sculpture in Campania*, chs. 5 and 6; M. D'Onofrio and V. Pace, *Campania*, 346–50; S. Bottari, "Rapporti;" A. Venditti, "Scala e i suoi borghi, ii."

30. G. B. Bolvito, "Registri," BNN, FSM 101, p. 294. Also Carlo De Lellis, *Discorsi delle famiglie nobili del Regno di Napoli*, vol. 3, 253–8; includes inscription on tomb of Bartolomeo (d. 1240).

31. On fragments, D. Glass, *Romanesque Sculpture in Campania*, 120–4.

32. An unpublished inventory of 1369, known through Mansi's eighteenth-century copy in Cava, Badia di Cava, Fondo Mansi 31, fols. 176r–177v.

33. General contours of Byzantine law: J. P. Thomas, *Private Religious Foundations*, 253; E. Herman, "'Chiese private,'" 309–17. Salerno: H. Tavaini-Carozzi, *Principauté lombarde de Salerne*, 1011–15.

34. R. Bergman, "S. Michele Arcangelo," 424. See earlier mention of *arenga*.

35. It is one of two around Amalfi. See Maria Russo, "La scoperta di una nuova chiesa a croce greca inscritta: San Lorenzo del Piano di Amalfi," *Apollo* 16 (2000): 127–58.

36. That being said, it must be underlined that the merchants would not have been able to enter these buildings and observe their interiors because they were monastic, imperial foundations. More accessible variations in southern Italy, such in Rossano and Otranto, helped diffuse this type of design.

37. SS. Annunziata: Apparently founded by Filippo Freccia in 1278 or 1281. Matteo Camera, *Memorie*, vol. 2, 327; Giuseppe Gargano, "Ravello medievale: Aspetti di topografia e storia urbanistica," in *Atti della Giornata di studio per il IX centenario della fondazione della Diocesi di Ravello, 1986* (Ravello, 1987), 120. By 1375, SS. Annunziata was used as burial chapel for De Furno clan of judges. Archivio della Badia di Cava, Fondo Mansi 13, doc. 70, fol. 20r.

Sant'Angelo dell'Ospedale: A hospital located in a cave near the *platea S. Adiutori*, also founded by the Freccia family. One of a handful of rock-cut church hospital chapels, a feature of the region's unusual medical culture. See Chapter 4.

38. The cathedral was originally dedicated to the Assumption, although a vial of Pantaleon's blood was in the church treasury as early as 1112. Ravellese merchants probably brought the vial from Constantinople, for a sample of Pantaleon's blood was noted at Hagia Sophia around 1200. His blood liquefies on his feast day, like that of his Neapolitan rival Gennaro. Luigi Kalby, "Culto ed iconografia di S. Pantaleone," in *Diocesi di Ravello*, 165–74.

39. Overview of early restorations in J. Caskey, "Rufolo Palace," 48–9; restorations of the late 1990s in Ruggero Martines, ed., *La Cattedrale di Ravello e i suoi pulpiti* (Viterbo, 2001).

40. Jole Mazzoleni, "*Maior Ravellensis Ecclesia*," in *Diocesi di Ravello*, 36; Errico Cuozzo, "La nascita della diocesi di Ravello (a. 1086): Un'episodio della ristrutturazione diocesana nel Mezzogiorno del XI secolo," in *Diocesi di Ravello*, 45–52.

41. According to the *Chronica monasterii Casinensis*, Amalfitan masons worked on the site. See Introduction, n. 59.

42. The income for the new bishopric largely came from agricultural production in Apulia, reflecting the interest and participation of the Norman Duke Roger Borsa in the foundation and apparent alignment with the Ravellese. E. Cuozzo, "Nascita del diocese."

43. Bishoprics were established at Minori in 987, Sorrento in 968, and Scala, before 987.

44. Rogadeo's altar commission is recorded in BNN, Biblioteca Brancacciana, III C 12, 106r, and later in F. Pansa, *Istoria*, vol. 2, 83.

45. Dorothy Glass, "Jonah in Campania: A Late Antique Revival," *Commentari* 27 (1976): 179–93.

46. Carla Guglielmi Faldi, *Il Duomo di Ravello* (Milan, 1974). Pantaleo Pironti, bishop of Ravello from 1210 to 1220, was also buried on that site.

47. For the precedent of the tomb of Gregory of Tours, see Nino Zchomelidse, "*Amore virginis* und *honore patriae* – Die Rufolo Kanzel im Dom von Ravello," *Analecta Romana Instituti Danici* 26 (1999): 99–117.

48. William Melczer, *La porta di bronzo di Barisano da Trani a Ravello: Iconografia e stile* (Cava de' Tirreni, 1984), 52–4, n. 17, for the various commercial and judicial activities of the Muscettola clan; David Walsh, "The Iconography of the Bronze Doors of Barisanus of Trani," *Gesta* 21 (1982): 91–106; Albert Boeckler, *Die Bronzetüren des Bonanus von Pisa und des Barisanus von Trani. Die frühmittelalterlichen Bronzetüren*, vol. 4 (Berlin, 1953); É. Bertaux, *AIM*, 418–23.

49. See n. 25 to this chapter. That clan's presence in this zone of the cathedral was still in evidence in the early fifteenth century, as Giovanni Muscettola endowed a vaulted funerary chapel adjacent to the bronze doors in 1419. For Sergio, G. B. Bolvito, "Registri," BNN, FSM 101, pp. 257–8; for Giovanni, Cava, Fondo Mansi 13, fol. 150r–v, doc. 654, 29 March 1419.

50. The vast range of inscriptions recorded by Schulz before 1850 and published posthumously in his *Denkmaeler* (1860) include many monuments that are now lost; these inscriptions similarly indicate that no major liturgical furnishings in southern cathedrals were the fruit of lay initiative. H. W. Schulz, *Denkmaeler*.

51. Andrew Martindale, "Patrons and Minders: The Intrusion of the Secular into Sacred Spaces in the Late Middle Ages," in *The Church and the Arts*. Papers read at the 1990 Summer Meeting and the 1991 Winter Meeting of the Ecclesiastical History Society, ed. Diana Wood (Oxford, 1992), 143–78.

52. For example, representative viewpoint of Natalia Teteriatnikov, "Private Salvation Programs and their Effect on Byzantine Church Decoration," *Arte medievale* 7 (1993): 47–63.

53. Scholars agree that *magister* Nicola's father must have been the *protomagister Bartholomeo* who signed in 1223 the portal of Frederick II's palace in Foggia. Maria Stella Calò Mariani, *L'arte del Duecento in Puglia* (Turin, 1984), 193–7.

54. For Nicola's work on Angevin construction sites, see Francesco Aceto, s.v. "Nicola di Bartolomeo da Foggia," *EAM* vol. 8 (Rome, 1997), 685–7; Caroline Bruzelius, "*ad modum franciae*. Charles of Anjou and Gothic Architecture in the Kingdom of Sicily," *JSAH* 50 (1991): 414.

55. Ferdinando Ughelli, *Italia sacra* (Venice, 1720, reprint Lichtenstein, 1970), vol. 6, col. 448. This piece was already lost at the time of Ughelli, although he recorded the inscription of 1276: "Mille ducentenis cum sexto septuagenis/Hoc opus expletur a Praecedente jubetur./Giraldi cura signatur quoque figura/Collatis annis fratris sub sede Johannis./Andreas fieri, Christus velit huic misereri./Matthaeusque comes fuit ipsi Narnia pro[l]es."

56. Discussion of "de Narnia" as place of origin rather than family name in J. Caskey, "Rufolo Palace," 83–5; Anna Carotti, "La seppellettile sacra e l'arte dell'intarsia in Campania dall'XI al XIII secolo," Tesi di laurea, Univ. of Rome, 1966–7. Many thanks to Valentino Pace for loaning me a rare copy of this thesis. Also, Alberto White, "Il ciborio della Cattedrale di Ravello," in *Diocesi di Ravello*, 188 (unsupported hypothesis of Roman formation).

57. Significant or recent studies of the work include Maria Stella Calò Mariani, "L'orizzonte culturale. Committenti e *magistri*," in *Foggia medievale*, ed. M. S. Calò Mariani (Foggia, 1997), 139–47; F. Gandolfo, *Scultura normanno-sveva*; N. Zchomelidse, "Rufolo Kanzel;" A. Carotti, in *Aggiornamento AIM*, 982–5; Stefano Bottari, "Intorno a Nicola di Bartolomeo da Foggia," *Commentari* 6 (1955): 159–63; Ferdinando Bologna, "Per una revisione dei problemi della scultura meridionale dal IX al XIII secolo," in *Sculture lignee in Campania* (Naples, 1950), 21–30; É. Bertaux, *AIM*, 779–86.

58. After the ciborium was dismantled, some parts of it were incorporated into various structures in the church. The architraves formed three steps leading up to the bishop's throne, two capitals flanked the arched entrance to the sacristy until the late 1990s, and the Agnus Dei was placed into the wall above the baptismal font. Overview of history in F. Gandolfo, *Scultura normanno-sveva*, 120–1; A. White, "Ciborio della Cattedrale di Ravello," 188.

59. The Cathedral of Ravello is one of the few churches in southern Italy with two surviving pulpits. Salerno offers another example, and Amendola's description of Sant'Andrea of Amalfi from the seventeenth century mentions two pulpits as well; it is likely that the prestigious and large-scale Salerno monuments provided inspiration for the Amalfi works. D. Glass, *Romanesque Sculpture in Campania*, 92; A. Carotti, "Seppellettile sacra."

60. This eagle takes a step away from hieratic imperial imagery toward a freer naturalism. Its head is slightly cocked in an attentive pose, its wings lie to its side, and long downy feathers form its mane. The maroon pigment that now covers the work is not original because Bolvito described the eagle as being "as white as alabaster" in 1585. G. B. Bolvito, "Registri," FSM 101, p. 258.

61. This paradisiacal motif frequently appears on liturgical furnishings, including altar frontals and chancel barriers, as with the famous examples in Cimitile and Torcello, and also in nearby Atrani. The profusion of bird life is also seen on the second Salerno pulpit.

62. The sea monster panel was removed presumably when the steps to the platform were lowered in 1767. It was then incorporated into the bishop's throne and later displayed in the Museo.

63. Document mentioned in E. Allen, *Ravello* (London, 1909), 24 (dated 1288); ed. and pub. by François Widemann, "Le triptych disparu de la Madonna della Bruna de la Cathédrale de Ravello," *Apollo* 7 (1991): 70–3.

64. Cava, Fondo Mansi 13, fol. 12v–13r, doc. 45, dated 13 October 1392.

65. Edmond Jean-Baptiste Paulin won the Prix de Rome in 1875 and remained in Rome through 1879. The extraordinary amount of detail on this print indicates that he was interested in creating an accurate image of the pulpit, down to the precise shape and arrangement of tesserae. There is some discrepancy between his print, however, and other nineteenth-century renderings of the cathedral, in which the same wooden altar visible today stands in the niche. But grooves in the marble floor under the niche suggest a heavy marblelike altar originally occupied that space, lending weight to his credible design. Hector d'Espouy, *Fragments d'architecture du Moyen Âge et de la Renaissance d'après les relevés & restaurations des anciens pensionnaires de l'Academie de France à Rome* (Paris, ca. 1897), Plate 1.

66. The uncertain chronology of the cathedral renders assigning a date to the lost mosaic impossible. Description of mosaic and chronological issues: J. Caskey, "Una fonte cinquecentesca per la storia dell'arte medievale ad Amalfi," *RCCSA* 12 (1992): 71–81.

67. For a discussion of this altarpiece and its date in the mid-fourteenth century, see J. Caskey, "Rufolo Palace," 96–110. Given the heavy repainting of the altarpiece and the fact that it was stolen in 1974, this study does not address that work. *Pace* Widemann, however, I stand by my initial observations – an altarpiece of this form and composition cannot date from the 1280s without overturning the chronology of late medieval painting in Italy as currently understood. F. Widemann ascribes the work to the patronage of Nicola Rufolo: "Madonna della Bruna"; and idem, "La Villa Rufolo de Ravello et ses propriétaires avant Nicola," *Apollo* 13 (1997): 14.

68. "'...calice uno argenteo desuper deaurato; et turribulo uno argenteo et planeta una de insamato rubeo cum lista una ad aurum ad arma Rufolorum; et panno uno pro altari cum insignis eorum et pannis aliis lineis pro altari et pro canendo missam.'" F. Widemann, "Madonna della Bruna," 72.

69. Bolvito, for example, mentions the four marble columns of the *altare*; this presumably refers to the ciborium. G. B. Bolvito, "Registri," BNN, FSM 101, p. 256.

70. "...la chiesa è in trè ali, una colla sua Croce, in mezzo cui vi è una Tribuna tutta di marmo, sostenuta da quattro colonne, in ciascheduna vi stà l'Aquila, il Bue, il Leone, e l'Angelo, geroglifici de'quattro Evangelisti, e dal piano delle base sopra dette colonne da principio un ordine di cupola, sostenuta da 24 colonnette, e sopra detta cupola vi è un altro ordine d'altre 16 colonnette con la sua cupuletta, sopra cui vi è un tonno, entro del quale vi è il geroglifico dell'*Agnus Dei*, e nel frontispicio della prima base, sopra delle quattro colonne, che è tutta di Mosaico con l'impresa della nobilissima Famiglia de'Rufali." F. Pansa, *Istoria*, vol. 2, 82.

71. These beams measure 25 × 279 and 25 × 315 cm. The inscribed beam lacks tesserae.

72. The nearly identical measurements of the four capitals identify them as a group. Carla Guglielmi Faldi, *Il Duomo di Ravello* (Milan, 1974); Francesco Aceto, "Pulpiti di Salerno," 190–1, n. 80.

73. This building up of a bell's planes and the multiplication of plant imagery in flat relief was already apparent in twelfth-century sculpture; compare the Ravello capitals to the Salerno pulpits. D. Glass, *Romanesque Sculpture in Campania*, figs. 75 and 79.

74. Prof. Ruggero Martines kindly informed me via written communication (March 2003) that these were removed to allow for the eventual reconstruction of the ciborium.

75. Labors of the month theory, F. Aceto, "Pulpiti di Salerno," 190–1. The sacristy capital resembles types that were diffused in the early thirteenth century and does not follow those forms with great success. Amalfi capitals in D. Glass, *Romanesque Sculpture in Campania*, figs. 88, 90, and 91, and Toronto, 122–5.

76. Originally anchored to the baldachin by a small knob and beveled base, the piece is about seventy centimeters high. The frame bears minute ceramic and glass tesserae in two bands of contiguous four-point stars.

77. A southern Italian cameo depicting an eagle with prey, dated circa 1240, figures feathers in the same way as the two Ravello pieces, and helps anchor the work to the early part of the century. St. Petersburg, Hermitage Inv. K 2141. In *Die Zeit der Staufer, Geschichte – Kunst – Kultur*, Katalog der Ausstellung, ed. Reiner Haussherr (Stuttgart, 1977), vol. 1, cat. 877, 686.

78. Because the pieces were not thoroughly examined or photographed before the theft, many of their characteristics cannot be specified, including measurements or key structural features.

79. R. Martines, ed., *Cattedrale di Ravello*; A. White, "Ciborio della Cattedrale di Ravello."

80. The twelfth-century ciborium in San Pietro al Monte in Civate bears the symbols of the Evangelists above the capitals in this way; but it is made of stucco, and this lighter material renders the arrangement structurally sound.

81. "Non prima si giunge alla città di Ravello, che sì vede nel centro della disadorna sua piazza una meschinissima fonte, ove sono state allogate due marmoree figure degli alati leone e vitello, rozzamente scolpite, le quali, mostrando le schiene spianate, ed essendo immagine di san Luca e san Marco, furono per fermo altra volta in qualche chiesa sottoposte a colonne." Scipione Volpicella, *Delle antichità d'Amalfi* (Naples, 1859), 45–6.

82. Glazed ceramic tesserae were not typically used in medieval mosaics, although there are cases in Byzantine art where they supplemented insufficient local resources – for instance, where red glass was limited, glazed terracotta was used in its place. Eve Borsook, Fiorella Gioffredi Superbi, and Giovanni Pagliarulo, eds., *Medieval Mosaics. Light, Color, Materials* (Cinisello Balsamo, 2000), 204–5.

83. The upper registers, completed by the archbishop Filippo Augustariccio in 1276, are decorated with ceramics. Paolo Peduto, "L'ambone della chiesa di San Giovanni a Toro: L'uso della ceramica nei mosaici," *Apollo* 7 (1991): 103–9.

84. Chemical analyses of some of the Ravello materials in P. Moioli and C. Seccaroni, "Pigmenti, vetri e ceramiche nell'ambone e nel pulpito della Cattedrale di Ravello," in *Duomo di Ravello e i suoi pulpiti*, 51–66; some Islamic comparanda in Otto Mazzuccato, "Le tessere musive in ceramica," in ibid., 67–76.

85. For example, turquoise and cobalt underglaze works with black linear designs that were produced in various locations in Ayyubid and Mamluk Syria in the twelfth and thirteenth centuries (some kilns survived the Mongolian invasions of 1258–9). Comparanda: Damascus, first half of twelfth century, now Paris, Musée du Louvre 2463, in Jean Soustiel, *La céramique islamique* (Fribourg, 1985), 115, fig. 126. Similar azure pieces were also manufactured in Iran between ca. 1100 and 1300.

86. On the appearance of lustreware in Abbasid Iraq and controversies concerning its origins, Géza Fehérvári, *Islamic Pottery. A Comprehensive Study based on the Barlow Collection* (London, 1973), 41–44. Technique and examples in J. Soustiel, *Céramique islamique*, 46–52.

87. Surviving parallels include works from Fatimid Egypt of the eleventh and twelfth centuries, displayed on the Torre Civica in Pavia (like the Ravello ambo fragment, this work includes an Arabic inscription; see O. Mazzuccato, "Tessere musive," 76); similar pieces from Fustat (late ninth or early tenth century) and twelfth-century Iran, in J. Soustiel, *Céramique islamique*, 113 and 90, respectively.

88. Robert Mason, *Shine Like the Sun: Lustre-Painted and Associated Pottery from the Medieval Middle East* (Costa Mesa, CA and Toronto, forthcoming), ch. 5. I am grateful for Prof. Mason's assistance at the Royal Ontario Museum and for showing me his forthcoming book.

89. Peduto and his colleagues have located many sources for the Toro bowls, including sites in the eastern Mediterranean. Part of the difficulty in assigning exact provenance stems from the fragmented evidence in Ravello and the diaspora of Fatimid potters into Syria, Iraq, and the Maghreb after 1168. Petrographic analysis would help resolve these issues. Paolo Peduto, "L'ambone della chiesa di San Giovanni a Toro;" M. Schvoerer et al., 'Bacini et tesselles en

céramique glaçurée de l'église San Giovanni del Toro, Ravello," *Apollo* 8 (1992): 74–96. Fatimid Egypt theory: G. Ballardini, "'Bacini'"; Syria: Umberto Scerrato and Francesco Gabrieli, *Gli arabi in Italia* (Milan, 1984).

90. For example, works in the Haags Gemeentemuseum, The Hague, and Khalili Collection, London, in J. Soustiel, *Céramique islamique*, 85, fig. 75, and Ernst Grube, ed., *Cobalt and Lustre, The Nasser D. Khalili Collection of Islamic Art*, vol. IX (Oxford and London, 1994), 177, cat. 174, respectively. A few tesserae on the Rogadeo pulpit also are of this type.

91. The Capocci reliquary chapel of 1256, formerly in Santa Maria Maggiore in Rome, may have displayed ceramic bowls on its gable. Julian Gardner, "The Capocci Tabernacle in Santa Maria Maggiore," *Papers of the British School at Rome* 38 (1970): 220–30.

92. *Bacini* architectural ornament appears across the Italian peninsula. It has been argued that the earliest *bacini* on church façades (in Pisa) were trophic displays of booty from the sack of Mahdiyyah in 1087. The theory does not explain the persistence of the decorative practice or its appearance in such disparate sites as the church of SS. Giovanni e Paolo in Rome, the episcopal palace in Bergamo, and remote monasteries such as Vezzolano in Piedmont. Peduto presents a related but more peaceful interpretation of the Ravello *bacini* as "souvenirs" and declarations of sophisticated taste. Ravello: P. Peduto, "Materiali arabo-islamici nella Ravello del XIII secolo. Eredità o moda?" in *Presenza araba ed islamica in Italia*, Atti del Convegno sul tema, 1989, ed. Agostino Cilardo (Naples, 1992), 467–72; Pisa: Graziella Berti and Liana Tongiorgi, *I bacini ceramici medievali delle chiese di Pisa*, Quaderni di cultura materiale, 3 (Rome, 1981); Vezzolano: Giovanni Romano, ed., *Gotico in Piemonte* (Turin, 1992), 62–7, and Renate Wagner-Rieger, *Die italienische Baukunst zu Beginn der Gotik*, vol. 1 (Graz and Cologne, 1956), 128–32; Bergamo: Maureen Miller, *The Bishop's Palace* (Ithaca, 2000), 110; Rome: Ann Priester, "Bell Towers and Building Workshops in Medieval Rome," *JSAH* 52 (1993): 199–220, and David Whitehouse, "The Bacini of SS. Giovanni e Paolo," and "Bacini at Gaeta," in *Medieval Lazio, Studies in Architecture, Painting, and Ceramics*. Papers in Italian Archaeology III, ed. John Osborne, David Andrews, and David Whitehouse (Oxford, 1982), 347–61 and 362–71; importance for economic history: David Abulafia, "The Pisan 'Bacini' and the Medieval Mediterranean Economy: A Historian's Viewpoint," *Papers in Italian Archaeology* IV, ed. Caroline Malone and Simon Stoddart (Oxford, 1985), 290–1.

93. D. Whitehouse, "Bacini of SS. Giovanni e Paolo," 351, cat. 5; 355, cat. 10.

94. For example, Maghrebi ceramics unearthed at the Rufolo House and domestic sites in Scala. Paolo Peduto, "Ceramica magrebina nella costa di Amalfi," *Apollo* 11 (1995): 116–22; Ada De Crescenzo, "Ceramiche invetriate e smaltate della Campania meridionale," unpublished paper given at the Tavola Rotonda "La ceramica e le Crociate," September 1991, Ravello; and idem, *La ceramica graffita del Castello di Salerno* (Naples, 1990).

95. Robert Bergman, "The Frescoes of Santissima Annuciata in Minuto (Amalfi)," *DOP* 41 (1987): 71–83. These works bear the markings of the eclectic art of *mercatantia*. As Bergman established, their style blends local and up-to-date Constantinopolitan styles, creating a variation on the mannered Comemnian mode far from the capital. The stories depicted draw on Latin and Greek sources.

96. "Agarenes," or Saracens, a term derived from Hagar, the slave of Abraham and mother of Ishmael who came to Mecca, according to the Koran. Jacobus de Voragine, *Golden Legend, Readings on the Saints*, trans. William Granger Ryan (Princeton, 1993), vol. 1, 26–7.

97. Chemical analysis and ancient precedents in P. Moioli and C. Seccaroni, "Pigmenti, vetri e ceramiche," 57.

98. VIRGINIS ISTUD OPUS RUFULUS NICOLAUS AMORE/VIR SICLIGAYTE, PATRIAEQUE DICAVIT HONORE/EST MATHEUS AB HIIS URSO JACOBUS QUOQUE NATUS/MAURUS ET A PRIMO LAURENTIUS EST GENERATUS./HOC TIBI SIT GRATUM PIA VIRGO PRAECAREQUE NATUM/UT POST ISTA BONA DET EIS CELESTIA DONA./

LAPSIS MILLENIS. BIS CENTUM. BISQUE TRICENIS./CHRISTI BIS SENIS ANNIS AB ORIGINE PLENIS. EGO MAGISTER NICOLAUS DE BARTHOLOMEO DE FOGIA MARMORARIUS HOC OPUS FECIT.

99. N. Zchomelidse, "Rufolo Kanzel," on inscription instating Nicola as "ruler" of Ravello.

100. "HOC MATTHEUS OPUS RUFULUS MANDAVIT HONORE VIRGINIS/ET NATI FIERI PRIEQUE DECORE CUI CONIUX EST ANNA/VIRO ST. HII QUOQUE GRATI ILLO. PRIM. LAURENT. ORDINE/NATI BARTH. S ADEST HUIC PROBITATE SCDS/SIMON ET HIS JUNIOR FRANCISCUS CRIMINE MUNDUS HII/GENITI PRIMOGENITI NICOLETT(O) JOHS MATTHEUS PUER URSO./QUIBUS NE CORPORA DAMNES. TERTIUS HINC SEQUITUR MATHEUS/SIMONE NATUS. QUIS SUCCEDAT AVO FAMA VITAQUE/BEATUS HOS OMNES TU SUMME DEUS PIETATE PATERNA/TEMPORA PER MULTA SALVA DEFENDE GUBERNA./ ANNO MILLENO BIS CENTUM SEPTUAGENO HISQUE NOVE MISCE TEMPUS/ SIC ADVENA DISCE. MAGISTER MATHEUS DE NARNIA FECIT HOC OPUS." Transcription by Vega de Martini, in *Ravello, il Duomo e il Museo*, ed. Mario De Cunzo (Salerno, 1984), 53.

101. These personal texts contrast vividly and indeed are incompatible with the broader tradition of inscriptions that reify the symbolic function of architectural elements, as studied by Calvin B. Kendall, *The Allegory of the Church: Romanesque Portals and Their Verse Inscriptions* (Toronto, 1998), ch. 14.

102. "HOC OPUS ANDREE MEMORI CONSTITIT/HONORE AUCTORIS STUDIIS/ EFFECTU(M) PANTALEONIS HIS/UT PRO GESTIS SUCCEDAT GRA(TIA) CULPIS." And: "HOC OPUS FIERI IUSSIT PRO RE/DEMPTIONE ANIME SUE PANTAL(EO)/FILIUS /MAURI/DE PANTA(LEONE)/DE MAURO/DE MAURONE COMITE." Transcription and translation in Herbert Bloch, *Monte Cassino in the Middle Ages* (Cambridge, MA, 1986), vol. 1, 140–1. Recent study of the door commissions within a web of political, commercial, and diplomatic interests: Maria Vittora Marini Clarelli, "Pantaleone d'Amalfi e le porte bizantine in Italia meridionale," in *Arte profana e arte sacra a Bisanzio*, ed. Antonio Iacobini and Enrico Zanini (Rome, 1995), 641–51.

103. Now in the Museo del Duomo, Ravello, this fragment (96 × 95 cm) reads "Filius Filippi Frezze ad onore Dei et Sci Johis Fieri."

104. "ANNO MILLESIMO/CENTESIMO SEPTUAGESI/MO NONO INCARNACIO IESU/XPO DNO NRO MEMENTO DNE FA/MULO TUO SERGIO MUSETULE ET/UXORI SUE SICLIGAUDE ET FI/LIIS SUIS MAURO ET IOHES ET/FILIA SUA ANNA QOT ISTA POR/TA FACERE AGIT AD HO/NOREM DEI ET SANCTE MA/RIAE VIRGINIS." Giuseppe Imperato, *Ravello nella storia civile e religiosa* (Cava, 1990), 279.

105. "SUSCIPE VAS MODICUM DIVINIS CULTIB[US] APTUM/AC TIBI DIRECTUM DEVOTA MENTE TUORUM/NOMINA NOSTRA TIBI QUESUMUS SINT COGNITA PASSIM/HAEC TAMEN HIC SCRIBI VOLUIT CAUTELA SALUBRIS;" "IURE VOCOR MARUS QUONIAM SUM NIGRA SECUTUS/ME SEQUITUR PROLES CUM PANTALEONE IOHANNES/SERGIUS ET MANSO MAURUS FRATER QUOQUE PARDO/DA SCELERUM VENIAM CAELESTEM PREBE CORONAM." Transcription, translation, and bibliography in R. Bergman, *Salerno Ivories*, 128.

106. H. Bloch, *Monte Cassino*, vol. 1, 40–65.

107. Alphanus's inscriptions include those of the triumphal arch, apse, and hexameters accompanying the cycle of wall paintings of the Old and New Testaments in the atrium. H. Bloch, *Monte Cassino*, vol. 1, 53–62; D. Glass, *Romanesque Sculpture in Campania*, ch. 1. Also, Valentino Pace, "La cattedrale di Salerno. Committenza, programma, e valenze ideologiche di un monumento di fine XI secolo nell'Italia meridionale," in *Desiderio di Montecassino e l'arte della Riforma gregoriana*, ed. Faustino Avagliano (Monte Cassino, 1997), 289–330.

108. Above the lectern of the Rogadeo ambo: "(CONSTANT)INUS CONSTRUXIT PRE-SUL OPIMUS;" on the aisle side: "SIC CONSTANTINUS MONET ET TE PASTOR OVINUS/ ISTUD OPUS CARUM QUI FECIT MARMORE CLARUM." Antonia d'Aniello, in *Ravello: Il Duomo, Il Museo*, 22.

109. Vera von Falkenhausen, "Il ducato di Amalfi," in *Il Mezzogiorno dai Bizantini a Federico II*, ed. André Guillou (Turin, 1983), 344–6.

110. For example, cases discussed in S. D. Goitein, *A Mediterranean Society. The Jewish Communities of the World as Portrayed in the Documents of the Cairo Geniza*, vol. III, *The Family* (Berkeley and Los Angeles, 1978), 3–48.

111. Thus the devices can merely be placed between ca. 1187, an early year of construction, and the mid-sixteenth century, when the roof collapsed. G. B. Bolvito, "Registri," BNN, FSM 101, p. 294.

112. The pilaster strip is damaged, although fragments of the shields are still visible; they are fully rendered in the Paulin engraving of ca. 1875. H. d'Espouy, *Fragments d'architecture*, Plate 1.

113. The crypt pavement is mentioned in Bolvito's detailed description of the cathedral, as "nel suolo di detto subcorpo si veggano intexute l'arme de Rufuli." G. B. Bolvito, "Registri," BNN, FSM 101, p. 258. Liturgical objects document transcribed in F. Widemann, "Madonna della Bruna," 72.

114. For overviews of the origins of heraldry in Roman circus uniforms, symbology of the ancient Near East, banners, protoemblems, and so on, see Hannelore Zug Tucci, "Un linguaggio feudale: l'Araldica," in *Storia d'Italia*, Annali I: *Dal feudalismo al capitalismo* (Turin, 1978), 826–30; Michel Pastoureau, *Traité d'héraldique* (Paris, 1993), 20–30; on the northern European sources for medieval heraldry, see M. Pastoureau, "L'héraldique nouvelle" (1977), reprinted in *L'hermine et le sinople. Études d'héraldique médiévale* (Paris, 1982), 9–26.

115. If absent from a battlefield, for example, the body of the sovereign was manifest in a designated surrogate wearing his insignia, as Arrigo of Cosenza represented Charles of Anjou at Tagliacozzo in 1268. H. Zug Tucci, "Araldica," 832.

116. With a few exceptions (Gardner, *Pace*), most assessments of heraldry in the South are genealogical and serve primarily to document the emergence and authority of the feudal nobility. Recent exhibitions on Frederick II have helped collect royal and episcopal seals, although evidence from other segments of society is absent. See *Zeit der Staufer*, also *Federico II e l'Italia*, Rome, Palazzo Venezia exhibition, 1995–6. Versus "old school," Scipione Mazzella, *Descrittione del Regno di Napoli* (Naples, 1551; reprint, Bologna 1970).

117. The arms consist of a checkerboard red-and-silver pattern with four squares, the top two of which each contain an image of a knife, a design with no parallels until the later Middle Ages. On these supposed arms of Desiderius, Ferruccio Pasini Frassoni, "Una scoperta araldica: Il più antico stemma conosciuto," in *Rivista araldica* (1914): 419–23 (many thanks to Maria Laura Marchiori for sharing this article with me). On the chronology of the church, Enrico Parlato and Serena Romana, *Roma e il Lazio*. Italia romanica, vol. 13 (Milan, 1992), 77–80; Beat Brenk, "Roma e Montecassino: Gli affreschi della chiesa inferiore di S. Crisogono," *RACAR* 12 (1985): 227–34.

118. The earliest surviving uses of heraldry in Rome coincide with his rule and family, for example, tomb of his nephew Guglielmo Fieschi, d. 1254, in San Lorenzo fuori le Mura. *Pace* hypothesizes that this interest in heraldry came from the proximity of the family's home base, Lavagna, to France. Valentino Pace, "Committenza aristocratica e ostentazione araldica nella Roma del Duecento" (1998), reprinted in *Arte a Roma nel Medioevo. Committenza, ideologia e cultura figurativa in monumenti e libri* (Naples, 2000), 175–97; M. Pastoureau, *Traité d'héraldique*, 49.

119. The seals and coins of Frederick and Manfred feature either the enthroned emperor or the classicizing profile bust of the gold *augustalis*, with an eagle on the obverse. Free-floating rather than represented on a shield, these emblems of the enthroned emperor with an orb and scepter were found on a range of earlier seals, including Frederick Barbarossa (1152–55). *Zeit der Staufer*, vol. 3, cat. 28, cat. 33; *Federico II e l'Italia*, cat. II.1, 190.

120. Julian Gardner, "Seated Kings, Seafaring Saints and Heraldry: Some Themes in Angevin Iconography," in *L'État angevin. Pouvoir, culture, et société entre XIIIe et XIVe siècle*, Actes du colloque international, 1995 (Rome, 1998), 119–20.

121. On the lily as a common and polysemous emblem within and outside the West, see M. Pastoureau, "La fleur de lis: Emblème royal, symbole marial ou thème graphique?" (1978), reprinted in *L'hermine et le sinople*, 158–80.

122. Twenty branded cows sent to the household near Bari of the Countess of Artois described in document of 1286. Giuseppe Del Giudice, *Una legge suntuaria inedita dal 1290* (Naples, 1881), 234, doc. 3.

123. Unlike the gold *reale*, the design of this seal is conservative, and it closely follows the conventions of French designs of the twelfth century, for example, the seal of Galeran II, count of Meulan and Worchester (ca. 1136–8); M. Pastoureau, "L'apparition des armoiries en Occident. État du problème" (1976), reprinted in *L'hermine et le sinople*, 50–70.

124. For example, the Cividale Casula of circa 1300, and textiles now in the Musée historique des Tissus, Lyons (Inv. 27–584 and 24–397). Pierluigi Leone de Castris, *Arte di corte nella Napoli angioina* (Florence, 1986), ill. 13–14, 28; 98, figs. 6 and 7. Julian Gardner, "St. Louis of Toulouse, Robert of Anjou and Simone Martini," *ZKg* 39 (1976): 12–33.

125. This discussion of the altarpiece draws on Adrian Hoch, "The Franciscan Provenance of Simone Martini's Angevin St. Louis in Naples," *ZKg* 58 (1995): 22–38; J. Gardner, "St. Louis of Toulouse, Robert of Anjou and Simone Martini"; and idem, "The Cult of a Fourteenth-Century Saint: The Iconography of Louis of Toulouse," reprinted in *Patrons, Painters, and Saints: Studies in Medieval Italian Paintings* (London, 1993); Andrew Martindale, *Simone Martini* (Oxford, 1988), cat. 16; Ferdinando Bologna, *I pittori alla corte angioina di Napoli, 1266–1414, e un riesame dell'arte nell'età fridericiana* (Rome, 1969).

126. The use of arms in the *Regno* was not controlled by royal processes and privileges in this period, and thus was not an expression of official noble stature. *Pace* Widemann, who argues that the Rufolo arms prove the family's noble status. F. Widemann, "Les Rufolo. Les voies de l'anoblissement d'une famille de marchands en Italie méridionale," in *La noblesse dans les territoires angevins à la fin du Moyen Âge*, Actes du colloque international organisé par l'Université d'Angers, 1998, ed. Noël Coulet and Jean-Michel Matz (Rome, 2000), 124.

127. Edward Said, *The World, the Text, the Critic* (Cambridge, MA, 1983), esp. Introduction.

128. On comparable devotional juxtapositions in English architecture and manuscripts, see Michael Michael, "The Privilege of 'Proximity': Towards a Re-definition of the Function of Armorials," *Journal of Medieval History* 23 (1997): 55–74.

129. M. Michael, "Privilege of 'Proximity.'"

130. Views of cultural production written from the perspectives of sociology and anthropology provide models of interpretation that are helpful here, because they allow for the transformations that inevitably occur in cases of cultural exchange or appropriation. Although such theories have largely been generated around postcolonial settings, the structural similarities between those settings and the world of the Rufolos, with its multicultural and imperialist features, render these models apt. David Howes, "Introduction: Commodities and Cultural Borders," in *Cross-Cultural Consumption: Global Markets, Local Realities*, ed. D. Howes (London, 1996), 1–18; Arjun Appandurai, *Modernity at Large: Cultural Dimensions of Globalization* (Minneapolis, 1996), 66–7 (on the "Veblen Effect"); Homi Bhabha, *The Location of Culture*

(London, 1994); James Ferguson, "Cultural Exchange: New Developments in the Anthropology of Commodities," *Cultural Anthropology* 3 (1988): 489–513; M. Douglas and B. Isherwood, *World of Goods*; H. Leibenstein, "Bandwagon, Snob, and Veblen Effects in the Theory of Consumer's Demand," *Quarterly Journal of Economics* 64 (1950): 183–207.

131. This syncretism is also present in some of the first monuments in central Italy to employ armorials, the tombs of French cardinals in Rome and Viterbo. In contrast to the Rufolos' adept and powerful use of this new tool, however, curial officials first timidly embraced heraldry, perhaps because its fundamentally dynastic message was at odds with clerical celibacy. On Roman tombs and heraldry, Julian Gardner, *The Tomb and the Tiara: Curial Tomb Sculpture in Rome and Avignon in the Later Middle Ages* (Oxford, 1992); V. Pace, "Committenza aristocratica e ostentazione araldica."

132. Thorstein Veblen, *The Theory of the Leisure Class. An Economic Study of Institutions* (New York, 1889; reprint, 1967).

133. For example, on the bronze doors at San Paolo fuori le Mura in Rome (1070), St. Paul introduces the donor Pantaleo to Christ. Pantaleo, represented at a fraction of the scale of Jesus and Paul, kneels in proskynesis. As with donor portraits from all over the Latin West and Byzantium, these images tend to be schematic and formulaic and most often depict the entire figure striking a pious or reverential pose appropriate to the site where the works were installed – in the case of the early Amalfi works, the threshold between exterior and interior of holy or episcopal space.

134. Recent remarks on Gothic naturalism and its tendency to fuel (modern) assumptions about portraiture in Georgia Sommers Wright, "The Reinvention of the Portrait Likeness in the Fourteenth Century," *Gesta* 39 (2000), 117–34.

135. *Pace* local writers, but carved portraits of laypeople's children were unknown at this time, and, as the dedication informs us, Nicola Rufolo had no granddaughters in 1272. Carotti interpreted these children as representations of profound suffering, like the lion column base below them or the caryatids of the Bari throne. A. Carotti, "Seppellettile sacra," 400. On Abyssus in other Campanian works: D. Glass, *Romanesque Sculpture in Campania*; Wolfgang Fritz Volbach, "Ein antikisierendes Bruchstück von einer kampanischen Kanzel in Berlin," *Jahrbuch der Preußischen Kunstsammlungen* 53 (1932): 197.

136. On this identification of idealized rather than realistic portraits (the alleged subjects were grandparents when the work was made): Lech Kalinowski, "Entre Reims et Ravello: Diffusion ou convergence?" in *Pierre, lumière, couleur. Études d'histoire de l'art du Moyen Âge en l'honneur d'Anne Prache*, ed. Fabienne Joubert and Dany Sandron (Paris, 1999), 235; N. Zchomelidse, "Rufolo Kanzel"; François Widemann, "Giacomo Rufolo. Rôles et fonctions dans une famille patricienne de Ravello au XIIIe siècle," *Apollo* 12 (1996): 87; R. W. Lightbown, "Portrait or Idealization: The Ravello Bust," *Apollo, The International Magazine of the Arts* 127 (1988): 109; A. Carotti, "Seppellettile sacra," ch. 8; Antonio Filangieri di Candida, "Del preteso busto di Sigilgaita Rufolo nel Duomo di Ravello," *NN* 12 (1903): 3–9, 34–7.

137. Reims connections explored in L. Kalinowski, "Entre Reims et Ravello." The similarities between the niche designs at Reims and the trefoil portal at Ravello are striking. Rather than signaling a direct relationship between the two sites, they can be understood as part of a larger interest in antique profile busts, as explored below.

138. Cameo: Vienna, Kunsthistorisches Museum, Sammlung für Plastik und Kunstgewerbe (Inv. XII 3). In *Zeit der Staufer*, vol. 1, cat. 895, 698–9; French or southern Italian provenance. On connections between the cameo and pulpit, Enrico Castelnuovo, "Arte della città, arte delle corti tra XIII e XIV secolo," in *Storia dell'arte italiana* vol. 5, *Dal Medioevo al Quattrocento*, ed. Federico Zeri (Turin, 1983), 167–227; N. Zchomelidse, "Rufolo Kanzel"; L. Kalinowski, "Entre Reims et Ravello." Also see Rainer Kahsnitz, "Staufische Kameen," in *Zeit der Staufer*, vol. 5.

477–520, on the cameo in conjunction with the pulpit and Frederick II's *augustalis*. Hans Wentzel, "Der Augustalis Friedrichs II. und die abendländische Glyptik des 13. Jahrhunderts," *ZKg* 15 (1952): 183–7; idem, "Portraits 'à l'antique' on French Mediaeval Gems and Seals," *Journal of the Warburg and Courtauld Institutes* 16 (1953): 342–50.

139. In 1540, the Spanish viceroy Don Pedro of Toledo took it to Naples, returning it only after the residents of Ravello complained bitterly. The earliest evidence linking the bust to the pulpit is Bolvito's text of 1585, which does not specify its exact position. G. B. Bolvito, "Registri," BNN, FSM 101, pp. 258–9. On the Don Pedro incident: M. Camera, *Memorie*, vol. 2, 313, n. 1.

140. Bottari precipitated debate when he rejected the attribution to Nicola of Foggia. Stefano Bottari, "Intorno a Nicola di Bartolomeo da Foggia," *Commentari* 6 (1955): 159–63. Gandolfo, meanwhile, recently dated the bust to ca. 1250 (versus the inscribed date of the pulpit, 1272), although he attributes it to Nicola of Foggia. F. Gandolfo, *Scultura normanno-sveva*, 126–8.

141. Portrait: É. Bertaux, *AIM*, 784; W. R. Valentiner, "Studies on Nicola Pisano," *Art Quarterly* 15 (1952): 33–6; Giovanna: F. Pansa, *Istoria*, 83. Most recent "Sigilgaita" theory: M. S. Calò Mariani, "Orizzonte culturale. Committenti e *magistri*," 145.

142. Recent summary of scholarship on the busts in Lisbeth Castelnuovo-Tedesco, "Il capitello e la testa di donna del Metropolian Museum of Art di New York," in *Federico II, immagine e potere*, ed. Maria Stella Calò Mariani and Raffaella Cassano (Venice, 1995), 395–402.

143. "Ecclesia": L. Kalinowski, "Entre Reims et Ravello"; A. Carotti, "Seppellettile sacra," ch. 8; Adolfo Venturi, *Storia dell'arte italiana*, vol. 3: *L'arte romanica* (Milan, 1904), 677–84. "Ravello": N. Zchomelidse, "Rufolo Kanzel"; Josef Deér, *The Dynastic Porphyry Tombs of the Norman Period in Sicily*, trans. G. A. Gilhoff (Cambridge, MA, 1959), 175; W. F. Volbach, "Kanzel in Berlin," 197. Fuller assessments of these theories in J. Caskey, "Rufolo Palace," ch. 2.

144. The two Troia capitals, a male head in the museum of the Badia di Cava, the busts of the façade arcade at San Paolo a Ripa in Pisa could be added to this list, as could the four north triforium capitals and the twenty-two cupola busts in the Cathedral of Siena. Examples in Marina Righetti Tosti-Croce, "La scultura del Castello di Lagopesole," in *Federico II e l'arte del Duecento italiano*. Atti della III Settimana di studi di storia dell'arte medievale dell'Università di Roma, 1978, ed. A. M. Romanini (Galatina, 1980), vol. 1, 237–52; M. S. Calò Mariani, *Duecento in Puglia*; Vera Ostoia, "To Represent What Is as It Is," *Metropolitan Museum of Art Bulletin* 23 (1965): 367–72; Enrico Castelnuovo, "Arte della città, arte delle corti," 181–7; Maria Laura Cristiani Testi, *Nicola Pisano, architetto scultore. Dalle origini al pulpito del battistero di Pisa* (Pisa, 1987).

145. In the handling of architectural details and figural carvings on the Ravello work, Nicola of Foggia adopted schema established for Hohenstaufen secular projects. For example, the elegant column bases feature a type of molding that has prestigious antecedents at the Capuan Gate, Castel del Monte, and ultimately Notre-Dame of Paris. The Cistercian masons employed by Frederick II are a likely source of this transmission, perhaps through the Abbey of Fossanova or the Cathedral of Cosenza; perhaps these masons also explain some of the compositional parallels between Reims and Ravello noted by L. Kalinowski in "Entre Reims et Ravello." Creswell Shearer, *The Renaissance of Architecture in Southern Italy. A Study of Frederick II of Hohenstaufen and the Capua Triumphator Archway and Towers* (Cambridge, 1935), 167; Renate Wagner-Rieger, *Beginn der Gotik*, vol. 2; Antonio Cadei, "Fossanova e Castel del Monte," in *Federico II e l'arte del Duecento italiano*, vol. 1, 191–216.

146. On San Vincenzo, John Mitchell, "The Crypt Reappraised," in *San Vincenzo al Volturno*, vol. 1: *The 1980–86 Excavations*, ed. Richard Hodges (Rome, 1993), 75–114.

147. Although the communal movements associated with early humanism did not dominate political life in the *Regno*, governing bodies known as *sedili* or *seggi* provided liaisons between the royal administration and local affairs. First limited to the nobility, the *seggi* later multiplied to include many social classes, including artisans, merchants, and the *popolo*. By the fifteenth century, two *seggi* formed the Amalfi town council, the *magnus* and *parvus*, the latter of which shared its facilities with the governing bodies of outlying towns. M. Camera, *Memorie*, vol. 2, 278–9. Also Giuseppe Gargano, *La città davanti al mare. Aree urbane e storie sommerse di Amalfi nel Medioevo* (Amalfi, 1992), 80–3.

148. On the development of this building type from porticoes that were sites of informal social encounter to a formalized institution within domed or vaulted chambers in the late Angevin period, Arnaldi Venditti, "Urbanistica e architettura angioina," in *Storia di Napoli*, vol. 3 (Naples, s.d., ca. 1970), 685–9; Michelangelo Schipa, "Alcune opinioni intorno ai seggi o sedili di Napoli," *NN* 15 (1906): 97–9.

149. "L'antico simulacro di Amalfe, et suo imaginario Regno." "Conciosiache depinsero Amalfe, in forma di una bellissima donzella, ornata di una corona reale: et riccamente vestita di broccato, la quale assisa in una sedia reale, con la sua destra, monstra un Pomo di oro: et con la sua sinistra mano, manutiene un Leone che segli riposa ingrembo. Volendono p(er) queste cose significare: che, essendo la soprascritta bella Ninfa Amalfe, capo et Regina di tutta la Costa, siede nela Reale sedia di quella Republica, [131] Reggendo dal suo Tribune, tutto tribunale, tutto quel paese al suo dominio soggetto: et ornata di tutte le sue vestimenti di oro: cio' è, delle molte richeze, che in ogni parte di q(ue)sto Regno possedono gli huomini de' suoi populi." G. B. Bolvito, "Registri," BNN, FSM 101, pp. 130–1.

150. Destroyed in the Second World War. Francesco Negri Arnoldi, "Pietro d'Oderisio, Nicola da Monteforte, e la scultura campana del primo Trecento," *Commentari* 23 (1972): 19–20.

151. Nearly every medieval church in the region of Amalfi contains some ancient spoils. Toponymy holds clues about their sources in the Middle Ages: the settlement on the hill below Ravello toward the sea was called "Marmorata" in the high Middle Ages, as it is today (akin to the northwest corner of Greek *Neapolis*, also called Marmorata in the eleventh century, where the fifth-century B.C. city walls are still visible). Heavy building materials might have been transported to the Amalfi area by sea, or through the surprisingly gentle Chiunzi pass linking the Sarno Valley to the coast. For "Roman" Amalfi, see Chapter 2, n. 24.

152. Salient works on the varied uses and meanings of *spolia* include Dale Kinney, "Rape or Restitution of the Past? Interpreting Spolia," in *The Art of Interpreting*. Papers in Art History from the Penn State University, ed. Susan C. Scott (University Park, PA, 1995), 53–67; and idem, "Spolia from the Baths of Caracalla in Sta. Maria in Trastevere," *AB* 68 (1986): 379–97; Michael Greenhalgh, *The Survival of Roman Antiquities in the Middle Ages* (London, 1989); Beat Brenk, "Spolia from Constantine to Charlemagne: Aesthetics versus Ideology," *DOP* 41 (1987): 103–9; Herbert Bloch, "The New Fascination with Ancient Rome," in *Renaissance and Renewal in the Twelfth Century*, ed. Robert Benson and Giles Constable (Oxford, 1982), 615–36; Christiane Klapisch-Zuber, *Carrara e i maestri del marmo* (Massa, 1973); Arnold Esch, "Spolien. Zur Wiederverwendung antiker Baustücke und Skulpturen im mittelalterlichen Italien," *Archiv für Kulturgeschichte* 51 (1969): 1–64; J. Deér, *Porphyry Tombs*.

153. On the purported "maleducazione" of Matteo Rufolo and his rejection of the "avantguardia," see F. Gandolfo, *Scultura normanno-sveva*, 120.

154. Bertaux wrote that this archaizing campaign had an analogue in texts, for documents about the antiquity of Monte Sant'Angelo were falsified at the sanctuary in the mid–twelfth

century. É. Bertaux, *AIM*, 447–9. Also Lawrence Nees, "Forging Monumental Memories in the Early Twelfth Century, in *Memory and Oblivion*. Proceedings of the XXIXth International Congress of the History of Art held in Amsterdam, 1996, ed. Wessel Reinick and Geroen Stumpel (Dordrecht, 1999), 773–82; Inge Herklotz, *"Sepulcra" e "Monumenta" del medioevo. Studi sull'arte sepolcrale in Italia* (Rome, 1985), ch. 2; Hans Wentzel, "Antiken-Imitationen des 12. und 13. Jahrhunderts in Italien," *Zeitschrift für Kunstwissenschaft* 9 (1955): 29–72; J. Deér, *Porphyry Tombs*.

155. For example, Caroline Bruzelius, *"ad modum franciae"*; Paul Binski, "The Cosmati at Westminster and the English Court Style," *AB* 72 (1990): 6–34; Julian Gardner, "A Princess among Prelates. A Fourteenth-Century Neapolitan Tomb and Some Northern Relations," *RJK* 23/24 (1988): 29–60. It must be pointed out that Charles I, while able to identify the materials proper for a "Roman" tomb, was as a patron in the *Regno* less than eclectic with his fervent support of French forms.

156. San Francesco, for instance, was established on the site of the twelfth-century church of San Giovanni Battista; the earliest local references to the new monastery date from 1305. Santa Chiara was established in 1297 around preexisting houses and the church of San Nicola. Franciscans: *PAVAR* vol. 5, 72, doc. CXII; Clares, *PAVAR* vol. 5, 70, doc. CVIII. On the difficulty of establishing exact chronology, due in part to common legend of Francis's direct role in foundations, see Luigi Pellegrini, "Territorio e città nell'organizzazione insediativa degli ordini mendicanti in Campania," *RSS* 5 (1986): 9–41. Also Giuseppe Imperato, *Ravello nella storia civile e religiosa* (Cava, 1990), 429–44.

157. M. Camera, *Memorie*, vol. 2, 303–29; G. Imperato, *Ravello nella storia civile e religiosa*; J. Mazzoleni, *"Maior ravellensis ecclesia."*

158. J. Mazzoleni, *"Maior ravellensis ecclesia,"* 39; F. Pansa, *Istoria*, vol. 1, 153; F. Ughelli, *Italia sacra*, vol. 1, col. 1118. This is likely the same Giovanni "archdeacon" who signed the foundation document for Nicola's funerary chapel in 1287.

159. G. Del Giudice, *Legge suntuaria*, 157.

CHAPTER FOUR

1. Petrarch's letter to Cardinal Colonna recounts the devastation that he witnessed from Naples; his description led many historians to assume that most of medieval Amalfi was destroyed in that storm of November 1343. This perspective has proved to be an exaggeration, although some damage to the port undoubtedly occurred. On underwater investigations that disproved traditional accounts of the storm, Robert Bergman, *"Amalfi sommersa:* Myth or Reality?" *ASPN* 18 (1979): 23–30. Francesco Petrarca, *Le familiari*, ed. Ugo Dotti (Rome, 1991), vol. 5, 518–29.

2. Amalfitans had maintained a *fondaco* and churches in Crusader outposts through the final decades of Latin rule. Acre: *PAVAR* vol. 4, 19–22, doc. IV (dated 1267); *fondaco* in Tripoli de Suria (in Lebanon), *PAVAR* vol. 4, 86–90, doc. XXX (dated 1286).

3. This is a comprehensive of view neither all of Amalfitan art in the early fourteenth century nor of all Neapolitan art; rather, it examines representative works in Amalfi that testify to the decline of the art of *mercatantia*. This chapter does not contend with residential architecture because there are too few houses or fragments thereof that can be securely dated to the period in question.

4. The key works on painting and sculpture for this period are Pierluigi Leone de Castris, *Arte di corte alla Napoli angioina* (Florence, 1986); Ferdinando Bologna, *I pittori alla corte angioina di Napoli, 1266–1414, ed un riesame dell'arte nell'età fridericiana* (Rome, 1969).

5. Bartolomeo's commissions include a chapel dedicated to Thomas Aquinas in Capua, a church in Naples entrusted to Montevergine in 1314 and the main portal at San Domenico

Maggiore (Naples) around 1324. Giovanni Vitolo, "Il monachesimo benedettino nel Mezzogiorno: Tra crisi e nuove esperienze religiose," in *L'État angevin. Pouvoir, culture, et société entre XIIIe et XIVe siècles*. Actes du colloque international, Rome/Naples, 1995 (Rome, 1998), 213; Silvana Savarese, "Il portale trecentesco della chiesa di S. Domenico Maggiore in Napoli," in *Scritti in onore di Ottavio Morisani* (Catania, 1982), 131–45.

6. Royal service also almost guaranteed upward social and economic mobility, as many office holders of humble background eventually gained feudal rights. Giuliana Vitale, "Nobiltà napoletana della prima età angioina. Elite burocratica e famiglia," in *Ricerche sul Medioevo napoletano: Aspetti e momenti della vita economica e sociale a Napoli tra decimo e quindicesimo secolo*, ed. Alfonso Leone (Naples, 1996), 187–223. Also, foundational theories of Alexander Murray, *Reason and Society in the Middle Ages* (Oxford, 1978).

7. Bolvito described the now-destroyed tomb as a marble slab of an armed knight with heraldic insignia of two elevated dragons. He recorded the following inscription: "Hic iacet corpus Nobilis et egregii Militis domini Rogerii Trara de Scalis, qui obiit anno d(omi)ni 1363 die 18 nove(mbris)." The tomb of Roger's wife Philippa de Nuceria was also in Santa Chiara. G. B. Bolvito, "Registri," BNN FSM 101, p. 303.

8. Key works on Santa Chiara and royal involvement therein include Caroline Bruzelius, "Queen Sancia of Mallorca and the Convent Church of Santa Chiara in Naples," *Memoirs of the American Academy in Rome* 50 (1995): 69–100; Ronald Musto, "Queen Sancia of Naples (1286–1345) and the Spiritual Franciscans," in *Women of the Medieval World. Essays in Honour of John H. Mundy*, ed. Julius Kirschner and Suzanne Wemple (Oxford, 1985), 179–214.

9. *PAVAR* vol. 5, 62–3, doc. XCI.

10. Cava, Fondo Mansi 13, doc. 343; Cava, Fondo Mansi 13, doc. 447.

11. Cava, Fondo Mansi 13, doc. 534. Carlo as "legu(m) doctor." The string of Rufolo judges includes Andrea in the 1350s, Purcilletto in the 1370s, Lodovico and Covello in the 1380s, and Giovannotto in 1392. *PAVAR* vol. 7, docs. LIX, LXXXII, CIV, CXIII, CXXIV, etc. See Chapter 1 for additional sources and references.

12. Ferdinando Ughelli, *Italia sacra* (Venice, 1720; reprint, Lichtenstein, 1970), vol. 6, col. 258 (discussed later). During their studies at the university, the Rufolos perhaps encountered the young Boccaccio, who for five or six years pursued a legal education in the city in the 1330s. Boccaccio could have written his tale about the merchant-pirate Landolfo without knowing any Rufolos personally, of course, because many episodes in the *Decameron* embellish well-known events of the previous generation or two. But it is possible that their paths crossed in that setting. On Boccaccio's legal studies, Vittore Branca, *Boccaccio, the Man and His Works*, ed. Dennis J. McAuliffe, trans. Richard Monges (New York, 1976), 31.

13. This Rufolo chapel was likely in the northeast corner of the transept, where Ughelli recorded Francesco's epitaph: "'Hic jacet Reverendus Pater & Dominus./Dominus Franciscus Rufulus de Neapoli/Legum Doctor Dei gratia Episcopus Nolanus/qui obiit anno domini MCCCLXX die 5 junii V ind.'" The existence of the chapel is also documented in a mid-eighteenth-century inventory of the monastery, which is based on an earlier source: "La detta cappella, la quale è situata doppo la cappella di St Stefano.... primo loco fù de Signori Rufuli, doppo de Signori Brancacci, per l'ultimo pervenne alli Signori Blanchi...' ASN, Monasteri soppressi 425 (San Domenico), p. 83. The document corroborates the comments of early historians, including Bolvito and F. Della Marra, *Discorsi delle famiglie estinte, forastieri, o non comprese ne'Seggi di Napoli, imparentate colla Casa della Marra* (Naples, 1641). Epitaph: F. Ughelli, *Italia sacra*, vol. 6, col. 258.

14. Bartolommeo Capasso, *Napoli Greco-Romano* (Naples, 1905; reprint, Naples, 1987), 159–160.

15. This movement toward Nido began soon after the year 1000. Giovanna Vitale, "Case ed abitanti della *regio Nilensis* in età ducale. Osservazioni," in *Palazzo Corigliano tra archeologia*

e storia, ed. Irene Bragantini and Patrizia Gastaldi (Naples, 1985), 12–18; Gabriele Capone and Alfonso Leone, "La colonia scalese dal XIII al XV secolo," in *Ricerche sul Medioevo napoletano*, 173–86; Riccardo Filangieri, "Note al *Privilegium libertatis* concesso dai napoletani agli amalfitani nel 1190," in *Scritti di paleografia e diplomatica di archivistica e di erudizione* (Rome, 1970), 105–18.

16. Jean-Paul Boyer, "La noblesse dans les sermons des dominicains de Naples (première moitié du XIVe siècle)," in *La noblesse dans les territoires angevins à la fin du Moyen Âge*. Actes du colloque international organisé par l'Université d'Angers, 1998 (Rome, 2000), 567–83; Tommaso Kaeppeli, "Dalle pergamene di San Domenico di Napoli. Rilievo dei domenicani ivi menzionati con due appendici sui priori conventuali e provinciali fino al 1500," *Archivum Fratrum Praedicatorum* 32 (1962): 285–326; Gennaro Maria Monti, *Da Carlo I a Roberto d'Angiò. Ricerche e documenti* (Trani, 1937), 243–65.

17. On the various interventions at San Domenico and the little remaining medieval fabric, Arnaldo Venditti, "Urbanistica e architettura angioina," in *Storia di Napoli*, vol. 3 (Naples, 1970), 731–9.

18. The rest of his remains were interred at Notre-Dame-de-Nazareth in Aix. Early modern description of heart discussed in Katherine L. Jansen, *The Making of the Magdalen. Preaching and Popular Devotion in the Later Middle Ages* (Princeton, 2000), 331, although *pace* Jansen, the king's heart has long been noted as lost. *Storia dei monumenti del Reame delle Due Sicilie*, vol. 2: *Principi edificii della città di Napoli descritti da Scipione Volpicella* (Naples, 1847), 273. Tanja Michalsky, *Memoria und Repräsentation. Die Grabmäler des Königshauses Anjou in Italien* (Göttingen, 2000), 271–4, cat. 16.

19. ASN, Monasteri soppressi 425 (San Domenico), p. 83. The Cappella del Crocifisso (p. 133; Della Marra), Cappella di San Nicola di Bari (p. 149, Grisone), and Cappella degli Angioli (p. 155, Freccia).

20. For example, structural shifts, political crises, and old and new casts of characters discussed in Norbert Kamp, *Kirche und Monarchie im Staufischen Königreich Sizilien*, vol. 1 (Munich, 1973), 88–96, 390–420. Also, Robert Brentano, *Two Churches. England and Italy in the Thirteenth Century* (Princeton, 1968; paperback ed., Berkeley, 1988); Norman Housley, *The Italian Crusades. The Papal-Angevin Alliance and the Crusades against Christian Lay Powers, 1254–1343* (Oxford, 1982, 1999).

21. Gugliemo O. P. was buried in San Domenico in Naples, where Pansa recorded his epitaph: "Hoc sepultus est Dominus Vrater/Guglielmus natione Lombardus/Ordine Fratrum Praedict. Episcopus/Scalensis, qui obiit anno Domini MCCCXLII. die XXVII mensis Julii x.indit." Francesco Pansa, *Istoria dell'antica repubblica d'Amafi* (Naples, 1724; reprint, Salerno, 1989), vol. 1, 166.

22. The Celestine order emerged following his canonization in 1313. On Charles II's rapport with Pietro, G. Vitolo, "Monachesimo benedettino."

23. For example, Santa Maria sopra Minerva in Rome, begun ca. 1280. Caroline Bruzelius, "Charles I, Charles II, and the Development of an Angevin Style in the Kingdom of Sicily," in *État angevin*, 99–114.

24. Caroline Bruzelius, "*Il Gran Rifiuto*. French Gothic in Central and Southern Italy in the Last Quarter of the Thirteenth Century," in *Architecture and Language: Constructing Identity in European Architecture, c. 1000–c. 1650*, ed. Georgia Clarke and Paul Crossley (Cambridge, 2000), 36–45. Given the current archival lacunae concerning Charles II, it is difficult to determine the extent to which this aesthetic change in direction was official royal policy and thus ideologically charged. Overall, the policies of the second king were generally more accommodating to Christian *regnicoli* than those of his father's notorious *mala segnoria*; hence, it is tempting to assume that "his" architecture underwent similar ideological transformations.

25. On the significant expense of constructing complex Gothic moldings and the shortage of specialized labor during the reign of Charles I and its relevance to Charles II, C. Bruzelius, "Charles I, Charles II, and the Development of an Angevin Style," 109.

26. Although some of the new movements within the Benedictine rubric, such as the Celestines and Verginiani, expanded at this time. G. Vitolo, "Monachesimo benedettino."

27. See Chapter 2, ns. 42 and 43.

28. For example, Janis Elliott, "The Judgement of the Commune: The Frescoes of the Magdalen Chapel in Florence," *ZKg* 4 (1998): 509–19; Julian Gardner, "Seated Kings, Seafaring Saints and Heraldry: Some Themes in Angevin Iconography," in *État angevin*, 115–26; Gert Kreytenberg, "La tomba di Donato Acciaiuoli in Santi Apostoli a Firenze – Un'opera d'importazione," in *Skulptur und Grabmal des Spätmittelalters in Rom und Italien*, Akten des Kongresses (Rom, 1985), ed. Jörg Garms and Angiola Maria Romanini (Vienna, 1990), 345–52.

29. Cycle discussed in Chapter 3, "Mosaics and the Material Culture of *Mercatantia*".

30. Note the clever metonymy behind this heraldic device, from Spina (literally, "thorn") to images of roses. Description of arms in G. B. Bolvito, "Registri," BNN, FSM 101, p. 301; illustration in Scipione Mazzella, *Descrittione del Regno di Napoli* (Naples, 1551; reprint, Bologna, 1970), 737.

31. M. Camera, *Memorie*, vol. 2, 254.

32. Documentary evidence about family, M. Camera, *Memorie*, vol. 2, 284–6. Account without sources in S. Mazzella, *Descrittione del Regno*, 737.

33. M. Del Treppo, *Amalfi medioevale*, 95, n. 27; M. Camera, *Memorie*, vol. 2, 284–5.

34. Now in a chapel in the chevet of San Lorenzo Maggiore. "Hic iacet Lancelloctus Spina de Scalis qui obiit anno Domini 1383 die VIII mensis decembris VII indict. cuius anima requiescat in *pace*. Amen." This unusual inscription does not mention Lancilotto's status or profession, in stark contrast to others of this era that repeatedly underscore this sort of prestige. For instance, an adjacent tomb slab dated 1346 elaborated that "Hic iacet nobilis egregius vir dominus guillelmus de brusaco miles regius reginalisque cabellanus et familiaris." Brussaco tomb in Raffaele Mormone, ed., *Sculture trecentesche in S. Lorenzo Maggiore a Napoli* (Naples, 1973), cat. 15, 36.

35. "In 1855 this pulpit was pulled down by the parish priest of the day, and ground to powder, to mix with lime for building material." Recounted in E. Allen, *Ravello* (London, 1909), 66.

36. H. W. Schulz, *Denkmaeler*, vol. 2, 265–7; lost painting illustrated in A. Schiavo, *Monumenti*, fig. 147. Pulpit mentioned in Arnaldo Venditti, "Scala e suoi borghi, iii: Le chiese scalesi da Minuto a S. Caterina," *NN* (1963): 214.

37. My observations regarding the frame stem from close inspection of canopy of stucco tomb of Marinella Rufolo during its restoration in 1992 (discussed later). Additional technical discussion: A. Segagni Malacart, s.v. "Stucco," in *EAM*, vol. 11 (Rome, 2000), 1–2; and Hermann Kühn, "Was ist Stuck? Arten – Zusammensetzung – Geschichtliches," in *Stuck des frühen und hohen Mittelalters. Geschichte, Technologie, Konservierung*. Eine Tagung des Deutschen Nationalkomitees von ICOMOS, Hildesheim, 1995, ed. Matthias Exner (Munich, 1996), 17–24.

38. Those earlier pieces in the far South, generally altar frontals or other panel-like compositions with stylized designs reminiscent of textiles, are the offspring of Islamic stucco carving techniques that flourished in Spain and North Africa through the fourteenth century and were rooted in Byzantine traditions.

39. Alessandra Perugini, "Der Ambo von Moscufo und Beobachtungen zur Stucktechnik in den Abruzzen," in *Stuck des frühen und hohen Mittelalters*, 140–9; Otto Lehmann-Brockhaus, "Die Kanzeln der Abruzzen im 12. und 13. Jahrhundert," *RJK* 6 (1942–4): 257–426.

40. Although the majority of the stucco works in southern Italy have not been examined in depth by art historians, the few scholarly works that mention them – generally locally

published guidebooks, handbooks of southern Italian art, or conservation reports – tend to dismiss them as second class. Remarks on these historiographical issues in Jill Caskey, "The Stucco Tomb of Bartolommeo Franconi in Teggiano: Introduction and Implications," in *Napoli, il Mediterraneo, l'Europa*, ed. Francesco Aceto and Renata De Gennaro (Naples, forthcoming).

41. Investigations into the radical wing of the Franciscans who were protected by the court in Naples during the 1330s. Giuseppe Imperato, *Amalfi nella storia religiosa e civile* (Amalfi, 1987), 296–302; M. Palma, s.v. "Landolfo Caracciolo," in *DBI*, vol. 19 (Rome, 1976), 406–10. Also Darleen Pryds, "The Politics of Preaching in Fourteenth-Century Naples: Robert d'Anjou (1309–43) and his Sermons" (Ph.D. diss., Univ. of Wisconsin, 1994), 62–4.

42. *PAVAR* vol. 6, 28, doc. XLVIII (dated 1333).

43. Donations of fruit from a range of properties in Maiori, Minori, and Amalfi endowed the chapel "Santa Maria de marmore" in the crypt in 1365, in *PAVAR* vol. 6, 51, doc. CXXIV (dated 1365). Mill in *AMA*, 61–2, doc. 7 (undated). Sale of real estate of Costanza Quatrario (dated 1297) in M. Del Treppo, *Amalfi medioevale*, 134, n. 74. Whether the Amalfitans were related to the Quatrario in Sulmona, the family that included the famous humanist Giovanni Quatrario (d. 1402) is not clear.

44. Analysis of legend in K. Jansen, *Making of the Magdalen*. Of course the Magdalen's status as a prominent devotional figure was not new at this time; for earlier representations of her and approaches to her cult, see Magdalena Elizabeth Carrasco, "The Imagery of the Magdalen in Christina of Markyate's Psalter (St. Albans Psalter)," *Gesta* 38 (1999): 67–80; and Xavier Barral i Altet, "L'image pénitentielle de la Madeleine dans l'art monumental roman," *MÉFR* 104 (1992): 181–5.

45. On the foundations of Charles II, K. Jansen, *Making of the Magdalen*, 310–14.

46. F. Bologna, *Pittori*, 311–14. Also, K. Jansen, *Making of the Magdalen*, 316–17 (assumes earlier date for San Pietro); Giuliana Vitale, "I santi del re: Potere politico e pratiche devozionali nella Napoli angioina ed aragonese," in *Pellegrinaggi e itinerari dei santi nel Mezzogiorno medievale*, ed. Giovanni Vitolo (Naples, 1999), 93–128.

47. Adrian Hoch, "Pictures of Penitence from a Trecento Neapolitan Nunnery," *ZKg* 61 (1998): 206–26.

48. K. Jansen, *Making of the Magdalen*.

49. For example, the will of Giacomo Candido of Minori, dated 1294, specifies that vespers be celebrated in his name on the eve of the feast of the Magdalen in the cemetery of Minori. Endowed with land in the *retroterra* of Andita, donated to the Minori church. *PAVM*, 190–1, doc. 192; altar and chapel (*cappella nova*) in Cathedral of Ravello, documented in 1313, Cava, Fondo Mansi 13, doc. 414, f. 94r. As for the Atrani church, which likely predates the rediscovery of the Magdalen's relics near Aix, see M. Camera, *Memorie*, vol. 2, 237–8; Giuseppe Imperato, *Amalfi nella storia religiosa e civile* (Amalfi, 1987), 265.

50. The cloister had been used as an unofficial homeless shelter after 1883. Giuseppe Fiengo and Maria Russo, "Il Chiostro del Paradiso in Amalfi," *Apollo* 12 (1996): 117.

51. It is not impossible that this Crucifixion scene belonged to a larger Magdalen cycle and thus was part of the Quatrario chapel, although there is no specific evidence to support such a hypothesis.

52. Bologna's magisterial reconstruction of the career of Roberto is confirmed and expanded by Leone de Castris and subsequent publications. F. Bologna, *Pittori alla corte*, chs. 6 and 7; P. Leone de Castris, *Arte di corte*, 374–87. Recapitulation of salient issues with some revisions in F. Bologna, "Momenti della cultura figurativa nella Campania medievale," in *Storia e civiltà della Campania, Il Medioevo*, ed. Giovanni Pugliese Carratelli (Naples, 1992), 240–56; P. Leone de Castris, "A margine di 'I pittori alla corte angioina.' Maso di Banco e Roberto d'Oderisio," in *Napoli, l'Europa. Ricerche di storia dell'arte in onore di Ferdinando*

Bologna, ed. Francesco Abbate and Fiorella Sricchia Santoro (Catanzaro, 1995) 45–9. Earlier reference to Amalfi work, Pietro Toesca, *Storia dell'arte italiana, Il Trecento* (Turin, 1951), 687 (attributed to painter in a Cavallini mode).

53. "…de regio hospitio et in magistrum pictorem regium." Document of 1382 from the Angevin chancery quoted in P. Leone de Castris, *Arte di corte*, 382, n. 2.

54. This appointment and analogues in Andrew Martindale, *Rise of the Artist in the Middle Ages and Early Renaissance* (London, 1972), 37–41.

55. P. Leone de Castris, "La Cappella Palatina. Il ciclo giottesco," in *Castel Nuovo. Il Museo Civico*, ed. P. Leone de Castris (Naples, 1990), 65–83; F. Bologna, *Pittori*, ch. 5.

56. In the last decades of the thirteenth century, the archbishop of Naples Filippo Minutolo challenged the primacy of local painting traditions by seeking out artists from Umbria and Tuscany. It is likely that Minutolo's taste was shaped when he served as ambassador to Florence in the 1270s. Works associated with him include the Franciscan missal in Salerno that has been identified as a first step in this movement: it was likely painted in Deruta in the early 1280s. Attribution of the wall paintings in the Minutolo chapel in the Cathedral of Naples to another artist from central Italy, Montano of Arezzo (ca. 1285–90). P. Leone de Castris, *Arte di corte*, part III.2; F. Bologna, "Cultura figurativa," part 3; F. Bologna, *Pittori*, ch. 2.

57. It must be underscored that the artists who came to Naples were hired for specific reasons of taste. Robert likely commissioned Simone Martini to paint the altarpiece of the king's holy brother St. Louis of Toulouse because at that early phase of his career, the Sienese artist was already an elegant painter, whose style and sumptuous use of color and expensive materials must have corresponded to the self-image that the Angevins wished to convey. His early *Maestà* in the Palazzo Pubblico in Siena (1315) also was a potent political image that helped strengthen community identity and allegiance, which was no doubt one of the purposes of the Louis commission. Furthermore, its French features were likely a selling point to Robert. Tino, meanwhile, already had established a reputation for creating monumental tombs for ecclesiastical and imperial authorities and whose Sienese mode also had French stylistic overtones. His first project in Naples was the tomb of the wife of Charles of Calabria, Catherine of Austria (d. 1323), a fitting commission since Tino had carved the tomb of her first fiancé Henry VII in Pisa around 1314. He also had a connection to the Neapolitan court through his teacher Arnolfo di Cambio, who carved the Capitoline portrait of Charles I in 1280s. Discussions of the Simone commission: Adrian Hoch, "The Franciscan Provenance of Simone Martini's Angevin St. Louis in Naples," *ZKg* 58 (1995): 22–38; Julian Gardner, "Saint Louis of Toulouse, Robert of Anjou and Simone Martini," *ZKg* 39 (1976): 32–33; Julian Gardner, "The Cult of a Fourteenth Century Saint: The Iconography of Louis of Toulouse," in *Patrons, Painters, and Saints: Studies in Medieval Italian Painting* (Aldershot, 1993); F. Bologna, *Pittori*, ch. 4. On the "French" overtones of Tino's style that apparently appealed to the Angevins, W. R. Valentiner, *Tino di Camaino* (Paris, 1935), 47, 83, 86, etc.

58. P. Leone de Castris, *Arte di corte*, 323, n. 37; on Tino's legacy, Giulietta Chelazzi Dini, *Pacio e Giovanni Bertini da Firenze e la bottega napoletana di Tino di Camaino* (Prato, 1996); Francesco Negri Arnoldi, "Scultura trecentesca in Calabria: Apporti esterni e attività locale," *BA* 21 (1983): 1–48; and idem, "Pietro d'Oderisio, Nicola da Monteforte, e la scultura campana del primo Trecento," *Commentari* 23 (1972): 12–36.

59. That Simone did not come to Naples argued convincingly in Francesco Aceto, "Pittori e documenti della Napoli angioina: Aggiunte ed espunzioni," *Prospettiva* 67 (1992): 53–65; J. Gardner, "Cult of a Fourteenth-Century Saint."

60. For example, Stefaneschi altarpiece for the high altar of St. Peter's in Rome (disputed date) and the Baroncelli altarpiece for Santa Croce, Florence. Critiques in Julian Gardner, "The Decoration of the Baroncelli Chapel in Santa Croce," *ZKg* 34 (1971): 89–114; John White, *Art and Architecture in Italy 1250–1400*, 2nd ed. (New York, 1987), 343.

61. "Ruberto re di Napoli scrisse a Carlo duca di Calavria suo primogenito, il quale se trovava in Firenze, che per ogni modo gli mandasse Giotto a Napoli, perciò che, avendo finito di fabricare S. Chiara, monasterio di donne e chiesa reale, voleva che da lui fusse di nobile pittura adornata" (1568 text). Giorgio Vasari, *Le Vite de' più eccellenti pittori scultori e architettori nelle redazioni del 1550 e 1568*, ed. Rosanna Bettarini, vol. 2 (Florence, 1967), 108.

62. Bernardo De Dominici, *Vite de' pittori, scultori, ed architetti napoletani* (Naples, 1742; reprint, Bologna, 1979), vol. 1, introductory passages, s.p. On De Dominici's reputation as *falsario*, Judith Colton, "The Fall and Rise of Bernardo De Dominici," in *A Taste for Angels, Neapolitan Painting in North America* (New Haven, 1987), 57–68; F. Bologna, *Pittori*, 4–7; Benedetto Croce, "Sommario critico della storia dell'arte napoletana," *NN* 1 (1892): 140–4.

63. It is significant that in a classic move of the colonized, De Dominici bolsters his claims by turning to a Sienese authority, Marco di Pino, as if a Neapolitan one would not suffice. Also it is interesting that many of Marco's comments have as a constant point of reference the "time of Cimabue"; thus he replicates the chronological parameters of Vasari.

64. P. Leone de Castris, *Arte di corte*, 239 (critique of Paul Hetherington's monograph on Cavallini of 1979).

65. Negative views but with qualifications: Gert Kreytenberg, "Tino di Camaino," in *Scultura dipinta. Maestri di legname i pittori a Siena, 1250–1450*, Exhibition Pinacoteca Nazionale, Siena, 1987 (Florence, 1987), esp. 41.

66. He seems to find courtly settings inherently inferior, lacking an interest in the individual that is essential to his humanist focus. Hence, court culture is used to explain the discernible shift in character in Tino's later works. John Pope-Hennessy, *Italian Gothic Sculpture* (London, 1955; New York, 1985), 17. Recent work is even-handed: Anita F. Moskowitz, *Italian Gothic Sculpture, c. 1250–c. 1400* (Cambridge and New York, 2001), chs. 3 and 5; Franceso Aceto, "Per l'attività di Tino di Camaino a Napoli: Le tombe di Giovanni di Capua e di Orso Minutolo," *Prospettiva* 53–56 (1988–9): 134–42.

67. Pope-Hennessy's sexualized language finds exact parallels in late-nineteenth-century texts about Unification and the *Questione*, in which the South's supposedly weak, indolent, and effeminate characteristics justified the conquest of the region by the vigorous armies of the North. This language is also, of course, the language of colonialism, pitched often (but not exclusively) against Muslims and others in the "East."

68. ". . . e opere di pittura e scultura profuse dappertutto e per le quali lavorarano artisti fiorentini e senesi." "Queste figure, queste tragedie, questi romanzi e questi aneddoti irraggiano d'attrattiva quell'alta storia, che si rappresentò sulla nostra terra. Ma la nostra storia non può esser quella a cui abbiamo offerto il teatro." Benedetto Croce, *Storia del Regno di Napoli*, 1925, ed. Giuseppe Galasso (Milan, 1992), 49, 126. Translation from Benedetto Croce, *History of the Kingdom of Naples*, ed. H. Stuart Hughes, trans. Frances Frenaye (Chicago, 1970), 16, 30. This same anxiety infiltrated erudite travel literature, as in *Naples, Painted by Augustine Fitzgerald and Described by Sybil Fitzgerald* (London, 1904), 62–3.

69. Although earlier works such as Duccio's *Maestà* and Giotto's Crucifixion in the Scrovegni Chapel include numerous redheads, Roberto used this hair color far more consistently than other early Trecento practitioners. His altarpieces in particular are peopled with veritable communities of redheads, including angels, saints, and the holy family.

70. As for the composition, a dense crowd of mourners and soldiers occupy the lower register of the work and the three tall crosses extending into the arched vault of the chapel. Such an arrangement would signal the painter's intelligent use of the architectural space at hand, if it were not for the fact that a second group hovers above the mourners and Romans, this one on horses rather than standing. The horsemen appear to be floating, and the two horizontal registers of the composition do not mesh. Of comparable awkwardness are the large bodies of the soldiers gathered below Christ. They appear contorted, as if the artist were

uncomfortable creating figures of Giottesque bulk, or with depicting them from behind, or both.

71. P. Leone de Castris, *Arte di corte*, 376.

72. On Santa Chiara, P. Leone de Castris, *Arte di corte*, part V.2; F. Bologna, *Pittori*, ch. 5; on Santa Maria Donna Regina, Stephan Wolohojian, "Closed Encounters: Female Piety, Art and Visual Experience in the Church of Santa Maria Donna Regina in Naples" (Ph.D. diss., Harvard Univ., 1995) (argues for foundation ex novo, attribution to Cavallini with some workshop assistance); Rosa Anna Genovese, *La chiesa trecentesca di Donna Regina* (Naples, 1993) (argues rebuilt older foundation following devastating earthquake, followers of Cavallini); P. Leone de Castris, *Arte di corte*, part IV.3; F. Bologna, *Pittori*, ch. 3.

73. This Christological devotional focus is of course neither new nor unique to the Franciscans, but the status of St. Francis as *alter Christus*, the early appearance of passion cycles in thirteenth-century Clarissan and Franciscan houses, and their correspondence to devotional guides affiliated with the Order, including the *Meditationes vitae Christi*, place them at the forefront of many of these new practices. Discussion in Anne Derbes, *Picturing the Passion in Late Medieval Italy. Narrative Painting, Franciscan Ideologies, and the Levant* (Cambridge, 1996), Introduction. Caution regarding the *Meditations* and its relatively restrained emotions in Mosche Barasch, *Gestures of Despair in Medieval and Early Renaissance Art* (New York, 1976), 92.

74. This one possible signification of quasi nudity was particularly important in Byzantium following the repeal of iconoclasm, where artists sought to underscore Jesus's human side (e.g., Hosios Lukas narthex mosaic, Mt. Sinai Crucifixion icon of the twelfth century). A. Derbes, *Picturing the Passion*, 27–34.

75. For example, Adrian Hoch, "Pictures of Penitence"; A. Derbes, *Picturing the Passion*. Barasch's idea of "gesture figures" comes into play here, as images of ritualized mourning such as the distraught Magdalen and swooning Mary help underline the significance of the events and their emotional immediacy. M. Barasch, *Gestures of Despair*.

76. Quoted and translated in K. Jansen, *Making of the Magdalen*, 205, n. 28.

77. In contrast to the emotive Franciscan mode, the spare and symmetrical composition of the scene in the Brancaccio Chapel, coupled with the controlled emotions of its figures, dovetails with generalizations about the relatively sober and meditative character of Dominican art. Henk von Os, *Sienese Altarpieces, 1215–1460* (Groningen, 1988), vol. 1, 66–7; Joanna Cannon, "Simone Martini, the Dominicans, and the Early Sienese Polyptych," *Journal of the Warburg and Courtauld Institutes* 45 (1982): 69–93. On the unusual presence of three crosses, likely a Byzantine motif transmitted through manuscripts with large cycles of Christ's life (e.g., Mt. Athos Iviron 5 and relatives), see James Stubblebine, "Byzantine Sources for the Iconography of Duccio's Maestà," *AB* 57 (1975): 176–85; S. Woholojian, "Closed Encounters," 229.

78. For example, Cioffo Bove's donation of shares of land, rooms, and cistern in Lacco for masses at altar of St. John (1250): Cava, Fondo Mansi 13, doc. 456, fol. 101v–2r; lease of vineyards and olive groves in Giovinazzo by Altadonna, widow of Mottulo de Vito and daughter and heir of Rogerio Pironti for daily mass in crypt of San Giovanni, near *vocabulo* of St Nicholas (1369); endowment of masses for Giovanelli Acconzio (1412).

79. Chapels in the cemetery of San Giovanni del Toro; masses funded with candles lit in perpetuity (1412). Marble tombs noted in document dated 1480. Cava, Fondo Mansi 13, doc. 405, f. 104r (1412) and doc. 495, f. 114r (1480).

80. See also subsequent practices, namely, the Magdalen chapel founded under the pulpit in the Cathedral of Amalfi around 1400 by the archbishop Roberto Brancia, a site intended for his eventual tomb. P. Pirri, *Duomo di Amalfi*, 128, citing inventory from a pastoral visit in 1484.

81. Jacobus de Voragine, *The Golden Legend. Readings on the Saints*, trans. William Granger Ryan (Princeton, 1993), vol. 1, 375.

82. K. Jansen, *Making of the Magdalen*, 155–67.

83. This version of the scene not only departs from the examples of Giotto and Cavallini but also differs fundamentally from the more energized and active compositions of Barnaba da Modena or Duccio.

84. Discovery recounted in Adolfo Avena, *Monumenti dell'Italia meridionale* (Rome, 1902), 355.

85. F. Bologna, *Pittori*, 283, n. 56; P. Toesca, *Il Trecento*, 373. Also, Arnaldo Venditti, "Scala e suoi borghi, iii," 216.

86. The handbook dates from ca. 1400 but reflects practices of the era of Giotto. Cennino Cennini, *The Craftsman's Handbook, "Il libro d'arte,"* trans. Daniel V. Thompson, Jr. (New Haven, 1933; reprint, New York, 1960), chs. cii, cxxvi, cxxviii, etc.

87. For example, Simone Martini's Chapel of St. Martin in Assisi or the mid-fourteenth-century wall painting in the Norman foundation of SS. Trinità in Venosa. For Venosa, F. Bologna, *Pittori*, ch. 7, ill. 59 (attributed to the "First Master of the Bible Moralisée"); Bernard Berenson, "A Panel by Roberto Oderisi" (1922), reprinted in *Studies in Medieval Painting* (New York, 1975), 75–81.

88. Jacobus de Voragine, *Golden Legend*, vol. 2, 334–41.

89. In representations from the later Middle Ages, Catherine typically holds a single wheel, as seen in Simone Martini's chapel of St. Martin in Assisi, the so-called altarpiece of Robert the Wise in Brno, or the wall painting in Santa Maria in Casale, Brindisi, where the wheel includes lurid spikes and hooks.

90. Jacobus de Voragine, *Golden Legend*, vol. 2, 339–40; *Menelogium* quoted in Katherine J. Lewis, *The Cult of St. Katherine of Alexandria in Late Medieval England* (Woodbridge, 2000), 47.

91. Cycles of Sts. Agnes and Elizabeth of Hungary appear in Donna Regina as well, the latter saint related to the royal founder and Franciscan ideology, the former (with Catherine) likely intended to appeal to the audience of nuns. On the Elizabeth cycle, see P. Leone de Castris, *Pittori* (dates to ca. 1325–30), IV.3; S. Wolohojian, "Closed Encounters" (dates to ca. 1320), 235–47.

92. Émile Bertaux, "Magistri Johannes et Pacius de Florentia Marmorarii fratres, iii: La leggenda di Santa Caterina," *NN* 4 (1894): 148–52. Recent references: A. F. Moskowitz, *Italian Gothic Sculpture*, 193–5; Giulietta Chelazzi Dini, *Pacio e Giovanni Bertini da Firenze e la bottega napoletana di Tino di Camaino* (Prato, 1996), 49–62.

93. From his Neapolitan period, from a private collection. Discussed and illustrated in F. Aceto, "Per l'attività di Tino."

94. In Santa Maria del Casale in Brindisi, a wall painting thought to be commissioned by Catherine of Valois depicts the saint standing and holding a small wheel; scenes from her life and martyrdom are arrayed in adjacent vertical strips, with four small scenes per side (dated ca. 1330). This composition is unusual both for its mural context and date; it appropriates the designs of thirteenth-century hagiographic altarpieces, such as the Santa Chiara dossal. Catherine of Valois was the second wife of Philip of Taranto, the founder of the church; her patronage in part explains the subject matter as well as what Leone de Castris calls the "gusto trasalpino" of the painter. P. Leone de Castris, *Arte di corte*, 159–60, 186, fig. 21. On the Ottanà polyptych, generally attributed to the Master of the Franciscan Temperas, P. Leone de Castris, *Arte di Corte*, 101.

95. For example, tomb of Nicola Merloto in Santa Chiara, Naples (ca. 1358), and of Nicola Ruffo in San Francesco, Gerace (ca. 1373). Francesco Negri Arnoldi, "Scultura trecentesca in Calabria: Apporti esterni e attività locale," *BA* 21 (1983): Figs. 10 and 43.

96. Sancia's highly personal letters to the Franciscans discussed in Ronald Musto, "Queen Sancia of Naples."

97. On the unusual religiosity of the extended families of Robert and Sancia, see David Burr, *The Spiritual Franciscans. From Protest to Persecution in the Century after St. Francis* (University Park, PA, 2001); C. Bruzelius, "Queen Sancia of Mallorca and the Convent Church of Sta. Chiara"; S. Wolohojian, "Closed Encounters"; R. Musto, "Sancia of Naples."

98. K. Jansen, *Making of the Magdalen*, 74–7.

99. This quality perhaps also explains their importance to the Dominican Order; the Magdalen was, as previously mentioned, the official protectress of the Order, and Catherine's brave outspokenness corresponded with the role of defending the faith. See discussion of Simone Martini's polyptych for Santa Caterina in Pisa, H. van Os, *Sienese Altarpieces*, vol. 1, 66–7.

100. For instance, in one episode of her conversion (stressed in late medieval texts but not in the earlier ones or the *Golden Legend* that emphasize her *passio*), a hermit shows her a Tino-esque sculpted image of the Virgin and Child, and her vision of her marriage to Christ consequently ensues. This representation reinforces the position of holy men as monitors of female religious practice, a concept that is correct for this setting – particularly if, as Bertaux argued, the reliefs formed a balustrade around the choir of the monks. The critical role of the sculpted image of Mary also helps emphasize the centrality of the visual arts in the development of affective piety. In other words, the Santa Chiara reliefs, with their narrative details and deviations from the older *passio* texts, temper Catherine's independence and place her within a male-dominated and instructive religious environment.

101. Bertaux's attribution to Pacio and Giovanni sustained in G. Chelazzi Dini, *Pacio e Giovanni Bertini*; appropriately critiqued in A. F. Moskowitz, *Italian Gothic Sculpture*, 193–5, and idem, "Four Sculptures in Search of an Author: The Cleveland and Kansas City Angels and the Problem of the Bertini Brothers," *Cleveland Studies in the History of Art* 1 (1996): 98–115.

102. Such foundations were far less common in Amalfi than in the southeast part of the *Regno* (Matera, the Salento, and so on) or Cappadocia, to be sure, but they are numerous. Recent work with bibliography on the Maiori site is Robert Bergman and Andrea Cerenza, *Maiori, S. Maria de Olearia* (Amalfi, 1994).

103. Its dedication and cave form indicate associations with cult practices at the pilgrimage site of Monte Sant'Angelo in Apulia, where miraculous healings occurred inside a cave that St. Michael was thought to have visited. Other grotto-hospitals have Marian associations: one dedicated to the Annunciation once stood along the port of Amalfi, and the extant Grotta dell'Annunziata, dating from the second half of the fourteenth century, is constructed in a cave along the shore of Minori.

104. First documented in 1402, but with earlier remains. *PAVAR* vol. 7, 53, doc. CL.

105. SS. Cosma e Damiani was the first cathedral church that is parallel to and contiguous with the structure dedicated to St. Andrew. Presepio founded "que vocatur le grotti" as noted in record of pastoral visit of 1484. P. Pirri, *Duomo di Amalfi*, 124.

106. For example, Paul Binski, *Medieval Death. Ritual and Representation* (Ithaca, 1996); D. L. D'Avray, *Death and the Prince: Memorial Preaching before 1350* (Oxford, 1994); Jacques Le Goff, *The Birth of Purgatory*, trans. Arthur Goldhammer (Chicago, 1984).

107. The mediating role of the Franciscans in the care for the dead signals the paradox of Italian merchants in the later Middle Ages, who often found spiritual solace among the very orders that renounced their worldly wealth and power. Amintore Fanfani, *Le origini dello spirito capitalistico in Italia* (Milan, 1933), 43–4. On the Salerno episode and related bulls issued by Nicholas IV, G. De Blasiis, "La dimora di Boccaccio a Napoli," *ASPN* 17 (1892): 83.

108. SS. Annunziata, Ravello: Leonardo Benevolo, "La chiesa e l'oratorio della SS. Annunziata a Ravello," *Quaderni dell'Istituto di storia dell'architettura* 12 (1955): 9–16; Santa Maria Rotunda, Minori: will of Florita (*PAVM*, 89, doc. 88, dated 1199); Sant'Eustachio, see Chapter 3.

109. On Orso de Vito and his donation of 1297, G. Imperato, *Ravello nella storia civile e religiosa* (Cava, 1990), 439. On Giovanni and Sapia, M. Camera, *Memorie*, vol. 2, 389. Her tomb slab is previously unpublished. Its striking stylistic similarities to the slab of Guglielmo di Brussaco in San Lorenzo suggest a Neapolitan sculptor made the work, which is plausible given the status of her husband in the court. Brussaco tomb, dated 1346, in R. Mormone, ed., *Sculture trecentesche in S. Lorenzo Maggiore*, cat. 15, 36; see also n. 34, to this chapter.

110. *PAVM*, 85–7, doc. 85.

111. For example, Minori: *PAVM*, 50–2, doc. 45 (dated 1128); Ravello: Muscettola tombs described earlier.

112. Boccia, daughter of Leone the monk of Monte, created a *sepoltura* on lands owned by the cathedral. *PAVM*, 35–7, doc. 34 (dated ca. 1092).

113. Cava, Fondo Mansi 13, doc. 513, fol. 118v (dated 23 September 1351); later redaction in 1392, doc. 45.

114. Cava, Fondo Mansi 13, doc. 513, fol. 118v (dated 29 October 1392).

115. In this source Giovanni is described as *nobilis vir*, the first reference to literal nobility for the Rufolo family. Cava, Fondo Mansi, 13, doc. 635, fol. 146r–v (dated 29 May 1394).

116. Most references to the tomb tend to mention it only in terms of the altarpiece discussed later, including P. Leone de Castris, *Arte di corte*, 375; F. Bologna, *Pittori alla corte*, 259, 262, etc. Also A. Venditti, "Scala e i suoi borgi, iii," 215–16 (proposes same artist as Catherine relief in Ravello). Fuller assessment in J. Caskey, "Rufolo Palace," 239–48; Daniela Sinigalliesi, "Scala: Il monumento a Marinella Rufolo," *Bollettino storico di Salerno e Principato Citra* 7 (1989): 222–3 (proposes a French artist). See my forthcoming article for a more in-depth discussion of the tomb.

117. A. Venditti, "Scala e i suoi borghi, iii," 223, n. 16. The inscription from an eighteenth-century renovation reveals the hypothetical date of the tomb: "Divo Antonio Abati/sacellum/ab Antonio Coppola viro patricio/CCCC ab hinc annis excitatum/vetustate fatiscens et situ squalens/comes Antonius Coppola patricius scalensis/Regii patrimonii praeses/avito patronatus iure et pietate/restituit expolivit ornavit/anno a Partu Virginis MDCCXXXII."

118. For example, reference to the "bona cappella s(an)c(t)i Antonii de Coppulis constructe in subcorpore majoris Eccle(sia) Scalen(sis)," Cava, Fondo Mansi 13, fol. 12r, doc. 546 (dated 24 January 1440). The few writers who have mentioned the tomb noted that Antonio Coppola initiated its construction (some have even misidentified the tomb as his). A document of the succeeding generation throws into question the likelihood of Antonio planning the tomb of his wife, as it refers to Marinella as his widow. *AMA*, 117–18, doc. 71, dated 5 February 1396.

119. Hence it provides a tool for reconstructing approaches to Gothic polychromy, the extent of which is made clear by recent discoveries in Orvieto and elsewhere. Giusi Testa, "Tinte e coloriture in alcuni manufatti del duomo di Orvieto: La scoperta e questione del recupero," in *Il colore nel Medioevo. Arte, simbolo, tecnica*. Atti delle giornate di studi, Lucca, 1995, ed. Enrico Castelnuovo, Théo-Antoine Hermanès, et alia (Lucca, 1996), 77–89; Angiola Maria Romanini, "Arnolfo pittore: Pittura e spazio virtuale nel cantiere gotico," *Arte medievale* 11 (1997): 3–23 (tomb of Cardinal De Braye).

120. The work was restored in the early 1990s, but its condition has already deteriorated significantly, with mold threatening to erode basic features of the gisant and canopy.

121. Attributed to Montano of Arezzo, dated 1300–10; this artist is a key figure in the construction of the "apertura alla grande arte" in Neapolitan patronage toward central Italy. Leone de Castris, *Arte di corte*, part III, ch. 2.

122. Farfa: Robert Bergman, *The Salerno Ivories. Ars sacra from Medieval Amalfi* (Cambridge, MA, 1980), ch. 3 and 128–30; Herbert Kessler, "An Eleventh Century Ivory Plaque from South Italy and the Cassinese Revival," *Jahrbuch der Berliner Museen* 8 (1966): 67–95. Fourteenth-century Dormition at Santa Maria delle Cerrate, in Valentino Pace, "Pittura del Duecento e del Trecento in Puglia, Basilicata e nell'Italia meridionale 'greca,'" in *La Pittura in Italia. Il Duecento e il Trecento*, ed. Enrico Castelnuovo (Venice, 1986), vol. 2, 456; twelfth-century Dormition and Transito in Santa Maria in Grotta, Rongolise, F. Bologna, in *Storia e civiltà della Campania*.

123. Jacobus de Voragine, *Golden Legend*, vol. 2, 77–97. Jacopo's account follows closely the early text by the Pseudo-Mileto. On various text traditions, including that of Pseudo-Mileto, Rudolph Willard, "The Two Accounts of the Assumption in Blickling Homily XIII," *The Review of English Studies* 14, n. 53 (1938): 1–19.

124. Now in a private collection in Bergamo. F. Bologna, *Pittori*, ch. 6.iv. Subsequent references in P. Leone de Castris, *Arte di corte*, ch. 5.iv; and idem, "In margine."

125. The legible part of the text reads, HEC CONA FECIT FIERI ANTONI C...PTAS INCORONAVIS VIRGINIS MARIE. Bologna connected the inscription with the location of the painting in the nineteenth century, Ravello, and ascertained that the altarpiece was commissioned by Antonio Coppola for the chapel of St. Anthony in Scala. His attribution of the work to Roberto d'Oderisio has been accepted and has served as the basis for reconstructing many phases of the painter's long career.

126. P. Leone de Castris, *Arte di corte*, 313–27; 347–87.

127. "...nec non pictura unius cone dipicte de mandato nostro in domo Magistri Zocti prothomagistri operis dicte picture." An early modern description of an altarpiece of the Assumption in that site secures the iconographic identity of the lost work. Discussed in F. Bologna, *Pittori*, ch. 5; P. Leone de Castris, *Arte di corte*, 323, n. 37 (transcription of chancery document).

128. Two surviving altarpieces for Florentine settings, the Dormition dossal from Ognissanti (now in Berlin) and the Coronation altarpiece for the Baroncelli Chapel in Santa Croce, also date from this phase of Giotto's life and suggest compositional and thematic parallels with both works in Scala. They provide a broader indication of Giotto's work at this time and specific motifs and features that were useful to the artists who worked in Scala. For the Dormition, Miklós Boskovits, ed., *Frühe italienische Malerei*, Gemäldegalerie Berlin, Katalog der Gemälde (Berlin, 1988), cat. 24.

129. For example, the placement and posture of the mourner crouched before the funeral bier in the Berlin Dormition and Coppola altarpiece, as well as modelling of his drapery. Significant deviations from the Berlin dossal (and the Castel Nuovo *cona?*) are considered subsequently.

130. Fundamental views of Tino's work in Naples: A. F. Moskowitz, *Italian Gothic Sculpture*, ch. 5; Francesco Aceto, s.v. "Tino di Camaino," in *EAM*, vol. 11 (Rome, 2000), 180–8; idem, "Tino di Camaino a Napoli. Una proposta per il sepolcro di Caterina d'Austria e altri fatti angioini," *Dialoghi di storia dell'arte* 1 (1995): 10–27; idem, "Per l'attività di Tino"; J. Gardner, "Princess among Prelates"; Ottavio Morisani, *Tino di Camaino a Napoli* (Naples, 1945); W. R. Valentiner, *Tino di Camaino*, chs. 9–11; Enzo Carli, *Tino di Camaino scultore* (Florence, 1934), 80–8.

131. For Norman, Hohenstaufen, and contemporary Roman tomb traditions, see Julian Gardner, *The Tomb and the Tiara: Curial Tomb Sculpture in Rome and Avignon in the Later Middle Ages* (Oxford, 1992); Inge Herklotz, *"Sepulcra" e "Monumenta" del medioevo. Studi sull'arte sepolcrale in Italia* (Rome, 1985); A. M. Romanini, *Arnolfo di Cambio e lo "stil novo" del gotico italiano* (Florence, 1980); Josef Deér, *The Dynastic Porphyry Tombs of the Norman Period in Sicily*, trans. G. A. Gillhoff (Cambridge, MA, 1959).

132. For example, Stigmatization of St. Francis depicted in mosaic on the canopy of the tomb of Catherine of Austria in San Lorenzo (ca. 1323); virtue caryatids, tomb of Charles of Calabria, 1332–3, Santa Chiara.

133. Interpretation of brass inlay tombs as modest and less open to moralizing critiques in P. Binski, *Medieval Death*.

134. For example, Andrew Butterfield, "Social Structure and the Typology of Funerary Monuments in Early Renaissance Florence," *Res* 26 (1994): 47–67.

135. Sermon with friars in a fifteenth-century manuscript with texts of previous century: Mary Gripkey, "Mary Legends in Italian Manuscripts in the Major Libraries of Italy, Part II," *Mediaeval Studies* 15 (1953): 27, n. 122. Origins of Barlaam and Josaphat story: Jürgen Stohlmann, "Orient-Motive in der lateinischen Exempla-Literatur des 12 und 13 Jahrhunderts," in *Orientalische Kultur und Europaisches Mittelalter*, ed. Albert Zimmermann, Ingrid Craemer-Ruegenberg (Berlin and New York, 1985): 123–50; Amalfitan connections at Mt. Athos with first translation into Latin, Gerardo Sangermano, "Uomini di cultura e forme dell'arte nel Medioevo amalfitano e sorrentino," *RSS* 2 (1985): 112; Paul Peeters, "La première traduction latine de 'Barlaam et Joasaph' et son original grec," *Analecta Bollandiana* 49 (1931): 276–312.

136. Boyer sees this sermon (possibly intended for Charles II) as part of Dominican efforts to define positive Christian characteristics of the Neapolitan nobility in terms indebted to Thomas Aquinas. J.-P. Boyer, "Noblesse dans les sermons," 575.

137. For instance, Giordano preached that the material splendors that serve to glorify a king – gold and silver vessels, divans, and *ornamenti mirabili* – matter little to pious philosophers who are properly focused on the immaterial. *Racconti esemplari di predicatori del Due e Trecento*, ed. Giorgio Varanini and Guido Baldassari, vol. 2 (Rome, 1993), no. 139, 284–8; also no. 36, 115–16.

138. For example, traces of gold paint on hems of drapery on Cava relief; blue on Virgin's mantle on Altar of San Raniero; dark brown paint on fur hat in San Raniero; background in apex of triangle redish tint in places; alternating blue and gold on cusps of arch on tomb of Mary of Valois.

139. The fresco appears in an apse in a side chapel in the chamber where the Grotto of St. Catherine is located. I have not been able to substantiate the identification of this as a Coppola chapel, as claimed by Leone de Castris, *Arte di corte*, and A. Venditti, "Scala ed i suoi borghi, iii," n. 17.

140. Antoine Wenger, *L'Assomption de la T.S. Vierge dans la tradition byzantine du VI au X siècle, études et documents* (Paris, 1955), 48–9; transcription, 237.

141. In Jacopo's version, the priest's hands stick to the bier rather than being severed. "The chief priest, seeing what was happening, was astounded and filled with rage, and said: 'Look at the tabernacle of that man who disturbed us and our people so much! Look at the glory that is now paid to that woman!' After saying this he put his hands on the litter, intending to overturn it and throw the corpse to the ground. But suddenly his hands withered and stuck to the bier, so that he was hanging by his hands; and he moaned and cried in great pain." Urged by Peter to convert and kiss the bier, the priest does so, and his arms are freed. Jacobus de Voragine, *Golden Legend*, vol. 2, 81.

142. While an unusual subject in Western medieval art, the high priest still is portrayed in various contexts in the later Middle Ages: on portals at the Cathedrals of Paris and Rouen, in English prayer books (e.g., the Luttrell and St. Mary Psalters), at the northern Italian monastery at Chiaravalle, and so on. Representations of the Assumption with Jephonias survive in a variety of Byzantine contexts (e.g., Yilanli Kiliss in Cappadocia, a twelfth-century monastery near Kastoria, and a thirteenth-century icon from Mt. Sinai). Elisabeth Ravel-Neher, *The Image of the Jew in Byzantine Art*, trans. David Maizel (Oxford, 1992); Anne Wharton Epstein, "Frescoes

of the Mauriotissa Monastery near Kastoria: Evidence of Millenarianism and Antisemitism in the Wake of the First Crusade," *Gesta* 21 (1982): 21–7.

143. This same notion infiltrates the *Golden Legend*, in which the most virulent anti-Semitism appears in stories related to the New Testament. Jean-Pierre Myette, "L'image du Juif dans la *Legende dorée*," *Le Moyen français* 32 (1993): 114–15.

144. For example, R. I. Moore, *Formation of a Persecuting Society. Power and Deviance in Western Europe, 950–1250* (Oxford, 1987, 2000); Jeremy Cohen, *The Friars and the Jews: The Evolution of Medieval Anti-Judaism* (Ithaca, 1982); John Boswell, *Christianity, Social Tolerance, and Homosexuality* (Chicago, 1980).

145. On the connections between crusade, anti-Jewish sentiments, and usury, see R. I. Moore, *Formation of a Persecuting Society*, 33–4, 84; this development contrasts with the earlier discourse of usury discussed in Chapter 1 that clearly addressed and damned Christian practitioners. The *Constitutions of Melfi* (1231) secured the rights of Jews to lend money, thereby suggesting Frederick's efforts to normalize an inflamed situation. *The Liber Augustalis, or Constitutions of Melfi, Promulgated by the Emperor Frederick II for the Kingdom of Sicily in 1231*, ed. and trans. James M. Powell (Syracuse, 1971), 12–13.

146. On Charles II's expulsions, Joseph Shatzmiller, "Les Angevins et les Juifs de leurs états: Anjou, Naples et Provence," in *État angevin*, 289–300; David Abulafia, "Monarchs and Minorities in the Christian Western Mediterranean around 1300: Lucera and its Analogues," in *Christendom and its Discontents. Exclusion, Persecution, and Rebellion, 1000–1500*, ed. Scott L. Waugh and Peter D. Diehl (Cambridge, 1996), 234–63; Joshua Starr, "The Mass Conversion of Jews in Southern Italy, 1290–1293," *Speculum* 21 (1946): 203–11.

147. R. I. Moore has argued that the new bureaucracies of royal and papal courts established, consolidated, and expanded their power by exercising it over small and vulnerable groups; such states reified an "apparatus of persecution" that could readily pit majority against minority. In other words, enacting repressive religious policies was a potent way for popes, kings, queens, and monks to establish and renew their hegemonic status. R. I. Moore, *Formation of a Persecuting Society*. Apt criticisms of Moore's portrait of a single monolithic "state" in Maureen C. Miller, *The Bishop's Palace* (Ithaca, 2000), 5–6.

148. The king was persuaded in part by the promise of revenue sharing: any financial rewards were divided among the Order, the royal treasury, and the Church in Rome, which supported such efforts. But perhaps Charles II's abrupt change of mind (particularly regarding Lucera) stemmed from a gnawing sense that the sustained presence of "noxious" groups, however useful they may have been, diminished a king of blessed lineage, as Abulafia has posited. D. Abulafia, "Monarchs and Minorities;" G. M. Monti, *Da Carlo I*, ch. 12. J. Cohen, *Friars and the Jews*, 888; J. Starr, "Mass Conversion."

149. Benjamin of Tudela, the traveler from Navarre who stopped in Trani soon after 1173, noted that there were 200 Jews in that city. The Salerno community, first documented in the ninth century, was comprised of scholars and doctors associated with the medical school as well as theologians, weavers, dyers, and merchants. Benjamin of Tudela claimed that 600 Jews lived there. Epigraphic evidence and the location of the community, along with discussion of the life of the prominent philosopher and commentator on Maimonides Rabbi Moshé, son of Shelomò (d. 1279), in Nello Pavoncello, "Epigrafe ebraica nel Museo del Duomo di Salerno," *Annali* (Istituto Orientale di Napoli), n.s. 18 (1968): 198–203. On the conversions, see J. Shatzmiller, "Angevins et les Juifs"; J. Starr, "Mass Conversion." Also, *The Itinerary of Benjamin of Tudela*, trans. Marcus Nathan Adler (London, 1907), 8–9.

150. Carlo Carucci, ed., *Codice dipomatico salernitano*, vol. 3 (Subiaco, 1946), 140, doc. 110.

151. "...fuoro piue d'ottomilia." Giordano da Pisa, in *Racconti esemplari*, vol. 2, 329. Analysis in D. Abulafia, "Monarchs and Minorities," 167.

152. For example, under Frederick II, Jews and Muslims were protected in the *Regno* in their capacity as *servi* of the king, and Jews were allowed under the law to lend money (see n. 145, this chapter). Yet at the same time Frederick II adhered to the Fourth Lateran Council and required Jews to wear distinguishing clothes. He expelled Muslims from Sicily and resettled them in Lucera in northern Apulia, in part to sever their ties with the Islamic world. Although he apparently enjoyed spending time in Lucera and was relatively sophisticated about the faith of its inhabitants, he also actively campaigned for their conversion, inviting Dominican and Franciscan preachers to the town in 1233. On such inconsistencies and resulting vulnerability of minorities, David Abulafia, "Ethnic Variety and its Implications: Frederick II's Relations with Jews and Muslims," in *Intellectual Life at the Court of Frederick II Hohenstaufen*, ed. William Tronzo (Washington, DC, 1994), 213–26; Christoph T. Maier, "Crusade and Rhetoric against the Muslim Colony of Lucera: Eudes of Châteauroux's *Sermones de Rebellione Sarracenorum Lucherie in Apulia*," *Journal of Medieval History* 21 (1995): 343–85. On the legal status of *servus* as developed in the *Regno* likely by the legal scholar, protonotary, and logothete Bartolomeo of Capua as a means of consolidating monarchical authority, D. Abulafia, "Monarchs and Minorities."

153. N. Housley, *Italian Crusades*, ch. 1; C. T. Maier, "Crusade and Rhetoric."

154. Bull of Alexander IV, *Pia matris*, 1255. Quoted in C. T. Maier, "Crusade and Rhetoric," 353.

155. "...sic luna in excelso posita ea que infra se sunt, perturbat ventis, pluviis, ed grandinibus, sic hec Lucheria Sarracenorum totam viciniam suam usque ad hoc tempora perturbavit predis et incendiis debastavit. Huius etiam Lucherie odor, id est fama, usque ad remotos pervenit." Yeast imagery adopted from Sirach appears in the same sermon. The purported moral failures of Muslims were also pointed out, such as materialism that defies Christian doctrine and extreme sexual practices. Eudes portrayed Lucera as a modern Jericho and Charles I as Joshua, a metaphor that helped establish the Angevins' sacral authority over the South. Quotation from transcription in C. T. Maier, "Crusade and Rhetoric," 380. On pollution fear and discourse of intolerance, R. I. Moore, *Formation*, ch. 3.

156. Despite this anti-Muslim propaganda, Charles I suppressed the inhabitants of Lucera only after their rebellion in 1268, and after a short siege he let them maintain their culture and faith and even promoted some to the knighthood. As Frederick and Manfred had done before him, he relied on Muslims for strength in battle, court entertainment, and tax revenue. One weapon used to convert Muslims and Jews was the promise of financial gain, for Charles II and Robert generally exempted converts from all taxes for life. Because non-Christians were highly taxed, considerable sums of money were involved. On high-ranking Muslims, Jean-Marie Martin, "La colonie sarrasine de Lucera et son environnement. Quelques réflexions," in *Mediterraneo medievale. Scritti in onore di Francesco Giunta*, vol. 2 (Soveria Mannelli, 1989), 801. On taxation: G. M. Monti, *Da Carlo I a Roberto*, ch. 12; J. Starr, "Mass Conversion."

157. Overview of these groups in É. Léonard, *Angevins de Naples*, ch. 3.

158. See, for instance, references to problems in Sessa, Brindisi, Cosenza, Trani, and other sites over seemingly trumped-up charges. Romolo Caggese, *Roberto d'Angio e i suoi tempi* (Florence, 1922), 295–310; J. Shatzmiller, "Angevins et les Juifs."

159. The categories of Raymond Williams work well here in part because, following Gramsci, they magnify the various ways in which dominant and dominated cultures bump up against each other and intersect, as do the related postcolonial models referred to elsewhere in this study. Raymond Williams, *The Sociology of Culture* (Chicago, 1981); and idem, "Base and Superstructure in Marxist Cultural Theory" (1973), reprinted in *Problems in Materialism and Culture. Selected Essays* (London, 1980).

SELECT BIBLIOGRAPHY

PRIMARY SOURCES

Manuscripts

Cava dei Tirreni, Archivio dell'Abbazia della Trinità.
 Fondo Mansi 13 and 31.
Naples, Archivio di Stato.
 Frammenti di Fuoco 232 and 246.
 Monasteri soppressi 425, San Domenico Maggiore.
Naples, Biblioteca Nazionale.
 Bolvito, Giovanni Battista. "Registri delle cose familiari di casa nostra." *Fondo San Martino*
 101 and 102.

Edited

Benjamin of Tudela. *The Itinerary of Benjamin of Tudela.* Trans. Marcus Nathan Adler. London:
 Henry Frowde and Oxford University, 1907.
Boccaccio, Giovanni. *Decameron.* Ed. Enzo Quaglio. Milan: Garzanti, 1974.
de Boüard, Alain, and Paul Durrieu, eds. *Documents en français des archives angevines de
 Naples.* 2 vols. Paris: E. de Boccard, 1933–5.
Ciano, Cesare, ed. *La 'Practica di mercatura' datiniana (sec. xiv).* Milan: Giuffrè, 1964.
Criscuolo, Vincenzo, ed. *Le pergamene dell'archivio vescovile di Minori.* Amalfi: CCSA,
 1987.
Dante Alighieri. *La Divina Commedia.* Ed. C. H. Grandgent and Charles S. Singleton. Cam-
 bridge, MA: Harvard University Press, 1972.
De Leone, Andrea, and Alessandro Piccirillo, eds. *Consuetudines civitatis amalfie.* Cava dei
 Tirreni: Di Mauro, 1970.
Del Giudice, Giuseppe. *Una legge suntuaria inedita del 1290.* Naples: Regia Università,
 1881.
Dotson, John E., ed. and trans. *Merchant Culture in Fourteenth Century Venice: The Zibaldone
 da Canal.* Medieval and Renaissance Texts and Studies 98. Binghamton, NY: Medieval
 and Renaissance Texts and Studies, 1994.
Filangieri di Candida, Riccardo, ed. *Codice diplomatico amalfitano.* Naples: Silvio Morano,
 1917.

Filangieri, Riccardo, ed. *I Registri della Cancelleria angioina riconstruiti da Riccardo Fi-langieri, con la collaborazione degli Archivisiti Napoletani.* 10 vols. Naples: Accademia Pontaniana, 1950–.

Hoffmann, Harmut, ed. *Chronica monasterii casinensis.* Monumenta Germaniae Historica, Scriptores, vol. 34. Hannover: Hahnsche Buchhandlung, 1980.

Jacobus de Voragine. *The Golden Legend. Readings on the Saints.* Trans. William Granger Ryan. 2 vols. Princeton: Princeton University Press, 1993.

Jamison, Evelyn, ed. *Documents from the Angevin Registers of Naples, Charles I.* Rome: British School, 1949.

Mazzoleni, Bianca, ed. *Archivio vescovile di Ravello. Atti diversi, a. 1220–1753.* Ravello and Salerno: "Ravello Nostra," s.d. (ca. 1973).

Mazzoleni, Bianca, ed. *Le pergamene degli archivi vescovili di Amalfi e Ravello,* vol. 3: *Es-empi di scrittura minuscola in carte ravellesi dei secoli XII–XIII.* Naples: Arte tipografica, 1975.

Mazzoleni, Jole, ed. *Le pergamene degli archivi vescovili di Amalfi e Ravello,* vol. 1. Naples: Arte tipografica, 1972.

Mazzoleni, Jole, and Renata Orefice, eds. *Codice Perris, Cartulario amalfitano, X–XV secolo.* 5 vols. Amalfi: Centro di cultura e storia amalfitana, 1985–9.

Mazzoleni, Jole, et alia, eds. *Testi e documenti di storia napoletana. Registri della Cancelleria angioina.* Naples: Accademia Pontaniana, 1963–.

Orefice, Renata, ed. *Le pergamene degli archivi vescovili di Amalfi e Ravello,* vol. 6: *Le pergamene dell'archivio arcivescovile di Amalfi.* Amalfi: Centro di cultura e storia amal-fitana, 1983.

Orefice, Renata, ed. *Le pergamene degli archivi vescovili di Amalfi e Ravello,* vol. 7: *Le pergamene dell'archivio arcivescovile di Ravello.* Amalfi: Centro di cultura e storia amal-fitana, 1983.

Palmieri, Stefano, ed. *Le pergamene amalfitane della Società Napoletana di Storia Patria.* Amalfi: Centro di cultura e storia amalfitana, 1988.

Pescatore, Luigi, ed. *Le pergamene degli archivi vescovili di Amalfi e Ravello,* vol. 4: *Le pergamene dell'archivio arcivescovile di Amalfi.* Naples: Arte tipografica, 1979.

Powell, James M., ed. and trans. *The Liber Augustalis, or Constitutions of Melfi, Promulgated by the Emperor Frederick II for the Kingdom of Sicily in 1231.* Syracuse: Syracuse University Press, 1971.

Rossi, Giuliana. *Le pergamene degli archivi vescovili di Amalfi e Ravello,* vol. 5: *Le pergamene dell'archivio vescovile di Ravello.* Naples: Arte tipografica, 1979.

Salvati, Catello, ed. *Le pergamene degli archivi vescovili di Amalfi e Ravello,* vol. 2. Naples: Arte tipografica, 1974.

Salvati, Catello, and Rosa Pilone, eds. *Gli archivi dei monasteri di Amalfi (S. Maria di Fontanella, S. Maria Dominarum, SS. Trinità).* Amalfi: Centro di cultura e storia amalfi-tana, 1986.

eds. *Le pergamene del Fondo Mansi conservate presso il Centro di cultura e storia amalfitana.* Amalfi: Centro di cultura e storia amalfitana, 1987.

Santeramo, Salvatore, ed. *Codice diplomatico barlettano.* Barletta: G. Dellisanti, 1924–62.

Schwarz, Ulrich. "Regesta amalfitana. Die älteren Urkunden Amalfis in ihrer Überlieferung." *QFIAB* 58 (1978): 1–136; 59 (1979): 1–157; 60 (1980): 1–156.

Sicard, Enrico, G. Carducci, and V. Fiorini, eds. *Due croniche del Vespro in volgare siciliano del XIII: Rebellamentu di Sicilia.* Rerum Italicarum scriptores n.s., 34. Bologna: Zanichelli, 1917.

Varanini, Giorgio, and Guido Baldassari, eds. *Racconti esemplari di predicatori del Due e Trecento.* 3 vols. Rome: Salerno, 1993.

SECONDARY SOURCES

Abbate, Francesco. *Storia dell'arte nell'Italia meridionale. Dai longobardi agli svevi.* Rome: Donzelli, 1997.

———. *Storia dell'arte nell'Italia meridionale. Il Sud angiono e aragonese.* Rome: Donzelli, 1998.

Abulafia, David. *The Two Italies. Economic Relations between the Norman Kingdom of Sicily and the Northern Comunes.* Cambridge and New York: Cambridge University Press, 1977.

———. "The Pisan *bacini* and the Medieval Mediterranean Economy: A Historian's Viewpoint." In *Papers in Italian Archaeology IV: The Cambridge Conference, Classical and Medieval Archaeology.* BAR International Series 246. Ed. Caroline Malone and Simon Stoddart. Oxford: BAR, 1985, 287–302.

———. "A Tyrrhenian Triangle: Tuscany, Sicily, Tunis 1276–1300." *Studi di storia economica toscana nel Medioevo e nel Rinascimento in memoria di Federigo Melis.* Biblioteca del Bolletino storico pisano, Collana Storica 33. Pisa: Pacini, 1987, 53–75.

———. *Frederick II : A Medieval Emperor.* Cambridge and New York: Cambridge University Press, 1992.

———. "Ethnic Variety and Its Implications: Frederick II's Relations with Jews and Muslims." In *Intellectual Life at the Court of Frederick II Hohenstaufen.* Ed. William Tronzo. Washington, DC: National Gallery of Art, 1994, 213–26.

———. "Monarchs and Minorities in the Medieval Mediterranean, ca. 1300: Lucera and Its Analogues." In *Christendom and Its Discontents. Exclusion, Persecution, and Rebellion, 1000–1500.* Ed. Peter D. Diehl and Scott L. Waugh. Cambridge and New York: Cambridge University Press, 1996, 234–63.

———. *The Western Mediterranean Kingdoms: 1200–1500, the Struggle for Dominion.* London: Longman, 1997.

Abu-Lughod, Janet L. *Before European Hegemony. The World System AD 1250–1350.* Oxford: Oxford University Press, 1989.

Aceto, Francesco. "I pulpiti di Salerno e la scultura romanica della costiera di Amalfi." *NN* n.s. 18 (1979): 169–94.

———. "Scultura in costiera di Amalfi nei secoli VIII–X: Prospettive di ricerca." *RSS* n.s. 1 (1984): 49–59.

———. "Per l'attività di Tino di Camaino a Napoli: Le tombe di Giovanni di Capua e di Orso Minutolo." *Prospettiva* 53–56 (1989): 134–42.

———. "Il 'Castrum novum' angiono di Napoli." In *Cantieri medievali.* Ed. Roberto Cassanelli. Milan: Jaca, 1995, 251–67.

———. "Tino di Camaino a Napoli. Una proposta per il sepolcro di Caterina d'Austria e altri fatti angioini." *Dialoghi di storia dell'arte* 1 (1995): 10–27.

Ackerman, James S. *The Villa: Form and Ideology of Country Houses.* Princeton: Princeton University Press, 1990.

Agnew, Jean-Christophe. "Coming up for Air: Consumer Culture in Historical Perspective." In *Consumption and the World of Goods.* Ed. John Brewer and Roy Porter. London: Routledge, 1994, 19–39.

Amari, Michele. *Un periodo delle istorie siciliane del secolo XIII.* 1841. Reprint. Palermo: Accademia nazionale di scienze lettere e arti di Palermo, 1988.

Andrews, David. "Medieval Domestic Architecture in Northern Lazio." In *Medieval Lazio.* BAR International Series 125. Ed. David Andrews, John Osborne, and David Whitehouse. Oxford: BAR, 1982, 1–121.

Antal, Frederick. *Florentine Painting and Its Social Background. The Bourgeois Republic before Cosimo de Medici's Advent to Power.* London: K. Paul, 1948.

Appadurai, Arjun. *The Social Life of Things: Commodities in Cultural Perspective*. 1986. Reprint. Cambridge and New York: Cambridge University Press, 1987.

Avagliano, Faustino, ed. *Desiderio di Montecassino e l'arte della riforma gregoriana*. Montecassino: Pubblicazioni cassinesi, 1997.

Balard, Michel. "Notes sur le commerce entre l'Italie et l'Égypte sous les Fatimides." In *L'Égypte fatimide, son art et son histoire*. Actes du colloque organisé à Paris, 1998. Ed. Marianne Barrucand. Paris: Université de Paris-Sorbonne, 1999, 627–33.

Baldwin, John W. *Masters, Princes and Merchants: The Social Views of Peter the Chanter and His Circle*. 2 vols. Princeton: Princeton University Press, 1970.

Balenci, Patrizia. "L'originaria cattedrale di Amalfi, attuale chiesa del S. Crocifisso. Osservazioni sui lavori di ripristino in corso." *Architettura, città, trattatistica nell'età del Rinascimento. Quaderni di Storia dell'architettura e restauro (Florence)* 6–7 (1991–2): 113–28.

Ballardini, Gaetano. "'Bacini' orientali a Ravello." *BA* 27 (1934): 391–400.

Banfield, Edward C., and Laura Fasano Banfield. *The Moral Basis of a Backward Society*. Glencoe, Ill.: Free Press, 1958.

Barley, Maurice Willmore. *Houses and History*. London: Faber and Faber, 1986.

Belli D'Elia, Pina. *La Puglia*. Italia romanica. Vol. 8. Milan: Jaca, 1987.

Belting, Hans. "Byzantine Art among Greeks and Latins in Southern Italy." *DOP* 28 (1974): 3–29.

Bergman, Robert. "A School of Romanesque Ivory Carving in Amalfi." *Metropolitan Museum Journal* 9 (1974): 163–86.

The Salerno Ivories. Ars sacra from Medieval Amalfi. Cambridge, MA: Harvard University Press, 1980.

"Amalfi medievale: La struttura urbana e le forme dell'economia e della società." In *Istituzioni civili e organizzazione ecclesiastica nello stato medievale amalfitano*. Atti del Congresso internazionale di studi amalfitani, Amalfi, 1981. Amalfi: Centro di cultura e storia amalfitana, 1986, 95–111.

"The Frescoes of Santissima Annunciata in Minuto (Amalfi)." *DOP* 41 (1987): 71–83.

"Byzantine Influence and Private Patronage in a Newly Discovered Medieval Church in Amalfi: S. Michele Arcangelo in Pogerola." *JSAH* 50 (1991): 421–45.

Berry, Christopher J. *The Idea of Luxury: A Conceptual and Historical Investigation*. Cambridge and New York: Cambridge University Press, 1994.

Bertaux, Émile. "Magistri Johannes et Pacius de Florentia Marmorarii fratres, iii: La leggenda di Santa Caterina." *NN* 4 (1894): 148–52.

Santa Maria di Donna Regina e l'arte senese a Napoli nel secolo XIV. Naples: Francesco Giannini & Figli, 1894.

"Les arts de l'Orient musulman dans l'Italie méridionale." *MÉFR* 15 (1895): 419–53.

L'art dans l'Italie méridionale: De la fin de l'Empire romain à la conquête de Charles d'Anjou. 5 vols. Paris and Rome: École française de Rome, 1903. Some redactions bear imprint date 1904.

Bevilacqua, Piero. "Old and New in the Southern Question." *Modern Italy* 1 (1996): 81–92.

Bhabha, Homi K. *The Location of Culture*. London: Routledge, 1994.

Binski, Paul. "The Cosmati at Westminster and the English Court Style." *AB* 72 (1990): 6–34.

Medieval Death. Ritual and Representation. Ithaca: Cornell University Press, 1996.

Bloch, Herbert. *Montecassino in the Middle Ages*. Cambridge, MA: Harvard University Press, 1986.

"Origin and Fate of the Bronze Doors of Abbot Desiderius of Monte Cassino." *DOP* 41 (1987): 89–102.

Bloom, Jonathan. "The Origins of Fatimid Art." *Muqarnas* 3 (1985): 20–38.

Boeckler, Albert. *Die Bronzetüren des Bonanus von Pisa und des Barisanus von Trani.* Die frühmittelalterliches Bronzetüren, vol. 4. Ed. Richard Hamann. Berlin: Deutscher Verein für Kunstwissenschaft, 1953.

Boer, Inge E. "This Is Not the Orient: Theory and Postcolonial Practice." In *The Point of Theory: Practices of Cultural Analysis.* Ed. Mieke Bal and Inge E. Boer. Amsterdam: Amsterdam University Press, 1994, 211–19.

Bologna, Fedinando. *I pittori alla corte angioina di Napoli, 1266–1414, e un riesame dell'arte nell'età fridericiana.* Rome: Ugo Bozzi, 1969.

"'Cesaris imperio regni custodia fio': La porta di Capua e la 'interpretatio imperialis' del classicismo." In *Nel segno di Federico II : Unità politica e pluralità culturale del Mezzogiorno.* Ed. Mario Del Treppo. Naples: Bibliopolis/Fondazione Napoli Novantanove, 1989, 159–92.

Bornstein, Christine Verzár. "Romanesque Sculpture in Southern Italy. A Revaluation." In *The Meeting of Two Worlds: Cultural Exchange between East and West during the Period of the Crusades.* Ed. Vladimir P. Goss. Kalamazoo: Medieval Institute of America, 1986, 285–94.

Bornstein, Christine Verzár, Priscilla Parsons Soucek, et alia, eds. *The Meeting of Two Worlds: The Crusades and the Mediterranean Context.* Univ. of Michigan Museum of Art, 1981. Ann Arbor: University of Michigan Press, 1981.

Bottari, Stefano. "I rapporti tra l'architettura siciliana e quella campana del Medioevo." *Palladio* 5 (1955): 7–28.

"Intorno a Nicola di Bartolomeo da Foggia." *Commentari* 6/3 (1955): 159–63.

"Nicola Pisano et la cultura meridionale." *Arte antica e moderna* 5 (1959): 43–51.

Boyd, Catherine Evangeline. *Tithes and Parishes in Medieval Italy. The Historical Roots of a Modern Problem.* Ithaca: Cornell University Press, 1952.

Boyer, Jean-Paul. "Parler du roi et pour le roi. Deux 'sermons' de Barthélemey de Capoue, logothète du Royaume de Sicile." *Revue des sciences philosophiques et théologiques* 79 (1995): 193–248.

"Sacre et théocratie, le cas des rois de Sicile Charles II (1289) et Robert (1309)." *Révue des sciences philosophiques et théologiques* 81 (1997): 561–607.

Branca, Vittore, ed. *Mercanti scrittori: Ricordi nella Firenze tra Medioevo e Rinascimento.* Milan: Rusconi, 1986.

Brenk, Beat. "Spolien und ihre Wirkung auf die Ästhetik der varietas. Zum Problem alternierender Kapitelltypen." In *Antike Spolien in der Architecktur des Mittelalters und der Renaissance.* Ed. Joachim Poeschke. Munich: Hirmer, 1996, 49–92.

Brentano, Robert. "The Archepiscopal Archives at Amalfi." *Manuscripta* 4 (1960): 98–105.

"Sealed Documents of the Mediaeval Archbishops at Amalfi." *Mediaeval Studies* 23 (1961): 21–46.

Two Churches. England and Italy in the Thirteenth Century. Princeton: Princeton University Press, 1968; Berkeley and Los Angeles: University of California Press, 1988.

Rome before Avignon. A Social History of Thirteenth-Century Rome. New York: Basic Books, 1974.

Bresc, Henri. "1282: Classes sociales et révolution nationale." In *La società mediterranea di epoca del Vespro.* XI Congresso di Storia della Corona d'Aragona, 1982. Ed. Francesco Giunta and Pietro Corrao. Vol. 2. Palermo: Accademia di Scienze, lettere, ed arti, 1983, 241–58.

Brunschvig, Robert. *La Berberie orientale sous les Hafsides dès origines à la fin du XV siècle.* Paris: Adrien-Maisonneuve, 1940.

Bruzelius, Caroline A. "ad modum franciae. Charles of Anjou and Gothic Architecture in the Kingdom of Naples." *Journal of the Society of Architectural Historians* 50 (1991): 402–20.

"I coro di San Lorenzo Maggiore e la ricezione dell'arte gotica nella Napoli angiona." In *Il Gotico europeo in Italia*. Ed. Valentino Pace and Martina Bagnoli. Naples: Electa, 1995, 265–77.

"Queen Sancia of Mallorca and the Convent Church of Santa Chiara in Naples." *Memoirs of the American Academy in Rome* 50 (1995): 69–100.

"Charles I, Charles II, and the Development of an Angevin Style in the Kingdom of Sicily." In *L'État angevin. Pouvoir, culture, et société entre XIIIe et XIVe siècle*. Actes du colloque international organisé par l'American Academy in Rome, l'École française de Rome, l'Istituto storico italiano per il Medio Evo, l'U.M.R.Telemme et L'Université de Provence, l'Université degli studi di Napoli, 1995. Rome: École française de Rome, 1998, 99–114.

"Giovanni Pipino of Barletta: The Butcher of Lucera as Patron and Builder." In *Pierre, lumière, couleur: Études d'histoire de l'art du Moyen Âge en l'honneur d'Anne Prache*. Ed. Fabienne Joubert. Paris: Presses de l'Université de Paris-Sorbonne, 1999, 255–67.

"*A Torchlight Procession of One*. Le Choeur de Santa Maria Maggiore de Barletta." *Revue de l'art* 125 (1999): 9–19.

"Trying to Forget: The Lost Angevin Past of Italy." In *Memory & Oblivion*. Proceedings of the 29th International Congress of the History of Art held in Amsterdam, 1996. Ed. Wessel Reinick and Jeroen Stumpel. Dordrecht: Kluwer Academic, 1999, 735–43.

"*Il gran rifiuto*. French Gothic in Central and Southern Italy in the Last Quarter of the Thirteenth Century." In *Architecture and Language: Constructing Identity in European Architecture, ca. 1000–1650*. Ed. Georgia Clarke and Paul Crossley. Cambridge and New York: Cambridge University Press, 2000, 36–45.

Burr, David. *The Spiritual Franciscans. From Protest to Persecution in the Century after Saint Francis*. University Park, PA: Pennsylvania State University Press, 2001.

Butterfield, Andrew. "Social Structure and Typology of Funerary Monuments in Early Renaissance Florence." *Res* 26 (1994): 47–67.

Cadei, Antonio. "Fossanova e Castel del Monte." *Federico II e l'arte del Duecento italiano*. Atti della III Settimana di studi di storia dell'arte medievale dell' Università di Roma, 1978. Ed. A.M. Romanini. Galatina: Congedo, 1980, 191–216.

"Architettura federiciana. La questione delle componenti islamiche." In *Nel segno di Federico II : Unità politica e pluralità culturale del Mezzogiorno*. Ed. Mario del Treppo. Naples: Bibliopolis/ Fondazione Napoli Novantanove, 1989, 143–58.

ed. *Arte d'Occidente, temi e metodi. Studi in onore di Angiola Maria Romanini*. Rome: Sintesi, 1999.

Cadier, Léon. *Essai sur l'administration du royaume de Sicile sous Charles Ier et Charles II d' Anjou*. Bibliotèque des Écoles françaises d'Athènes et de Rome, fasc. 59. Paris: E. Thorin, 1891.

Cagiano de Azevedo, Michelangelo. "Policromia e polimateria nelle opere d'arte della tarda antichità e dell'alto medioevo." *Felix Ravenna* 1 (1970): 223–59.

Cahen, Claude. "Un texte peu connu relatif au commerce oriental d'Amalfi au Xe siècle." *ASPN* 34 (1953–4): 61–6.

Calò Mariani, Maria Stella. "Aspetti della scultura sveva in Puglia e in Lucania." *Archivio storico pugliese* 26 (1973): 441–74.

L'arte del Duecento in Puglia. Turin: Istituto Bancario San Paolo, 1984.

Camera, Matteo. *Memorie storico-diplomatiche dell'antica città e ducato di Amalfi*. Salerno, 1876 and 1881. Reprint. Salerno: W. Casari, 1972.

Carabellese, Francesco. *Carlo d'Angiò nei rapporti politici e commerciali con Venezia e l'Oriente*. Bari: Commissione provinciale di archeologia e storia patria, 1911.

Caronia, Giuseppe. *La Zisa di Palermo. Storia di restauro*. Rome: Laterza, 1982.

Carotti, Anna. "La suppellettile sacra e l'arte dell'intarsia in Campania dall' XI al XIII secolo." *Tesi di laurea*. University of Rome, 1966–7.

Caruso, Angelo. "Le scritture pergamenacee e cartacee raccolte da Gaetano Mansi. Loro vicende. Elenco di quelle – nella quasi totalità cartacee – conservate adesso presso la Badia di Cava." *RCCSA* 4 (1982): 101–21.

Caskey, Jill. "Una fonte cinquecentesca per la storia dell'arte medievale ad Amalfi." *RCCSA* 12 (1992): 71–81.

"The Rufolo Palace in Ravello and Merchant Culture in Medieval Campania." Ph.D. diss., Yale University, 1994.

"An Early Description of the Villa Rufolo in Ravello." *Apollo* 11 (1995): 123–28.

"Steam and *sanitas* in the Domestic Realm. Baths and Bathing in Southern Italy in the Middle Ages." *JSAH* 58 (1999): 170–95.

"The House of the Rufolos in Ravello: Lay Patronage and Diversification of Domestic Space in Southern Italy." In *The Christian Household in Medieval Europe, c. 850–c.1550: Managing Power, Wealth, and the Body*. Ed. Cordelia Beattie, Anna Maslakovic, and Sarah Rees Jones. Turnhout: Brepols, 2003. 315–34.

Cassatta, Giovanella, and Gabriella Costantino, et alia. *La Sicilia*. Italia Romanica. Vol. 7. Milan: Jaca, 1986.

Castelnuovo, Enrico. "Arte della città, arte delle corti tra XII e XIV secolo." *Storia dell' arte italiana*. Vol. 5: *Dal Medioevo al Quattrocento*. Ed. Federico Zeri. Turin: Einaudi, 1983, 167–227.

ed. *La Pittura in Italia. Il Duecento e il Trecento*. Venice: Electa, 1986.

and Carlo Ginzburg. "Centro e periferia." In *Storia dell'arte italiana*. Vol. 1: *Questioni e metodi*. Ed. Giovanni Previtali. Turin: Einaudi, 1979, 285–352.

Catalioto, Luciano. *Terre, baroni e città in Sicilia nell'età di Carlo I d'Angiò*. Collana di Testi e studi storici 7. Messina: Intilla, 1995.

Cavallo, Guglielmo, Vera von Falkenhausen, Raffaella Farioli Campanati, Marcello Gigante, Valentino Pace, and Franco Panvini Rosati. *I Bizantini in Italia*. Milan: Scheiwiller, 1982.

La Chiesa di Amalfi nel Medioevo. Convegno internazionale di studi per il Millenario dell'archidiocesi di Amalfi, 1987. Amalfi: Centro di cultura e storia amalfitana, 1996.

Ciccuto, Marcello. "Figures et culture des images dans les récits exemplaires du XIVe siècle." In *Les exempla médiévaux: Nouvelles perspectives*. Ed. Jacques Berlioz and Marie Anne Polo de Beaulieu. Paris: Honoré Champion, 1998, 371–84.

Cilardo, Agostino, ed. *Presenza araba e islamica in Campania*, Atti del convegno sul tema, 1989. Naples: Istituto universitario orientale, 1992.

Citarella, Armand. "The Relations of Amalfi with the Arab World before the Crusades." *Speculum* 42 (1967): 299–312.

"Patterns in Medieval Trade: The Commerce of Amalfi before the Crusades." *Journal of Economic History* 28 (1968): 531–55.

Claussen, Peter Kornelius. *Magistri doctissimi Romani: Die römischen Marmorkünstler des Mittelalters*. Corpus Cosmatorum, vol. 1. Wiesbaden: Steiner, 1987.

Cohen, Jeremy. *The Friars and the Jews: A Study in the Development of Medieval Anti-Judaism*. Ithaca: Cornell University Press, 1982.

Conant, Kenneth, and Henry Willard. "Early Examples of the Pointed Arch and Vault in Romanesque Architecture." *Viator: Medieval and Renaissance Studies* 2 (1971): 203–9.

Constable, Olivia Remie. *Trade and Traders in Muslim Spain: The Commercial Realignment of the Iberian Peninsula, 900–1500*. Cambridge and New York: Cambridge University Press, 1994.

Cristiani Testi, Maria Laura. *Nicola Pisano, architetto scultore. Dalle origini al pulpito del battistero di Pisa*. Pisa: Pacini, 1987.

Croce, Benedetto. "Sommario critico della storia dell'arte napoletana." *NN* 2 (1893): 55–61, 85–9, 130–4, 152–6, 164–7, 179–85; 3 (1894): 39–41, 56–60, 70–2.

 Storia del Regno di Napoli. Bari: Laterza, 1925. Reprint, with an introduction by Giuseppe Galasso. Milan: Adelphi, 1992.

Cuozzo, Errico. "La nascita della diocesi di Ravello (a. 1086): Un episodio della ristrutturazione diocesana nel Mezzogiorno dell'XI secolo." In *Atti della Giornata di Studio per il IX Centenario della fondazione della Diocesi di Ravello, 1986*. Ravello: Associazione "Ravello Nostra," 1987, 45–58.

 'Quei maladetti normanni.' Cavalieri e organizzazione militare nel Mezzogiorno normanno. Naples: Guida, 1989.

Cutler, Anthony. "The Parallel Universes of Arab and Byzantine Art (with special reference to the Fatimid period)." In *L'Égypte fatimide, son art et son histoire*. Actes du colloque organisé à Paris, 1998. Ed. Marianne Barrucand. Paris: Université de Paris-Sorbonne, 1999, 635–48.

De Cunzo, Mario, ed. *Ravello. Il Duomo e il Museo*. Salerno: Pietro Laveglia, 1984.

De Dominici, Bernardo. *Vite de'Pittori, scultori, ed architetti napoletani*. 3 vols. Naples: Ricciardo, 1742–1745. Reprint. Bologna: Arnaldo Forni, 1979.

Deér, Josef. "Die Basler Löwenkamee und der süditalienische Gemmenschnitt des 12. und 13. Jahrhunderts: Ein Beitrag zur Geschichte der abendländischen Protorenaissance." *Zeitschrift für schweizerische Archaeologie und Kunstgeschichte* 14 (1953): 129–58.

 The Dynastic Porphyry Tombs of the Norman Period in Sicily. Dumbarton Oaks Studies 5. Trans. G. A. Gillhoff. Cambridge, MA: Harvard University Press, 1959.

Delogu, Paolo. *Mito di una città meridionale (Salerno, secoli VIII–XI)*. Naples: Liguori, 1977.

 "Patroni, donatori, committenti nell'Italia meridionale longobarda." In *Committenti e produzione artistico-letteraria nell'alto medioevo occidentale*, 1991. Spoleto: Centro italiano di studi sul alto medioevo, vol. 39, 1992, 303–39.

Del Treppo, Mario, and Alfonso Leone. *Amalfi medioevale*. Naples: Giannini, 1977.

Del Treppo, Mario, ed. *Nel segno di Federico II : Unità politica e pluralità culturale del Mezzogiorno*. Naples: Bibliopolis/Fondazione Napoli Novantanove, 1989.

Derbes, Anne. *Picturing the Passion in Late Medieval Italy. Narrative Painting, Franciscan Ideologies, and the Levant*. Cambridge and New York: Cambridge University Press, 1996.

Dickie, John. *Darkest Italy: The Nation and Stereotypes of the Mezzogiorno, 1860–1900*. Basingstroke: Macmillan, 1999.

Di Stefano, Guido. *Monumenti della Sicilia normanna*. Palermo, 1955. Second edition, with a forward by Wolfgang Krönig. Palermo: Flaccovio, 1979.

Dodds, Jerrilyn D. *Architecture and Ideology in Early Medieval Spain*. University Park, PA: Pennsylvania State University Press, 1989.

Dodds, Jerrilynn D., ed. *Al-Andalus. The Art of Muslim Spain*. New York: Metropolitan Museum of Art, 1992.

D'Onofrio, Mario. *La Cattedrale di Caserta Vecchia*. Rome: Editalia, 1974.

 and Valentino Pace. *La Campania*. Italia romanica. Vol. 4. Milan: Jaca, 1981.

Douglas, Mary, and Baron Isherwood. *The World of Goods*. New York: Basic Books, 1979.

Duby, Georges. *Hommes et structures du moyen âge: Recueil d'articles*. École pratique des hautes études, VIe section: Le savoir historique, 1. Paris: Mouton, 1973.

 The Chivalrous Society. Trans. Cynthia Postan. Berkeley and Los Angeles: University of California Press, 1977.

 and Philippe Ariès, eds. *A History of Private Life*, vol. 2: *Revelations of the Medieval World*. Trans. Arthur Goldhammer. Cambridge, MA: Belknap Press of Harvard University Press, 1988.

Dunbabin, Jean. *Charles I of Anjou. Power, Kingship and State-Making in Thirteenth-Century Europe*. Edinburgh: Addison Wesley Longman, 1998.

Elias, Norbert. *The Court Society*. 1969. Trans. Edmund Jephcott. Oxford: Blackwell, 1983.

Enderlein, Lorenz. *Die Grablegen des Hauses Anjou in Unteritalien. Totenkult und Monumente, 1266–1343*. Worms: Wernersche Verlagsgesellschaft, 1997.

Esch, Arnold. "Spolien. Zur Wiederverwendung antiker Baustücke und Skulpturen im mittelalterlichen Italien." *Archiv für Kulturgeschichte* 51 (1969): 1–64.

Exner, Matthias, ed. *Stuck des frühen und hohen Mittelalters. Geschichte, Technologie, Konservierung*. Eine Tagung des Deutschen Nationalkomitees von ICOMOS, Hildesheim, 1995. Munich: ICOMOS, 1996.

von Falkenhausen, Vera. "I gruppi etnici nel regno di Ruggero II e la loro participazione al potere." In *Società, potere, e popolo nell'età di Ruggero II : Atti delle terze giornate normanno-sveve, 1977*. Bari: Daedalo, 1979, 133–56.

"Il Ducato di Amalfi." In *Il Mezzogiorno dai Bizantini a Federico II*. Ed. André Guillou. Turin: UTET, 1983, 339–46.

Fanfani, Amintore. *Le origini dello spirito capitalistico in Italia*. Milan: Società editrice 'Vita e pensiero,' 1933.

Fentress, Elizabeth. "Social Relations and Domestic Space in the Maghreb." In *Maisons et espaces domestiques dans le monde méditerranéen au Moyen Âge*. Castrum 6. Collection de l'EFR 105/6. Ed. André Bazzana and Étienne Hubert. Rome and Madrid: École française de Rome/Casa de Velázquez, 2000, 15–26.

Fiengo, Giuseppe, and Gianni Abbate. *Case a volta della costa di Amalfi*. Amalfi: Centro di cultura e storia amalfitana, 2001.

Fiengo, Giuseppe, and Maria Russo. "Il Chiostro del Paradiso di Amalfi." *Apollo* 12 (1996): 105–23.

Figliuolo, Bruno. "Gli amalfitani a Cetara: Vicende patrimoniale e attività economiche (secoli X–XI)." *Annali dell'Istituto italiano per gli studi storiche* 6 (1979–80): 31–82.

"Amalfi e il Levante nel Medioevo." In *I comuni italiani nel Regno crociato di Gerusalemme*. Atti del Colloquio, Jerusalem, 1984. Collana di Fonti e Studi XLVIII. Ed. G. Airaldi and B. Z. Kedar. Genoa, 1986, 571–664.

Fonseca, Cosimo Damiano. "'Ordines' istituzionali e ruoli sociali." In *Condizione umana e ruoli sociali nel Mezzogiorno normanno-svevo*. Atti delle none giornate normanno-sveve, 1989. Bari: Dedalo, 1991, 9–18.

Frazer, Margaret. "Church Doors and the Gates of Paradise: Byzantine Bronze Doors in Italy." *DOP* 27 (1973): 145–62.

Freccia, Marino. *De Subfeudis Baronum et investituris Feudorum*. Naples: M. Cancer, 1554; Venice: De Bottis, 1579.

Friedman, David. *Florentine New Towns. Urban Design in the Late Middle Ages*. Cambridge, MA: MIT Press, 1988.

Gabrieli, Francesco. "Il palazzo hammadita di Bigaya, descritto da Ibn Hamdis." In *Aus der Welt der Islamischen Kunst*. Festschrift für Ernst Kühnel zum 75. Geburtstag am 26.10.1957. Berlin: Mann, 1959, 54–8.

and Umberto Scerrato, eds. *Gli arabi in Italia: Cultura, contatti e tradizioni*. Milan: Garzanti Scheiwiller, 1985.

Galasso, Giuseppe. "Le città campane nell'alto medioevo." *ASPN* 77 (1958): 11–42; 78 (1959): 9–53.

"Il commercio amalfitano nel periodo normanno." In *Studi in onore di Riccardo Filangieri*. Naples: L'arte tipografica, 1959, I, 81–103.

L'altra Europa. Per un'antropologia storica del Mezzogiorno d'Italia. Milan: Mondadori, 1982.

Il Regno di Napoli. Turin: UTET, 1992.

Gandolfo, Francesco. *La scultura normanno-sveva in Campania: Botteghe e modelli.* Bari: Laterza, 1999.

and Domenico de Masi. *Ravello.* Milan: FMR, 1995.

Gardner, Julian. "St. Louis of Toulouse, Robert of Anjou, and Simone Martini." *ZKg* 39 (1976): 12–33.

"A Princess among Prelates. A Fourteenth-Century Neapolitan Tomb and Some Northern Relations." *RJK* 23/24 (1988): 29–60.

The Tomb and the Tiara: Curial Tomb Sculpture in Rome and Avignon in the Later Middle Ages. Oxford: Clarendon Press, 1992.

"L'introduzione della tomba figurativa in Italia centrale." In *Il Gotico europeo in Italia.* Ed. Valentino Pace and Martina Bagnoli. Naples: Electa, 1995, 207–19.

"Il patrocinio curiale e l'introduzione del gotico, 1260–1305." In *Il Gotico europeo in Italia.* Ed. Valentino Pace and Martina Bagnoli. Naples: Electa, 1995, 85–8.

"Seated Kings, Sea-faring Saints and Heraldry: Some Themes in Angevin Iconography." In *L'État angevin. Pouvoir, culture, et société entre XIIIe et XIVe siècle.* Actes du colloque international organisé par l'American Academy in Rome, l'École française de Rome, l'Istituto storico italiano per il Medio Evo, l'U.M.R. Telemme et L'Université de Provence, l'Université degli studi di Napoli, 1995. Rome: École française de Rome, 1998, 115–26.

Gargano, Giuseppe "Ravello medievale: Aspetti di topografia e storia urbanistica." In *Atti della Giornata di Studio per il IX Centenario della fondazione della Diocesi di Ravello, 1986.* Ravello: Associazione "Ravello Nostra," 1987, 99–143.

"La casa medievale amalfitana." *RCCSA* 9 (1989): 113–28.

La città davanti al mare. Aree urbane e storie sommerse di Amalfi nel Medioevo. Amalfi: Centro di cultura e storia amalfitana, 1992.

Garms, Jörg, and Angiola Maria Romanini, eds. *Skulptur und Grabmal des Spätmittelalters in Rom und Italien.* Akten des Kongresses "Scultura e monumento sepocrale del tardo medioevo a Roma e in Italia, 1985." Vienna: Verlag der Österreichischen Akademie der Wissenschaften, 1990.

Genovese, Rosa Anna. *La chiesa trecentesca di Donna Regina.* Naples: Edizioni scientifiche italiane, 1993.

Gillerman, Dorothy. *Enguerran de Marigny and the Church of Notre-Dame at Ecouis. Art and Patronage in the Reign of Philip the Fair.* University Park, PA: Pennsylvania State University Press, 1994.

Glass, Dorothy. "Romanesque Sculpture in Campania and Sicily: A Problem of Method." *AB* 56 (1974): 315–24.

"Jonah in Campania: A Late Antique Revival." *Commentari* 27 (1976): 179–93.

"Pseudo-Augustine, Prophets and Pulpits in Campania." *DOP* 41 (1987): 215–26.

Romanesque Sculpture in Campania. Patrons, Programs, Style. University Park, PA: Pennsylvania State University Press, 1991.

Gnudi, C. "Considerazioni sul gotico francese, l'arte imperiale e la formazione di Nicola Pisano." In *Federico II e l'arte del Duecento italiano.* Atti della III Settimana di studi di storia dell'arte medievale dell'Università di Roma, 1978. Ed. A. M. Romanini. Galatina: Congedo, 1980, 1–17.

Goitein, S. D. "Medieval Tunisia, the Hub of the Mediterranean." In *Studies in Islamic History and Institutions.* Leiden: Brill, 1966, 308–28.

A Mediterranean Society. The Jewish Communities of the Arab World as Portrayed in the Documents of the Cairo Geniza. 6 vols. Berkeley and Los Angeles: University of California Press, 1968–93.

"Sicily and Southern Italy in the Cairo Geniza Documents." *Archivio storico per la Sicilia orientale* 67 (1971): 9–33.

"A Mansion in Fustat. A Twelfth-Century Description of a Domestic Compound in the Ancient Capital of Egypt." In *The Medieval City. Essays in Honor of Robert S. Lopez.* Ed. David Herlihy, Harry Miskimin, and A. L. Udovitch. New Haven: Yale University Press, 1977, 163–78.

Goldschmidt, Adolf. "Die normannischen Königspaläste in Palermo." *Zeitschrift für Bauwesen* 48 (1898): 543–90.

Goldthwaite, Richard. "The Florentine Palace as Domestic Architecture." *American Historical Review* 77 (1971): 977–1012.

"The Empire of Things: Consumer Demand in Renaissance Italy." In *Patronage, Art, and Society in Renaissance Italy.* Ed. Frances Kent and Patricia Simons. Oxford: Clarendon, 1987, 153–175.

Wealth and the Demand for Art, 1300–1600. Baltimore: Johns Hopkins University Press, 1993.

Golvin, Lucien. *Recherches archeologiques à la Qal'a des Benû Hammâd.* Paris: Maisonneuve et Larose, 1965.

Goss, Vladimir P., ed. *The Meeting of Two Worlds: Cultural Exchange between East and West during the Period of the Crusades.* Kalamazoo, MI: Medieval Institute Publications, 1986.

Grabar, André, and Oleg Grabar. "L'essor des arts inspirés par les cours princières à la fin du premier millénaire: Princes musulmans et princes chrétiens." In *L'art de la fin de l'antiquité et du Moyen Âge.* By André Grabar. Paris: Collège de France, 1968, vol. 1, 121–44.

Grabar, Oleg. *The Formation of Islamic Art.* New Haven: Yale University Press, 1973. Second ed., 1987.

The Alhambra. London: Allen Lane, 1978.

"Trade with the East and the Influence of Islamic Art on the 'Luxury Arts' in the West." In *Il Medio Oriente e l'Occidente nell'arte del XIII secolo.* Atti del XXIV Congresso internazionale di storia dell'arte. Ed. Hans Belting. Bologna: CLUEB, 1982, 27–34.

"Patterns and Ways of Cultural Exchange." In *The Meeting of Two Worlds. Cultural Exchange between East and West during the Period of the Crusades.* Ed. Vladimir Goss. Kalamazoo, MI: Medieval Institute, 1986, 441–6.

Gramsci, Antonio "Alcuni temi della quistione meridionale." In *2000 pagine di Gramsci,* vol. 1. Ed. Giansiro Ferrata and Niccolò Gallo. Milan: Il Saggiatore, 1971, 797–819.

Selections from the Prison Notebooks of Antonio Gramsci. Ed. and trans. Quinton Hoare and Geoffrey Nowell Smith. London: Lawrence and Wishart, 1971.

Greenhalgh, Michael. *The Survival of Roman Antiquities in the Middle Ages.* London: Duckworth, 1989.

Guglielmi Faldi, Carla. *Il Duomo di Ravello.* Milan: A. Pizzi, 1974.

Guidoni, Enrico. "Urbanistica islamica e città medievali europee." *Storia della città* 7 (1979): 4–10.

ed. *Storia della città,* vol. 46: *Il mondo islamico, immagini e ricerche.* Milan: Electa, 1988.

Guillaume, Jean, ed. *Architecture et vie sociale: L'organisation intérieure des grandes demeures à la fin du moyen âge et à la Renaissance.* Actes du colloque tenu à Tours du 6 au 10 Juin 1988. Paris: Picard, 1994.

Heers, Jacques. *Le clan familial au Moyen Âge. Étude sur les structures politiques et sociales des milieux urbains.* Paris: Presses universitaires de France, 1974.

　　La ville au Moyen Âge en Occident. Paris: Fayard, 1990.

Herde, Peter. *Karl I von Anjou.* Stuttgart: Kohlhammer, 1979.

　　"Carlo I d'Angiò nella storia del Mezzogiorno." In *Unità politica e differenze regionali nel Regno di Sicilia.* Atti del Convegno internazionale di studio in occasione del VIII centenario della morte di Guglielmo II, 1989. Ed. Cosimo Damian Fonseca, Hubert Houben, and Benedetto Vetere. Galatina: Congredo, 1992, 181–204.

Herklotz, Ingo. "'*Sepulcra*' e '*monumenta*' del Medioevo. Studi sull'arte sepolcrale in Italia.* Rome: Nantes, 1985.

Herman, Emil. "'Chiese private' e diritto di fondazione negli ultimi secoli dell'impero bizantino." *Orientalia christiana periodica* 12 (1946): 302–21.

Hetherington, Paul. "Pietro Cavallini, Artistic Style and Patronage in Late Medieval Rome." *Burlington Magazine* 114, no. 826 (1972): 4–10.

　　Pietro Cavallini. A Study in the Art of Late Medieval Rome. London: Sagittarius, 1979.

von Heyd, Wilhelm. *Histoire du commerce du Levant au Moyen-Âge.* Leipzig: Otto Harrassowitz, 1923.

Hirschman, Albert O. *The Passions and the Interests. Political Arguments for Capitalism before Its Triumph.* Princeton: Princeton University Press, 1977.

Hoch, Adrian S. "The Franciscan Provenance of Simone Martini's Angevin St. Louis of Toulouse." *ZKg* 58 (1995): 22–38.

　　"Pictures of Penitence from a Trecento Neapolitan Nunnery." *ZKg* 61 (1998): 206–26.

Hofmeister, Adolf. "Maurus von Amalfi und die Elfenbeinkassette von Farfa aus dem 11. Jahrhundert." *QFIAB* 24 (1932): 273–83.

　　"Der Übersetzer Johannes und das Geschlecht Comitis Mauronis in Amalfi." *Historische Vierteljahrschrift* 27 (1932): 225–84, 493–508, 831–33.

Housley, Norman. *The Italian Crusades. The Papal-Angevin Alliance and the Crusades against Christian Lay Powers, 1254–1343.* 1982. Oxford: Clarendon Press, 1999.

Howard, Deborah. *Venice & the East: The Impact of the Islamic World on Venetian Architecture, 1100–1500.* New Haven: Yale University Press, 2000.

Hughes, Diane Owen. "Sumptuary Laws and Human Relations in Renaissance Italy." In *Disputes and Settlements. Law and Human Relations in the West.* Ed. John Bossy. Cambridge and New York: Cambridge University Press, 1983, 69–94.

　　"Distinguishing Signs: Ear-rings, Jews, and Franciscan Rhetoric in the Italian Renaissance City." *Past and Present* 112 (1986): 3–59.

Hunt, Alan. *Governance of the Consuming Passions: A History of Sumptuary Law.* New York: St. Martins, 1996.

Jacobs, Fritz. "Die Kathedrale S. Maria Icona Vetere in Foggia. Studien zur Architecktur und Plastik des 11.–13. Jahrhundert in Süditalien." Ph.D. diss., University of Hamburg, 1966 (1968).

Jansen, Katherine Ludwig. *The Making of the Magdalen. Preaching and Popular Devotion in the Later Middle Ages.* Princeton: Princeton University Press, 2000.

Johns, Jeremy. "The Norman Kings of Sicily and the Fatimid Caliphate." *Anglo-Norman Studies* 15 (1992): 133–59.

Kalby, Luigi. *Tarsie ed archi intrecciati nel romanico meridionale.* Salerno: Testaferrata, 1971.

　　"Culto ed iconografia di S. Pantaleone." In *Atti della Giornata di Studio per il IX Centenario della fondazione della Diocesi di Ravello, 1986.* Ravello: Associazione "Ravello Nostra," 1987, 165–74.

Kalinowski, Lech. "Entre Reims et Ravello. Diffusion ou covergence?" In *Pierre, lumière,*

couleur: Études d'histoire de l'art du Moyen Âge en l'honneur d'Anne Prache. Ed. Fabienne Joubert. Paris: Presses de l'Université de Paris-Sorbonne, 1999, 231–42.

Kamp, Norbert. "Vom Kämmerer zum Sekreten. Wirtschaftsreformen und Finanzverwaltung im staufischen Königreich Sizilien." In *Probleme um Freidrich II.* Vorträge und Forschungen 16. Herausgegeben vom Kostanzer Arbeitskreis für mittelalterliche Geschichte. Ed. J. Fleckenstein. Sigmaringen: J. Thorbecke, 1974, 43–92.

——— "Politica ecclesiastica e struttura sociale nel Regno di Sicilia." *ASPN* n.s. 16 (1977): 1–20.

——— "Gli amalfitani al servizio della Monarchia nel periodo svevo del Regno di Sicilia." In *Documenti e realtà nel Mezzogiorno italiano in età medievale e moderna.* Atti delle Giornate di studio in memoria di Jole Mazzoleni, Amalfi, 10–12 dicembre 1993. Amalfi: Centro di cultura e storia amalfitana, 1995, 9–37.

Kantorowicz, Ernst. *Frederick the Second, 1194–1250.* 1928. Trans. E. O. Lorimer. New York: F. Ungar, 1957.

Kiesewetter, Andreas. *Die Anfänge der Regierung König Karls II. von Anjou (1278–1295). Das Königreich Neapel, die Grafschaft Provence, und der Mittelmeeraum zu Ausgang des 13. Jahrhunderts.* Husum: Matthiesen, 1999.

Kinney, Dale. "Rape or Restitution of the Past? Interpreting Spolia." In *The Art of Interpreting.* Papers in Art History from the Pennsylvania State University. Ed. Susan C. Scott. University Park, PA: Department of Art History, the Pennsylvania State University, 1995.

Kreutz, Barbara. *Before the Normans: Southern Italy in the Ninth and Tenth Centuries.* Philadelphia: University of Pennsylvania, 1991.

——— "Ghost Ships and Phantom Cargoes: Reconstructing Early Amalfitan Trade." *Journal of Medieval History* 20 (1994): 347–57.

Kreytenberg, Gert. *Tino di Camaino.* Florence: Museo Nazionale del Bargello, 1986.

——— "Tino di Camaino e Simone Martini." In *Simone Martini.* Atti del convegno, Siena, 1985. Ed. Luciano Bellosi. Florence: Centro Di, 1988, 203–9.

Krönig, Wolfgang. *Il Castello di Caronia in Sicilia: Un complesso normanno del XII secolo.* Rome: Edizioni dell' Elefante, 1977.

Krüger, Jürgen. *S. Lorenzo Maggiore in Neapel: Eine Franziskanerkirche zwischen Ordensideal und Herrschaftsarchitektur.* Werl-Westfalen: Dietrich-Coelde, 1986.

Kühnel, Ernst. *Die islamischen Elfenbeinskulpturen.* Berlin: Deutschen Verlag für Kunstwissenschaft, 1971.

Langholm, Odd. *Economics in Medieval Schools: Wealth, Exchange, Value, Money, and Usury according to the Paris Theological Tradition, 1200–1350.* Leiden: Brill, 1992.

Le Goff, Jacques. *Marchands et banquiers au Moyen Âge.* Paris: Presses universitaires de France, 1956.

——— "Métier et profession d'après les manuels de confesseurs du Moyen Âge." In *Miscellanea mediaevalia* 3. Beiträge zum Berufsbewussten des mittelalterlichen Menschen. Berlin, 1964, 44–60.

——— "The Usurer and Purgatory." In *The Dawn of Modern Banking.* Center for Medieval and Renaissance Studies, University of California, Los Angeles. New Haven: Yale University Press, 1979: 25–52.

——— *Your Money or Your Life. Economy and Religion in the Middle Ages.* 1986. Trans. Patricia Ranum. New York: Zone Books, 1989.

Lehmann-Brockhaus, Otto. "Die Kanzeln der Abruzzen im 12. und 13. Jahrhundert." *RJK* 6 (1942–44): 257–426.

Léonard, Émile. *Les Angevins de Naples.* Paris: Presses universitaires de France, 1954.

Leone, Alfonso, ed. *Ricerche sul Medioevo napoletano. Aspetti e momenti della vita economica e sociale a Napoli tra decimo e quindicesimo secolo.* Biblioteca storica meridionale, Testi e ricerche 9. Naples: Athena, 1996.

Leone de Castris, Pierluigi. *Arte di corte nella Napoli angioina*. Florence: Catini, 1986.

"La Cappella Palatina. Il ciclo giottesco." In *Castel Nuovo. Il Museo Civico*. Ed. P. Leone de Castris. Naples: Elio de Rosa, 1990, 65–83.

"Napoli 'capitale' del gotico europeo: Il referto dei documenti e quello delle opere sotto il regno di Carlo I e Carlo II d'Angiò." In *Il Gotico europeo in Italia*. Ed. Valentino Pace and Martina Bagnoli. Naples: Electa, 1995, 239–52.

Lézine, Alexandre. *Mahdiya, recherches d'archéologie islamique*. Paris: C. Klincksieck, 1965.

Architecture de l'Ifrikiya: Recherches sur les monuments aghlabides. Paris: C. Klincksieck, 1966.

Lightbown, R.W. "Portrait or Idealization: The Ravello Bust." *Apollo, the International Magazine of the Arts* 127, no. 312, n.s. (1988): 108–12.

Little, Lester. "Pride Goes before Avarice: Social Change and the Vices in Latin Christendom." *American Historical Review* 76 (1971): 16–49.

Religious Poverty and the Profit Economy in Medieval Europe. Ithaca: Cornell University Press, 1978.

Long, Jane C. "Salvation through Meditation: The Tomb Frescoes of the Holy Confessors Chapel at Santa Croce in Florence." *Gesta* 34 (1995): 77–88.

Lopez, Robert Sabatino. "Economie et architecture médiévales: Cela aurait-il tué ceci?" *Annales* 7 (1952): 433–8.

"Le marchand génois. Un profil collectif." *Annales* 13 (1958): 501–15.

"The Culture of the Medieval Merchant." *Medieval and Renaissance Studies: Proceedings of the Southeastern Institute of Medieval and Renaissance Studies, Summer 1976*. Ed. Dale Randall. Durham, NC: Duke University Press, 1979, 52–73.

Lowry, Glenn. "Islam and the Medieval West: Southern Italy in the Eleventh and Twelfth Centuries." *RCCSA* 3 (1983): 5–58.

MacDonald, William L., and John A. Pinto. *Hadrian's Villa and Its Legacy*. New Haven: Yale University Press, 1995.

Maier, Christoph T. "Crusade and Rhetoric against the Muslim Colony of Lucera: Eudes of Châteauroux's *Sermones de Rebellione Sarracenorum Lucherie in Apulia*." *Journal of Medieval History* 21 (1995): 343–85.

Maleczek, Werner. *Petrus Capuanus: Kardinal, Legat am vierten Kreuzzug, Theologe*. Vienna: Verlag der österreichischen Akademie der Wissenschaften, 1988.

Marçais, Georges. *L'architecture musulmane d'Occident*. Paris: Arts et métiers graphiques, 1954.

Marini Clarelli, Maria Vittoria. "Pantaleone d'Amalfi e le porte bizantine in Italia meridionale." In *Arte profana e arte sacra a Bisanzio*. Ed. Antonio Iacobini and Enrico Zanini. Rome: Argos, 1995, 641–51.

Martin, Jean-Marie "La colonie sarrasine de Lucera et son environnement. Quelques réflexions." In *Mediterraneo medievale. Scritti in onore di Francesco Giunta*, vol. 2. Ed. Centro di studi tardoantichi e medievali di Altomonte. Soverio Mannelli: Rubbettino, 1989, 797–811.

"Palais princièrs et impériaux en Italie méridionale et en Sicilie (VIIIe–XIVe siècles)." In *Palais royaux et princiers au Moyen Âge*. Actes du colloque international tenu au Mans, 1994. Ed. Annie Renoux. Le Mans: Université du Maine, 1996, 173–80.

"Quelques données textuelles sur la maison en Campanie et en Pouille (Xe–XIIe siècle)." In *Maisons et espaces domestiques dans le monde méditerranéen au Moyen Âge*. Castrum 6. Collection de l'EFR 105/6. Ed. André Bazzana and Étienne Hubert. Rome and Madrid: École française de Rome/Casa de Velázquez, 2000, 74–87.

Martindale, Andrew. *Heroes, Ancestors, Relatives, and the Birth of the Portrait*. The Hague: G. Schwarz, 1988.

Simone Martini. London: Phaidon, 1988.

"Patrons and Minders: The Intrusion of the Secular into Sacred Spaces in the Late Middle Ages." In *The Church and the Arts*. Studies in Church History 28. Ed. Diana Wood. Oxford: Blackwell Publishers, for the Ecclesiastical History Society, 1991: 143–78.

Martines, Ruggero, ed. *La Cattedrale di Ravello e i suoi pulpiti*. Viterbo: Betagamma, 2001.

Mathews, Thomas. "'Private' Liturgy in Byzantine Architecture." *Cahiers archéologiques* 30 (1982): 125–37.

Mazzoleni, Jole. "*Maior Ravellensis ecclesia 1086–1986*." In *Atti della giornata di studio per il IX centenario della fondazione della Diocesi di Ravello, 1986*. Ravello: Associazione "Ravello Nostra," 1987, 35–43.

Melczer, William. *La porta di bronzo di Barisano da Trani a Ravello: Iconografia e stile*. Cava de' Tirreni: De Rosa & Memoli, 1984.

Meredith, Jill. "The Arch at Capua: The Strategic Use of *Spolia* and References to the Antique." In *Intellectual Life at the Court of Frederick II Hohenstaufen*. Ed. William Tronzo. Washington, DC: National Gallery of Art, 1994, 109–28.

Michael, Michael. "The Privilege of 'Proximity': Towards a Re-definition of the Function of Armorials." *Journal of Medieval History* 23 (1997): 55–75.

Michalsky, Tanja. *Memoria und Repräsentation. Die Grabmäler des Königshauses Anjou in Italien*. Göttingen: Vandenhoeck, 2000.

Middeldorf-Kosegarten, Antje. *Sienesische Bildhauer am Duomo Vecchio. Studien zur Skulptur in Siena, 1250–1330*. Munich: Bruckmann, 1984.

Miller, Maureen C. *The Bishop's Palace. Architecture & Authority in Medieval Italy*. Ithaca: Cornell University Press, 2000.

Moe, Nelson. *The View from Vesuvius. Italian Culture and the Southern Question*. Berkeley: University of California Press, 2002.

Moore, R. I. *The Formation of a Persecuting Society: Power and Deviance in Western Europe, 950–1250*. 1987. Oxford: Blackwell, 2000.

Mortet, Victor. "Hugue de Fouilloi, Pierre le Chantre, Alexandre Neckam et les critiques dirigées au douzième siècle contre le luxe des constructions." In *Mélanges d'histoire offerts à M. Charles Bémont par ses amis et ses élèves à l'occasion de la XXVe année de son enseignement à l'École Pratique des Hautes Études*. Paris: Félix Alcan, 1913, 105–37.

Moskowitz, Anita Fiderer. *Italian Gothic Sculpture, ca. 1250–ca. 1400*. Cambridge and New York: Cambridge University Press, 2001.

Murray, Alexander. *Reason and Society in the Middle Ages*. Oxford: Clarendon Press, 1978.

Musto, Ronald. "Queen Sancia of Naples (1286–1345) and the Spiritual Franciscans." In *Women of the Medieval World. Essays in Honor of John H. Mundy*. Ed. Julius Kirschner and Suzanne Wemple. New York and Oxford: Blackwell, 1985, 179–214.

"Franciscan Joachimism at the Court of Naples, 1309–1345: A New Appraisal." *Archivum Franciscanum Historicum* 90 (1997): 419–86.

Necipoğlu, Gülru. *Architecture, Ceremonial, and Power. The Topkapi Palace in the Fifteenth and Sixteenth Centuries*. Cambridge, MA: The Architectural History Foundation and MIT Press, 1991.

The Topkapi Scroll. Geometry and Ornament in Islamic Architecture. Topkapi Palace Museum Library Ms. H 1956. Santa Monica: Getty Center for the History of Art and the Humanities, 1995.

Nelson, Benjamin. "The Usurer and the Merchant Prince: Italian Businessmen and the Ecclesiastical Law of Restitution, 1100–1550." *Journal of Economic History* 7 (1947): 104–22.

Nitschke, August. "Karl II als Fürst von Salerno." *QFIAB* 36 (1956): 188–204.

Noonan, John T. *The Scholastic Use of Usury*. Cambridge, MA: MIT Press, 1957.

Pace, Valentino. "Aspetti della scultura in Campania." *Federico II e l'arte del Duecento italiano*. Atti della III Settimana di studi di storia dell'arte medievale dell'Università di Roma, 1978. Ed. A. M. Romanini. Galatina: Congedo, 1980, 301–24.

"Il programma decorativo nel XIII secolo." In *La Cattedrale di Sessa Aurunca*. Ed. Antonio Marcello Villucci, Mario d'Onofrio, Valentino Pace, and Francesco Aceto. Sessa: Centro Studi Suessa, 1983, 29–39.

"Scultura 'federiciana' in Italia meridionale e scultura dell'Italia meridionale di età federiciana." In *Intellectual Life at the Court of Frederick II Hohenstaufen*. Ed. William Tronzo. Washington, DC: National Gallery of Art, 1994, 151–78.

"Presenze europee dell'arte meriodionale. Aspetti della scultura nel 'Regnum' nella prima metà del XIII secolo." In *Il Gotico europeo in Italia*. Ed. Valentino Pace and Martina Bagnoli. Naples: Electa, 1995, 221–37.

Arte a Roma nel Medioevo. Committenza, ideologia e cultura figurativa in monumenti e libri. Naples: Liguori, 2000.

Pansa, Francesco. *Istoria dell'antica repubblica di Amalfi*. Naples: Lailardo, 1724. Reprint. Bologna: Arnaldo Forni, 1989.

Pastoureau, Michel. *Traité d'heraldique*. Paris: Picard, 1979.

L'hermine et le sinople: Études d'heraldique médiévale. Paris: Léopard d'Or, 1982.

Pavoni, Romeo. "Il mercante." In *Condizione umana e ruoli sociali nel Mezzogiorno normanno-svevo*. Atti delle none giornate normanno-sveve, Bari, 1989. Bari: Dedalo, 1991, 215–50.

Peduto, Paolo. "L'ambone della chiesa di San Giovanni a Toro di Ravello: L'uso della ceramica nei mosaici." *Apollo* 7 (1991): 103–9.

"Materiali arabo-islamici nella Ravello del secolo XIII. Eredità o moda?" In *Presenza araba e islamica*. Atti del Convegno sul tema, 1989. Ed. Agostino Cilardo. Naples: Istituto universitario orientale, 1992, 467–72.

"Un giardino-palazzo islamico del secolo XIII: L'artificio di Villa Rufolo." *Apollo* 12 (1996): 57–72.

Pellegrini, Luigi. "Territorio e città nell'organizzazione insediativa degli ordini mendicanti in Campania." *RSS* 5 (1986): 9–41.

Pirenne, Henri. "L'instruction des marchands au Moyen Âge." *Annales d'histoire économique et sociale* 1 (1929): 13–28.

Pirri, Pietro. *Il Duomo di Amalfi e il Chiostro del Paradiso*. Rome: Don Luigi Guanella, 1941.

Poeschke, Joachim. "Zum Einfluss der Gotik in Süditalien." *Jahrbuch der Berliner Museen* 22 (1980): 91–106.

Powell, James M. "Economy and Society in the Kingdom of Sicily under Frederick II: Recent Perspectives." In *Intellectual Life at the Court of Frederick II Hohenstaufen*. Ed. William Tronzo. Washington, DC: National Gallery of Art, 1994, 263–72.

Prandi, Adriano, ed. and dir. *L'art dans l'Italie méridionale: Aggiornamento dell'opera di Émile Bertaux*. Rome: École française de Rome, 1978.

Pryds, Darleen, N. "Clarisses, Franciscans, and the House of Anjou: Temporal and Spiritual Partnership in Early Fourteenth Century Naples." In *Clare of Assisi: A Medieval and Modern Woman*. Clarefest Selected Papers. Ed. Ingrid Peterson. St. Bonaventure, NY: The Franciscan Institute, 1996, 99–114.

Rabbat, Nasser O. *The Citadel of Cairo: A New Interpretation of Royal Mamluk Architecture*. Islamic History and Civilization, Studies and Texts 14. Leiden: Brill, 1995.

Radke, Gary. "Form and Function in Thirteenth-Century Papal Palaces." In *Architecture et vie sociale. L'organisation intérieure des grandes demeures à la fin du Moyen Âge et à la Renaissance*. Actes du colloque tenu à Tours, 1988. Ed. Jean Guillaume. Paris: Picard, 1994, 11–24.

"The Palaces of Frederick II." In *Intellectual Life at the Court of Frederick II Hohenstaufen.* Studies in the History of Art, vol. 44. Ed. William Tronzo. Washington, DC: National Gallery of Art, 1994, 179–88.

 Viterbo. Profile of a Thirteenth Century Papal Palace. Cambridge and New York: Cambridge University Press, 1996.

Raspi Serra, Joselita. *Amalfi, Montecassino, Salerno. Un corso fondamentale nella strutturazione e nel lessico dell'architettura'romanica.'* Salerno: Pietro Laveglia, 1979.

 "L'architettura degli ordini mendicanti nel Principato salernitano." *MÉFR* 93 (1981): 605–81.

Renouard, Yves. *Les hommes d'affaires italiens du Moyen Âge.* 1949. Paris: Armand Colin, 1968.

Renoux, Annie, ed. *Palais royaux et princiers au Moyen Âge.* Actes du colloque international tenu au Mans, 1994. Le Mans: Université du Maine, 1996.

Revault, Jacques. *Palais et demeures de Tunis, XVIII–XIX siècles.* Paris: Centre national de la recherche scientifique, 1971.

 Palais et résidences d'été de la région de Tunis, XVIe–XIXe siècles. Paris: Centre national de la recherche scientifique, 1974.

Riall, Lucy. "Which Road to the South: Revisionists Revisit the Mezzogiorno." *Journal of Modern Italian Studies* 5 (2000): 89–100.

Romanini, Angiola Maria, ed. *Federico II e l'arte del Duecento italiano.* Atti della III Settimana di studi di storia dell'arte medievale dell'Università di Roma, 1978. Galatina: Congedo, 1980.

 ed. *Roma anno 1300.* Settimana di studi dell'arte medievale dell' Università di Roma, 1980. Rome: L'Erma di Bretschneider, 1983.

Romano, Chiara Garzya. *La Basilicata, la Calabria.* Italia romanica. Vol. 9. Milan: Jaca, 1988.

Romito, Matilde, and Paolo Peduto, François Widemann, Sergio Vitolo, and Prisca Giovannini. "Villa Rufolo di Ravello: Le campagne di scavo del 1988–89." *RSS* 14 (1990): 253–87.

de Roover, Raymond. "The Scholastic Attitude toward Trade and Enterpreneurship." In *Business, Banking, and Economic Thought in Late Medieval and Early Modern Europe.* Ed. Julius Kirschner. Chicago: University of Chicago Press, 1974, 336–45.

Rudolph, Conrad. *The 'Things of Greater Importance.' Bernard of Clairvaux's Apologia and the Medieval Attitude toward Art.* Philadelphia: University of Pennsylvania Press, 1990.

Ruggles, D. Fairchild. "The Mirador in Abbasid and Hispano-Umayyad Garden Typology." *Muqarnas* 7 (1990): 73–82.

 Gardens, Landscape and Vision in the Palaces of Islamic Spain. University Park, PA: Pennsylvania State University Press, 2000.

Runciman, Steven. *The Sicilian Vespers. A History of the Mediterranean World in the Later Thirteenth Century.* Cambridge and New York: Cambridge University Press, 1958.

Said, Edward. *Orientalism.* New York: Random House, 1978.

 Culture and Imperialism. New York: Random House, 1993.

Sangermano, Gerardo. *Caratteri e momenti di Amalfi medievale e del suo territorio.* Amalfi: Centro di cultura e storia amalfitana, 1981.

 "Uomini di cultura e forme dell'arte nel Medioevo amalfitano e sorrentino." *RSS* n.s. 2 (1985): 109–32.

 "La storiografia." In *Scala nel Medioevo.* Atti del convegno di studio, 1995. Amalfi: Centro di cultura e storia amalfitana, 1996, 19–32.

Sapori, Armando. *Studi di storia economica medievale.* Florence: Sansoni, 1946.

Sarre, Friedrich. "L'arte mussulmana nel Sud d'Italia e in Sicilia." *Archivio storico per la Calabria e Lucania* 3 (1933): 441–8.

Sauerländer, Willibald. "Two Glances from the North: The Presence and Absence of Frederick II in the Art of the Empire; the Court Art of Frederick II and the *opus francigenum*." In *Intellectual Life at the Court of Frederick II Hohenstaufen*. Ed. William Tronzo. Washington, DC: National Gallery of Art, 1994, 189–209.

"Dal Gotico europeo in Italia al Gotico italiano in Europa." In *Il Gotico europeo in Italia*. Ed. Valentino Pace and Martina Bagnoli. Naples: Electa, 1995, 8–22.

Schiavo, Armando. "Villa Rufolo." *Le vie d'Italia* 46 (1940): 478–90.

Monumenti della Costa di Amalfi. Milan: Rizzoli, 1941.

Schneider, Jane, ed. *Italy's 'Southern Question': Orientalism in One Country*. Oxford: Berg, 1998.

Schulz, Heinrich Wilhelm. *Denkmaeler der Kunst des Mittelalters in Unteritalien von Heinrich Wilhelm Schulz*. Dresden: Schulz, 1860.

Schvoerer, Max, Claude Ney, Claire Raffaillac-Desfosse, and Paolo Peduto. "Bacini et tesselles en céramique glaçurée de l'église San Giovanni del Toro, Ravello." *Apollo* 8 (1992): 74–98.

Schwarz, Ulrich. *Amalfi im frühen Mittelalter (9.–11. Jahrhundert)*. Tübingen: Max Niemeyer, 1978.

Shalem, Avinoam. *Islam Christianized. Islamic Portable Objects in the Medieval Church Treasuries of the Latin West*. Frankfurt and Vienna: Peter Lang, 1998.

Shearer, Creswell. *The Renaissance of Architecture in Southern Italy. A Study of Frederick II of Hohenstaufen and the Capua Triumphator Archway and Towers*. Cambridge: Heffer, 1935.

Skinner, Patricia. *Family Power in Southern Italy: The Duchy of Gaeta and its Neighbours, 850–1139*. Cambridge and New York: Cambridge University Press, 1995.

Sombart, Werner. *Luxury and Capitalism*. 1922. Trans. W. R. Dittmar. Ann Arbor: University of Michigan Press, 1967.

Der Moderne Kapitalismus. 2 vols. Munich: Duncker and Humblot, 1919–28.

Staacke, Ursula. *Un palazzo normanno a Palermo, la Zisa: La cultura musulmana negli edifici dei Re*. Palermo: Comune di Palermo, 1991.

Starr, Joshua. "The Mass Conversion of Jews in Southern Italy, 1290–1293." *Speculum* 21 (1946): 203–11.

Sthamer, Eduard. *Die Bauten der Hohenstaufen in Unteritalien. Die Verwaltung der Kastelle im Königreich Sizilien unter Kaiser Friedrich II und Karl I*. Leipzig: Karl Hiersemann, 1914.

Die Bauten der Hohenstaufen in Unteritalien. Dokumente zur Geschichte der Kastellbauten Kaiser Friedrichs II und Karls I von Anjou, vol. 2: *Apulien und Basilicata*. Leipzig: Karl Hiersemann, 1926.

"Der Sturz der Familien Rufolo und Della Marra nach der sizilischen Vesper." *Abhandlungen der Preußischen Akademie der Wissenschaften* 3.iv (1937): 1–68.

Beiträge zur Verfassungs- und Verwaltungsgeschichte des Königreichs Sizilien im Mittelalter. Ed. Hubert Houben. Aalen: Scientia, 1994.

Swoboda, Karl Maria. *Römische und romanische Paläste. Eine architekturgeschichtliche Untersuchung*. Vienna: Schroll, 1959.

"The Problem of Iconography of Late Antique and Early Medieval Palaces." *JSAH* 20 (1961): 78–89.

Taviani-Carozzi, Huguette. *La Principauté lombarde de Salerne, IX–XI siècle. Pouvoir et société en Italie lombarde méridionale*. 2 vols. Rome: École française de Rome, 1991.

Thomas, John Philip. *Private Religious Foundations in the Byzantine Empire*. Washington, DC: Dumbarton Oaks, 1987.

Trachtenberg, Marvin. "Gothic/Italian 'Gothic': Toward a Redefinition." *JSAH* 50 (1991): 22–37.

Dominion of the Eye. Urbanism, Art, and Power in Early Modern Florence. Cambridge and New York: Cambridge University Press, 1997.

Travaini, Lucia. "I tarì di Salerno e di Amalfi." *RCCSA* 10 (1990): 7–71.

Tronzo, William. *The Cultures of His Kingdom. Roger II and the Cappella Palatina in Palermo.* Princeton: Princeton University Press, 1997.

Valentiner, W. R. *Tino di Camaino. A Sienese Sculptor of the Fourteenth Century.* Paris: Pegasus, 1935.

Vauchez, André. *Les laïcs au Moyen Âge. Pratiques et expériences religieuses.* Paris: Éditions du cerf, 1987.

Veblen, Thorstein. *The Theory of the Leisure Class. An Economic Study of Institutions.* 1889. Reprint, with the addition of a review by William Dean Howells. New York: Kelly, 1965.

Venditti, Arnaldo. "Scala e suoi borghi, i: Un insedimento medioevale sui monti amalfitani." *NN* (1962): 128–40.

"Scala e suoi borghi, ii: Un villaggio rudere: Pontone d'Amalfi." *NN* (1963): 163–76.

"Scala e suoi borghi, iii: Le chiese scalesi da Minuto a S. Caterina." *NN* (1963): 214–26.

"Scala e suoi borghi, iv: L'architettura della costiera amalfitana." *NN* (1963): 9–15.

Architettura bizantina nell'Italia meridionale. 2 vols. Naples: Edizioni scientifiche italiane, 1967.

"Urbanistica e architettura angioina." In *Storia di Napoli.* Vol 3. Naples: Società editrice Storia di Napoli, ca. 1970, 685–888.

Verdicchio, Paolo. "Reclaiming Gramsci: A Brief Survey of Current and Potential Uses of the Work of Antonio Gramsci." *Symposium* 49 (1995): 169–76.

Villari, Rosario, ed. *Il Sud nella storia d'Italia. Antologia della questione meridionale.* Bari: Laterza, 1972.

Vitale, Giuliana. "Nobiltà napoletana della prima età angioina. Elite burocratica e famiglia." In *Ricerche sul Medioevo napoletano: Aspetti e momenti della vita economica e sociale a Napoli tra decimo e quindicesimo secolo.* Ed. Alfonso Leone. Naples: Edizione Athena, 1996, 187–223.

Vitolo, Giovanni. *Città e coscienza cittadina nel Mezzogiorno medievale (sec. XI–XIII).* Salerno: Laveglia, 1990.

"'Vecchio' e 'nuovo' monachesimo nel regno svevo di Sicilia." *In Friedrich II.* Tagung des Deutschen historischen Instituts in Rom im Gedenkjahr 1994. Ed. Arnold Esch and Norbert Kamp. Tübingen: 1996, 182–200.

"Il monachesimo benedettino nel Mezzogiorno angioino: Tra crisi e nuove esperienze religiose." In *L'État angevin. Pouvoir, culture, et société entre XIIIe et XIVe siècles.* Actes du colloque international, Rome/Naples, 1995. Rome: École française de Rome, 1998, 205–20.

"La noblesse, les ordres mendiants et les mouvements de réforme dans le royaume de Sicile." In *La noblesse dans les territoires angevins à la fin du Moyen Âge.* Actes du colloque international organisé par l'Université d'Angers, 1998. Ed. Noël Coulet and Jean-Michel Matz. Rome: École française de Rome, 2000, 553–66.

Tra Napoli e Salerno. La costruzione dell'identità cittadina nel Mezzogiorno medievale. Salerno: Carlone, 2001.

Vitolo, Giovanni, and Alfonso Leone. "Riflessi della guerra del Vespro sull' economia della Campania." In *La società mediterranea all'epoca del Vespro.* XI Congresso di storia della Corona d'Aragona, 1982. Vol. 4. Palermo: Accademia di Scienze, lettere, ed arti, 1984, 433–42.

Volbach, W. F. "Ein antikisierendes Bruchstück von einer kampanischen Kanzel in Berlin." *Jahrbuch der Preußischen Kunstsammlungen* 53 (1932): 183–97.

"Oriental Influences in the Animal Sculpture of Campania." *AB* 24 (1942): 172–80.

Wagner-Rieger, Renate. *Die italienische Baukunst zu Beginn der Gotik*. 2 vols. Graz and Cologne: Hermann Böhlaus, 1956–7.

Walsh, David. "The Iconography of the Bronze Doors of Barisanus of Trani." *Gesta* 21 (1982): 91–106.

Wentzel, Hans. "Antiken-Imitationen des 12. und 13. Jahrhunderts in Italien." *Zeitschrift für Kunstwissenschaft* 9 (1955): 29–72.

"Portraits 'à l'antique' on French Mediaeval Gems and Seals." *Journal of the Warburg and Courtauld Institutes* 16 (1953): 342–50.

Wharton, Annabel Jane Epstein. *Art of Empire. Painting and Architecture of the Byzantine Periphery*. University Park, PA: Pennsylvania State University Press, 1988.

White, Alberto. "Il ciborio della Cattedrale di Ravello: Un'ipotesi ricostruttiva e qualche notazione." *Atti della Giornata di Studio per il IX Centenario della fondazione della Diocesi di Ravello, 1986*. Ravello: Associazione "Ravello Nostra," 1987, 175–89.

Widemann, François. "Primi risultati degli scavi archeologici condotti nel settembre 1988 nella Villa Rufolo di Ravello." *RCSSA* 9 (1989): 143–8.

"Le triptyque disparu de la Madonna della Bruna de la Cathédrale de Ravello." *Apollo* 7 (1991): 61–76.

"Giacomo Rufolo. Rôles et fonctions dans une famille patricienne de Ravello au XIIIe siècle." *Apollo* 12 (1996): 73–100.

"La Villa Rufolo de Ravello et ses propriétaires avant Nicola." *Apollo* 13 (1997): 93–110.

"Les Rufolo. Les voies de l'anoblissement d'une famille de marchands en Italie méridionale." In *La noblesse dans les territoires angevins à la fin du Moyen Âge*. Actes du colloque international organisé par l'Université d'Angers, Angers-Saumur, 3–6 Juin 1998. Ed. Noël Coulet and Jean-Michel Matz. Rome: École française de Rome, 2000, 115–30.

Willard, Henry M. *Abbot Desiderius and the Ties between Montecassino and Amalfi in the Eleventh Century*. Miscellanea Cassinese 37. Monte Cassino, 1973.

Willemsen, Carl Arnold. *Die Bauten der Hohenstaufen in Suditalien. Neue Grabungs- und Forschungsergebnisse*. Cologne: Westdeutscher Verlag, 1968.

Williams, Raymond. *Problems in Materialism and Culture. Selected Essays*. London: Verso, 1980.

The Sociology of Culture. Chicago: University of Chicago Press, 1981.

Zbiss, Slimane M. "Mahdiya et Sabra-Mansouriya. Nouveaux documents de l'art fatimide d'Occident." *Journal asiatique* 244 (1956): 79–93.

"Documents d'architecture fatimide d'Occident." *Ars Orientalis* 3 (1959): 27–31.

Zchomelidse, Nino. "*Amore virginis* und *honore patria* – Die Rufolo Kanzeln im Dom von Ravello." *Analecta romana instituti danici* 26 (1999): 99–117.

INDEX

Acre, 31
 Amalfitans in, 72
 fall of, 191
Alphanus, archbishop of Salerno, 168
Amalfi (town)
 Cathedral (general), 4, 124, 152
 bronze doors, 13, 21, 119, 167
 Cloister of Paradise, 61, 67, 91, 104,
 204
 Bell Tower, 57, 89, 146–147, 156
 Amalfi Crucifixion, 210–212, 230
 economic decline, 33
 foundation myths, 51–52
 Ruga bathing chamber, 106
 San Pietro, 91
 urban form and housing, general, 52–56,
 91
 Vallenula House, 91
Apulia, Amalfitan settlement in, 30–31
Arnolfo di Cambio, 222
Atrani
 Santa Maria Maddalena, 204
 urban form and housing, general, 52–56,
 91
Augustariccio, Filippo, archbishop of Amalfi,
 187, 204

bacini, see ceramics; Iran; Syria
Barisano of Trani, 13, 129, 140

Barletta
 Amalfitans in, 30
 housing in, 51, 54, 60, 109–110
 Santa Maria Maggiore, 31
Bartolomeo of Capua, 192
bathing chambers, 97, 202
Benjamin of Tudela, 37
Bertaux, Émile, 15–17, 61, 65–66
Bertini, Pacio and Giovanni, 220
Boccaccio, Giovanni, 4–6, 8–9, 196
Bolvito, Giovanni Battista, 12, 27, 47–48,
 60–61, 83, 118, 128
Bougie (Bigaya), 50

Cairo
 Amalfitan merchants in, 9, 30, 96
 Citadel of, 76
 Fatimid Eastern Palace, 82
Capua
 Amalfitans in, 30
 Capuan Gate, 51, 182
 currency used in, 9
 housing in, 51, 60, 109
Caracciolo, Landolfo, archbishop of Amalfi,
 194, 203–205, 211
Caserta Vecchia, 100, 232
Castel del Monte, 65, 84, 182
Castellomata family, 21, 28, 35, 119, 120, 133
Catherine of Alexandria (saint), 216–222

Cavallini, Pietro, 12, 66, 191, 198, 208, 211, 214, 230

Cennini, Cennino, 217

ceramics
 imported to Italy, 34
 used in mosaics, 124, 156–164

Charles I, and
 administration of kingdom, 20, 33, 34, 40–41, 43
 artistic patronage, 19, 115, 144, 172–174, 186
 imperialist policies, 19–21, 35, 38
 Rufolo family, 7, 29, 31–33

Charles II (Charles of Salerno), and
 administration of kingdom, 43, 44
 arrest of Rufolo/Della Marra men, 7, 24, 38–39, 42–44
 artistic patronage, 172, 194–195, 204
 cult of Mary Magdalen, 204
 religious minorities, 236, 237
 Rufolos, 32, 35
 Vespers rebellion, 40–41

Constantinople
 Amalfitan activities in, 9, 13, 30
 Great Palace of, 76
 impact on Amalfitan arts, 4, 13, 14, 21, 133

Constitutions of Melfi, 19, 36

Coppola, Antonio, 226, 228–229, 238
 heraldry of, 177

Coppola, Marinella Rufolo, see Rufolo, Marinella (Coppola)

Coppola, Marinella Rufolo, tomb of, see Scala, Cathedral

Coppola polyptych (Altarpiece of the Assumption), 6, 45, 228, 230

Cosenza, Cathedral of, tomb of Isabelle of Aragon, 220

Croce, Benedetto, 16–18, 209

d'Afflitto family, 71–72
 heraldry, 170, 176
 patronage, 13, 28, 121, 128

political and ecclesiastical activities, 32, 194

Dante Alighieri, 43

De Dominici, Bernardo, 208

Della Marra family, 31–32
 Anna, 182
 arrests, 38
 Egidia, 109

Desiderius of Monte Cassino (Victor III), 21, 118, 136, 168, 176

domestic architecture, Amalfitan
 basic features of, 103
 diversification of space in, 103

Eudes of Châteauroux, 237

Farfa Casket, 13, 167

Florence, see Tuscany

Freccia family, 32, 69, 124, 167, 177, 223

Freccia, Marino, 27, 48, 74

Freccia, Sapia de Vito, tomb slab of, 175, 223

Frederick II, and
 administration of kingdom, 31–32
 Amalfi and Amalfitans, 19, 30
 patronage of, 115, 143, 172, 180, 183
 religious and linguistic minorities, 20, 236
 residences of, 50, 84–86, 102, 177, 182

genealogy, cultural importance and expressions of, 25–26, 168–169

Giordano of Pisa, 111, 236

Giotto, 12, 66, 191, 196, 198, 206, 211, 214, 226, 228–229, 238

Giovinazzo, 30, 31

Gramsci, Antonio, 23, 64

Granada, Alhambra, 76, 94

heraldry, 164, 169, 186, 226

Hugonis de Folieto, 111

Iacobo of Benevento, 36, 111

Ibn Hawqal, 9

inscriptions, dedicatory /genealogical, 164–169, 186
intarsia, 57, 75, 82, 87, 88, 91–96
Iran, ceramics from, 158
Isabelle of Aragon, tomb of, *see* Cosenza, Cathedral

Jacopo da Varagine, 216, 218, 226, 228–229, 234
Jephonias, 234, 238
Jews in southern Italy, 7–13, 30, 43
 anti-Jewish sentiment, 234

Lagopesole, 182
Leo Marsicanus (bishop of Ostia), 21–22
liturgical objects and vestments, 126, 131, 140, 152, 170
Louis IX of France, 33, 50
Louis of Toulouse (saint), 172, 196, 219
Lucera, 34, 44, 94, 102, 172, 236–237
luxury, medieval critiques of, 110

Mahdiyya, 21, 50, 82, 105, 114
Malaspina, Saba, 41
Manfred, 32, 39, 187
Mary Magdalen, cult of, 204–205, 211, 213, 216, 219
Mary of Hungary, 174, 210, 219
Matteo of Narni, 144–152, 166, 184, 185
mercatantia (as cultural concept), 5–6, 10–11, 13, 15, 30, 69, 168–169, 183, 241
Messina, 30, 38, 112
Minori, 27, 52–56, 60
Minuto, Church of SS. Annunziata, 199–203
 crypt wall paintings, 162
 pulpit, 199, 200
misura, 112, 189
Monreale, Santa Maria la Nuova in, 62, 128, 140
Monte Cassino, 13, 21–22, 123, 135, 168, 176, 184
Monte Sant'Angelo, 13, 184

mosaic(s), 139, 146–147, 153, 156, 170, 176, 183
Muscettola family, 7–13, 28, 121, 127, 140, 167, 187
Muslims in southern Italy, 7, 10, 30, 34, 43, 44, 64, 94, 102, 114
 Violence against, 232–237

Naples
 Amalfitans in, 30, 45, 134, 192
 as cultural-artistic center, 12, 45–46, 172, 191, 192, 238
 royal tombs in (general), 231
 Castel Nuovo, 85, 207, 229, 234
 Santa Chiara, 172, 191, 193, 206, 210, 211, 218, 220
 San Domenico, 191, 193, 214
 San Lorenzo, 45, 228
 Santa Maria Donna Regina, 210–212, 218, 219
 San Martino, 234
 San Pietro a Maiella, 215
Nicola (di Bartolomeo) of Foggia, 143, 146, 165, 177, 181, 183, 184, 197
Nicola of Monteforte, 185
Nicola Pisano, 66, 143
Normans, and
 Amalfi, 19, 21, 26, 27, 30, 69
 Amalfitan art, 21
 ecclesiastical policies, 138
North Africa (general)
 Amalfitan commerce in, 30, 50–94
 art and architecture in, 81–82, 94
 ceramics from, 157
 impact on Italian art and architecture, 14, 21, 89–90, 100, 114

Orientalism, 62–67

Palermo
 Amalfitans in, 30
 Cuba, 105

Palermo (*cont.*)

 Cubula, 62, 82

 heterogeneous population, 43

 Norman tombs, 128, 231

 Zisa, 82, 105

Pantaleo of Maurus Comite, 13, 21, 119, 167

Pastena, housing in, 105

Peter of Durazzo, bishop of Ravello, 187, 188

Peter the Chanter, 111

Pironti family, 32, 121, 126–127, 187

Pisa, housing in, 109

Pogerola, San Michele Arcangelo in, 21, 119,
 133–134, 188

Pontone

 d'Afflitto House, 68, 71–73, 78, 82, 87, 97,
 103

 Sant'Eustachio, 21, 72, 128–133, 170, 188

 San Giovanni, 176, 199

 urban form and housing, general, 52

portraiture, 177

private churches

 in Amalfi, 117–120, etc. (ch. 3)

 in general, 117–118

 Byzantine, 133

Qal'ah of the Beni Hammad, 105

Qayrawan, 21, 81, 89, 96, 100

Quatrario family, 204–205

Questione del Mezzogiorno, see Southern
 Question

Ravello, general, 1

 Cathedral, general, 7, 12, 21, 135

 foundation of diocese, 30, 136–139, 186

 Rogadeo ambo, 139–140, 142, 149, 157,
 168

 Rufolo pulpit, 7, 12, 136, 140, 142–152,
 156–157, 165–166, 170, 177, 186

 ciborium, 7, 12, 136, 140, 144, 152–157,
 166–167, 170, 184–185

 bronze doors, 13, 127, 167

 crypt pavement, 170

Confalone House, 68, 89, 90

d'Afflitto House (Hotel Caruso), 131

Rufolo House, 7, 11, 42, 47, 57, 60–62,
 68–71, 77, 78, 82–83, 88, 98, 103,
 183, 187, 189

San Giovanni del Toro, 21, 28, 106,
 121–128, 187, 212–222

 Bove pulpit, 13, 124, 153, 157, 163,
 212–216, 218

 chancel screen, 165–169

 Dormition fresco, 234

 St. Catherine relief, 124

Santa Chiara, 175, 223

Santa Maria in Gradillo, 21, 106

South Toro House, 68, 75, 87, 98, 103

urban form and housing, general, 52, 56

Regina, Giovanni, 232–234

relics, around Amalfi, 4–15, 132

Remigio de'Girolami, 37

Robert (the Wise) of Anjou, general, 172,
 194, 196

 patronage of, 196, 206–208, 231

 piety of, 219–220

 relations with religious minorities, 237

 relations with Spiritual Franciscans, *see*
 Spiritual Franciscans

Roberto d'Oderisio, 12, 45, 205–206,
 208–210, 229–230, 234

Rogadeo family, general, 31, 69

 Constantine, bishop of Ravello, 139,
 149

 patronage of, 28, 121

Rome

 heraldry in, 171

 San Crisogono, 171

 San Paolo fuori le Mura, 13, 180

 Santa Maria Maggiore, 222

 SS. Giovanni e Paolo, 159

 tombs, general, 232–237

Rufolo

 Anna Della Marra (Rufolo), *see* Della
 Marra, Anna

Bernardo, 33
Giovanni, bishop of Ravello, 27–28, 140, 185, 188
Iacopo, 32, 34, 39, 147, 174, 193
Lorenzo, 6, 24, 32, 38–39, 166, 174
Marinella (Coppola), 7, 226, 238
Matteo, 7, 24, 31–35, 38–40, 45, 136, 144, 147, 166, 169, 174, 184, 187
Mauro, 147
Nicola, 7, 31–32, 34, 35, 69, 136, 143, 147, 165, 169, 170, 174, 175, 179, 183
Orso, 32–34, 39, 147, 174
Sigilgaita, 179, 182
Rufolo family
early history and family members, 27
late history and family members, 45–46, 149, 193, 224, 225
patronage, general, 140–142, 174

Salerno
Cathedral of, 124, 131, 140, 142, 144, 168, 179, 186
housing in, 57
religious violence in, 236
San Domenico, 91
San Francesco, 222
School of, 102
Sancia of Mallorca
patronage, 172, 210
piety of, 219–220
relations with Spiritual Franciscans, see Spiritual Franciscans
Sasso family, 74
Scala
Cathedral (general), 7, 12
Tomb of Marinella Rufolo Coppola, 7, 12, 45, 198, 225–228, 230, 231–234
"Palazzo Mansi," 68
San Giacomo, 74
Sasso House, 68, 73–75, 77, 80, 86

Trara House, 68, 80, 98, 103
urban form and housing, general, 52, 56, 68
Seggio or seggi, 183
Sessa Aurunca, 89, 183
Simone Martini, 172, 208
Sombart, Werner, 15
Southern Question (Questione del Mezzogiorno), 16–18, 33, 64–67, 208–209, 239
Spina family, 176, 199–200, 202, 216, 223
Spiritual Franciscans, 196, 203, 219
spolia, 57–58, 87, 184
stucco, 87, 104, 192, 198, 201–203, 216–218, 222, 226, 231–232, 234, 239
sumptuary laws, 38, 112–113, 189
Syria, ceramics from, 157–158

Tino di Camaino, 196, 198, 207, 220, 231, 233
Trani, religious violence in, 236
Trara family, 192–193
Tripoli of Syria, 31, 32
Tunis
Amalfitans in, 50
art and architecture in, 50–94, 100, 114
Crusade against, 33, 50
Tuscany (including Florence),
historiographical importance of, in accounts of merchant culture, 4–15
art history, 9, 65, 208–209
economic history, 9
Tuscany, housing in, general, 68

usury, 35–37

Vasari, Giorgio, 65, 208–210
Veblen, Thorstein, 22, 51, 177
Vespers, Sicilian, 7, 40–44, 66, 112

William of Apulia, 9